Helga Möbius

Woman of the Baroque Age

Abner Schram · Montclair

Translated from the German
by Barbara Chruscik Beedham

ALLANHELD, OSMUN & CO. PUBLISHERS, INC.
Totowa, New Jersey

ABNER SCHRAM LTD.
Montclair, New Jersey

Published in the United States of America in 1984
by Allanheld, Osmun & Co. (A Division of Littlefield, Adams & Co.)
80 Adams Drive, Totowa, N.J. 07512 and by Abner Schram Ltd.,
36 Park Street, Montclair, N.J. 07042

Designed by Volker Küster

83 84 85 / 10 9 8 7 6 5 4 3 2 1

Printed in the German Democratic Republic

Contents

INTRODUCTION

WE SHALL DISCUSS THE SEVENTEENTH AND EIGHTEENTH CENTURIES, AN AGE OF EXTREME CONTRADICTIONS, IN THIS BOOK.

They are manifest in all spheres of life. The unbelievable luxury of the wealthy contrasted starkly with the total misery of the impoverished. The various religious sects split into camps that were fanatically hostile to each other; believers attributed supernatural powers to the holy, and equated all that was unholy with the devil, whose works were to be condemned, not redeemed. Unlimited power was concentrated in the hands of a few, and ultimately in one person, the King. The people were at the mercy of his judgment. Their ignorance and dulled intelligence contrasted with the simultaneous emergence of modern science. So, too, did the development of highly sophisticated social conventions and thriving art and culture contrast sharply with the complete degeneration of morals and feelings in people who had been utterly brutalized by constant war. This polarization of events pointed to a collapse of the system, but nothing happened. On the contrary, feudal or absolutist society, with its extremely rational structure, was capable of absorbing these conflicts, of controlling the contradictory forces as well as generating them. It was an era both of perfection and decline.

The reasons behind this acute polarization are well known. Methods of producing goods were becoming increasingly bourgeois or capitalist in character at the very time that feudal absolutism was reaching its peak. In the most advanced countries of Europe, though the form differed from country to country, complex systems of confrontation and cooperation between the various social forces emerged. The first bourgeois republic was founded in Holland by a small class of wealthy burghers, who turned the country for a short time into a leading economic power. In France the stable centralized power of the monarchy made alliances with the bourgeoisie, effectively encouraged the growth of productive forces, and reaped impressive benefits from this policy. Both countries were extremely influential in the seventeenth century. In cultural and intellectual spheres, the greatest influence was still exerted by Italy and Spain, the major powers of the Renaissance. This was due mainly to the aggressive nature of Catholicism, which had to defend itself against the Reformation. Their economic and political decline could not go unnoticed, however. The Spanish monarchy missed a chance for economic development through its failure to imitate the French monarch's alliance with the bourgeoisie. Nevertheless, Spain could still be regarded as an important European power because of its rich southern Dutch

provinces and American colonial empire. Italy, like Germany, lacked a tightly centralized power structure, and the fact that both countries were split into many tiny states prevented their achieving any significant economic progress. With the English Revolution in the middle of the seventeenth century, England was preparing to take the lead in European social development. In the countries of eastern Europe political and economic processes had not yet reached a stage that could be described as "baroque" in the West European sense.

All this applies to the seventeenth century. When, in the chapters that follow, the seventeenth and eighteenth centuries are treated as a unit, one must constantly bear in mind that the two periods do in fact differ greatly from one another. In the seventeenth century, the economic and, even more, the social processes essentially were still linked with the fundamental upheavals of the preceding century—the conflict between early bourgeois revolution and the emergent feudal absolutism, between Reformation and Counter-Reformation. The eighteenth century, however, was, in essence, much more obviously a part of the bourgeois epoch, which began with the outbreak of the French Revolution. In the eighteenth century, the nature of the social and economic changes taking place in individual countries became much more evident. It became clear, for example, that the Dutch bourgeoisie was not capable of full capitalist development and that the political leadership of Italy, Spain, and Germany was sterile. The most positive steps in developing a strong bourgeoisie were made by the people of England and France, where the differences between the seventeenth and eighteenth centuries, in terms of social relationships, show up most sharply.

If we trace the many different and conflicting developments of this epoch by examining one particular problem, their effect on women, our view may be deemed limited. Nonetheless, a look at the position of women in a society and the way they act can highlight the general efforts being made at the time toward the emancipation of the human race. "Social progress can be measured exactly by the social position of the fair sex," wrote Karl Marx (letter to Ludwig Kugelmann dated 12/12/1868). This is particularly true of the seventeenth and eighteenth centuries. But the confusion and contradictions also encompassed the relationship between men and women and the structure of their social relations. This does not make it easy to determine the real level of human attainment open to women in the period between the end of the sixteenth and the end of the eighteenth centuries.

In the following chapters we will try to outline what life for women was really like in the various social groups. Without doubt, the information most readily available to us concerns women who were from the aristocracy or who were at court. However, for a long time now, especially in recent years, research in the social sciences and in economics has been dealing with working women. It has found that female labor in manufacturing, agriculture, and home work made a substantial contribution to the emergence of bourgeois productive forces. It was left to upper-class women, as a result of their way of life, to establish the intellectual and cultural preconditions for the ensuing struggle for equal rights with men. The nineteenth century saw the beginning of this struggle. The emergence of women as more independent individuals owed as much to women working in the most deplorable of conditions as it did to their richer contemporaries. At both extremes, women's material dependence on men was gradually weakening. The process started in the sixteenth century, but it should be noted that the seventeenth century seemed to move in the wrong direction in so far as real opportunities for women's development and self-awareness were concerned. It was only in the eighteenth century that women, especially in France and England, could further their emancipation to whatever extent the society of the day permitted.

Eduard Fuchs wanted to pinpoint the position of woman in society when in 1910 he referred to the eighteenth century in his *Illustrierte Sittengeschichte* (39) (Illustrated history of customs) as "the classical epoch of woman" in which she is proclaimed "the mighty ruler in all spheres" and is worshipped as a cult figure. He propounds the theory, which he immediately develops in great depth, that at the same time this epoch imposed "the most profound human degradation" on women. In 1964 his attempts to illustrate the wide-ranging contradictions were taken up by Jean Starobinski, whose social analysis of the eighteenth century views the "apparent dominance of women" as being based on the "rhetoric of self-confessed pretence" in a "mode of expression in which the reality of life and the tricks of language unfold at a respectful distance from one another." (113)

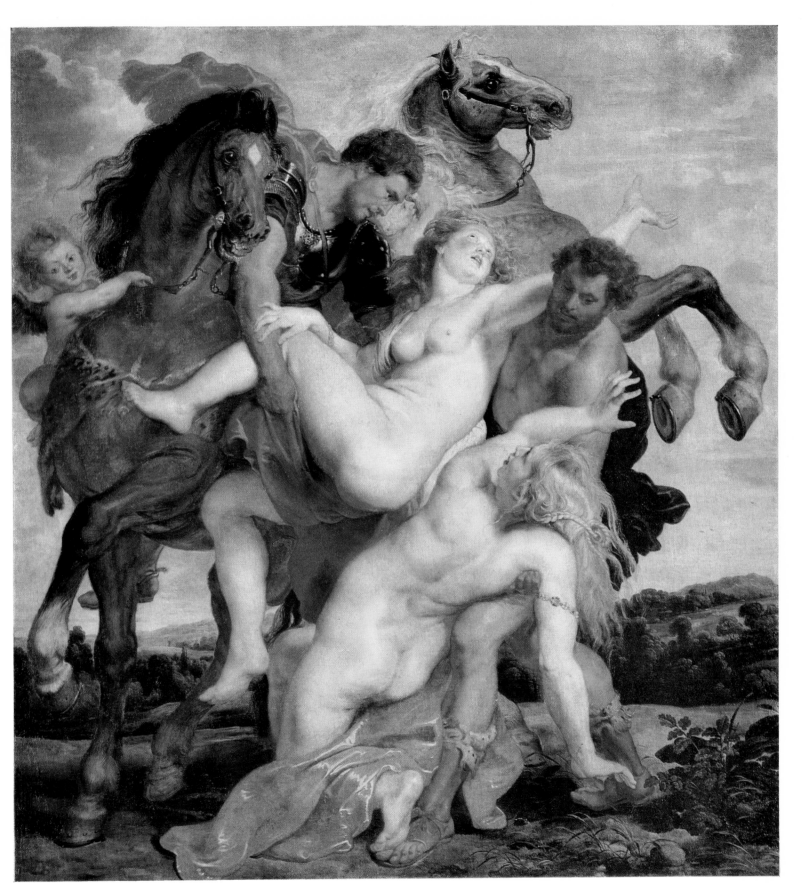

‹1› This ritualistic display of beauty celebrates the triumph of women, although the scene
here portrays their defeat in the face of male strength. A vivid relationship
between the sexes emerges from the storm of sumptuous colors and movements.

Peter Paul Rubens, *The Rape of the Daughters of Leucippus, c.* 1618.
Oil on canvas, 222 × 209 cm. Alte Pinakothek, Munich

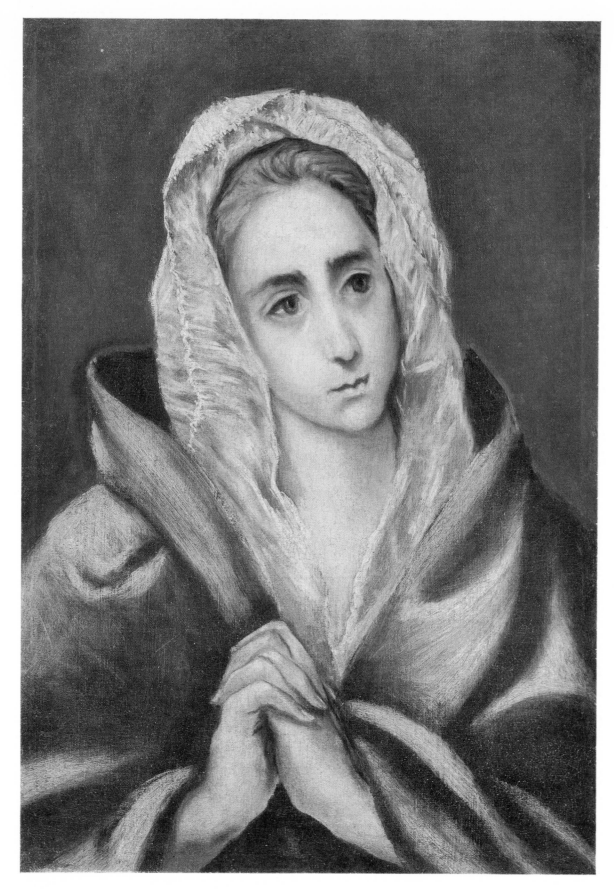

‹2› The greatly desired perfection of the spirit emerges from voluntary submission to
religious order and mystic abandon to it. This characteristically dignified
devotional painting reveals the visionary beliefs of the woman, devoutness and piety.

El Greco, *Mater Dolorosa*, *c.* 1590.

Oil on canvas, 63 × 48 cm. Staatliche Museen Preussischer Kulturbesitz, Berlin (West)

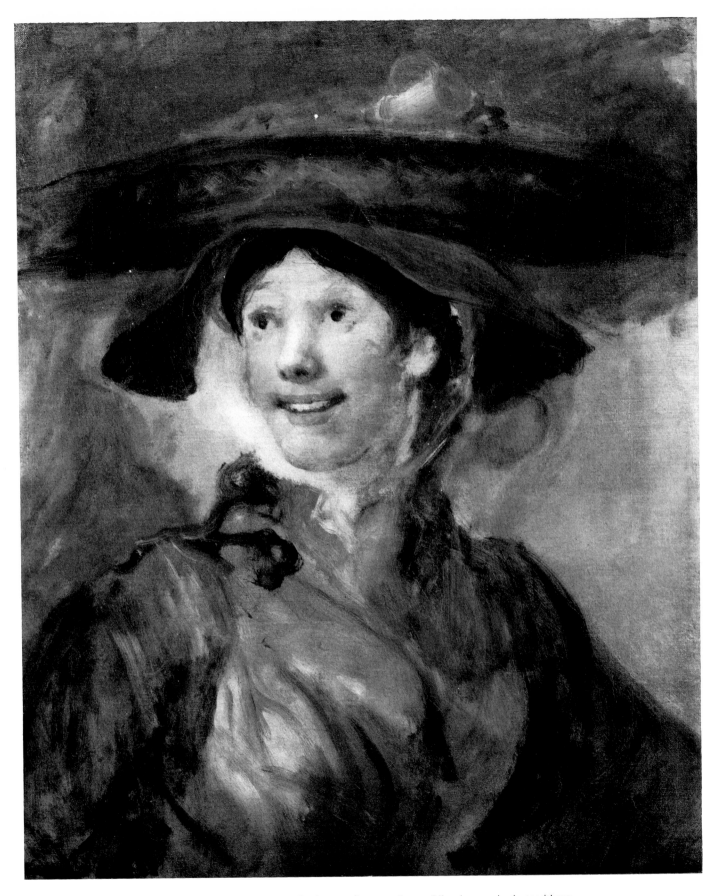

‹3› Her fresh face shows her to be the sort of person who can follow her own instincts without
the constraints of rank and morals. The informality of her behavior was regarded by contemporaries as vulgar,
but Hogarth had discovered new subjects and had entered new ground in painting.

William Hogarth, *The Shrimp Girl*, c. 1745.
Oil on canvas, 63.5 × 52.5 cm. National Gallery, London

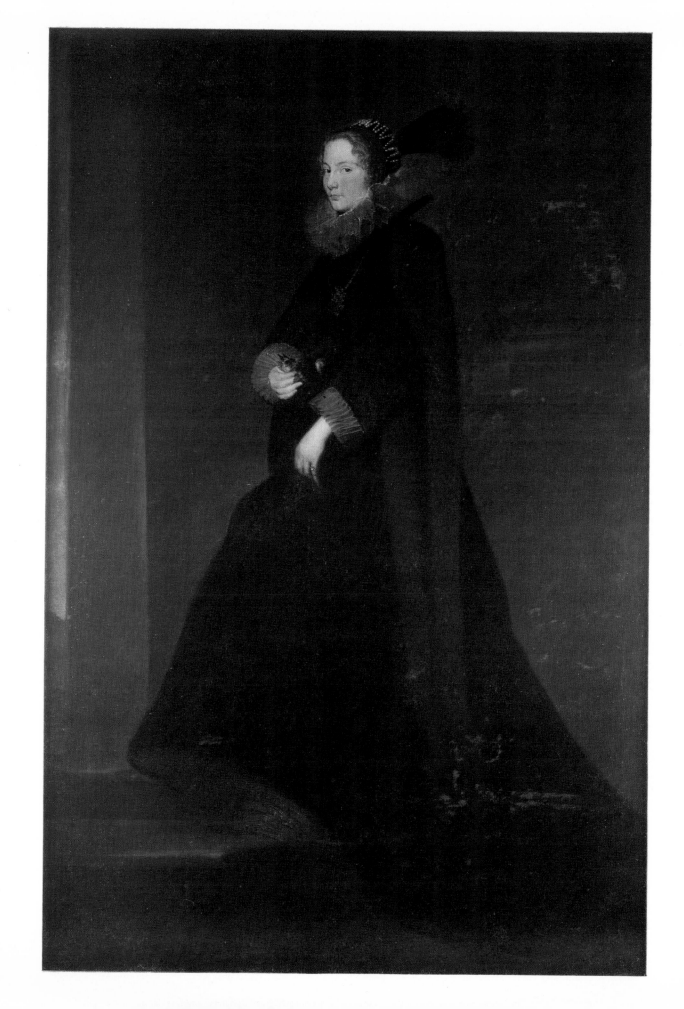

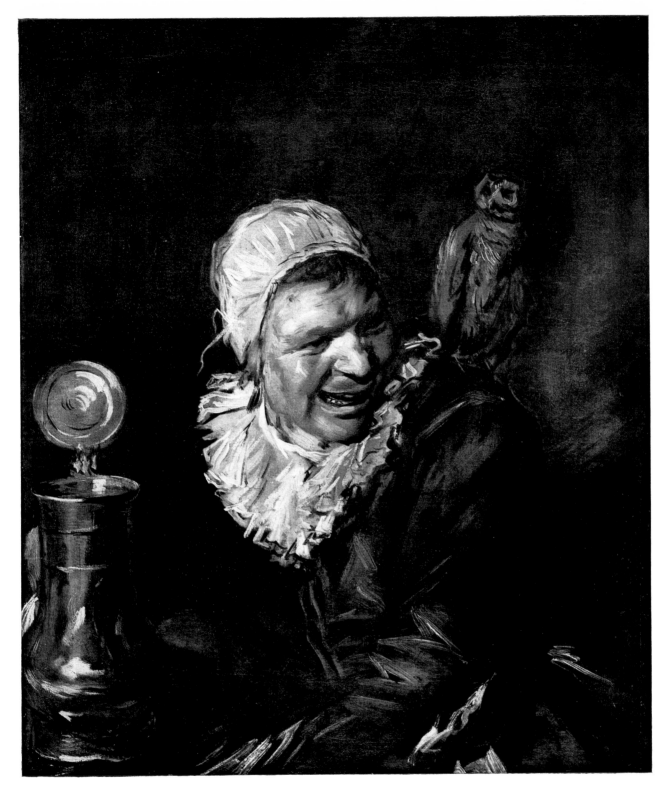

‹4› Exclusive simplicity and adherence to strict etiquette were the ideals of aristocratic women.
This is strangely contrasted by the charming vitality of her face.

Anthonis van Dyck, *Marchesa Geronima Spinola*, *c.* 1625.
Oil on canvas, 221 × 147 cm. Staatliche Museen Preussischer Kulturbesitz, Berlin (West)

‹5› The Witch of Haarlem was held up as an example of the madness that
resulted from alcoholism. Malle Babbe, however, gained her inner freedom and satisfaction from it.

Frans Hals, *Malle Babbe*, 1630s.
Oil on canvas, 75 × 64 cm. Staatliche Museen Preussischer Kulturbesitz, Berlin (West)

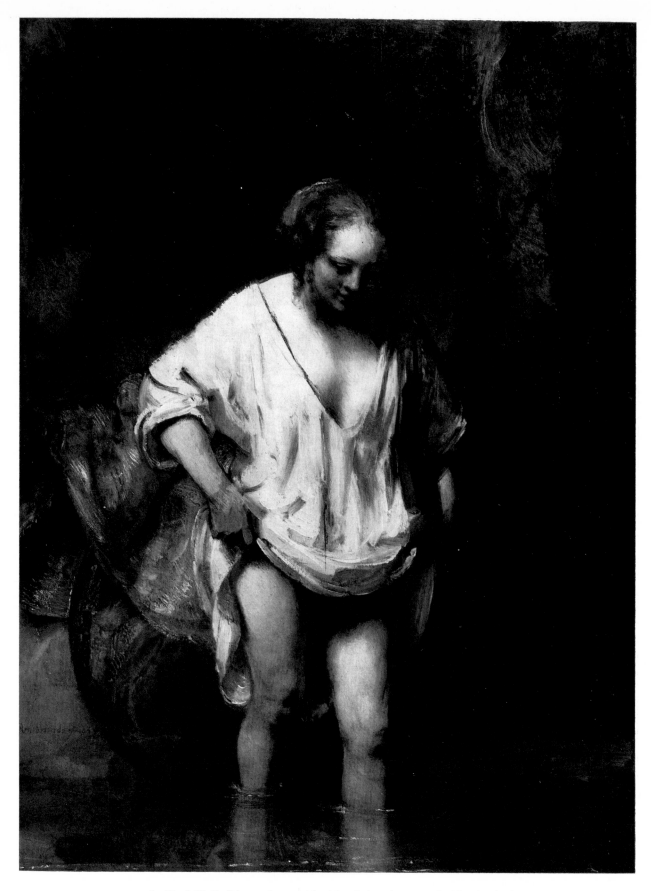

‹6› Hendrikje Stoffels was the model for this painting of a woman bathing, inspired
by the story of Bathsheba. The theme is, however, overshadowed by the natural sensuousness of the woman,
who is totally engrossed in her sensations of the moment.

Rembrandt Harmensz van Rijn, *Woman Bathing*, 1655.
Oak, 61.8 × 47 cm. National Gallery, London

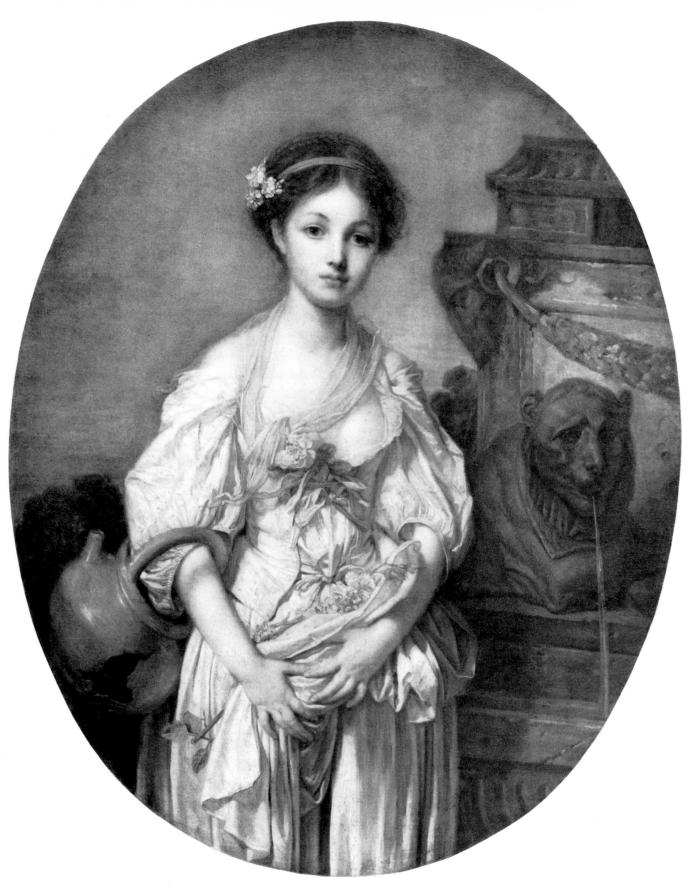

‹7› This moralizing allegory of lost innocence is full of ambiguity—sentimental and didactic,
naive and coquettish, pleasing and prudish.
It was popular as a contrast to the frivolous culture of the Rococo.

Jean-Baptiste Greuze, *The Broken Pitcher*, c. 1770.
Oil on canvas, 108 × 86 cm. Louvre, Paris

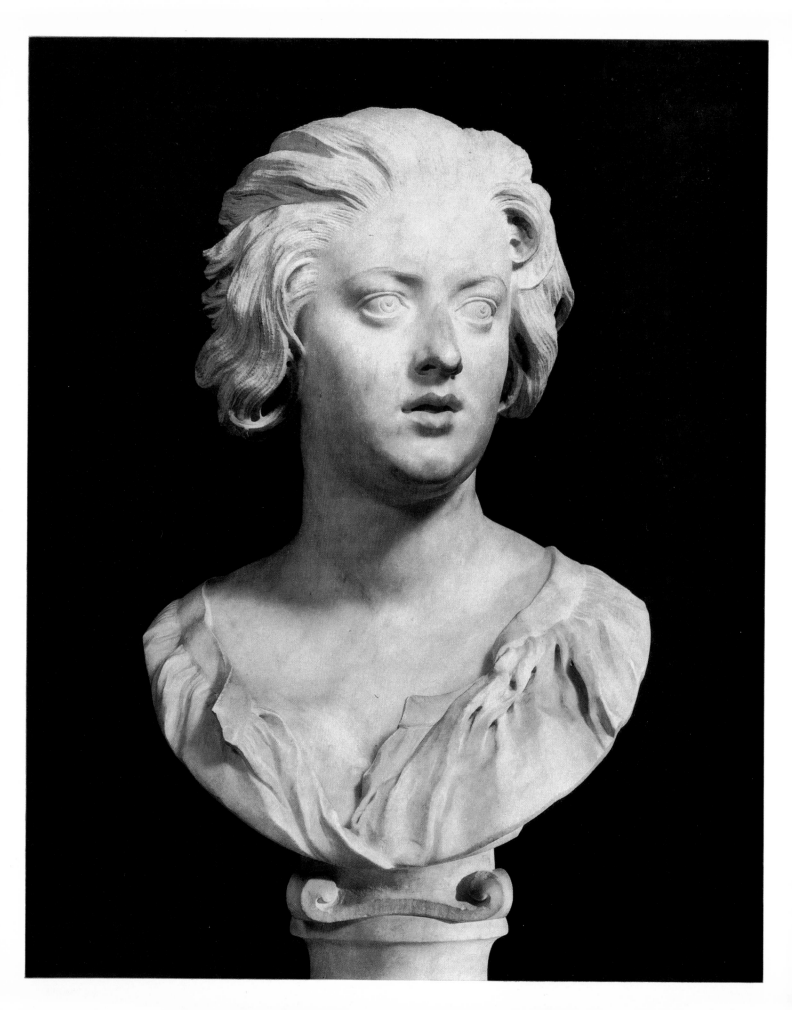

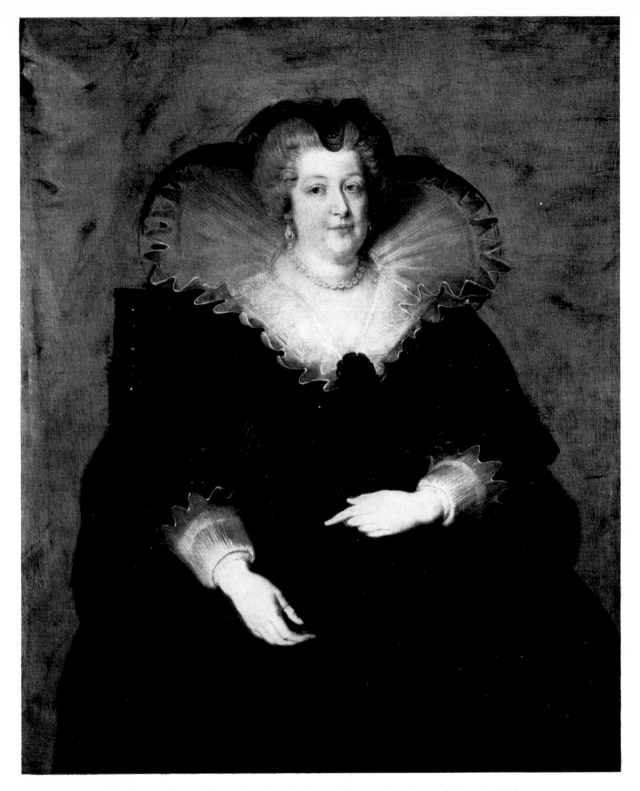

‹8› Costanza Buonarelli was the sculptor's mistress. Unconventional external simplicity heightens
the level of feeling emanating from this lovingly sculpted head.
This vivid "talking" pose expresses a great stir of emotion.

Giovanni Lorenzo Bernini, *Bust of Costanza Buonarelli*, *c.*1635.
Marble, height 70 cm. Museo Nazionale, Firenze

‹9› After the death of Henry IV in 1610 Marie de Medicis became regent for her son Louis XIII.
The portrait shows her in a majestic attitude and in the tranquil official
setting of power, which she had actually lost several years earlier.

Peter Paul Rubens, *Marie de Medicis*, 1622.
Oil on canvas, 130 × 108 cm. Prado, Madrid

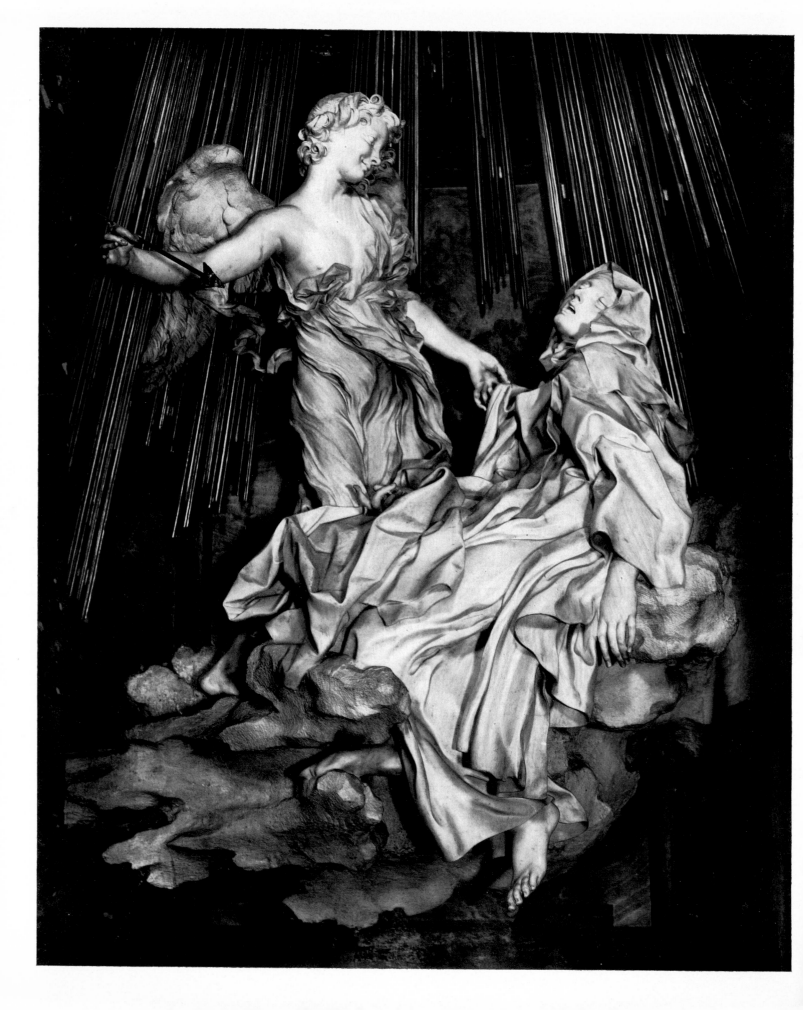

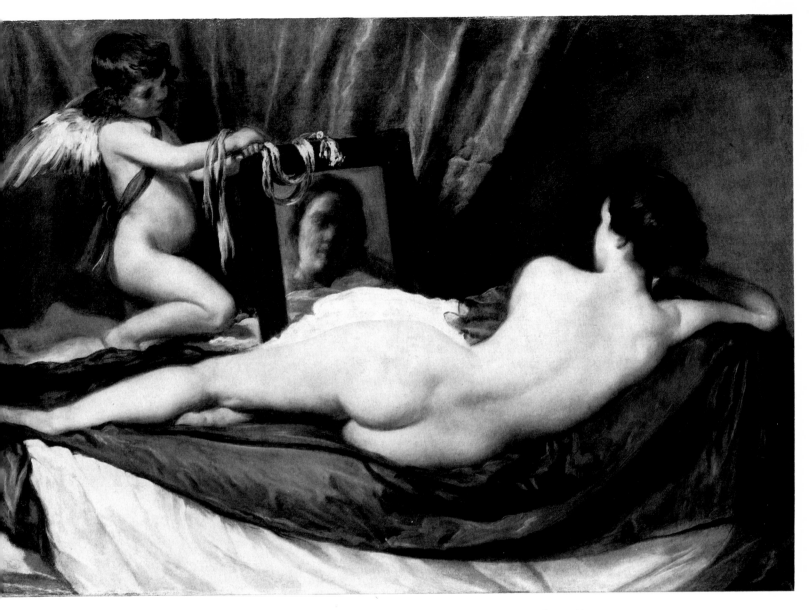

‹10› With the body and robes displaying flickering restlessness, Bernini captured something
very difficult to portray—the essence of spiritual and sensual love,
the enraptured abandon to God, where mysticism and eroticism are in equal balance.
St. Theresa also described her spiritual ecstasies using concepts of physical love. With stirring
sensuousness this Baroque sculpture attempts to recreate the force of violent emotion in religion.

Giovanni Lorenzo Bernini, *Ecstasy of St. Theresa*, 1644–1652.
Marble, life-size. Santa Maria della Vittoria, Rome

‹11› The portrayal of Venus with her back to the viewer indicates abstinence from sensual pleasure.
By holding back Velázquez made his painting even more alluring in the
delicate rhythm of her curves and the glimpse of her face in the mirror.
The ingenious interplay of enticement and denial has a very personal touch about it.

Diego Velázquez, *Toilet of Venus*, c. 1650.
Oil on canvas, 122.5 × 177 cm. National Gallery, London

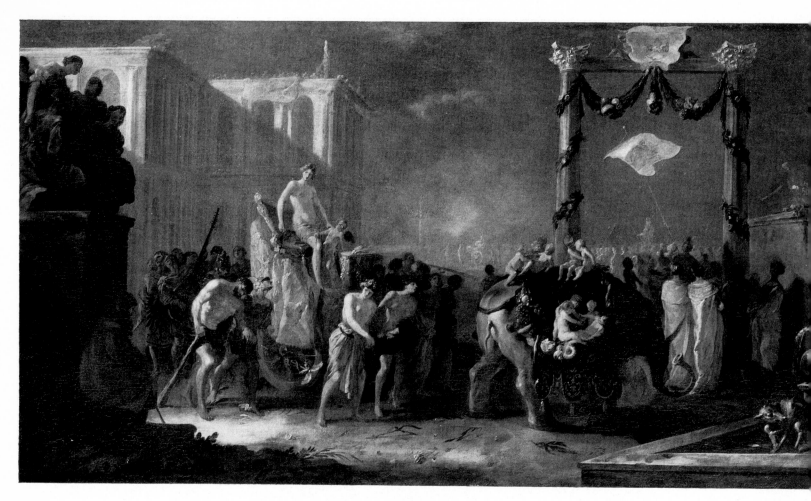

‹12› Magnificent processions bringing to life scenes from history and mythology were an
inherent part of Baroque festivities. The overwhelming vitality of the triumphal procession for the goddess of love escapes into
the makebelieve world of the theater, bathed in a magical light. The realm of love is at the same time immediate and unreal.

Johann Heinrich Schönfeld, *Triumph of Venus, c.* 1640/42.
Oil on canvas, 70 × 123 cm. Staatliche Museen Preussischer Kulturbesitz, Berlin (West)

‹13› A pensive atmosphere pervades the simple scene which is made complete with a ceremonial tone.

Jan Vermeer van Delft, *Lady Reading a Letter at an Open Window, c.* 1662/63.
Oil on canvas, 83 × 65 cm. Staatliche Kunstsammlungen, Gemäldegalerie Alte Meister, Dresden

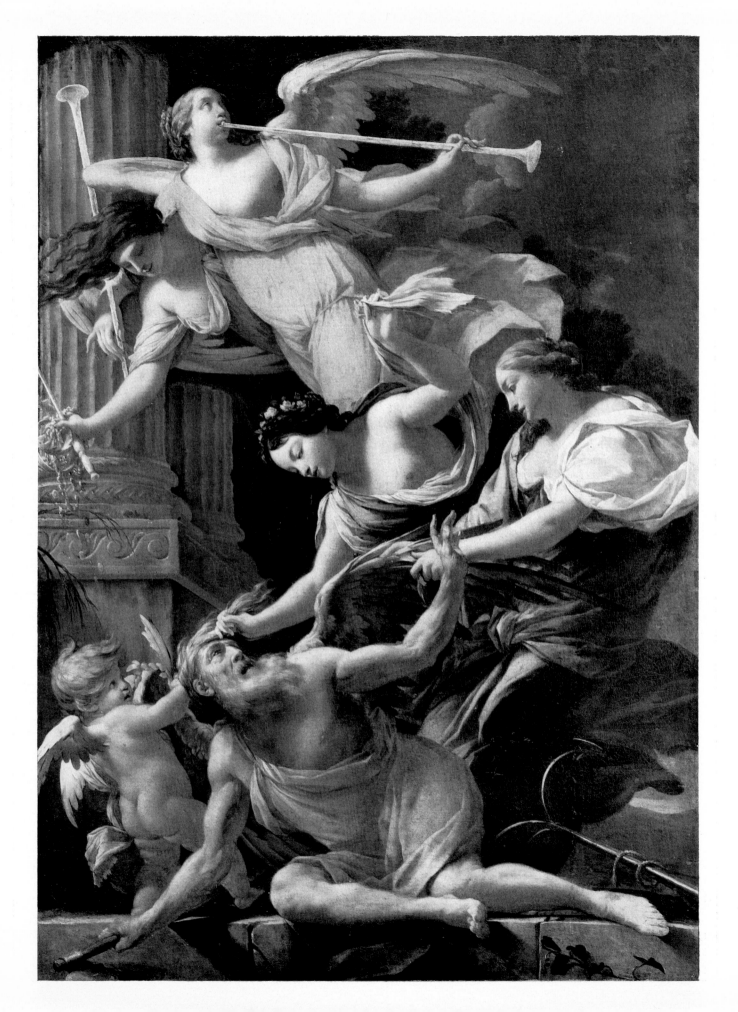

‹14› Baroque painters frequently used women to personify abstract concepts in their allegorical
compositions. The fourfold victory of women over Chronos, the god of time,
is taken from grammar (that is, the personification of the Latin words *gloria, fama, Venus, spes*;
all of female gender). But it is naturally a welcome opportunity to pay indirect tribute to women.

Simon Vouet, *Time Vanquished by Love, Hope and Glory, c.* 1630.
Oil on canvas, 184×133 cm. Musée de Berry, Bourges

‹15› The god of the sun rises up into the sky in his chariot and thus arouses Flora.
She in turn, with a dancing movement, wakes up the flowers, presented as male and female figures:
Ares, the symbol of winter, falls upon his sword. The mythological
story of nature depicted by Ovid in his *Metamorphoses* is symbolized here with charming, poetic
classicism. With the passage of time the realm of Flora still remains under the rule of a male God.

Nicolas Poussin, *Realm of Flora*, 1630/31.
Oil on canvas, 131 × 181 cm. Staatliche Kunstsammlungen, Gemäldegalerie Alte Meister, Dresden

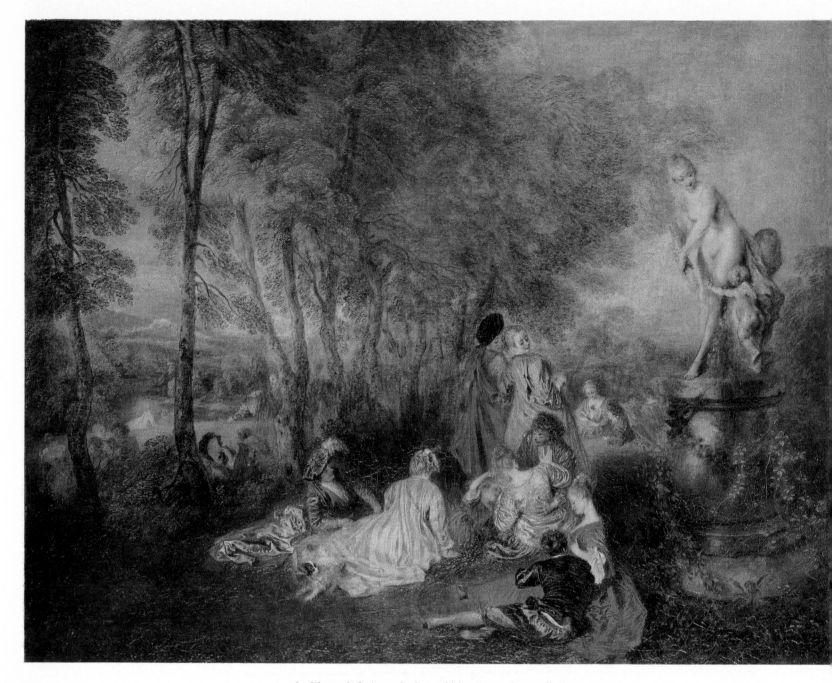

‹16› Watteau's festive gatherings, which appear to be very lively,
are really full of yearning for a pure and undisturbed beauty. They are elegies for
an ideal Arcadian perfection, which only art can produce. Their
atmosphere of unreality, of dreamlike charm, is as delicate, light, and transient as a breath.

Antoine Watteau, *Festival of Love*, c. 1717.
Oil on canvas, 61 × 75 cm. Staatliche Kunstsammlungen, Gemäldegalerie Alte Meister, Dresden

‹17› An atmosphere abounding in nuances which was prevalent in aristocratic
Rococo is transformed into the cultivation of sentimentality in the social setting of the third estate.
The simple event of saying grace becomes a hymn of praise to the moral ideal of natural
humanity, as expressed by the intimate relationship between the mother and her little girl.

Jean-Baptiste Siméon Chardin, *The Grace*, 1740.
Oil on canvas, 49 × 38 cm. Louvre, Paris

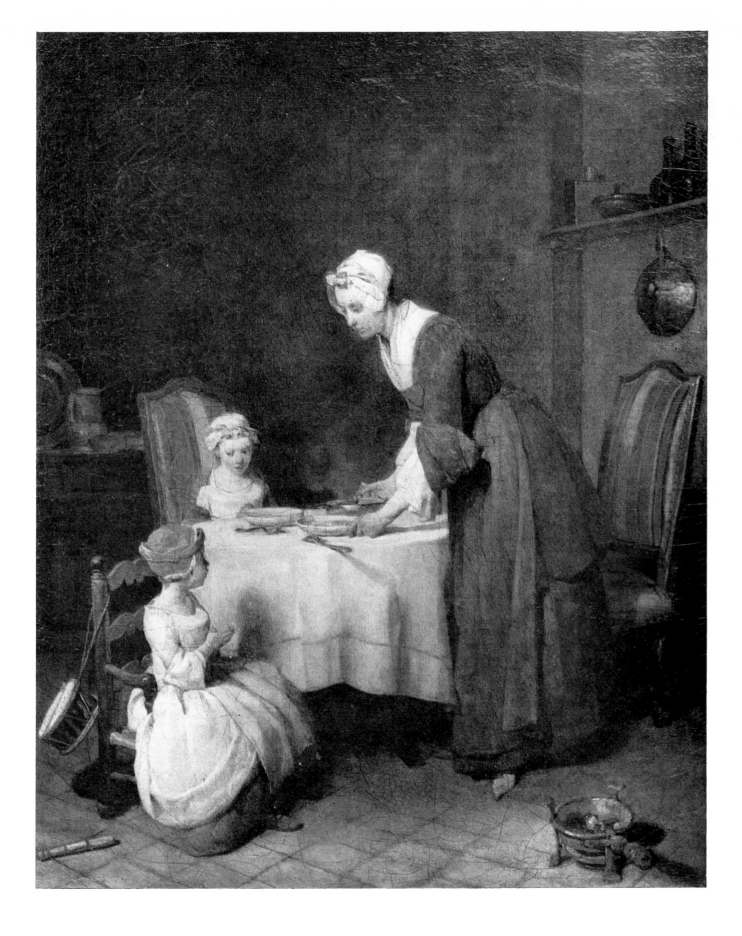

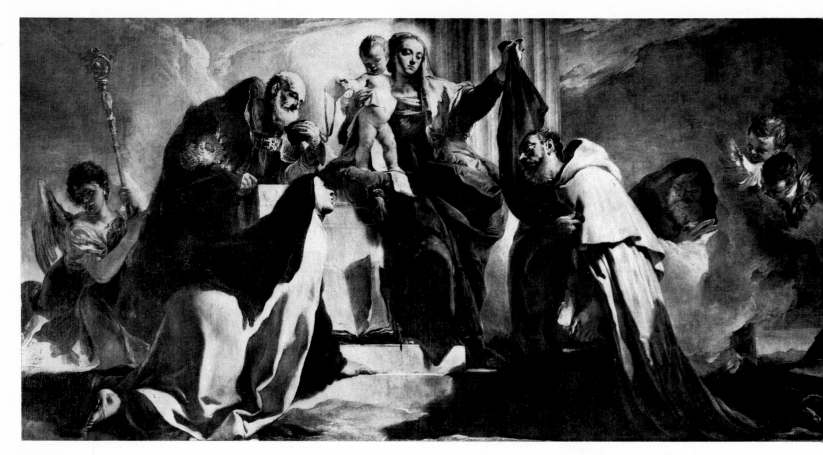

‹18› The classical tranquility of the composition together with the Baroque emphasis on the
interplay of light and color, on richness of movement, and not least the strong focus on the lower aspect,
intensifies this adoration of Mary to a glorious climax in which solemnity
and rhetorical emotionalism are united.

Giovanni Battista Tiepolo, *Madonna of Carmelo, c.* 1720.

Oil on canvas, 210 × 420 cm. Pinacoteca die Brera, Milan

‹19› The fervent piety of the southern German late Baroque age was happy to turn
people's love of festivity and theatrical splendor to its own advantage. The triumphal and dancelike
ascension of Mary provided visual sustenance for the curiosity of the common people
and their belief in miracles, and was equally well received by the cultural upper class.

Aegid Quirin Asam, *The Assumption,* 1717–1723.

Stuccowork, life-size. Klosterkirche, Rohr

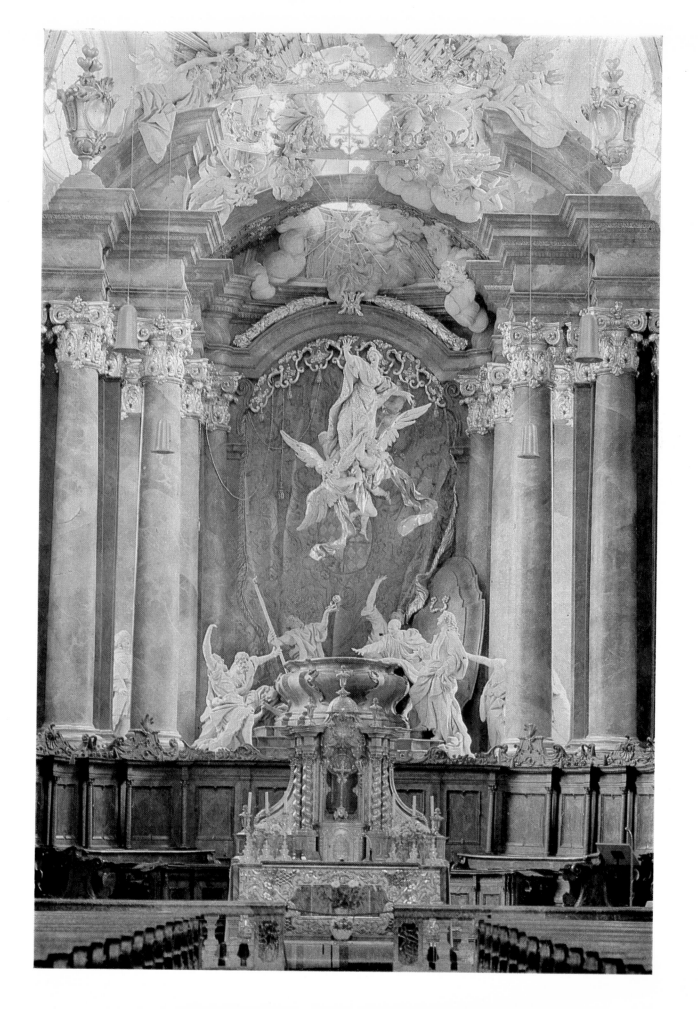

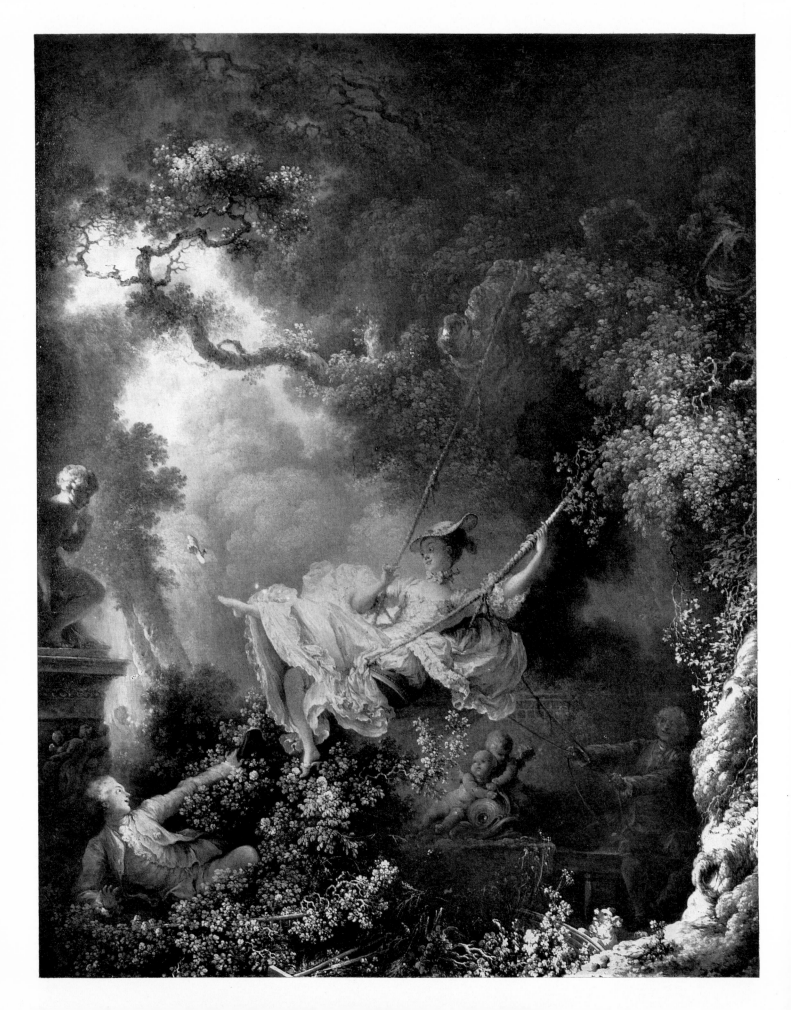

Both statements refer to the eighteenth century alone and to a particular group within European society—that of the court. This group has been accorded so much attention that it has come to be regarded as representative of the era. Indeed, there are two conflicting meanings of the phrase "self-confessed pretence," and this ambivalence is of the greatest consequence with respect to civilizing and disciplining society.

Initially, we may take the meaning quite literally. What can the world of paintings tell us about it? First of all, the dominant position of women, their triumphant emergence as cult figures, did not appear out of the blue in the eighteenth century, but was achieved with great deliberation in tandem with the development of Baroque culture. All kinds of iconographic traditions, themes, and motifs were used. First, there was the *trionfo* itself. Renaissance culture had revived the ancient as well as medieval tradition of the triumphal, magnificent procession of a victorious commander or glorious ruler. This splendid display of power and riches, which would sometimes dominate the life of a town for days, provided artists with stimulating subjects, and many of the most famous artists devoted all their talents to triumphal processions. Visually appealing scenes in the processions were incorporated into paintings especially to please the sponsors, who wanted to preserve the transitory nature of the festivities. The Renaissance theme of the *trionfo* displays a characteristic change begun in medieval times when the cult of the emperor was transferred to the cult of Christ, lending an ethical aspect to the victory of the stronger, the more powerful. The victor then is morally superior. This is of great interest for the Baroque application of the triumph motif. Most of the allegorical and mythological subjects had already been identified in the Renaissance, and the new contexts into which they were now placed can be recognized initially by the frequent use of female forms. Symbols of beauty, love, fertility, and the blossoming of nature are embodied in Venus, Ceres, Amphitrite, Galatea, and Flora triumphantly receiving homage, like true sovereigns, from their enormous entourages.

A direct depiction of the festive processions can be seen in the *Triumph of Venus* (1640/42) by Johann Heinrich Schönfeld. The accent on the goddess seated on her throne above her subject people follows the same kind of emotive formula as the massive buildings. In the structure of the painting the interplay between the top and the bottom is necessary in order to clarify the positions of ruler and vanquished clearly and conspicuously and thus their relationship with one another, too. The surest way of achieving this was to confront one of the conquered with his conqueror. An ideal scene would be Aurora, radiant and moving upward toward the heavens with Selene, the figure of night, below her, cloaked in clouds and shadows. In fact heroines feature surprisingly often as the winners of allegorical and mythological victories. This can be explained in part by the fact that many personified objects appear in the female gender; but we must also note a purposefulness in their selection and combination. The use of battle scenes between heavenly and fiendish powers, between virtues and vices, is also highly characteristic. In a darting movement Love, Hope, and Glory swoop down on Chronos, the god of time, who has been cast to the ground (Simon Vouet). The swift, though soft course of the movement emphasizes how different it is from the inexorable vehemence of the diagonal, which dominated, for instance, the Archangel Lucifer battles of the High Renaissance. The strong angels of wrath are replaced by a garland of the young and beautiful, who gain their victory with grace and tenderness. At the same time there is a clear similarity; here, too, battles are conducted and victories celebrated.

The alleged adoration of womankind also includes all those motifs that offer an opportunity to display the physical attributes of women, for example, the toilet of Venus, Diana bathing, and many similar mythological scenes. The moment of triumph is very much in the foreground as can be seen by the clear preference for themes allowing admiring men to be brought into the picture: Susanna and the two old men, Bathsheba bathing, Pan with nymphs, and above all the judgment of Paris. The charm of the contrast between joyfully presented beauty—even when this contradicts the fable, as in the one about Susanna—and unconditional homage is fully played out from the aesthetic and moral aspect. Nothing is more revealing than the ambiguity of the message, particularly in the judgment of Paris. The vertical accent dominating the painting is marked by the three nudes. The seated man is contrasted and subordinate to them in the composition, although at the same time he occupies the focus of their gaze.

<20> This charming picture of a swing gliding between heaven and earth achieves its own particular kind of excitement in the balance of contrasts. The swing moves between light and darkness, between youth and old age, and places the lovingly adorned beauty against a background of primeval nature.

Jean-Honoré Fragonard, *The Swing*, 1766.
Oil on canvas, 81 × 65 cm. Wallace Collection, London

It may seem absurd to include the abduction of women among the paintings of female triumph and dominance. Women are portrayed as the defenseless victims of male violence in all the various stories of female abduction, such as the rape of the Sabine women, the rape of the daughters of Leucippus, and the many women carried out by the equally numerous gods. But this is all part of the role play of these themes, for the abducted women are in fact the real heroines and victors through the sumptuous beauty of their bodies, which make them the coveted object of the rape and the cause of the tumult of battle. No one but Rubens could so perfectly find the balance between dramatic scene and gestures and rational, aesthetic structure. His *Rape of the Daughters of Leucippus* (about 1618) is rigorously structured like a monumental ornament, which is intensified concentrically from the horses' bodies on the outside through the dark-skinned men to the women's bodies in the middle. The thrashing figures of men and horses circle around them; the women are the power center, keeping the whole in motion and in order.

It should be added that portrait painting also played a part in elevating the position of the female sex through art. The most imposing attribute of grandeur, the royal full-bottomed wig, was reserved for men. Portraits of women displayed better ways of achieving the same effect. The custom of dressing up as mythological figures for portraits is certainly due, at least in part, to the widespread practice of amateur theater among the aristocracy. The mythological portraits, however, had a greater significance than just the immortalization of a favorite role. The woman who had her portrait painted as Venus, Flora, the youthful Hebe, or Cleopatra may have had a divine form and heroic greatness attributed to herself and her beauty, or she let herself be so persuaded. This exaggerated, fictitious world of allegorical and mythological characters for portraits, even if depicted through just a few costumes, was not to be taken without seriousness. At the same time it demonstrates what people of the day must have felt—that women found such make-believe grandeur and borrowed greatness necessary for their own self-esteem.

The literature on Baroque art recognizes all these triumphal themes and motifs and attaches great importance to them. They, together with various other types of painting, are characteristic of the Baroque desire to look prestigious and glorious as well as to display elemental vitality. The scenes of female glory, however, possess qualities over and above this general interpretation. They bear a surprising affinity with an iconographic complex whose spiritual character seems, at first sight, to be sharply contradictory. Initially this complex was regarded as a field of its own, relating to the Baroque art of the court, but later it was treated more generally. We are referring here, of course, to the class of images portraying religious ecstasy.

The subject of Christ's ascension into heaven provides a key to it all. Throughout the Middle Ages priority was accorded to the ascension of Christ into heaven after he had risen from death by crucifixion. The first painters to give the assumption of Mary into heaven equal status were the masters of the Italian High Renaissance. Titian, Raphael, and Correggio portrayed the scene with throngs of people, all charged with emotion. Baroque art picked up the theme and expanded it. The number of paintings of Mary's assumption into heaven rapidly increased; and there was growing drama in the flood of expressive movement and spiritual surrender rising from the throng of people in the bottom part of the picture of Mary floating on high, viewed already as the Queen of Heaven.

This basic theme of the Assumption now began to captivate other subjects. It was particularly important for one of the main theological problems of the period—the ecstatic state that could be reached through the spiritual exercises of the Jesuits as well as those of antiorthodox mystical movements. Practitioners described their spiritual rapture as a sensation of existing outside space and time. This could be visualized most easily in the venerable scene of the Assumption. A creation like the *Ecstasy of Saint Theresa* by Bernini, who portrayed these trancelike states as faithfully as he could, has to be considered unique. It was easy to go too far by when depicting spiritual abandon as a physical state of rapture. This peculiar image of Baroque religious frenzy could not be reduced to the trivial.

A scene of floating in ecstasy high in the heavens was thus perfect material for this type of art. The earth far below looked tiny and insignificant, contrasted with the woman who had just left it and was being carried upward by clouds of angels. Height and homage were the means of gaining honor, and moral perfection was its foundation. This is depicted by expressions of humility and

wide-open eyes, full of pious fervor. Moral triumphs are celebrated here—victory over vice, worldly arrogance, and halfhearted faith. The desire to use such pictures to provide comprehensible models for simple souls and the real need to identify with them, were in equal balance. The Church complied by rediscovering or simply introducing an enormous number of saints to serve this purpose. These were almost exclusively female saints. The Immaculate Conception was now added to the Assumption as material for the depiction of ecstasy in the skies. The old legend of the assumption into heaven of the sinner Mary Magdalen was revitalized, and many other saints and holy people were now depicted experiencing their ecstasy floating in the clouds. Above all, the late works—those of the eighteenth century—display some affinity with secular triumphal scenes. Aegid Quirin Asam's charming altar sculpture of the Assumption in Rohr Monastery displays an eminently secular character in its expressive elegance of movement— almost dancing up into the sky—and is distinctly reminiscent of Baroque theatrical refinements. With the most desirable clarity the figures here adopt basically the same pose as in secular and mythological triumphal scenes, thus making the *Triumph of Aurora* scarcely different from an Assumption, as the same iconographical devices are used in both.

The preponderance of women among the allegorical and mythological figures of ecstasy is an attempt to suggest the importance of women and to pay homage to them. What then was the point of shifting emphasis onto glorious female saints? Was it not also possible to demonstrate profound faith with such keynote themes of the oncoming era as the battle of the archangels and the temptation of Anthony? It appears that the female model of piety was accorded priority because of her psychological characteristics. The typically female nature was illustrated in copious contemporary literature on the problem of the sexes in a way which we might today call strategic. The qualities of importance included the ability to adapt, the capacity for enthusiasm, emotional malleability, and sensitivity. It was for these characteristics—whether they were already in existence or were just greatly desired will not be discussed here—that women were held up as models for the multitude of the faithful to follow. Thus support, guidance and consolation was provided to help the people lead good and moral lives.

The most important and, at the same time, most ambiguous figure in this field was the penitent Magdalen. Hearts were moved by her beauty, which she now disdained, and by her remorse. This exalted fervor for repentance, seen in a woman in the full blossom of her youth, gave impetus to the widespread tendency for enraptured dreaming. This was aided by a sensual and generous display of her naked flesh—of course out of total indifference to all that is physical—in a silent chamber or alone in nature. In spite of the rather dubious interests linked with the penitent Magdalen, she remained a decisive figure for the Catholic Church, which preached humility and submission to the doctrines of the faith. But she was studied by contemporaries from many different aspects besides the initial one of moral and theological didactics. The story of Magdalen goes hand in hand with the ideas of vanity and melancholy. Doubt in the human spirit's capacity for discovery and creativity turns into meditation about death and hope in the afterlife. The melancholic Magdalen supersedes Dürer's *Melancolia* (1514)—the highest goal of mankind is no longer the struggle of the mind for knowledge and achievement but the recognition of the emptiness of all earthly aspiration. And so the solitary sinner, carelessly casting aside the signs of human activity, is the symbol of victory over the unfathomable and unchangeable periods in the history of mankind.

Art was used with all the means at its disposal to persuade its Christian and secular public that the world should worship women. It is by no means true to say that this idea reached its climax in the Rococo. It merely took on a special form—one that celebrated passionate admiration in the field of gallantry and sensuous relations. The exaggerated expressions of emphatic adoration reveal an understanding that it is only a game.

Reality was indeed quite different. Whereas in art women were at the center of public interest, they were being gradually excluded from public life. A look at official royal functions and at entertainment at court, where women had a decisive decorative role to play, would appear to contradict this statement, and it seems belied by the famous exceptions—certain female rulers and great mistresses indeed had influence on the fate of nations. The fact that they were exceptions was no mean contribution to their fame. From the beginning of the sixteenth century women had been driven out of the one sphere where real influence could still be

exercised, a sphere where capitalist methods of production were just being introduced. In other words, they were being excluded from the whole of economic life. The total personal, financial, legal, and political dependence of women on men that ensued was justified systematically with the aid of philosophy, theology, and nature—which had been created by God's hand. Women had been rendered superfluous to the world of work on principle, and this had an immediate effect on the education and training of girls. In the lower and middle classes they were to learn only what was required of them for marriage and running a household, and in the ruling classes what they needed to know for official functions and entertaining at court. Thus began a cycle that continued long beyond this period of history, when women were excluded from and made incapable of independent historical activity. The following chapters will discuss this briefly summarized thesis in detail.

The world of paintings is one thing, but the world of real opportunities for developing human powers is quite another. Nevertheless, the two are not wholly independent of one another. It would appear that, in art, a social and political opposite was being created, serving to idealize and glorify the social processes of driving out women from work and politics.

This observation is not only valid for the art of the Church and the court, but also for Dutch painting. The simple urban settings—mostly small towns—and a faithfulness in depicting everyday objects and events earned it the name of "bourgeois realism." It was in stark contrast with the extravagance of form and persuasive emotionalism of absolutist art, portraying religious and royal scenes. The relationship of Dutch art to real living conditions is, however, not fundamentally different from absolutist art's relationship to reality. We will substantiate this statement by examining one of the most frequently occurring themes in its limited range of subjects—for example, a woman in a room or in a yard. She is in an enclosed space, usually on her own but at most with a child or servant, carrying out a simple task, calmly but intensively. The rooms do not look out on a view. The walls of the yards are high, the windows do not reveal anything outside. The action does not bring any movement into the picture, it takes place with the soundlessness of a vision. The outside world is not allowed to impinge on the scene, and no irregularity is tolerated within the safely enclosed space. In these rooms, which are set out like a still life, the woman herself is transformed into that part of a still life full of secret vitality. Harmony and comprehensible clarity are set consciously against the restlessness and disorder of the inn and peasant scenes. And similarly, an ordered world of images—from regents' families—is built up against the backdrop of the lack of discipline in the real world. All that we experience as collective silence, concentrated reflection, self-contemplation, and assurance in these priceless paintings can equally be understood as an idyll of seclusion from the world. Men never appear in such soundless and motionless rooms. They go about their business (and pleasure) in the economically powerful, bustling, and enlightened republic of Holland. Modern-day research has revealed the other side of Dutch realist painting. It has shown that the apparently true-to-life and realistic paintings are in fact stereotyped—a set kind of reproduction of real life—not primarily aimed at portraying reality, but intended to provide moralizing examples. With its direct reference to women these paintings hammer away at the ideal of the quiet, virtuous, and orderly housewife. Her opposite number—the depraved girl of inns and brothels—is equally a lesson in morality. The paintings of the virtuous, bourgeois wife depict inwardness in a stylized form; in reality this idealized picture of the "good" woman was a limitation on her freedom of movement and served to restrict her to the most narrow domestic sphere.

But the objective process of restricting women's personal development, incapacitating them, and ousting them from all areas of responsibility, had another side to it. If we regard the development of society as a whole it emerges as a part of a complex division of labor which was taking place in the whole of society and which itself was affecting the relationship between the sexes. The "natural differences" in the physical, mental and psychological make-up of men and women were discussed in the literature on the "problem" of the sexes. The discussions were not without purpose, as they served to delineate the social roles suitable for women. They were allotted clearly defined spheres of activity. "Family and the home" and "entertaining at court" are only a first indication of what society was to expect of a way of life, based on such a division of labor, in long-term processes of change. In the end women were given the responsibility of looking after human relationships and emotions of the heart and soul, while the masculine world of

government and work with expanding capitalist methods of production was assigned to rational functionality. The resulting conflicts only emerged after the French Revolution and finally took shape in the struggle for equal rights for women. The basis was already there in the seventeenth century. The power of paintings was used to serve significant historical processes. Their vehemence and sensuousness as well as their ordered clarity helped to explore the complicated world of human emotions and burrowed deep into the human social psyche, there to firmly fix the attitudes that formed the foundation of the continuing cultivation and rationalization of life in society.

WOMEN IN THE HOME

THROUGHOUT the Baroque there was one question that always stirred the emotions of men and women alike. What is a woman and what should she be? Which of her qualities should she develop, and which should she suppress? Where is her place in society, what should she do there and what should she most certainly not do? In sum, what should the relationship between the sexes be? All the treatises, advice, instructions, polemical statements, and apologias of the period concern women's duties and rights as wives and mothers. And the latter category can be broken down into two quite distinct types: the aristocratic "lady of the house" and the "housewife" of the less wealthy landed gentry and the bourgeoisie. The lower classes were ignored in the debates of the time, but we will return to them when we discuss work. All the charges and accusations, rules and bans, which men imposed on women, were based on this contrast between the two types.

Throughout her life the aristocratic lady had little to do with the "family" as we understand the word. As a child she grew up in the care of a wet nurse, a nanny and later a governess or convent. In general, her relationship with her mother was limited to courtesy visits that she was duty-bound to carry out. Her marriage was arranged by her parents in the interests of the family; it certainly had to be appropriate to their wealth and rank. The daughter usually agreed to the decision, a marriage suited to her rank guaranteed her the greatest possible freedom available to women in absolutist society.

But it was a strange kind of freedom. It originated in very strong ties to unwritten but all the more effective norms of behavior. The ladies of the large stately homes were totally free of any "housewifely duties." They did not have to care for their husbands or their children. They placed their own children into the hands of a nanny and governess, replicating their own childhood. Their husbands led their own lives in their own private chambers. In the French "hotels"—those magnificent houses of the nobility where the living rooms and reception rooms, kitchens, and servants' quarters were all under one roof—the chambers of the lord and lady were in the two wings separated from each other by the main section of the building containing the drawing rooms.

The few common interests shared by the spouses were governed by ceremonial courtesy. They did not share a "family life," and even their social obligations were usually different. As Jean de la Bruyère said, with only mild exaggeration: "They spend month after month in the same house without the slightest danger of meeting each other; they are really only neighbors. Monsieur pays the cooks, but one always dines at Madame's invitation. Such people often have nothing in common, neither their bed, their table, nor even their name . . ."[23]

A large number of servants saw to the smooth running of the household. If the lord and his lady and their hordes of guests were satisfied, the praise went to the lady of the house for having chosen the servants so well. She herself would simply not have had the time nor energy required to supervise the running of such an enormous household. Her own day was taken up with the duties that come with being a member of the ruling class and high society.

The morning toilet was one of these duties. While the maids were busy coping with the technical refinements of their lady's dress, with piling up her hair in a complicated structure, with putting the final touches on the work of art that was her face with powder ointments, make-up, and perfume, she was already receiving her first guests. Friends would inform her of the latest society gossip, poets would read their works to her, and merchants would show her their goods. Soon her morning business would be over, and she could now set out to pay her own courtesy calls. It was an unpardonable social offense to fail to pay the appropriate call at the appropriate time—whether that failure was inadvertent or due to a lack of enthusiasm. She would either have someone invited for lunch or be invited out herself. It was unthinkable that she should dine alone with her husband.

The day's amusements truly began in the afternoon and often continued until well after midnight. The company would meet in the drawing room. The spotlight was now on the lady of the house. It

was up to her to keep the conversation going and to ensure that no one was feeling left out. The course of the conversation had to be carefully monitored by all so that the subject matter would not peter out and so that new ideas would always enliven the gathering. Of the sophisticated "art" of conversation Edmond and Jules Goncourt wrote:

> *This indeterminable and incomprehensible talent which is as natural as beauty, this social genius of France, is the invention of the women of this period. They put their whole spirit to its service, all their charms, their desire to please, making manners and courtesy come to life . . ., conversation becomes an exquisite pleasure . . . with a touch of inimitable perfection The talk glides along, rises, falls, darts here and there. Its rapidity gives it character, its delicacy brings it into the realms of elegance. Women have such an enormous range of skills at their disposal, they speak with such ease, they can use such an abundance of apt remarks, they possess sparkle and zest to keep the swift and agile causerie about anything gliding along Every topic under the sun is included in women's conversation* [44]

If a woman had a distinctive and witty personality—and just look at the number of unconventional characters brought forth by the courts of the absolutist society!—then her salon could become a magnet for the elite and gain long-lasting fame. Although we can picture its singular atmosphere, we certainly cannot reproduce it. Admittedly the salons of a certain Madame Geoffrin, a Mademoiselle Lespinasse, and a Madame Marchais were very special eighteenth-century phenomena. The Encyclopedists met here to plan the strategy of their diplomacy toward society, to polish, strengthen, and check their philosophical and political views. And the *bureaux d'esprit*, organizations founded and directed by women, paved the way for literary successes and failures and shaped public opinion in the field of literature. However, *every* woman's salon, even in the seventeenth century, was basically an "institution of the intellect." In the time of Louis XIV it was certainly subject to more formal ceremony than in the atmosphere of consummate ease prevalent from the Régence. But it did not consequently demand any less wit, talent, and knowledge of a wide variety of subjects to keep boredom at bay, the threat of which lay just below the surface of this uninterrupted chain of amusements.

Pleasure, conversation, and celebration were the names given to what was really an extremely wearisome effort. A woman of the nobility would spend most of her waking life, which often included the night, in the public eye. She must at all times have her wits about her and appear totally composed, while "enhancing the splendor" of the aristocratic world in one of two ways: in honorable and much sought after service to the court which was extremely arduous because of the thousands of rules that governed all aspects of behavior; or in the more relaxed engagements outside of the court. In either situation she was expected to appear as a perfect work of art and behave with great presence of mind. This imposed an incredible strain on her, but was necessary if she wanted to stay in the right circles of high society. Enormous expenditure of energy was needed to keep up the complex hustle and bustle of social life in its detailed organization and refined tastes. "It [social life] is an indispensable instrument of social self-assertion, especially when all those involved are kept on tenterhooks by a never-ending battle for status and prestige—particularly true of society at court." [34] The privileges and obligations involved in a life of luxury consisted of consuming goods without performing any work. The patterned life of arduous indolence in the interest of prestige and fame was consistent with the aim of social separation from the lower classes. This way of life highlighted and strengthened a division of functions, and an ordered system of mutual contracts and dependence between the sexes and economic classes emerged, a system of great significance for later development. The system clearly outlined the function of women, made use of all their powers, took up all their time, and formed their personalities.

This way of life was enjoyed by a tiny and shrinking section of the population. Court society constituted no more than five percent of the population, but its influence was vast. Its life was conducted before the eyes of the people and radiated such splendor that it had great appeal to the lower classes, at least to those immediately below the nobility. In no way, however, could they adopt the living habits of the court. Their life was radically different in certain crucial ways.

If we describe the homes of the leading aristocracy as centers of consumption, the homes of the landed gentry, large-scale farmers, and upper classes in general could be described as centers of production. These centers of production included a variety of people and buildings. A large farm, for example, was a single *household* that included not only the farmer with wife and children but also all the servants, ranging from the steward or bailiff right down to the last milkmaid. The living quarters were directly connected to the working areas. A prime example of this integration was in the North German farmstead, where the farmer's wife could survey most of the house and courtyard from her central position at the stove. From there she could supervise all the activity around her and call all the members of the household together at mealtimes. The main thing is that the farmer, his family, and his servants all lived and worked together as a unit. This was even more true of the urban artisan or merchant, whose living and working quarters were under one roof; the journeymen, assistants, and apprentices were incorporated into the family.

The concept and doctrine of the "whole household" has its roots in antiquity. The Greek concept of "economy" united in the sixteenth century with theories of agriculture to give a comprehensive "theory of the household," which combined the household, as we understand it today, with a production unit. The *Hausväterliteratur* [58] was widely read in Germany, especially since the type of home which comprised living quarters and production area under one roof survived longer there than in Western Europe, which developed more quickly from

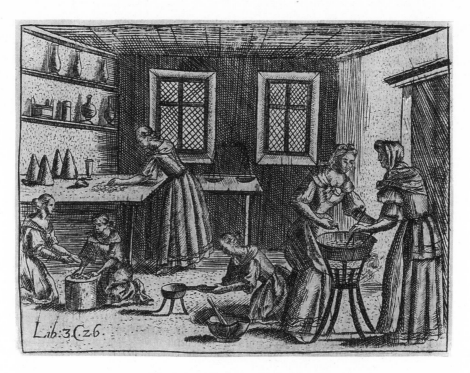

<21> The duties of the house-wife, her daughters,
and her maids included producing nearly all the things that
were necessary for everyday life on the farm.

Wolf Helmhard von Hohberg, *Georgica curiosa aucta.*
Chapter "On Sugar", p. 316. Nuremberg: 1687.

the economic point of view. This literature consisted of books on the theory of householding of a great farmhouse including horticulture and agriculture. The standard work on the subject was *Oeconomia ruralis et domestica* by Johann Coler, published in Wittenberg in 1593. A large number of similar books appeared well into the eighteenth century. Most of them were aimed at a specific area and level of the economy, basically because the authors were nearly always themselves estate owners/administrators who recorded their practical experience. *"Nulla enim professio amplior quam oeconomia"* (for there is no greater profession than the economy) were the proud words of the Austrian landowner Wolf Helmhard von Hohberg in the preface to his *Adeliges Land- und Feldleben* of 1687. And his book indeed covers every aspect of human relations within the home—the relationship between husband and wife, parents and children, master and servants—from the organizational as well as the moral standpoint, and it gives precise instructions on running the household and the farm.

The undisputed head of the community was the male head of the household, landowner, tenant, or merchant. The *Hausvater*—Luther's term in his translation of the Bible for the more exact *oikodespotes* of the New Testament—bore full responsibility for the physical and mental well-being of all those in his care. He had to make all the decisions about the running of the household, he was responsible for all legal and financial matters, and he was the sole representative of the household in any public affairs. In return he had extensive authority over all the members of the household and could expect exact obedience. The head of the household's privileged position was constantly emphasized, examined from all aspects, and justified.

It is unlikely, however, that his role of supreme ruler went entirely unchallenged. The position of the housewife in such a patriarchal and authoritarian management structure was certainly difficult. In 1735 Johann Heinrich Zedler's large and complete *Universallexikon* (Universal dictionary) defined the role of a householder's wife as follows: "She is assistant to the head of the household and is therefore second to him in authority. Without her it would not be easy to run the household and keep it in order. From the marital point of view her role is that of wife and mother, but as to her position in the management of the household she is to be regarded as the mistress and woman of authority." Harmless as the definition sounds, the whole problem of the housewife's position lies hidden within it.

She was relatively independent in her role of running the household, in the narrow sense, and in her responsibility for the children and the female servants. She was the mistress here, but on the other

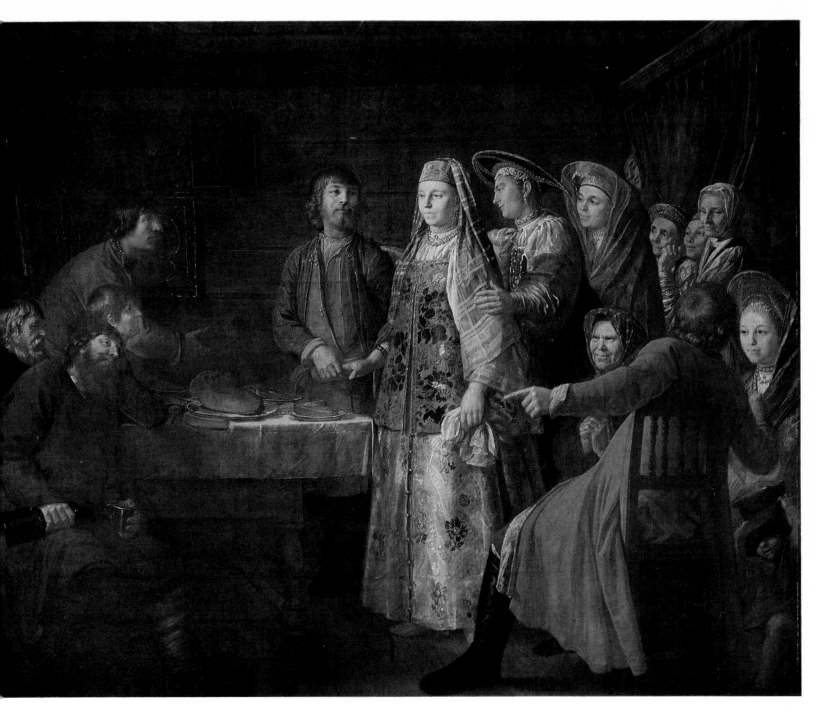

‹22› The peasant wedding is depicted with naive dignity.
The way in which the bride is presented to the bridegroom by her friends
reveals that she is the object of sober and practical considerations.

Mikhail Shibanov, *Wedding Ceremony*, 1777.
Oil on canvas, 199 × 244 cm. Tretyakov Gallery, Moscow

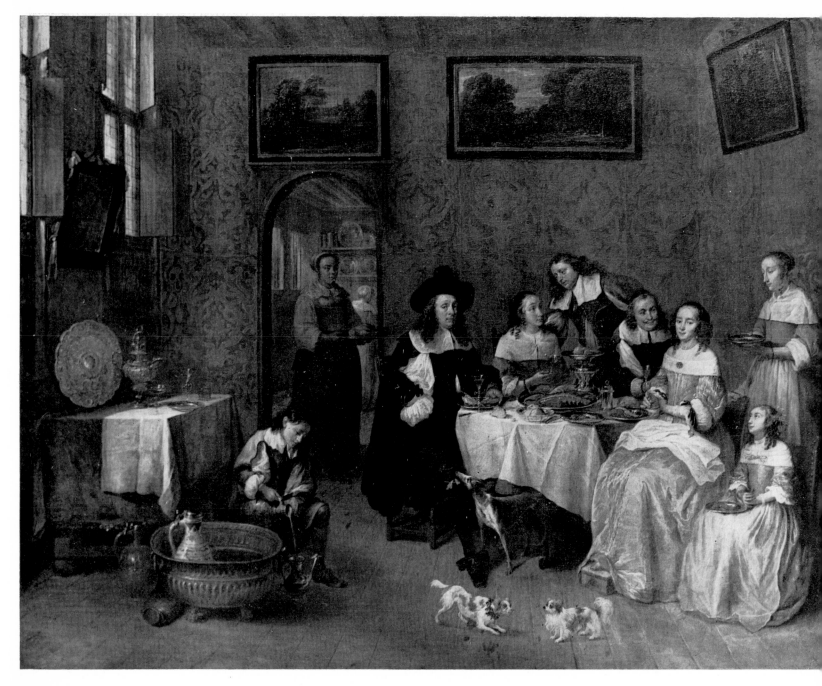

‹23› This Dutch bourgeois family is presented in a stately fashion.
There were frequent, popular little festivities, which provided a welcome opportunity
to display the richly furnished household and show off its expensive crockery, clothes, dainty dishes,
and of course its collection of art works.

Gillis van Tilborch, *Distinguished Family in a Room*, 17th century.
Oil on canvas, 81 × 101 cm. Museum of Fine Arts, Budapest

‹24› Marriage among the bourgeoisie required in the first place that feelings had
to be respected. This applied to family and friends as well as the bridal pair. This touching display
of emotion from the bride and bridegroom receiving the father's blessing is a direct
criticism of the calculating marriages within aristocratic circles.

Jean-Baptiste Greuze, *The Village Bride, c.* 1760.
Oil on canvas, 110 × 85 cm. Louvre, Paris

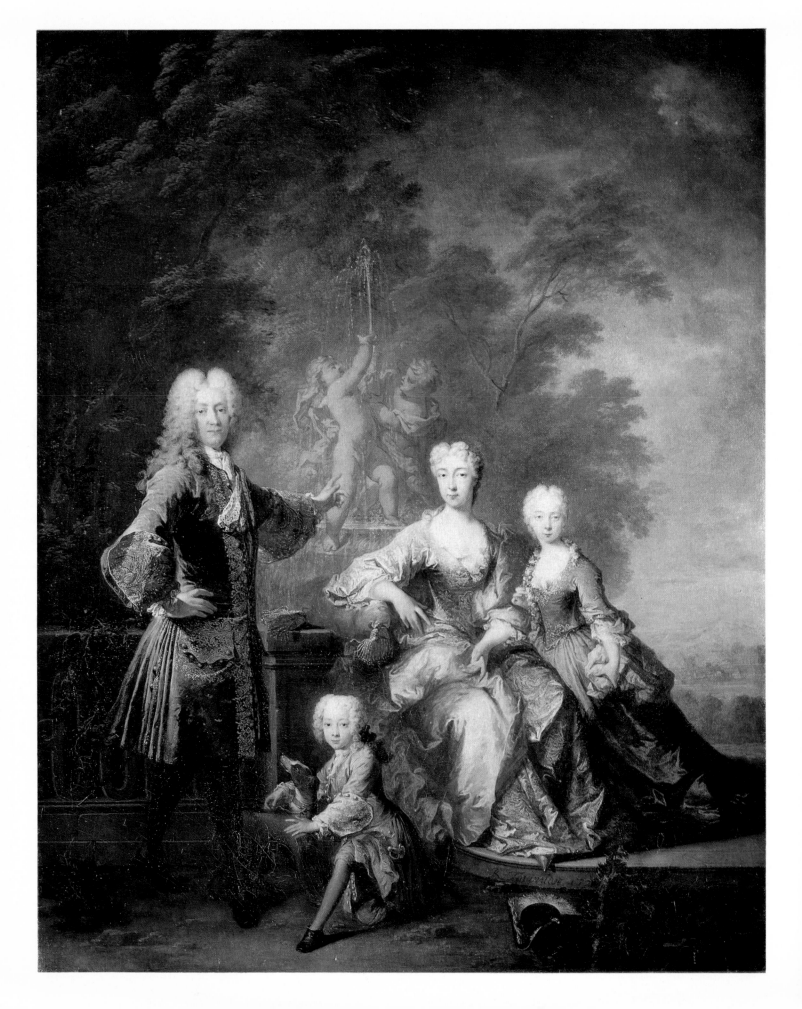

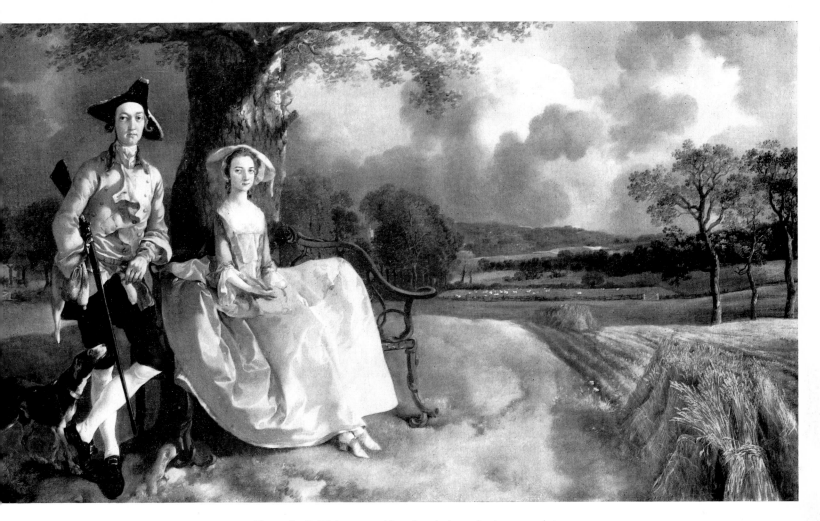

‹25› Happy family life is presented in a theatrical pose for the court painter
and supplemented by a decorative landscape as a backcloth. The old feudal nobility dressed up even its most
intimate relationships in a mythological setting and embellished them in an idyllic way.

Robert Tournières, *Count Plettenberg and Family*, 1727.
Oil on canvas, 92 × 74 cm. Museum of Fine Arts, Budapest

‹26› In the bright clear light of the carefully painted landscape the relationship
between this landowning couple appears somewhat cool. It seems to be dominated by a rational attitude
to their joint property: the flat land with vast sheep pastures
which provided the basis for prosperity for the English landed gentry.
Their land takes up more of the picture than the couple themselves.
This throws some interesting light on the practical and profitable
view of marriage common among this early capitalist class.

Thomas Gainsborough, *Mr. and Mrs. Andrews*, 1749/50.
Oil on canvas, 69.8 × 119.4 cm. National Gallery, London

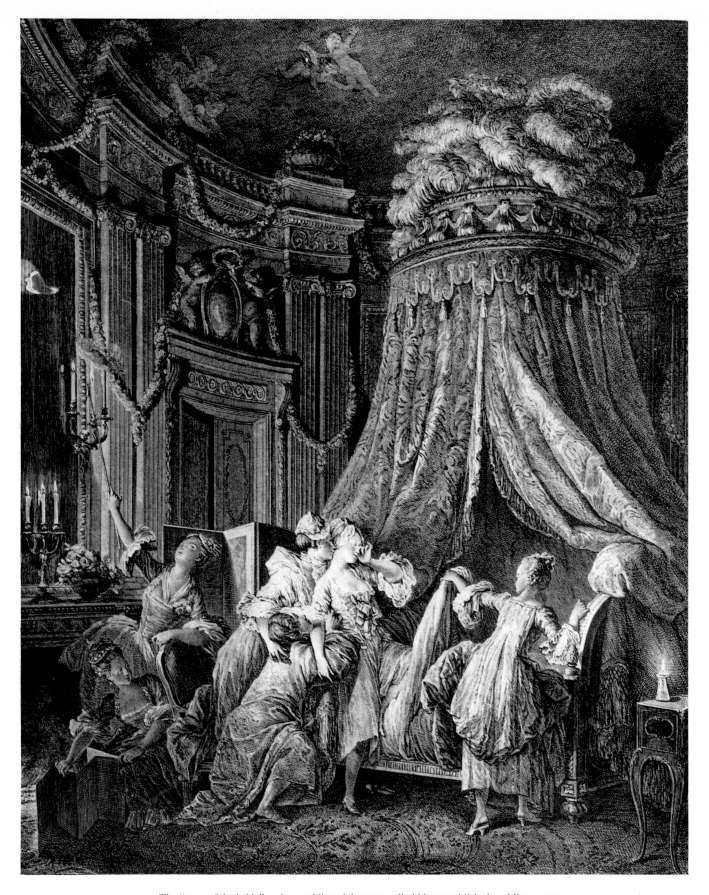

‹27› The "tears of the bride" on her wedding night were a ribald but established wedding custom.
The hustle and bustle in the palace in front of the four-poster bed gives an impression of comic exaggeration, as the servant girls and bridegroom try to hurry the bride into the bed.

Jean-Michel Moreau the Younger after Pierre-Antoine Baudouin, *Bride Going to Bed*, 1768.
Copperplate engraving, 38.3 × 30.8 cm. Bibliothèque Nationale, Paris

‹28› It was accepted for the husband to be present at his wife's
toilet only on the morning after the wedding night. The conventions of the aristocracy required husband and wife
to receive their own morning visitors in their separate apartments.

Joseph Flipart after Pietro Longhi, *Lady at Her First Toilet*, 1740s.
Copperplate engraving, 45.1 × 35.8 cm. Staatliche Museen, Kupferstichkabinett, Berlin

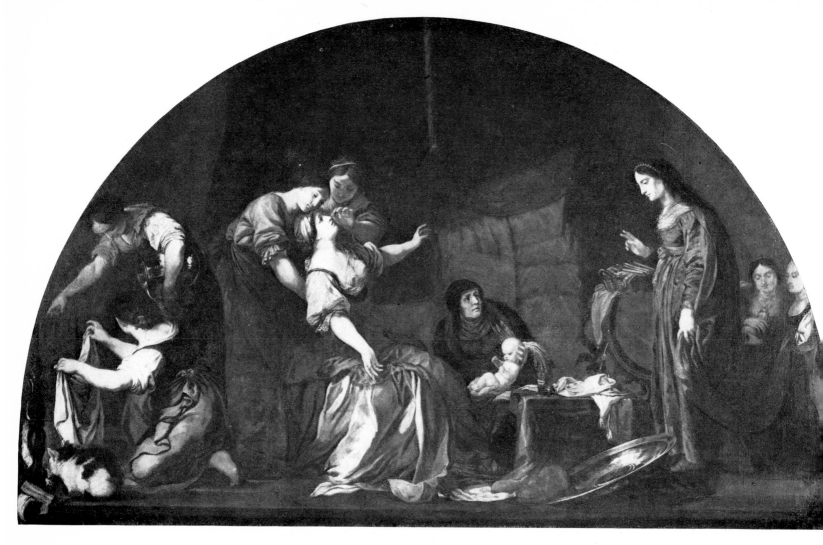

‹29› This scene depicting the birth of St. Wenceslas, the national saint
of Bohemia, combines an unaffected portrayal of the care of a newborn baby with the solemn
and wonderful aura of the legend. But even in this stately mural the baby's clothes are warmed
in front of the open fireplace, an element never omitted from paintings on this subject.

Karel Škréta, *The Birth of St. Wenceslas, c.* 1641.
Oil on canvas, 136 × 222 cm. Narodní Galerie, Prague

‹30› The use of the word "nurse" in the title of this painting *(Nurse with Child)* comes from
the previous century. A striking feature is the difference between their clothes. The woman is wearing
the rather conservative garments of a well-to-do burgher but children were lovingly and lavishly
adorned with lace, brocade, and jewelry for the family portrait.
The quiet, contented harmony emanating from them raises the human value of the double portrait
far beyond its sumptuous artistic charm.

Frans Hals, *Nurse with Child, c.* 1620.
Oil on canvas, 86 × 65 cm. Staatliche Museen Preussischer Kulturbesitz, Berlin (West)

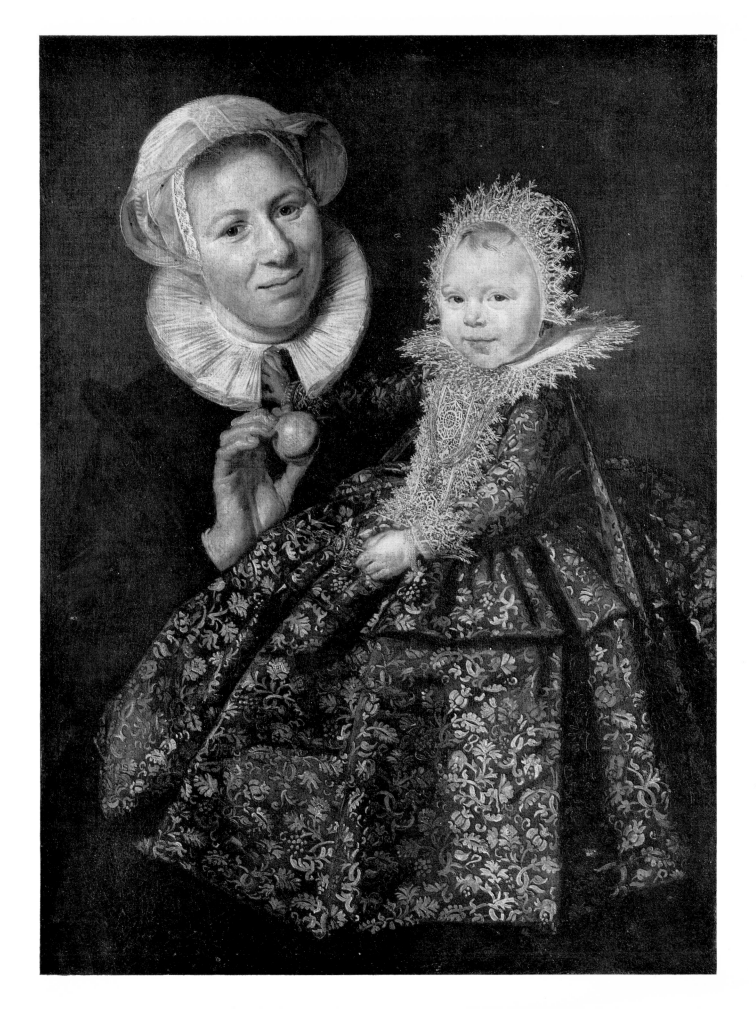

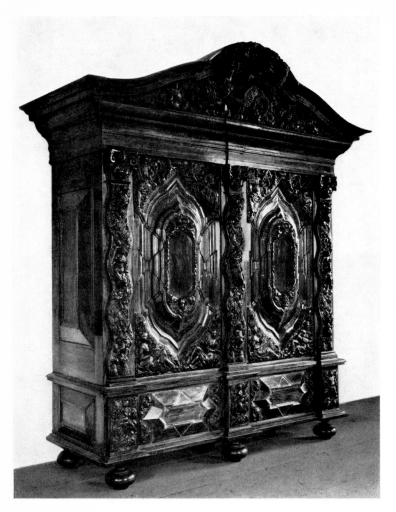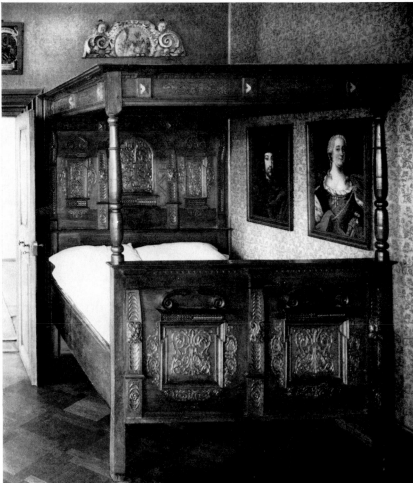

‹31› Baroque wardrobes were enormous and spacious enough to hold
all the housewife's linen (a sign of her wealth). This highly important, massive piece
of furniture was a part of every rich bourgeois household and was beautifully decorated,
displaying skilled craftsmanship.

Wardrobe in Lübeck style, north German, *c.* 1700.
Staatliche Kunstsammlungen, Museum für Kunsthandwerk, Dresden

‹32› This magnificent four-poster bed of 1663 is part
of a sophisticated life-style. Even in well-to-do houses it usually stood in the living room,
with its heavy curtains drawn during the day (not to be seen in the picture).

Four-poster bed in Baroque style, Lake Constance, 1663.
Städtisches Heimatmuseum, Überlingen/Lake Constance

‹33› Kitchen utensils in farmhouses, as collected and displayed today in museums,
would only have been found in such abundance with so much decoration and in such neat
order in the homes of wealthy farmers.

Bergische Küche, 17th century. Bergisches Museum, Schloss Burg on the Wupper

‹34› The living room of a Nuremberg dollhouse reveals the usual combination
of living and sleeping quarters. The washstand can be seen to the right of the stove.
Only a limited amount of washing could be done here.

Dollhouse, 1639. Height 217 cm, width 152 cm.
Germanisches Nationalmuseum, Nuremberg

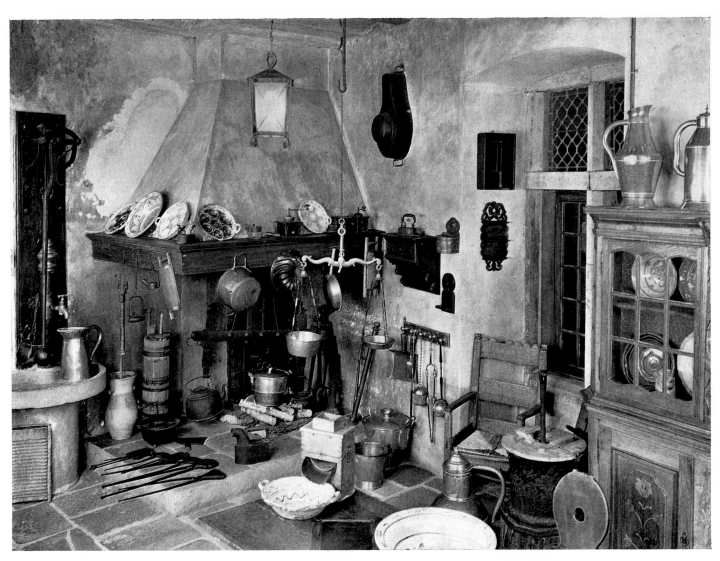

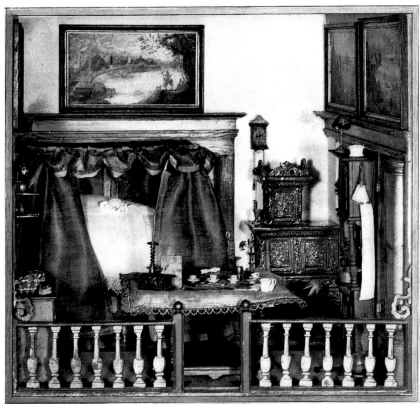

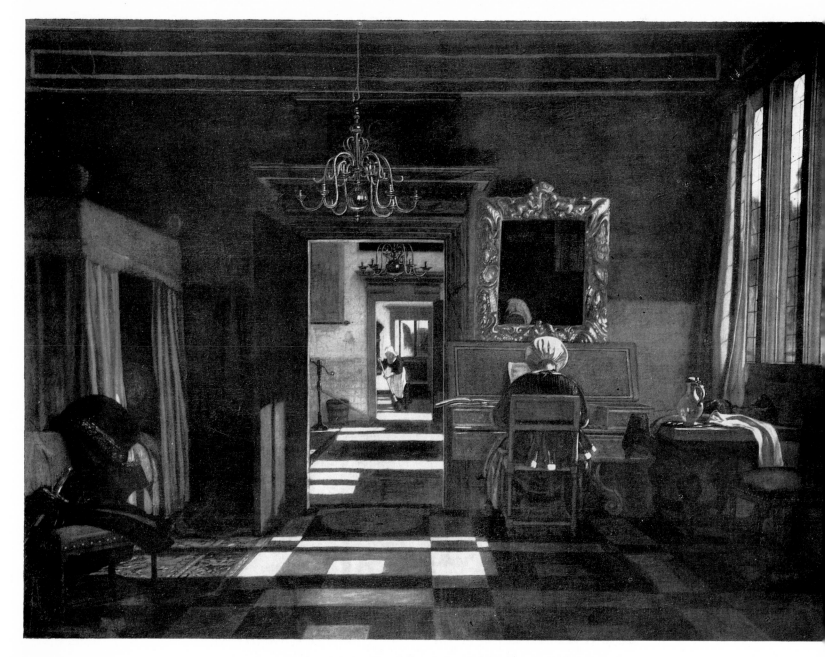

‹35› Thorough cleanliness and meticulous order are characteristic of
the richly furnished, comfortable, and sunny living quarters of the Dutch middle classes.
But the inner order was not always so unblemished.
The man in the bed by the left-hand wall—an officer, judging by his clothes—is
lovesick and has to be soothed with music.

Emanuel de Witte, *Interior with a Woman at a Spinet, c.* 1660.
Oil on canvas, 77.5 × 104.5 cm. Museum Boymans-van-Beuningen, Rotterdam

hand, she could not infringe on her husband's supreme authority. The greatest concern to the authors of the *Hauslehren* (rules of the home), which were a guide for agriculture, animal husbandry, horticulture, for cooking, preserving of food, making of clothes, children's education, relations to the servants, etc., was the subordination of women to men, and the laws of nature and religion were called upon to support this goal. Preachers everywhere for two centuries recognized this as one of their central themes. "It is a woman's nature to please her husband and do what he desires" was the message of the sermons preached by Bonifacius Stöltzlin in 1672 in Ulm. He expressed the common concern that male supremacy and with it the order in the household would be threatened if women refused to assume their subordinate role. The wide range of jobs and the high level of responsibility held by the mistress of the house seem to have led, in more than just a few exceptional cases, to a level of independence, a freedom of action and decision-making that gradually undermined the husband's unquestioned authority. There was, therefore, a substantial difference between women in real life and the ideal picture of the subservient and obedient woman, so convincingly described in the *Hausväterliteratur*.

The mistress of the house had to be, first of all, God-fearing, modest, and good-natured. Secondly, she must be domestic. This meant that she had to know all about and be able to do everything connected with running a household, so that she would supervise effectively. Thirdly, she had to be tidy, diligent, and watchful, so that she would look after the property well. These three requirements were the basic attributes of the ideal housewife as portrayed in Zedler's *Universallexikon*. He generalizes the detailed instructions given in the books on household management. The mistress of the house had to supervise the religious and moral behavior of the children and the servants. She had to make sure that the necessary prayers were said at the right time in the house, that church services were attended, and that no one got into bad habits. She had to instruct her servants in their work, watch over them, and see to their board and lodging. She was responsible for the proper storage of supplies in the larders, vaults, cellars, and attics, and for their correct distribution. The estates were generally self-sufficient, so the housewife had to make good use of foodstuffs such as milk, eggs, meat, cereals, fruit, and vegetables and preserve them for the whole year. She also had to supervise the production of large quantities of soap and candles, the processing of flax and hemp for household linen and work clothes, and the preparation of the hides of slaughtered animals for use as footwear and bridles. All this, on top of cleaning the house and farmyard every day, looking after the household goods, and supervising the sale of surplus products fully absorbed every housewife's time and energy. She also had to see to the children's education and training; her daughters in particular were her responsibility, and she assimilated them into the running of the household as early as possible.

In 1643 Hans-Michael Moscherosch tells his daughters, "Two things belong in a young woman's hands: a prayer book and a spindle." He wanted them to be pious and hard-working housewives. Little had changed a good century later. In 1768 Justus Möser wanted "an honest, Christian wife, with a good heart, common sense, a pleasant homely manner and lively, though modest, nature; a diligent and industrious housekeeper, a good and experienced cook with a sound knowledge of gardening." If we convert the achievements of such a woman during her married life into cash value then she brings in more for the husband than he gives her. Do not think that this arithmetical consideration of cash value was alien to the urban, petty bourgeois family enterprise in which every bit of work done by every member of the family counted.

A woman's scope for authority was substantially more restricted in the urban setting than for the mistress of an estate. However, the qualities she was expected to possess and her subservience to her husband remained the same.

In her limited field of activity, whether rural or urban, the housewife was responsible for people and economic processes, she was in fact the manager of a section of a production center, in the full sense of the word. Yet there was never the slightest doubt that she should subordinate herself to her husband, as he alone was responsible according to the law, only his decisions, his legal and financial actions were valid. As a result, a woman was expected to show absolute obedience to her husband. The duty to obey was so entrenched that she had to bend to the will of her husband even if it was against her better judgment. If she received orders from him which she considered to be wrong, then she could only express her opinion "with modest reason," cautiously and "with quiet persuasion," "movingly begging and beseeching" him "even with tears where they were called for," so that he recognized her dutiful respect.[58] If she did not succeed in convincing him then she was to yield, *even if it was detrimental to the household*. It was better to suffer damages here than for the master to see damage done to his authority!

"Marital love" was required to produce the right combination of superiority and inferiority between husband and wife. According to the household manuals it had little to do with any personal affection the spouses might feel for each other, and certainly a "marriage for love" was not a necessary basis for it. It was founded on common sense for the benefit of domestic order. For the husband, marital love meant ruling over his wife with as much consideration for her faults and weaknesses as possible. As her superior he was solicitous but condescending toward her, believing that without his guidance she was not capable of fulfilling herself. As a German émigré J. F. Knüppeln wrote in 1784 in a letter from America to Berlin, "the great thinkers of the past and of the present day" were unanimous in their opinion that women were "weak, helpless creatures who would be nothing in this world without the aid and support of the male sex."

‹36› Women's desire to get married is portrayed
as "chasing after breeches."
Copperplate engraving, 17th century.

For the wife, marital love was a rather different matter. She was under many more obligations. She had to love and honor her husband as her superior; she was not simply to show obedience, which was her duty, but to subordinate herself *freely* to him and not only where household tasks were concerned. She was to give way in all aspects of life, in her thoughts and feelings and follow the will of her husband. Philosophers, educationalists, churchmen, and writers tirelessly promoted this desirable characteristic: her ready, total, and joyful submission. Women were supposed to be patient and yielding, good-tempered and affectionate, concerned, hardworking, and home-loving. Somehow this would guarantee that existing social structures would prevail. These energetic exhortations about how women should be contain a clear polemical undertone that female insubordination and irresponsibility might endanger the order of the world.

Whereas Möser seemed at least to be expressing subjectively determined desires, the German philanthropical educationalists in particular expanded these ideas into a theoretical system. Basing their work on Rousseau's principle that *"la femme est faite spécialement pour plaire à l'homme,"* they formulated their view of women through "purpose": women were destined by nature to be wives and mothers. This was a logical continuation of the ideas of women's depend-

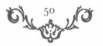

ence on men and their need to make themselves agreeable and useful to their husbands. The advice and rules of conduct issued to young girls at this time took on a generalized and apodictic character. Their authors went so far as to admit that men were imperfect and flawed beings; but nevertheless women were born to obey them and, with time, would learn to take injustice from them without complaint and even to tolerate their bad habits.

In 1789, Joachim Heinrich Campe advised his daughters—in fact, girls everywhere—to "get accustomed to dependence" and regard this as a virtue which was indispensable for the female sex: "This is your purpose both in nature and human society . . . Relinquish your independent will and especially your temper and any kind of contrariness. Learn to regard yourself as the second link in the chain of your future domestic life."[24] Johann Bernhard Basedow firmly believed that the female sex would never reach a state of independence. He therefore stressed that during their education girls should never be allowed to make an important decision without the consent of those on whom she depended. Such consistent training for dependence was perfectly suited to achieve the desired result: a woman who was in a position "to please her husband by being agreeable, by caring for many little needs and pleasures, by cleverly averting many little problems and other irksome things from her husband's attention, thus doing herself and her family a very great service."[12]

The educationalists of the Enlightenment in the latter half of the eighteenth century found Rousseau's Sophie in *Emile*, with her unspoilt naturalness (a clear indication of her husband's happiness) much more appealing than Julie in his *Nouvelle Héloïse*. The latter character, with her independence of mind and her own human dignity, disclosed that men and women could complement each other harmoniously on the basis of equality and partnership. This view of women was not generally accepted until the classical period. The concept of partnership was not really aimed at the development of a person's individual qualities, but concerned itself more with practical aspects. An intelligent and understanding partner—within limits—who could combine morality with polite manners, not only made married life much more pleasant in the home but increased her husband's prestige in his social circles.

It would, however, be wrong to judge this philanthropic standpoint in a negative way and only see its petty bourgeois limitations. Justus Möser's wistful description of a well-behaved, caring housewife finished on the following resigned note: "And that is the woman that I can no longer find." Instead, he is offered young ladies who have been brought up in the modern fashion, speaking French and English, who can sing and play extremely well, who can dance, and who are familiar with scholarly works. The thesis and antithesis of the woman with a bourgeois education and the aristocratically educated lady are the general subject of his "patriotic fantasies." With a number of well-observed situations he attempts to convince his read-

ers of the value of the modest, bourgeois woman within a strong patriarchal system, both for town and country and for every level of occupation. To his mind it was simply nonsensical to imitate the aristocratic way of life. Each of his entertainingly didactic essays expresses anxiety about the stability of the family in the sense of the "whole household," with its specific levels of production.

The bourgeois antifeudal opposition so rife in the latter half of the eighteenth century first appeared at the height of absolutism, and in the middle of its very own ranks. In 1687, François Fénelon, a member of the French aristocracy and archbishop and teacher to the royal family, wrote a manual on the education of girls. The type of woman described as the aim of his pedagogical measures is unmistakably characterized by the liberal and sumptuous life-style of the aristocratic woman. But the activities and ideals which he recommends were totally opposed to common aristocratic practice. Bringing up children, supervising the servants, personally running the household and any business connected with the leases were, in Fénelon's opinion, the most distinguished tasks for a woman of the aristocracy. "Keeping a whole family, a little state unto itself, under control" required great understanding, in his view, and was more fitting to the dignity of a woman "than playing, gossiping about fashions and delighting in the pretty art of conversation." The English moralists found reason to chide both the bourgeois and noble elements of their readership: "How many ladies distinguish themselves by the education of their children, care for their families, and love of their husbands which are the great qualities and achievements of womankind" (*Spectator*, No. 73, 1711). The German moralists of the Enlightenment soon followed with the reproachful description of how newborn babies were immediately handed into the care of simpleminded women and depraved attendants. They charged that the children "had to live among the servants until they were nine or ten and could count themselves lucky if they saw their parents once a week" (*Biedermann*, 1728). These accusations against women who had neglected their natural female duties were directed at the female sex in general and appear on the surface to express a perception of a general decline in morality. But they certainly have a deeper significance. They are the signs of the struggle for a new kind of life for the individual at the threshold between two types of society. Rousseau had a precise, though one-sided, interpretation of the incessantly discussed relationship between the sexes. He regarded it as a problem of the social development of mankind. "If only women would become mothers again, then men would soon become fathers and husbands." The problem here is not men and women but the social structures in which their common interests could become meaningful.

There was still a long way to go. Women's subordination to men was not only demanded in moralizing, philosophical treatises but was established in law. The freedom of everyday life gained through

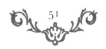

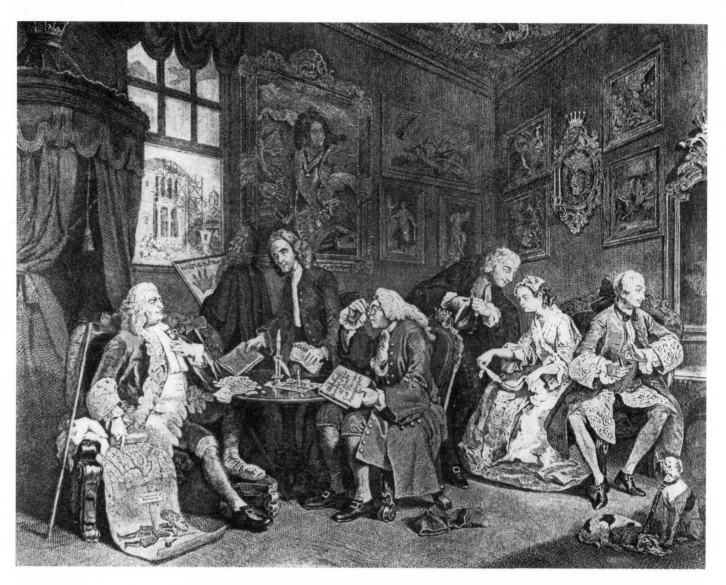

‹37› With biting satire Hogarth shows
how fathers negotiated "modern" marriages to their own advantage. The nobleman
needs money and the rich burgher wants an aristocratic title.

William Hogarth, *Marriage à la Mode: Scene 1—The Contract*, 1745.
Copperplate engraving, 35.2 × 43.8 cm. Staatliche Bücher- und Kupferstichsammlung, Greiz

marriage by aristocratic women was due more to their exceptional position in society and the traditions that went with it than to actual rights. If a nobleman felt that his conjugal role was being interfered with, he could easily make use of his legal power over his wife and exile her to a distant estate or lock her up in a convent and deprive her of her wealth. Admittedly, such cases were spectacular and exceptional in court circles. It was generally accepted among the bourgeoisie and the lesser nobility that women were identical with their husbands in legal matters. This was regarded as a right and privilege

for married women at that time. Through marriage men and women became one unit, but this unit was represented solely by the husband. From the moment she was married a wife was under the guardianship of her husband. This meant that a married woman could not undertake any legal or financial business—or at least she was greatly restricted in that exercise—without the assistance and agreement of her spouse. It was the husband's duty to administer joint property, including that which he gained from his wife upon marriage or that she later inherited. (England was an exception in

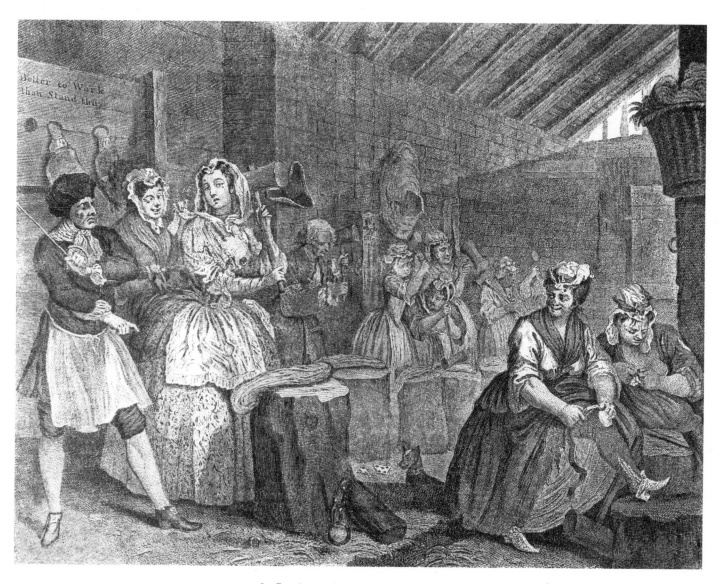

⟨38⟩ Prostitutes who were picked up off the streets
were sent to the workhouse, mainly to gain labor rather than, as claimed,
to improve their morals.

William Hogarth, *A Harlot's Progress: Scene 4—In Bridewell*, 1732.
Copperplate engraving, 29.9 × 38.5 cm. Staatliche Bücher- und Kupferstichsammlung, Greiz

that women retained the ownership of land after they married.) There were various special laws about the so-called "recepticia"; that is, those goods which women expressly reserved for their own supervision and use in the contract of marriage. The general rule, however, both in England and on the Continent was that all movable goods and any income, including the wife's earnings, were totally at the disposal of her husband. This was also the case in practice when there was joint ownership of goods in marriage—a feature of some German laws.

An anonymous work,[96] dated 1791, which set out to establish women's specific rights in the dispute about the advantages and disadvantages held by the two sexes, described in great detail the effect of these rights in practice. According to the author, the wife was not only "a companion to the work and complaints of her husband" but also "a joint owner of all goods brought with the dowry and acquired later." "Whatever the couple had at the outset of their marriage or acquired during it through their own hard work," would be "regarded as joint property." This certainly sounds like women's rights

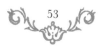

so far. The author, however, goes on to say that "after a man is made guardian of his wife by marriage and thus has the right to administer over her personal rights as well as her property, it is quite clear that she is totally at his beck and call and must submit utterly to his will . . . for this reason she neither has the right to dispose of any of her possessions without her husband's consent nor take up a loan or anything which might be regarded as an obligation."

The degree of restriction on women's activity varied from country to country. The worst was probably England, where the principle of "coverture" (that the wife was legally represented by her husband) removed all rights from a married woman as an entity in the eyes of the law. She could not conclude contracts nor enter into any other legal obligations; she could not issue bills of exchange nor any other forms of payment. By the same token, it must be said, she could not —from the legal point of view—commit a punishable offense (apart from certain "serious" crimes), because her husband bore the responsibility for her action. Even if proceedings were instituted against her, or if she herself was the prosecuting party, her husband always had to take her place in the court. Champions of women's rights of that period regarded this particular denial of legal rights as the most outrageous injustice. In a bold broadsheet for equal rights, Theodor Gottlieb von Hippel wrote in 1792: "The highest form of insult is to declare that one cannot be insulted by someone; and with the privilege of being unable to do wrong the privileged person is accorded no greater security than the insane."[56]

In Saxon law, too, women were treated as unfit to take legal action and unfit to undertake an obligation. It was laid down in the statutes of Hamburg of 1603 that "women can neither bring a matter up before the court nor transfer or hand over property without a guardian." In other words even if there was joint property through marriage, this neither helped the woman nor restricted her husband's freedom of action, for whatever she tried to do with her property had no validity in law.

Single women and widows had more freedom here than married women. They could freely choose their legal representative, if necessary a different one for each case, whereas married women made their choice of representative once and for all. But in this area, too, the laws varied from state to state. In Bavaria, Austria, and Franconia, guardianship over women had been abolished in the Middle Ages. The administration of property by men was, however, protected by law. As early as 1518, Bavarian law had totally withdrawn married women's rights over their property. "No woman has the power to sell anything without her husband's knowledge and consent. If she does so, it is not valid in law." In the law of 1616 the principle of this rule was still applicable, although those goods which a woman had reserved for her personal use were excepted.

In eighteenth-century Russia two concurrent, though totally different traditions gave rise to a somewhat vague legal interpretation.

The old *Russkaya Pravda*, a newspaper, which laid down rules for urban marriages, granted both noblewomen and the wives of merchants or artisans full legal rights, so that they could become the head of the household on the death of their husbands and continue to run the family business. In the rural areas, however, in actual practice, this was opposed by the estate owners and officials (who were mostly nobles) who did not recognize this legal independence of women and adhered to a patriarchal family code. The *svod zakonov*, a code of laws which did not come into force until 1832, is a record of the conditions of the time. It clearly states that marriage does not mean joint ownership of property. Each spouse had his or her own property and can dispose of it at will. "The spouses may sell their own property, pawn it, and do whatever else they like with it, in their own name, independently of each other and without needing permission or authorization from one another." Since there is separate ownership here and wives are allowed to do with their property what they will, women do not need to have guardians. Thus women are not otherwise restricted in legal matters. They can appear in a court and can undertake any kind of legal process without the consent or aid of their husbands.

In the seventeenth century in Western Europe a new concept of marriage started to gain ground through the doctrine of natural law, but even as late as the eighteenth century only a little of this was incorporated into legal codes. This delay was not only because the theories propounded by the supporters of natural law were so far removed from the prevailing laws. A greater difficulty was that their doctrines were not uniform and even the structure of their theories was inconsistent, as well as unsuitable for transforming the law current at the time. Nevertheless the proponents of natural law pointed the way for the future. Their most important principle was that everyone was equal and free in nature, regardless of his or her sex, and no one had the right to dominate anyone else because of "nature." However, and this is where the differences of opinion and inconsistencies start, there were "natural differences" between the sexes. One of the founders of natural law, the Dutch lawyer Hugo Grotius, explained these differences as innate male superiority; he believed that husbands should therefore automatically have power over their wives. In the seventeenth-century philosophy of France the privileged position of men was not challenged. Moyse Amyraut (1596–1664), Professor of Theology at Saumur and one of France's greatest philosophers on natural law, taught that there should be as much equality as possible in marriage and mutual obligations, for example, marital love. Nonetheless a woman's love for her husband must be respectful, as he had the greater physical qualities and a better intellect. The German philosophers of natural law went considerably further. Samuel Pufendorf (1632–1694), a champion of natural equality among men and women, held that the historical development of society had led to the emergence of inequalities. Thus one had to proceed from

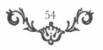

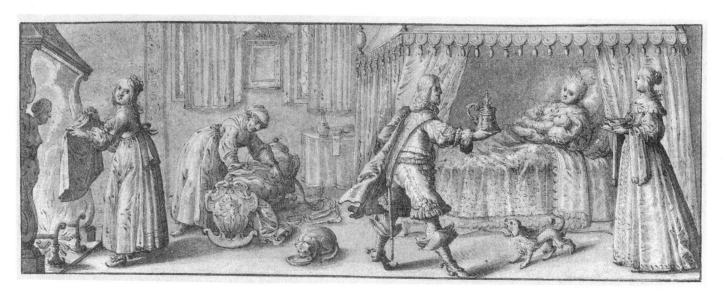

‹39› This drawing gives exact information about the living room of a rich patrician house, with all its expensive furnishings.
A charming feature is the hustle and bustle of visitors and servants.

Jonas Arnold the Younger, *Childbed*, 1656.
Wash drawing, 9 × 25.2 cm. Staatliche Museen Preussischer Kulturbesitz, Berlin (West)

the fact that male dominance in marriage existed, but this could only arise if a woman freely allowed it in the marriage contract. He interpreted the marriage contract as an alliance with mutual obligations; the husband promises protection and the wife obedience.

An interesting figure among these philosophers is Christian Thomasius (1655–1728), Professor of Jurisprudence at Halle. First of all he quite decisively radicalized the opinions of his teacher, Pufendorf. According to Thomasius, the contract of marriage gave both partners equal obligations, as there was no natural inequality between them and no question of the husband being naturally superior. It was their duty to beget children and satisfy each other's sexual needs. Moreover, a husband had no special and one-sided rights over his wife: there was no power to command on the part of the husband and no duty to obey on the part of the wife. This interpretation could have established real equality between the sexes in the eyes of the law, at least in marriage, but the historical conditions for this were not present. And later Thomasius retracted his bolder theories. He retreated to Pufendorf's concept of a freely entered into contract of subordination, gave natural and sociohistorical reasons for its necessity: women were weak by nature, so men had to carry the burdens of marriage and therefore had a right to issue orders.

There was a time span of three decades between these two marriage theories of Thomasius. In between the two, in 1705, he wrote the *Kurtzen Entwurff der Politischen Klugheit* (Brief outline of political prudence), a "guide to living" (Arnold Hirsch) for the middle classes. A bachelor when he propounded his "full equality" thesis, it

may have been his subsequent personal experience with marriage that caused him to change his view. "A husband's orders to his children and servants always take precedence over that of his wife if she opposes him A wife will always give way to her husband, if she is of a different opinion; but if she is clever, she will rarely be of a different opinion" Any other behavior "would go against the order of nature and the law of all sensible peoples."[121] With statements like these the former radical joined the ranks of the advocates of male dominance over women.

The division of responsibility between husband and wife—hers being the house and family and his, everything linked with the outside world—seems to make sense as long as the extended family, as a production unit, retained its economically justified function. While this was so, a woman could develop her personality and, even though she was restricted by her husband's power, she could cultivate and use specific skills which gave her inner satisfaction and fulfillment. The rise of a systematic campaign for women's rights and equality with men went hand in hand with the gradual erosion of the concrete, practical scope of work performed in the home, that is, with the disappearance of the "whole household." There is a direct link between this and the new structure of production. As the production of material goods became increasingly confined to factories, the independent work of women in household production grew less and less important. This economic process of change freed them from the worry and burden of housekeeping in a production unit. But at the same time it took from them their meaningful and useful position in

<40> Hatboxes like this were made
out of wood shavings and were used to store fashion accessories,
bonnets, ribbons, and the like. The inscription indicates that
this was an engagement or wedding present.

Hatbox, German, *c.* 1760.
Length 49.5 cm., height 10 cm. Museum für Volkskunst, Dresden

of the aristocracy, and is generally perceived as a literary movement. But it was more. The origin of the *précieuses* movement must be seen as a revolt against the position of women in aristocratic society and the low regard in which they were held. It was an attempt by some women to emancipate themselves from male privilege and superiority. Above all, they thought little of marriage—they preferred to remain unmarried than to yield to expediency and to the increase in property and prestige that accompanied marriage. Knowing well that they could not change the traditions of the time, they cultivated in their literary work and in the conduct of their circles a concept of love that was pure, perfect, and imbued with ideals. The gallantry and coquetry usually expected by society were totally out of place here. Their basic concept was that both partners were equal in love by proving themselves within traditional norms, like truth, friendship, and respect. And they tried to practice the necessary equality between men and women in other areas, not by catching up with men in their own domains but by developing their specifically female talents and skills. Originally this style grew out of the belief that natural feeling and healthy reason was superior to the academic—*pédantic*, as the *précieuses* would have said—scholarliness of men. Eventually, however, in their creative writing and literary criticism this led to an affected style of language which was effusive and rich in imagery. Their excessively refined style was scorned, not altogether unjustly, by their contemporaries. Molière's comedy *les Précieuses ridicules*, first performed in Paris in 1659, is evidence how the *précieuses* were perceived in their time. Its biting scorn ridiculed women's efforts to free themselves from conventions which had become meaningless. (The weapon of ridicule has since been used repeatedly and effectively in similar situations.) In the preface, Molière denied that he was ridiculing the movement, stating that the noble and "real *précieuses* would be wrong to feel hurt if one portrays the ridiculous ones, who are bad at copying them." This denial of his is not very believable, for although the women around Mademoiselle de Scudéry and the Marquise Rambouillet were tolerated by society because of their high birth, in fact their airs and graces were viewed with displeasure and disapproval.

A few of the wealthy, aristocratic *précieuses* were so daring as to stay single and still retain their full social standing. This was scarcely possible for the lesser nobility and the middle classes. Spinsters (and bachelors as well) were met with scorn and contempt—at best, incomprehension. Society functioned on the basis of the family; unmarried people disturbed its order. In addition, unmarried women could only fend for themselves in exceptional cases. What alternatives were open to them apart from the convent or prostitution?

the social system of the period. With this loss of a meaningful (albeit "secondary") role in the productive economy, the exclusion of women from public affairs and middle-class professions was much more pernicious.

Women from the wealthy middle classes were deeply affected by this change in the economic process. The upper middle classes assumed the status consciousness of the nobility. They had come to regard cultivated leisure as a prerequisite for social prestige. And since the men had to pursue their professions, it was left mainly to the women to display their wealth through idleness and the acquisition of luxurious material goods.

One of the earliest "protests" against women's position in society is found early in the seventeenth century. It took place in the salons

‹41› Seventeenth-century farmhouses often had only the most essential
pieces of equipment and furniture. It was normal to have the stable, barn, and living quarters
all in one room. The Dutch painters consciously emphasized the contrast
between peasant untidiness and bourgeois orderliness.
Another interesting feature of the painting is the stream of light
which penetrates into this dim but picturesque confusion.

Isack van Ostade, *Interior of a Farmhouse*, 1645.
Oak, 56.5 × 74.5 cm. Staatliche Museen Preussischer Kulturbesitz, Berlin (West)

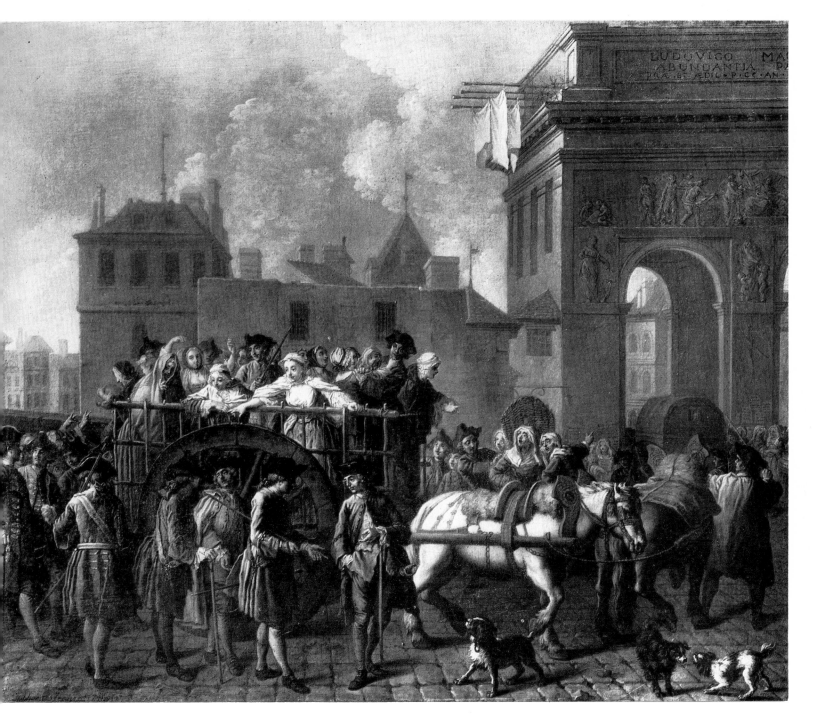

‹42› This self-portrait of Jan Kupetzky with his wife and child
appears split between bourgeois virtue and Bohemian carefree attitudes.
There are several portraits of the artist with his wife, each depicts with a personal,
individual touch a different stage in the tempestuous marriage of this eighteenth-century artist.

Jan Kupetzky, *Self-portrait with Wife and Son*, 1718/19.
Oil on canvas, 111 × 91 cm. Museum of Fine Arts, Budapest

‹43› Carting prostitutes off to the police
or to the hospital was not a common event and was usually triggered off by some special reason.
After all, there were numerous brothels in the cities and they were by no means banned.

Etienne Jeaurat, *Prostitutes Transported to the Police Station*.
Musée Carnavalet, Paris

‹44› Soft evening light fills this peasant house
with its open fire in the enormous stove. The clothing worn by the two women
sitting at the stove and the table covered by a white tablecloth indicate a higher standard of living
than the room itself suggests. A rustic scene of everyday life is
idealized by the free and bold brush strokes of this Rococo painter.

Jean-Honoré Fragonard, *At the Stove*, c. 1765.
Oil on canvas, 35 × 25 cm. Pushkin Fine Arts Museum, Moscow

‹45› Only sunlight from the upper part of the windows
can penetrate the concentration of the woman reading devotional literature.
She has taken off her outside shoes, which shows how clean the house is; an ideal picture of female virtue.

Pieter Janssens Elinga, *Woman Reading*, 1665/70.
Oil on canvas, 75 × 62 cm. Alte Pinakothek, Munich

‹46› The pictures of lively company, where young men drink with beautiful girls,
sing, play musical instruments and play cards are usually scenes from brothels. Although
they show pleasure in depicting a wicked enjoyment of life, they have a moralizing purpose.
It is the Prodigal Son who is frittering away his property and his honor with the prostitutes,
and has to eat with pigs. (see Ill. 48)

Nikolaus Knüpfer, *Scenes from a Brothel, c.* mid-17th century.
Wash drawing, 21.3 × 30.1 cm. Kunsthalle, Bremen

‹47› Gabriel Metsu portrays himself and his wife at a drinking party.
The painting admits to carefree festivities but at the same time cautions moderation—
the servant girl ostentatiously makes a note of the food—and instructs the viewer
not to fall prey to the evils of drink.

Gabriel Metsu, *Self-portrait of the Artist with His Wife Isabella de Wolff in an Inn,* 1661.
Oak, 35.5 × 30.5 cm. Staatliche Kunstsammlungen, Gemäldegalerie Alte Meister, Dresden

Following page:

‹48› Johann Liss, *The Prodigal Son, c.* 1620.
Oil on canvas, 85.6 × 69 cm. Gemäldegalerie der Akademie der Künste, Vienna

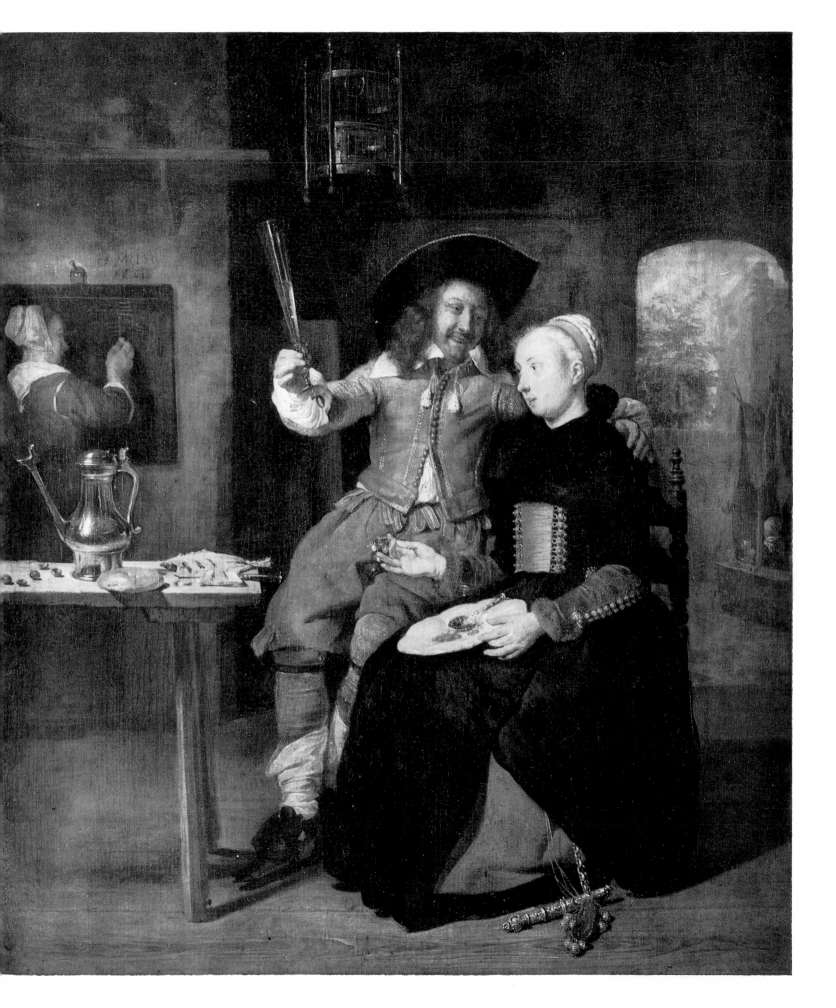

WOMEN'S WORK

We have taken a brief look at the lives of two women of the Baroque: the glamorous aristocrat and the industrious bourgeois housewife. What of the women who fell into neither of these categories? Were there choices beyond the convent or the streets? Something other than saint or sinner?

Mary Astell (1666–1739), a truly emancipated English writer, gave a very poor view of matrimony in *Reflections on Marriage*, published anonymously in 1700, when she wrote that marriage makes a woman "a Man's Upper-Servant" who has need of "a truly Christian and well-temper'd Spirit" and "all the Assistance the best Education can give her" to enable her to put up with marriage. For all the truth of this, for all the injustice that marriage entailed, it still offered the most secure and, in the eyes of contemporary society, the most comfortable existence. *Chasing after Breeches*, portraying panic and chaos, was a common caricature of the very real, almost desperate struggle of women to get married. The problem here was not that men were unwilling to get married, but that they were frequently unable to do so. Marriage regulations were authoritarian and largely consisted in obstacles presented by the civil authorities. Marriages were first limited by demanding "consent" from all parties—parents, guardians, officials, one's superiors, even from the landlord in the case of tenant farmers. Municipal authorities demanded proof of independent means and city rights to ensure that they would not be burdened with impoverished strangers and their families. Often a substantial marriage tax was levied. In sum, marriage meant the establishing of one's own household, and was only permitted if the necessary financial conditions were fulfilled. Men in a position to do so were not easily available.

If a wealthy upper-class woman had to remain single, there was always the convent as a last resort. But what was there for those who were not wealthy, who had no "dowry" to bring to their "marriage" to the Church? The convents, which themselves were struggling for survival and were dependent on monies and land brought in by new members, were not very attractive to women without money: they could, of course, enter, but only as servants (lay sisters), and it was not a popular life.

Apart from the few women who chose to remain single, and the unfortunate ones who weren't rich enough to marry, there were also many women who had lost their husbands in war or through the consequences of war and whose existence was endangered because they were not in a position to run the family business alone. According to the law of the time a widow could in fact succeed her husband in the running of a workshop, trading concern, or farm. But in practice this only happened in prosperous, soundly based enterprises that were not difficult to maintain. If a widow failed to remarry, she and her dependents frequently ended up among the scores of beggars who thronged the roads and towns of seventeenth-century Europe.

Not only women and children met this fate, but entire families, especially from the rural population, were forced to leave their homes. In England, this process was particularly drastic and was linked with the rapid development of early capitalist methods of production. The enclosure of large areas of arable land to create sheep pastures for the benefit of cloth production destroyed thousands of small tenant farms and drove out the families who had lived off the land onto the streets, with no means of support. In seventeenth-century England the number of families who had to be supported in poorhouses at the expense of the parish has been estimated to have been four hundred to five hundred thousand—about a quarter of the entire population.

In France, too, there was a trend toward combining farms into large profitable estates. The tenant farms were not very stable because of their small size—even one bad harvest could lead to debts and ruin. According to documents on the French region of Beauvaisis, independent peasant farmers had to hand over about a half of their produce, and tenant farmers, more than a third. In addition, the land was frequently devastated by war so that in the course of the seventeenth century the ranks of the poor and beggars swelled enormously. A report from that period estimated the number of beggars

acute by the Thirty Years' War. In 1891, almost two hundred years later, August Bebel wrote of this period in *Die Frau und der Sozialismus*: "Indeed a great period of suffering had begun for the female sex. Contempt for women had grown dramatically in this period of anarchy. It was on their shoulders that the greatest burden of unemployment lay."

Prostitution was rife under such desperate living conditions. For some women it was the most easily available livelihood, but for many others, whose opportunities were more severely limited, it was the *only* means to survival. The figures quoted for prostitutes living in large towns in the eighteenth century seem unbelievably high, but the reports are all very similar. The figures given for Paris are around the 40,000 mark; of these 22,000 had notary-attested contracts, which indicate that the women concerned had already reached a social level such that they no longer had to walk the streets. London is said to have had about 50,000 prostitutes around 1780. Their favorite meeting place, St. James' Park, was described by Mary de la Rivière Manley in her book *The New Atalantis* in 1709. She wrote that honest people could hardly go there anymore, as it had become a public market where young women would sell themselves for a day or an hour depending on what they were paid. In Berlin, the avenue Unter den Linden was inundated with prostitutes, and it was said that young seamstresses offered "more than their handkerchiefs" for sale on the Jungfernbrücke. In the latter part of the eighteenth century, only a tiny proportion of the prostitutes of Berlin lived in the one hundred officially sanctioned brothels, which had an average of eight women each. The regulation in paragraph 999 of Prussian law that "loose women who want to trade with their bodies must do so in the official whore houses supervised by the state" was most certainly unenforceable, as there were simply not enough brothels.

From time to time the authorities felt that they had to take action against this mass-scale immorality. Their measures ranged from draconian penalties for any kind of prostitution—from streetwalkers to brothels and mistresses—to the regulation of legal, police-supervised brothels. The German imperial police regulations of 1548 and 1577 severely punished prostitution and procuration in attempts to bring the syphilis epidemics under control. City councils tried throughout the century to enforce these rules, with little success. From the eighteenth century onward the laws and their custodians had to accept prostitution as a fact of life. To a certain extent it was kept under control by confining it to brothels. Prussian law legalized what had already been in existence for quite a while. "Such public houses will only be tolerated in large densely populated towns and only in quiet back streets or remote places." In the smaller towns where the tone was set by respectable middle-class families, public brothels were a rarity, although they had been quite common in the Middle Ages. Bourgeois family life positively disassociated itself from the immorality of the whore, who was despised for her

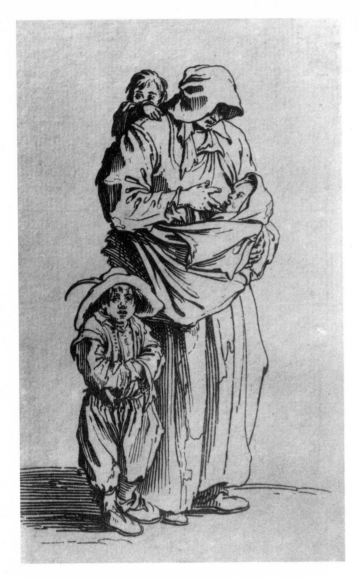

‹49› Beggars, such as the ones portrayed here by Jacques Callot, were all over the towns and countryside. What attracted Callot to these unfortunate souls, apart from their picturesque appearance, was not pity. An aura of pride and dignity radiates from these large individual figures, giving a better idea of the scale of their misery than would a realistic portrayal.

Jacques Callot, from the series *The Beggars*, c. 1622/23. Etching, 137 × 86 cm. Staatliche Museen, Kupferstichkabinett, Berlin

in Paris in 1634 to be 65,000. The "realm of vagabonds" was a state with its own laws. In 1698 the Seigneur de Vauban gave a report to King Louis XIV in an attempt to win support for his proposal for a just system of taxation. He stated that a tenth of the population was living by begging, as revealed by many years of investigation. In Germany the pauperization of the people was made all the more

lack of virtue and whose bourgeois rights and honor were declared forfeit. Indecently assaulting such a woman was not punishable, according to J. J. Beck in his treatise of 1743 on the "defloration and impregnation of virgins and honorable widows," as "her honor is not defiled nor is she ravished." For the same reason the punishments occasionally used against whores, such as stocks, flogging, and shaving the head, were sanctioned by the public. In spite of all this, prostitution certainly did not die out. We can presume, therefore, that it was made much use of, and probably as much in small towns as in the cities by the lower classes. The difficulty involved in setting up a home, which resulted in large numbers of men not marrying, made it indispensable.

In France, the *filles du monde* were threatened, according to police rules, with forced delivery into hospitals for suspected sexual diseases. The most notorious of these hospitals was the Salpêtrière in Paris. This action, always very arbitrary, was usually the exception, however. Moreover, it happened less and less throughout the eighteenth century. Prostitution had in no way decreased, but it had become less obvious. Some girls were kept as mistresses in brothels, while others moonlighted as prostitutes because the money they earned as seamstresses, for instance, was not enough for their daily needs. This is how the nineteenth century produced the Grisettes and Midinettes made famous by *La Bohème*.

The most radical attempt to curb prostitution was undertaken by Austria's Maria Theresa. Her famous Chastity Commission can only be described as tragicomic. Prince Khevenhüller, one of the closest advisers to the Empress, made a note in his diary in 1748 that she had "issued very strict orders on matters of sex and had formed a commission whose sole task was to prevent and disrupt any private meetings." We have a number of reports from travelers to Austria— all independent of one another—who described what happened in practice. It seems that all unsanctioned meetings were spied upon, and arbitrary checks were made on women out on their own. The diligent officials of the Chastity Commission are even said to have followed suspected couples back to their homes where they were then apprehended. There were cases of unmarried men being automatically married off to the prostitutes they were found with, and married men who were threatened with a petition for adultery. The girls themselves were punished on a massive scale. Their hair was cut, they had to wear chains, sweep alleyways, and push barrows through the streets of Vienna. But these grotesque and brutal measures had little success; at the most some prostitutes made a makeshift attempt to appear honest, as housekeepers or maids. The number of these "promoted" prostitutes in Vienna was put at about 50,000, and ordinary street prostitutes were estimated at twice that figure.

Of course prostitution was not the only way that women could earn a living. But it is certainly true that the opportunities for recognized and satisfying work for women had greatly diminished since the Middle Ages. From the thirteenth to the fifteenth centuries women were not generally excluded from learning a craft or trade. Women could work independently at virtually any trade if they were physically strong enough for it. According to official records, women were involved in two hundred trades in Frankfurt (Main), and some jobs in the textile trades were performed exclusively by women. Women had their own guilds in Cologne, especially in textiles. The fight against independent female workers began at the end of the fifteenth century, and the exclusion was completed by about the middle of the seventeenth century. By the end of the sixteenth century, there were more men than women working in silk production, a reversal of the proportion of the previous century. The guilds banned girls from taking up apprenticeships, even in traditional areas of women's work such as weaving, braid knitting, or passementerie manufacture. Around 1700 women were employed in Vienna only by weavers, but not to weave. They were only given spinning to do, and were paid by the piece. In 1601, women were banned from doing any work linked with braid knitting "because otherwise any maid or even unmarried whore, who did not have much patronage, could turn to this craft and practice it in odd corners." The passementerie workers of Frankfurt (Main) had in their rules of 1596 that master craftsmen should still take on girls as apprentices. This regulation was soon narrowed down to middle-class girls or relatives of the passementerie workers themselves. Finally, in two orders issued in quick succession in 1607, first, only two girls were to be allowed in "for menial work," and then, they had to be daughters of guild members. In 1683, the beadworkers of Vienna issued a ruling on large orders. The master craftsman was not permitted to use women to help him with the work; instead he was to share it out with another master craftsman. Master craftsmen or journeymen who allowed women into their workshops or, worse still, trained them, were to be expelled from the guild.

These and other similar regulations, of which we have only given a few examples, throw a great deal of light on the history of the exclusion of women from independent professional work. Interestingly, the many statements banning women from beginning an apprenticeship, made it clear that all the women and girls who had already learned the craft and had been allowed to practice it up till then should "continue until they die out." Thus in Württemberg, in 1701, the leaders of the braid knitters' guild threatened their master craftsmen with expulsion if they took on girls as apprentices, even if they were their own daughters. Wives, however, were allowed to work at their trade. The guilds were intent on driving women out forever, with the leaders making an effort to minimize conflicts where they could by allowing "attrition" to do the work for them.

Moreover, if a master craftsman's widow took over the running of the workshop after her husband's death, the guild showed great interest in seeing her married again quickly, preferably within the same guild. This can be seen in the regulations on masters' widows.

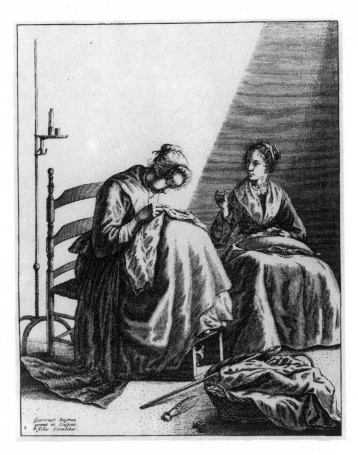

‹50› The Dutch artist Geertruydt Roghmann shows
young women engaged in the two most important forms of homeworking.

Young women sewing.

Almost without exception, a widow was permitted to run the workshop. Certain other benefits, on the other hand, such as the preferential allocation of journeymen were limited to a specified period. After that it was up to the widow either to remarry, marry off one of her daughters, or bring a son into the trade. Boys were not allowed, as a rule, to be apprenticed in widows' workshops. This clearly indicated that letting a workshop be run by a woman was regarded as an interim solution, nobody wanted her to continue to do so.

Women were also incapable of fulfilling the military obligations of the guildsmen. Up till then master craftswomen had always sent men to stand in for them. Master craftsmen would always learn the most important aspects of their work on their travels but, according to Adrian Beier, there was "little difference between a journeyman who had never traveled and a craftswoman who had traveled widely." Beier was Professor of Law at Jena and specialized in craft trades. He often took pains to prove that women were totally unsuited to this kind of work. In *Von der Zünfte Zwang* (On the obligations of the guilds), published in 1688, he made his point with a rhetorical

question: After all, his thesis went, women were born to marry, and what on earth should a skilled craftswoman do if she married a man who had a totally different trade? The real reason is never mentioned in arguments like these, but it can be inferred from the regulations themselves. Competition between the urban workshops had grown so fierce and the general economic situation so serious that most master craftsmen felt they had to eliminate as much of the competition as was possible and keep the number of craftsmen per shop low to guarantee their own survival. Those affected the most were women, as they were the first to go.

Midwives and doctors have somewhat different histories. In the Middle Ages female doctors were not unusual. Many of them received their training at the school of medicine in Salerno. The *mulieres Salernitanae* were specialized in gynecological disorders and children's illnesses, surgery, and ophthalmology. There are records of women doctors working in all the large towns of northern Germany throughout the late Middle Ages. The names of fifteen practicing women doctors can be found in the city records of Frankfurt (Main). But there is not a single name to be found for the sixteenth century. Women with medical skills were not unusual in France either; the *miresse* was trusted by the people. The medics at the University of Paris soon began to defame their work as "quack medicine." Fines and excommunication quickly followed. The word "quack" tells all. Women were driven out of the healing profession not because of their sex, but because of the clash between the first new scientific discoveries in medicine and the ancient healing practices. The new theoretically founded medical knowledge was a male preserve, since it required a university education. It still had its shortcomings and uncertainties, but was enforced all the more ruthlessly for that. Only one group could be right, either the doctors who were men with scientific training behind them, or the women whose methods of treatment were based entirely on empirical experience and natural remedies handed down over the centuries. From the start the doctors were at an advantage in this struggle because of their higher social status. Furthermore, it was widely held that there was a fair amount of superstition involved in the work of the women healers. There certainly were a few superstitious practices used by the alleged quack healers (just as there were some used by the doctors). When the persecution of witches was at its height this proved to be fatal for the women healers. They were accused of dangerous sorcery and were banned from their work because of insufficient training.

The profession of the midwife developed in a rather different way. Unlike women doctors, midwives were never banned from working, although the scope of their work underwent a substantial change. Their position, which had been unchallenged throughout the Middle Ages, was encroached upon by medically trained doctors who took over as obstetricians. The women, who were armed only with practical experience, were left with the dirty work or nothing at all.

Interestingly, there was probably more superstition in the work of the midwives than of the healers. Midwife assistance was mainly called upon in the country and among the lower middle classes in rural towns, where doctors were not available. Thus their old superstitious practices survived almost intact, and they themselves were regarded with a kind of superstitious respect. It was probably in their interest to surround themselves with an air of mystery as it stressed the importance and indispensability of their activities. This made the spiritual and secular authorities as well as the midwives' medical counterparts regard them with even more suspicion and accuse them of practicing witchcraft. All the regulations on midwives issued between the sixteenth and eighteenth centuries strictly prohibit these practices and prescribe punishments for the usual incantations, charms, and other customs. The traditional superstitious practices—which their female patients would never have wanted to dispense with either—and the use of largely unknown natural remedies made them prime targets for accusations of witchcraft. This was eagerly supported everywhere through the Inquisition. It must be said, however, that the midwives' knowledge of obstetrics was indeed poor and was getting worse, since their profession was not being promoted, training was neither required nor made possible to obtain, and they were not informed of the progress achieved by medicine. The first schools for midwives, founded in the mid-eighteenth century, had little influence. With conditions as they were, the few midwives who became famous were all the more spectacular for doing so. Marie-Louise Bourgeois was midwife to Marie de Médicis from 1601 to 1610 and had a wide practice among the aristocracy until 1627. When one of her patients died of childbed fever, the doctors used this as a welcome opportunity to accuse her of mishandling the situation and thus put an end to her work. Marie-Louise Bourgeois did, however, write an intelligent and informative book on her professional experience. The *Observations diverses sur la stérilité, perte de fruits, fécondité, acchouchements et maladies des femmes, et enfants nouveaux naiz* (in three volumes) enjoyed such a high reputation that it was translated into German. It was published in 1626 in Frankfurt (Main) by J. Th. de Bry with illustrations by Matthäus Merian sen. as *Hebammen-Buch. Darinn von Fruchtbarkeit und Unfruchtbarkeit der Weiber, zeitigen und unzeitigen Geburt, Zustand der Frucht in und ausserhalb Mutterleib, zufälligen Krankheiten sowohl der Kindbetterin als des Kindes, wie auch dero Cur und Mitteln, zusampt dem Ampt einer Wehemutter oder Hebammen weitläufftig gehandelt wird* (Manual for midwives comprising the following subjects: women's fertility and infertility, premature and late births, condition of the foetus inside and outside of the womb, illnesses that mother or child might contract and the means to cure them, together with the position of the midwife). The title alone gives a good idea of the wide-ranging responsibilities a midwife might have.

In Germany, too, there were some highly educated midwives who became famous through their distinguished clients. *Die Churbranden-*

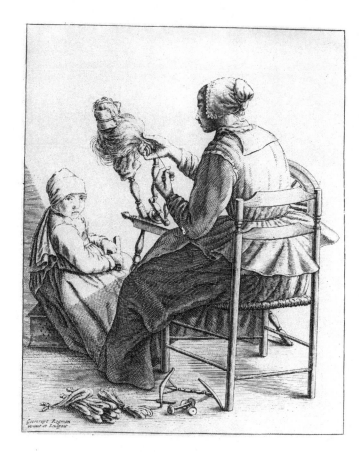

<51> Young woman spinning.
Geertruydt Roghmann (born *c.* 1650)

burgische Hoff-Wehe-Mutter. Das ist: Ein höchst nöthiger Unterricht von schweren und Unrecht stehenden Geburten (Court midwife to the Electorate of Brandenburg. That is: highly important instruction on difficult and complicated births) was published in Cölln on the Spree river in 1690. The author was Justine Siegemundin, whose excellent reputation as "municipal midwife" for the authorities of Liegnitz led to her being appointed "court midwife" to the Electorate of Brandenburg and later the royal court in Berlin. She used an interesting argument in a dispute with the anatomist and surgeon, Dr. Andreas Petermann, of Leipzig University, who described her obstetric methods as speculative, impracticable, and harmful to the patients, although she had developed them over many years of practical experience. She proved him wrong with confidence and conviction by reproaching him for attending only ninety births in his twenty years of practice, whereas she had been present at fifty thousand over the same period. The wealth of practical experience possessed by some midwives must have given them real superiority over the doctors.

Gainful employment in "service" was much more common than medicine, midwifery, or the crafts. This was a large and complex

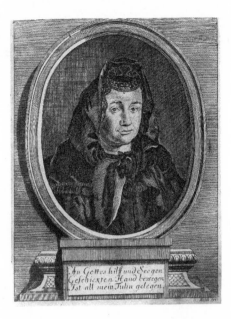

‹52› and ‹53› Title portrait and illustration to the book *Hof-Wehe-Mutter*,
in which the midwife Justine Siegemundin set out her practical experiences.

Georg Paul Busch, 1690. Deutsche Staatsbibliothek, Berlin

area of women's work, and as a method of earning a living it was never in jeopardy. On the contrary, servants' compulsory service, one of the vestiges of feudal medieval serfdom, took many girls from the country and placed them into the personal service of landowners, even though they might have preferred to earn a living working at home or in a factory. Women did a phenomenal amount of work as domestic servants in the towns and as farmhands on estates of all sizes.

At a historic moment in the middle of the nineteenth century Wilhelm Heinrich Riehl made a plea for the idyllic patriarchal family incorporating the servants within it, although the "large household" had long been in decline.[(100)] He praised the benefits of close links between master and servants which, on the one hand, guaranteed protection and care for the servants as for all members of the household, but on the other required total self-sacrifice from the servants in the interest of the master and his family. In a large number of cases, and in some areas without exception, this sacrifice was expected to last for the whole of their lives. What Riehl does not mention is that servants were thus expected to sacrifice their own independence, marriage, and family life, in other words, to give up their right to lead their own lives. Admittedly, servants' marriages are sometimes mentioned in the rules for servants and in household manuals. They recommend that the master and mistress encourage their servants to set up their own home, and if need be free them early from their contracts if the marriage is a particularly good one. They are far more

concerned that the servants should stay in the class they were born into, and patiently bear all the suffering, disadvantages, and injustice that went with it as God's will. A servant's life was fulfilled in the service of his or her master as this was also God's service.

These pious exhortations probably had less influence than the compulsory measures enforced by the authorities. Contracts of service were made for a minimum of one year. Premature notice could be given by the master but not by the servants. Servants who ran away would be brought back by force and could face imprisonment. Court records, however, show that despite the legal constraints, this occurred with some frequency. The regulations also tried hard, but without success, to prevent servants from taking up new jobs after their contracts had expired. According to various regulations, strong and healthy young men and women were supposed to hire themselves out within a fortnight after Christmas if they had left their previous jobs. The law encroached ruthlessly upon the personal decisions of the servants if the masters could benefit. Girls who spent the winter at home earning money by spinning wool, making lace, and other similar activities and only hired themselves out during the harvest, were heavily fined if they sold their products. If they continued to stay at home a monthly tax was imposed upon them.

Female servants were at the very bottom of the social pecking order, with maids far below the male servants. Their wages clearly illustrate this. In the middle of the seventeenth century the annual wage of a male servant in Saxony was fixed at 20–30 guldens; the

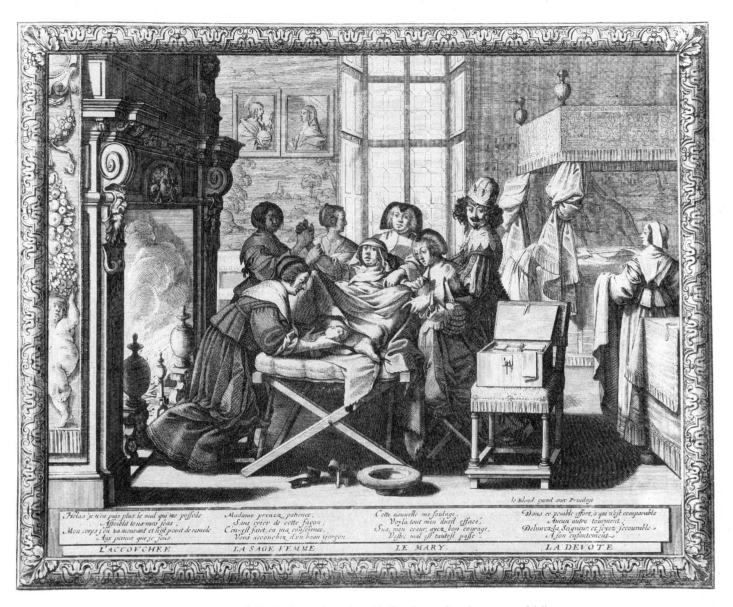

‹54› This unusually frank picture shows the midwife at her work at the moment of delivery.
With total concentration she takes the little head of the newborn into her hands.

Abraham de Bosse, *Childbirth Scene with a Midwife*, 1635/40.
Copperplate engraving, 26.3 × 33.7 cm. Staatliche Kunstsammlungen, Kupferstichkabinett, Dresden

wage was less than 10 guldens for female servants, without exception. In some areas a senior maid would only receive 3–3¹/₂ guldens (a pair of shoes cost about one gulden at the time). Between 1720 and 1740 in Hesse senior male servants received 18 talers, housemaids 7, dairymaids 8, and nannies only 4. In addition, payments in kind or gifts of money were often made at special occasions, but these were also paltry and entirely up to the master, who could thus save on their wage bill by claiming damages, and by paying with goods that were not convertible. Since masters were gently but frequently urged to be honest with their servants as regards wages, this was obviously not automatically the case.

For a meager wage, with no respect and no rights, women servants had to display total obedience and carry out any and every task required of them. The contract of work neither limited the working day nor allowed specific tasks to be spelled out and others excluded. A master could call upon his servants at any hour. In practice, women

were hired for particular jobs in the house or on the land, but if necessary they had to do other jobs as well. On large estates the mistress of the house needed housemaids and dairymaids. The most senior servant in the house was the housekeeper, who was in charge of the domestic chores. Hers was a special position of trust, and she could stand in for her mistress. She supervised the supplies, handed them out, and ensured that everything was well stocked. The cook generally had a kitchen maid to do the dirty work—scrub pans, fetch wood and water, and carry the shopping home. There was also a maid responsible for washing, ironing, and sewing, and a nanny in charge of the children. Then there were the housemaids who did all sorts of work in the house and outside. They had to look after the poultry, cook for the servants, and keep the house with all its equipment clean. At times they had to help with the milking and fetch fodder, although this was normally the work of the dairymaids. The dairymaids were responsible for the cows, goats, and pigs, and their tasks ranged from feeding and mucking out to making butter. They were supervised by the chief dairymaid, who had to see to it that they behaved "properly and dutifully," in other words, that they "aspired toward a quiet, honorable and virtuous way of life, humble, respectful, compliant and obedient to their master, mistress and other superiors, as well as being loyal, industrious, nimble, diligent and untiring."(132)

In the affluent households of the towns the mistress of the house would have at least three maids, and perhaps a housekeeper as well. These three were a housemaid or chambermaid entrusted with the major cleaning work, a cook, and a nanny. Aristocratic houses would also employ a lady-in-waiting or lady's maid for the mistress's personal service. If she was clever and quick-witted (as she was often portrayed in literature) she could develop her position to the point where she became her lady's confidante, almost her friend, and was indispensable to her. The nature of the support that she was supposed to give encouraged a close relationship. The nineteenth-century brothers Goncourt referred to the "light work of deft and nimble lady's maids."

In middle-class households "they could at most read and write, make beds, cook some soup, wash the small things, sew and mend." The lady's maids in aristocratic homes were quite different:

They were ladies-in-waiting, hairstylists, dressers, housekeepers and seamstresses. They knew how to do embroidery on canvas as well as delicate embroidery; they could sew on lace and pleats and do seams. They behaved toward Madame with an element of coyness although they were almost treated as companions by her. And since they came into such close contact with high society, they took on their behavior and fine manners, their moods and elegance in the anteroom and while waiting on her . . .(44)

Impoverished noblewomen regarded the positions of housekeepers, lady's companion, or governess as the only means of supporting themselves without sinking too low in the eyes of society.

The effusive tributes paid to lady's maids by authors of a later period, as the Goncourts above, contrast sharply with the endless complaints made by the masters and mistresses of the day. Their servants were inadequate, and clearly getting worse all the time. Fashionable society, whose members always made use of servants, simply took it for granted that the latter had no needs of their own, no personal desires, no limits to their physical powers, and that their own goal in life was the happiness of their masters. If the rich were then not satisfied with their servants they called them disloyal, selfish, profit-seeking, even thieving, impudent, and lazy. Only rarely does one find the admonition that servants "were also human"—and that usually merely meant religious equality in the eyes of God.

The educationalists of the early Enlightenment were the first to establish a human relationship with servants, but even then they were more interested in the moral education of their distinguished pupils than the rights of the socially disadvantaged. This is clearly illustrated in Fénelon's *L'Education des filles* (1687) with reference to the duties of the mistress, where he recommends that:

you should try to gain the love of your servants without being too familiar. Do not be intimate with them but neither shy away from discussing their needs with them with interest and without condescension. They must feel certain that they can obtain advice and sympathy from you It will not be easy to accustom aristocratic girls to such gentle and loving behavior; for the impatience and passion of youth together with the misconception which they are taught about their birth makes them view servants almost like horses; one believes that one is a different kind of being than that of servants; one assumes that they have been created for the convenience of their masters. Try to show how much these views run counter to one's modesty and to humanity and brotherly love.

This kind of reasonable approach to the relationship between mistress and servant was highly exceptional. A truer indication of the general view can be found in the tone of irritation adopted by Jonathan Swift in his *Directions to Servants*, published in Dublin in 1745. It was soon translated into German and appeared in Frankfurt and Leipzig in 1748. His advice to domestic servants contains a strange mixture of malicious bluntness and bitter, grotesque black humor. He recommends, for instance, that the waiting maid should get another key made to her lady's tea chest. ". . . but, as to the circumstances of honesty in procuring one I am under no doubt, when your mistress gives you so just a provocation by refusing you an ancient and legal perquisite. The mistress of the tea-shop may now and then give you half an ounce, but that will be only a drop in the bucket." The housemaid then receives some sound advice:

I am very much offended with those ladies who are so proud and lazy that they will not be at the pains of stepping into the garden to pluck a rose, but keep an odious implement, sometimes in the bed-chamber itself, or at least in a dark closet adjoining, which they make use of to ease their worst necessities; and you are the usual carriers away of the pan, which maketh not only the

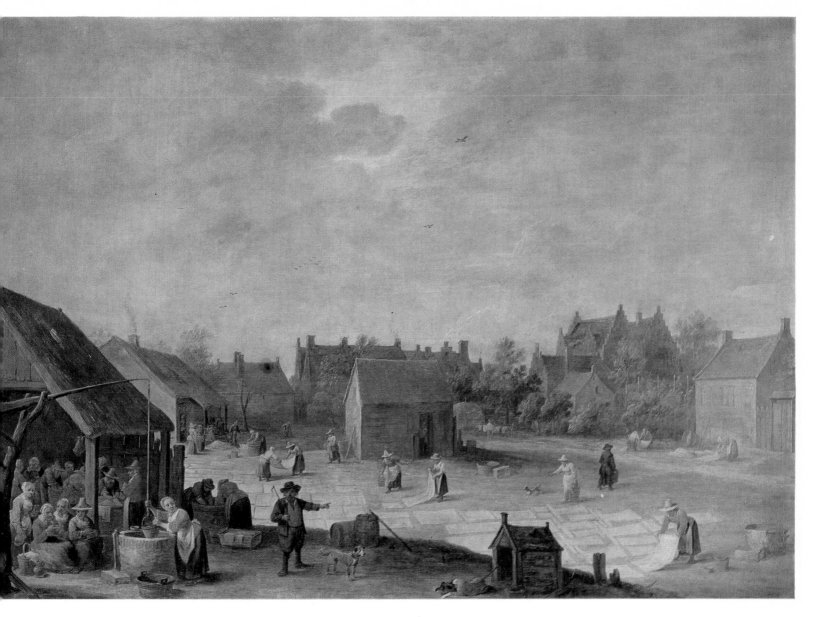

‹55› Women made up most of the workforce in the linen factories of Flanders.
They are busy here with bleaching, which was always done in front of the gates
of Dutch cities. With a theatrical gesture, a guard points to a hidden moral meaning:
the laundry being bleached by the sun was, for contemporaries, a sign
of the soul being purified by divine consolation.

David Teniers the Younger, *Bleaching, c.* 1670.
Oak, 48.5 × 70.5 cm. Staatliche Kunstsammlungen, Gemäldegalerie Alte Meister, Dresden

‹56› Women who lived as prostitutes with the army
were no better off than beggars. Roads and camps were their home.

Sébastien Bourdon, *Soldiers Playing Cards and a Woman with an Infant in a Camp*, 1643.
Wood, 36.8 × 50 cm. Staatliche Kunstsammlungen, Schloss Wilhelmshöhe, Kassel

‹57› A peasant family sets off to sell its wares at the market
or in the houses of the town. The peasant life of toil and hardship
was presented to the townspeople in a transfigured light.

Louis le Nain, *The Family of the Milk Seller*, c. 1645.
Oil on canvas, 51 × 59 cm. Hermitage, Leningrad

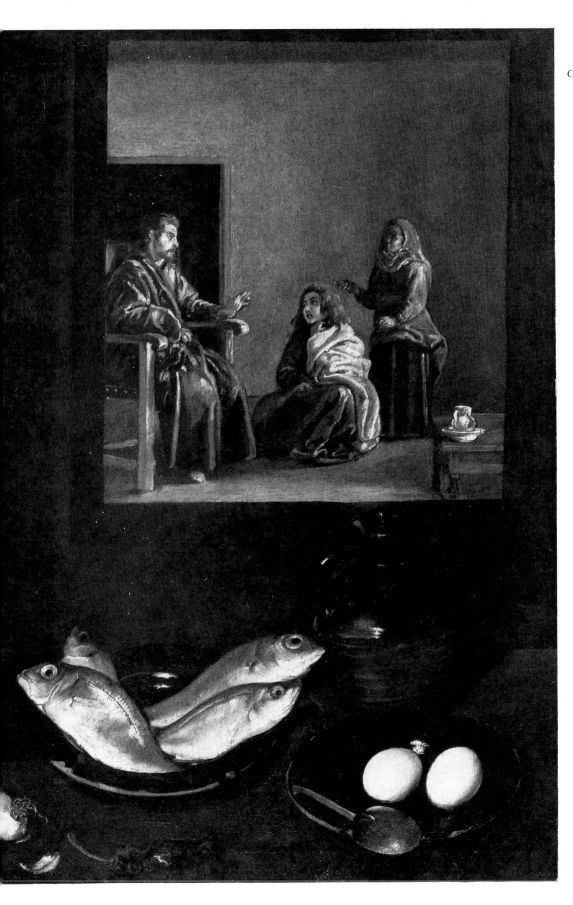

‹58› Kitchen scenes are often intended
to give guidance for good behavior in life.
The scene in the background proves it.
Christ in Mary and Martha's house is teaching
that Mary is on the right path,
as she is acting for the good of her soul.
The ordinary figures of the cook
and kitchen maid are assigned a place
of importance against the religious scene.
They, too, point to the true meaning of life.

Diego Velázquez,
Christ in the House of Martha and Mary, c. 1620.
Oil on canvas, 60 × 103.5 cm. National
Gallery, London

‹59› Many women earned their living by selling in the market.
It was not only to depict the trade that so many pictures were painted of women
selling fish—as offering fish was also a call for moderation.

Adriaen van Ostade, *Fishmonger, c.* 1670.
Wood, 29 × 26.5 cm. Museum of Fine Arts, Budapest

‹60› There must have been a very large number of girls
who earned money by taking in laundry from the rich patrician houses.

Jean-Baptiste Siméon Chardin, *The Laundress, c.* 1737.
Oil on canvas, 37.5 × 42.7 cm. Hermitage, Leningrad

‹61› This Dutch servant girl is busy ironing in a
cellar kitchen. Her simple workroom is beautifully tidy.
She is quite absorbed by her work,
while the child at the window is gazing out of the picture.
The toy windmill in his hand is meant to remind the viewer the Dutch
proverb about having foolish fancies in one's head.
The observer is supposed to decide for himself which of the
two he or she considers to be right—silly moods or domestic diligence.

Jacob A. Duck, *Girl Ironing*, second quarter of the 17th century.
Wood, 42.5 × 31.1 cm. Centraal Museum, Utrecht

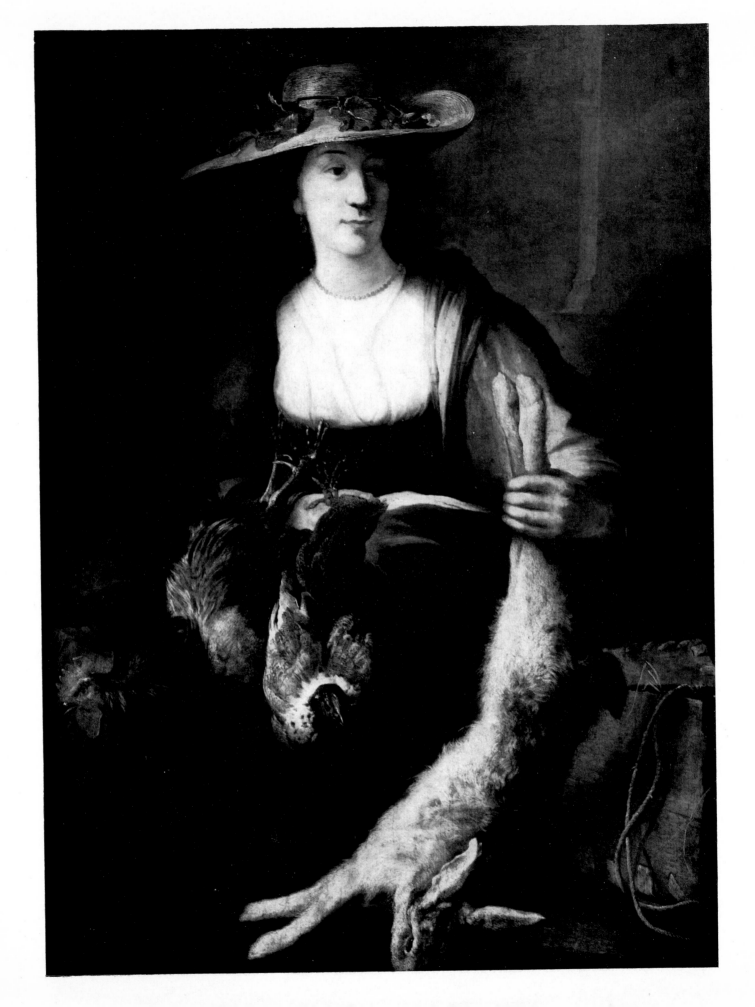

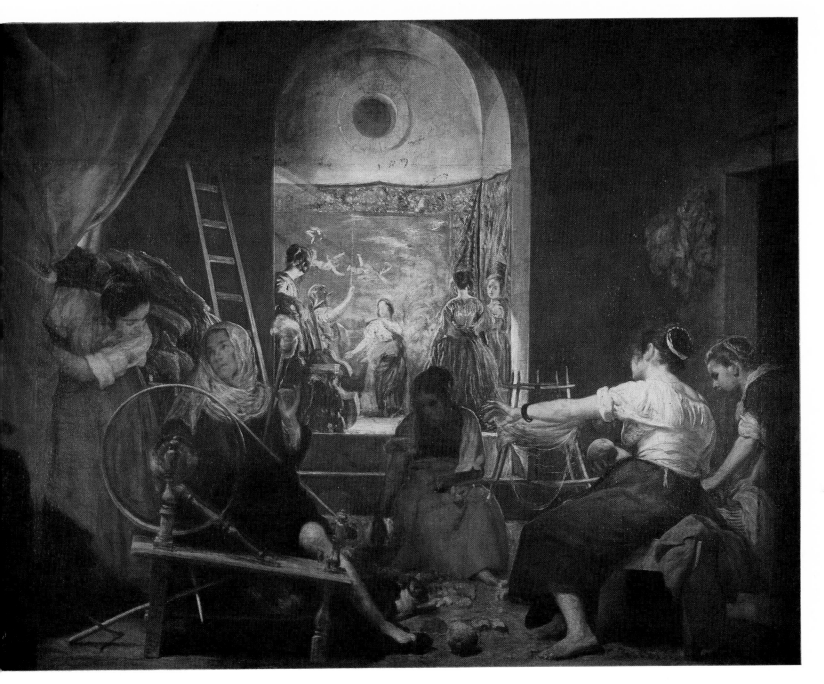

‹62› This painting of a beautiful woman selling game takes its theme
from the work of women traders in the markets. This girl is really a noblewoman
(posture, features, jewelry) who enjoys dressing up as a seller.
Hares and hens endow the offer with an intrigue of love.

Daniel Schultz, *Young Seller of Game*, c. 1665.
Oil on canvas, 136 × 101 cm. National Museum, Stockholm

‹63› The action takes place in the royal Spanish tapestry manufacture.
The painter is possibly accompanying a few ladies from the court on a tour. They are standing
in a well-lit room raised like a stage in the background in front of a finished Gobelin.
Only a few scattered shimmering rays of light fall into the dark room at the front,
where two tapestry weavers and three others are busily working.
This is the first portrayal of factory work in a court painting.
But it is not the main theme of the painting.
The weavers personify a story from Ovid's *Metamorphoses*, about a contest between
the skilled weaver Arachne and Pallas Athene, the goddess of weaving.
Their argument is about which is superior—art or craft?

Diego Velázquez, *Tapestry Weavers*, c. 1657.
Oil on canvas, 220 × 289 cm. Prado, Madrid

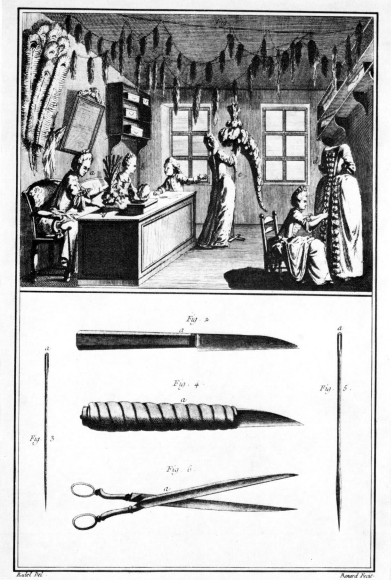

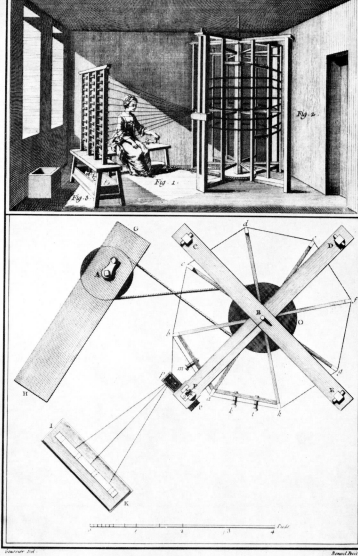

Plumassier-Panachier, Différens Ouvrages et Outils.

Soierie, l'Opération d'Ourdir la Chaine des Étoffes.

‹64› and ‹65› In the millinery studio specializing in feather decoration
the milliners are working on a feather hat for a high dignitary,
a plume for a parade horse, and the decoration for a lady's gown.
Thousands of women were employed in producing feather decoration and there
were equally large numbers working in the manufacture of silk in France.

Denis Diderot, *Encyclopédie*, 1751–1780.
Left: *Plumassier-Panachier*, Figure VIII, Plate 1
Right: *Soierie, l'Opération d'Ourdir*, Figure XI, Plate 23

‹66› There is a feeling of warmth about this typical everyday scene.
In rural families women used every bit of spare time to do some spinning,
both for their own needs and to sell.

Mathias Scheits, *At the Spinning Wheel*, c. 1700.
Wash drawing, 13.4 × 16.2 cm. Kunsthalle, Hamburg

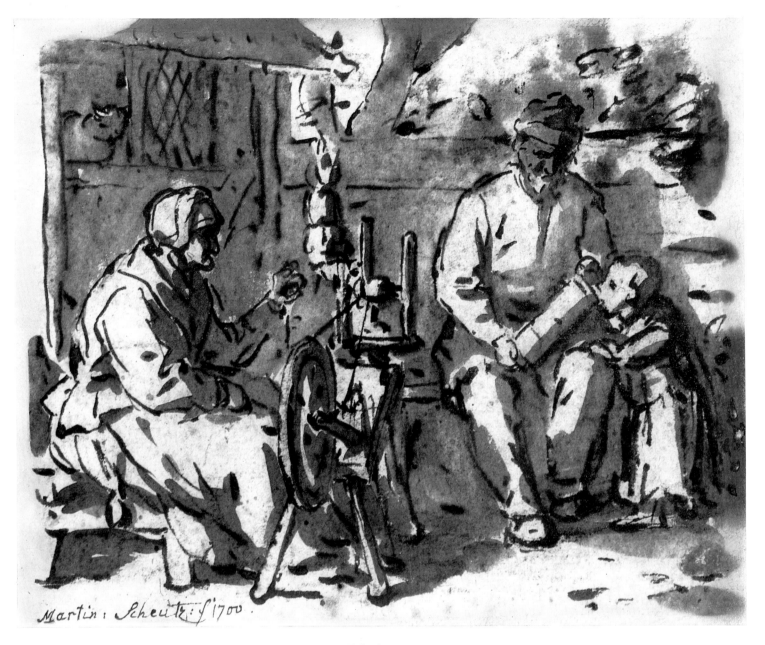

Martin: Scheitz: f 1700.

Following pages:

‹67› Wise women would quietly go about their natural healing practices.
A cupping glass is applied to a young woman for bloodletting.

Quiringh van Brekelenkam, *Bloodletting*, mid-17th century.
Wood, 48 × 37 cm. Mauritshuis, The Hague

‹68› The servant woman in her simple clothes hardly stands out at all against the background.
She is just one of the objects in the room surrounding the main figure.
She is only significant in the service she provides for her lady.
The latter is washing her hands symbolizing virtue and purity.

Gerard Terborch, *Woman Washing Her Hands, c.* 1655.
Oak, 53 × 43 cm. Staatliche Kunstsammlungen, Gemäldegalerie Alte Meister, Dresden

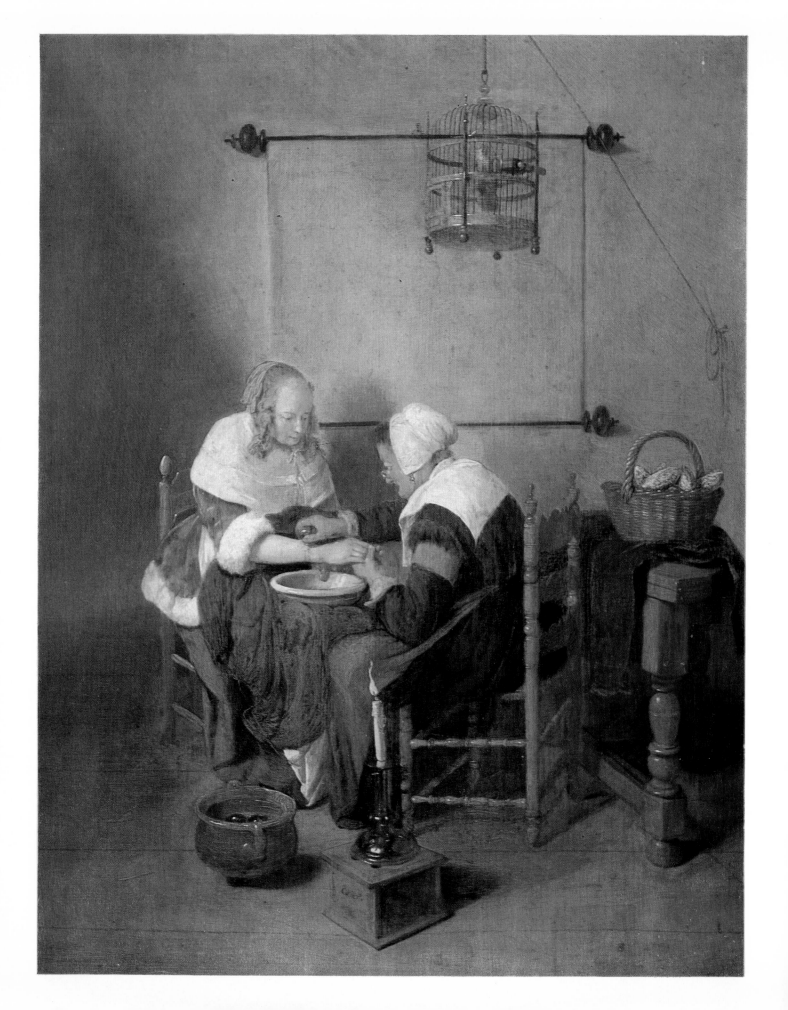

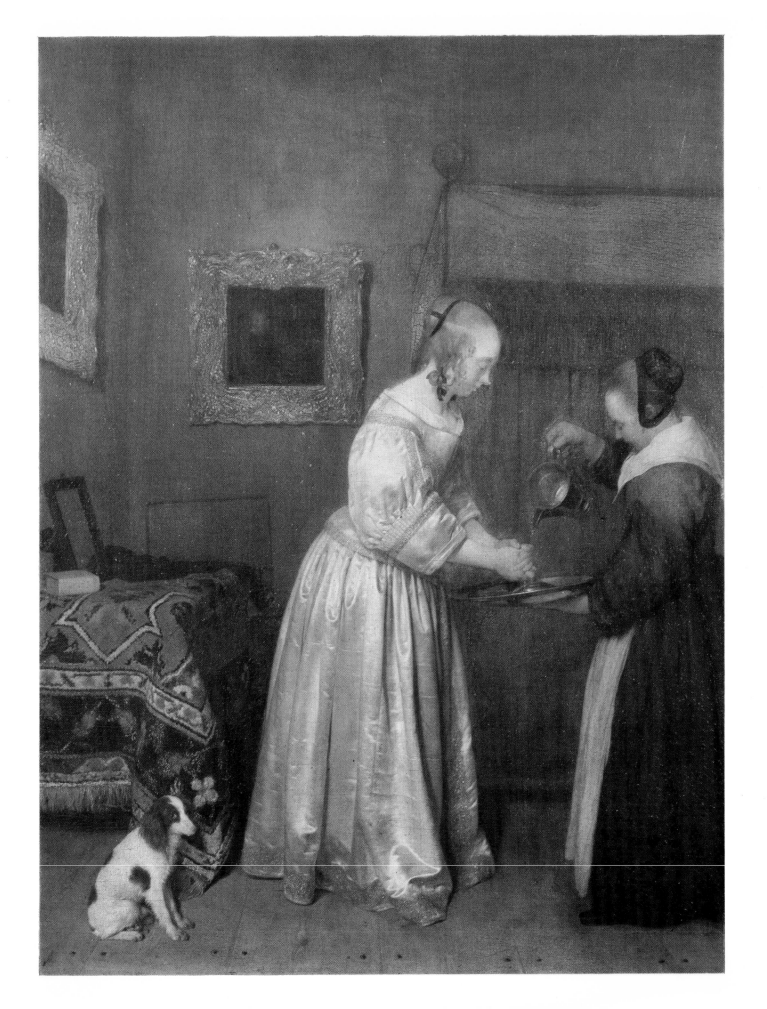

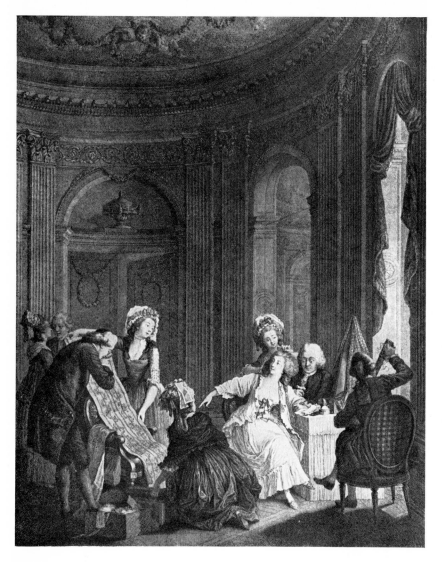

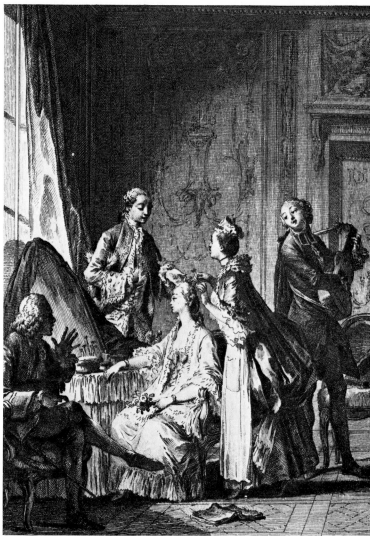

‹69› and ‹70› Ladies-in-waiting were responsible for their lady's toilet.
They were also indispensable assistants and confidantes in the idle life of the court,
which carried numerous duties and obligations. These scenes show
ladies-in-waiting dressing their mistress's hair,
while visitors endeavor to amuse her.

Left: Nicolas de Launay after Nicolas Lavreince, *The Toilet (Qu'en dit l'Abbé?)*, c. 1780.
Copperplate engraving, 30.7 × 39 cm. Staatliche Museen, Kupferstichkabinett, Berlin
Right: Jean-Michel Moreau the Younger, *La Toilette*, 1773.
Copperplate engraving, 12.5 × 9 cm. Staatliche Museen, Kupferstichkabinett, Berlin

‹71› A young woman is drinking wine in the company of two cavaliers.
The maid brings in something to eat in a pan. Although she stands in the background,
her figure is given emphasis by the devotional painting above the fireplace.
Maids held a respected position in Dutch households,
and the one pictured here represents domestic virtue in contrast to her carefree
mistress, who is enjoying herself in the company of men.

Pieter de Hooch, *Interior of a Dutch House*, c. 1660.
Wood, 73 × 63 cm. National Gallery, London

‹72› In contrast to the Dutch portrayals of peasants drinking
Siberechts depicts peasant women at work.
Apart from looking after the household and the children they had to see
to the farmyard animals and help out in the fields.

Jan Siberechts, *Farmyard, c.* 1660.
Oil on canvas, 123 × 189 cm. Musées Royaux d'Art, Brussels

chamber, but even their clothes, offensive to all who come near. Now, to cure them of this odious practice, let me advise you, on whom this office lies to convey away this utensil, that you will do it openly down the great stairs, and in the presence of the footman; and if anybody knocks, to open the street-door while you have the vessel filled in your hands: this, if anything can, will make your lady take the pains of evacuating her person in the proper place . . .

If female servants were really as malicious, rebellious, dishonest, and work-shy as Swift portrayed them, it was the result of centuries of derision, of being overworked and underpaid with little personal recognition and less sympathy.

We should now like to return to the subject of trades and guilds. There was no attempt to stop women from working altogether, but rather to prevent them from doing independent and skilled work. At the same time there was a growing demand for women's labor, initially in the craft trades, but mainly to do unskilled work at a low wage. This trend can be seen in the guilds' regulations on women's work. They set down, in precise terms, the jobs that women might take up. These were always simple, monotonous, repetitive tasks that did not require any previous training. This fact is also clearly illustrated under the entry for craftsmen's trades and manufacture in Diderot's *Encyclopédie*. Apart from a few areas in fashion and the textile industry, women only appeared in the background, doing menial jobs. All the skilled and specialized work was done by men. The women, forced into unskilled and badly paid work, soon amounted to a class of wage earners among craftsmen. Their labor was later wanted in the factories. Here we have the beginnings of the breakdown of the whole process of production into individual operations, each bearing a different value.

Workhouses and prisons were far more effective in paving the way for factory work, from the social and psychological point of view, too. These pre- and early capitalist institutions rounded up men and women indiscriminately for their labor. Women, however, were represented more permanently and in greater numbers in the production process. As Otto Rühle points out, workhouses were originally intended to "combine welfare with the duty to work." The governments of the day had little success in imposing their will on the hordes of unemployed and, let us acknowledge, largely work-shy vagabonds. Although the authorities used violence against them, the poor put up a strong passive resistance. The country people and craftsmen who had lost their land and their traditional occupations would not be coerced into doing regular work for a wage even though they had to suffer brutal punishments such as whipping, branding, and execution. Such were the punishments for begging, for instance, in the laws of Henry VIII's time. The poor felt that they should work when and how they chose and as much as was necessary for their own survival, and not to accumulate capital for an entrepreneur.

The authorities were more successful in the long run by making work a condition for receiving welfare. Italy was apparently the lead-

er here. In the first half of the sixteenth century there was a poorhouse in Genoa where women were employed at weaving. In sixteenth-century England, too, the cruel and useless penal legislation was replaced or supplemented by measures for reeducation. Orphans, beggars without masters, defiant servants and craftsmen, loose women and procuresses were all assigned to houses of correction where they were subjected to a very strict regime of work. Where it was not possible to set up such institutions, the parish authorities had to provide at least a permanent supply of flax, hemp, and wool so that there was always work available for beggars who were picked up off the streets. In the centers of the English textile industry these institutions finally turned into workhouses, as proposed by Thomas Stanley in *Remedy* in 1647. The helplessness of the poor and homeless was exploited to gain urgently needed labor for the factories. By 1567 in Paris there were also "public workshops" for beggars and vagabonds. About the middle of the seventeenth century, there were approximately six thousand inmates of poorhouses and workhouses working in the hosiery industry. Minister Colbert supported these penal institutions as much as he could in order to aid the rapid development of manufacturing. Since the population, including the most impoverished elements, opposed his economic policy by categorically refusing to work, he instructed the municipal authorities to hand over their unemployed inhabitants to the factory owners.

In contrast to the penal institutes for the poor, factory work was, in principle, voluntary. But the meager wages and prisonlike working conditions made a number of compulsory measures necessary. Admittedly the factories provided a certain amount of material security which other kinds of work did not offer, at least not to the female workers. Women in Paris earned, for example, 10 to 12 sous a day working for dressmakers. They needed more than twice that just to survive at a mere subsistence level. (A daily wage of even less than 10 sous was not rare.) The only way to earn enough money to survive seemed to be through prostitution. The factories prohibited this sort of secondary income and removed the need for it by introducing a patriarchal form of protection into their organization. Master craftsmen provided their journeymen and apprentices with board and lodging and other basic necessities, keeping them under constant supervision. Similarly, a large number of factory owners, especially in France, set up homes and hostels attached to their factories so that their employees would have little reason or opportunity to leave their workplace. These institutions resembled prisons or monasteries in that they strictly segregated the sexes. There are plenty of dismal stories about these institutions, which provided accommodation mainly for women working for the textile industry. There were often several hundred of them living in one hostel and nearly all of them young girls, as this sort of life was only feasible for unmarried women.

Anyone who wanted to enter such a hostel had to sign up for a number of years. The girls were in the charge of lay sisters who su-

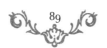

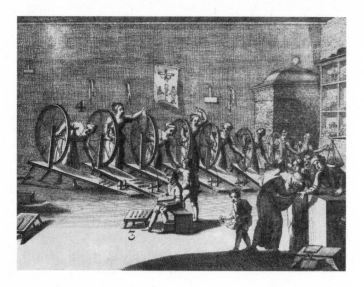

‹73› Women's labor was greatly in demand
in the textile industry. In the wool-mills of Bohemia—as in the mill
at Ober-Leutendorf pictured here—spinners in the eighteenth century
operated at large spinning wheels which they worked manually.

Unknown artist. *Spinnerey*, 1728:
Copperplate engraving, Klementinum, Státni technická knihovna, Prague

pervised the work and made sure that the house rules were kept. The working day normally began at 5 A.M. and ended at 8 P.M., with breaks only for breakfast and lunch. After work there was barely time for the evening meal and prayers before the girls had to go to bed. They did not have to work on Sundays, but the day was totally taken up with religious instruction, lessons in reading and writing, and guided "amusements" such as reading aloud, or a group walk escorted by the sisters. The girls only had one day off every six weeks. They never had a minute to themselves, neither at work, nor in their dormitory, nor during their "day of rest." The difference between a life as a factory worker and that of a religious or a prisoner must have been minimal indeed.

The textile mills preferred to hire women, not only because the jobs they offered were traditionally assigned to females, but because women were paid less than men. This is particularly significant when one realizes the great numbers of workers needed to produce and prepare enough yarn to keep the weavers busy, especially before the introduction of machinery. When the flying shuttle was introduced into English weaving in 1733, a weaver needed between eight and twelve spinners. In Austrian mills of the late eighteenth century, there were nearly ten times as many spinners and spool operators as weavers. If we take the textile industry as a whole, we see that the number of women employees far exceeded that of men. Similarly,

there were many other branches of industry that would not have been able to function properly without the work of women.

Women's labor was not limited to factories; substantial contributions were made by homeworking or the domestic system. Tenant farmers who did work at home (which was accepted as part of the rent), small farmers who were trying to supplement their incomes, impoverished peasants who had had to sell their land and were looking for a different way of earning a living—all these constituted together the new social group of homeworkers. As far as the textile industry was concerned there was a great demand for spinning. Every peasant woman knew how to spin, and now it was mostly women who supplied spun yarn to the mills through the municipal distributors. Many thousands of peasant families worked for the textile centers of Flanders and Picardy.

Other sources of yarn for the mills were in the prisons and poorhouses (the "spinning house" was the last refuge for families which had fallen on bad times), as well as the orphanages. The little girl apprentices (as young as eight years old), who were so common in the factories of the time, generally came from orphanages. But even with all these sources there was not always enough labor, so other means of pressure had to be found. Prussia's business-minded King Frederick William I exploited the *Höckerunwesen*, the fact that many women and girls earned a living by selling country produce and homemade goods on market day from packs on their backs. They were informed by royal edict in 1723 that since the Prussian wool manufacturers were short of spinners they, the women, would only obtain a permit to sell their goods if they were prepared to spin a pound of wool per week for the factories. Even craftswomen who sold the products of their own workshops were no longer allowed to sit idle waiting for customers—they too had to spin wool.

Not long afterward the spinning room keepers found it to their advantage to shut girls up in spinning rooms. Since their pay was extremely low, the girls soon turned their money advances into debts and thus became dependent on the keepers, who forced them to work in prisonlike conditions. In 1787 these wretched spinning girls complained to the police that they were not allowed to leave the spinning rooms in the evenings. They were informed, however, that the keepers were acting according to a law which had been in force for forty years. The proclaimed purpose of this law was to stop girls from leading a "dissolute" life which would have an "adverse effect" on their work.

The general development of women's work in the seventeenth and eighteenth centuries shows two trends. Women were systematically excluded from intellectually demanding or skilled work, while at the same time, the number of women engaged in the unskilled labor force rose dramatically.

‹74› Complaints were made in countless tracts and pamphlets about bad servants.
This pamphlet by unknown artists portrays the servant girls themselves discussing their alleged vices.

"Rathschluss der Dienst-Mägde"
Copperplate engraving, Nuremberg, 1652

Neuer Rathschluß der Dienst-Mägde.

Verzeih mir / Junafer Mäid / wann dir diß nit behag. Ich sag dir / was du thust; thu du nicht / was ich sag.

Ich weiß nicht / hab ich jüngst im Traume nur
gehen.
Diß weiß ich daß ich sah beysammen dorten stehen /
Fünff Thiere / die man sonst im Lande Mägde nennt.
Den Vogel man gar leicht an dem Gesänge kennt.
Das dritthalb Gänse-Paar trug gute Zähn im Maule.
Zur Arbeit waren sie / zum Plaudern gar nit / faule.
Hört / was ich hab gehört. Ich zeig nichts Falsches an /
Bey Jovis Zipfelbelz ich das betheuren kan.

A. Die Beschließerinn.

Mir hat der neue Sinn / ihr Mägde / wol gefallen /
daß ihr nit länger wolt also in Diensten wallen /
daß ihr die Frauen trägt. Gott lob / daß es einmal
noch kommen ist dahin / daß es bestellt so kahl /
daß sich üm eine Magd zehn Frauen wollen schlagen /
und alle Gassen durch nach einer müssen fragen /
Itzt hat sich ümgewandt das Blätlein / weil so theur
die Mägde: eine Frau gilt nur sechs Kreuzer heur /
zween Patzen eine Magd. Wer wolte nun nit sagen
daß Magde güldne Schuh / die Frauen solche tragen /
die nur von Silber sind. Ich stimme mit euch ein.
Ich bin zwar keine Magd / ich will genennet seyn
nur Jungfrau / bin es auch. Frau möcht ich gerne heissen:
Sind Frauen doch jtzt Herr. Wer wolt es dann verweisen
mir / daß ich was werd? Das treff nur eben ein.
Will meine Frau / daß ich ihr soll zu willen seyn /
das Haus versehen wol / sie muß / bey meinem Eyde /
viel stölzer noch / als sie / in einem töllern Kleide
mich lassen ziehen auf. Sie muß nit sauer sehn /
wann auch mit mir der Herr zu Bette wolte gehn /
mich lieber hätt / als sie. Wann aber zu mir käme
mein Buhle / muß sie ihrs auch lassen seyn genehme /
aufwarten mir und ihm. Und wann ich Bier / und Wein
abtrage / muß sie ihr auch nit zuwider seyn.
Wolt sie das leiden nit / ich kan für mich wol sitzen /
mich nehren / und üns Geld im Winckel wircken Spitzen.
Ich frage diß nach ihr und ihrem Bettel zohn.
Sagt sie ein einzig Wort / so wander ich davon.

B. Die Kindsmagd.

Ich auch ich halt es mit / bin nirgend hin verschworen;
Ich bin für eine Frau alleine nicht geboren.
Die Mägd jtzt Zucker sind / die Frauen täglichs Brod /
hab ich an einer satt / so fresse mich der Tod.
Zwölf Dienst in einem Ziel / das ist mir keine Schande /
ein Dutzent Frauen sind für eine Magd im Lande.
Will eine mich / sie kan mich haben anderst nicht /
als wann sie mir für voll das Wiegengeld verspricht /

so sie in Wochen ligt / und muß im Bette Kindeln.
Doch sag ich ihr zuvor: ich mag mir an den Windeln
die Händ besudeln nicht / und wann was auf die Banck
der kleine Unflat macht / es möchte den Gestanck
sonst riechen mein Galan. Ich lasse sie es wischen /
ich habe nit gelernt nach krummen Eyern fischen.
Ich kan mit Kindern auch nit fahren säuberlich /
darüm darf meine Frau gar nit entrüsten sich /
wann etwan ich das Kind zusamt dem Bad außschütte
und es zum Krüppel mach. Ein Narr wär / der es litte /
wann sie viel kollern wolt / so ich / du Batck act / sag.
ich lief bey Nacht davon / wann es nit wäre Tag.

C. Die Köchinn.

Ja / du hast meinen Sinn. Mir kamen diese Schnäncke
schon offt im Traume vor. Ich lache / wann ich dencke /
wie meine letzte Frau / der ungeschickte Troll /
die gar nit kochen kond / als sie mich machte toll /
den Korb von mir bekam. Ich bin so wolfeil nimmer /
Wir Mägde machen jtzt die schlimmen Frauen frümmer.
Acht Gülden oder zehn / der Lohn ist viel zu schlecht;
es müssen Thaler seyn / sonst ich nit dienen möcht.
Doch dingen laß ich mich allein mit dem Bedinge:
Wann ich das Fleisch nur halb vom Brunnen widerbringe /
(weil etwan mir der Hund ein Stück im Plaudern nahm.)
und wann es noch halb roh zu Tisch und Schüssel kam /
verbrannt / verdorben ist / wann Krüg und Töpfe brechen /
das Zinn verkrüppelt wird; so soll die Frau noch sprechen:
hab Danck / du liebe Magd / du hast gar recht gethan.
Wolt aber sie / auff mich zu schelten fangen an /
mich nennen / faule Hur / und ich ließ wiederschallen
den Titel / muste ihr der Echo nit mißfallen /
und dieses Wort darzu: Frau macht mich hinten rein.
darauf wird vor der Thür alsbalden draussen seyn.
Dem Feuer und dem Heerd mag ich nit gern mich nähen /
es macht ein rauh Gesicht: da mag die Jungfer stehen /
dann sie verkaufft ihr Geld / üms arme Mägdlein allein
das glatte Angesicht / Wir müssen schöne seyn.

D. Die Hausmagd.

Ich trett auch in die Zunfft / ich kan die Frauen butzen.
Trutz ihnen / ich will sie / sie sollen mich nit trutzen.
Wie wann sich gar einmal verkehrte so die Sach /
daß Mägde giengen vor / und Frauen hinten nach?
Ich zwar halt diese Weiß. Wann ich ward außgesendet /
so hab ich eher nicht zu Hause mich gewendet /
bis meine Fraue selbst mich einzuholen gieng.
Jüngst fiele mir noch ein / es wär ein seines Ding /
wann wir uns liessen dort lang auf der Gaß erblicken /
und dem Plaudermarckt / daß sie uns müssen schicken

uns Müden einen Stul / biß sag ich aber auch: **G.**
die Arbeit und viel Thun ist gar nit mein Gebrauch.
Die Frau die mag das Haus selbst kehren / waschen / fegen /
mich lassen sehen zu / in Schoß die Hände legen.
Nit gerne tragich Holz zur Küchen / weil die Spän
mich ritzen die Arm / die sähen dann nit schön /
wann ich mein feines Lieb wolt haben drein geschossen.
Deß Morgens bin ich auch zum Aufstehn gar verdrossen:
Will nun die Frau / daß sie die Stube warm und rein /
so steh sie selber auf / und kehr und heize ein.

E. Die Bauermagd.

Ich schlag auch nit schlimm bey. Ihr Bürgermägde grolet:
Wir Bauerdirnen sind nit so gar schlecht geholfet /
wir tragen auch den Spiel. Es ist / wie in der Stadt /
im Dorffe theure Zeit an Mägden / dünne Saat.
Wir haben schon am Bett die Zipfel alle viere
bekommen / nur daß uns auch noch zu Bette führe
der Herte: Mit dem Knecht ists nur alltäglichs Thun.
Wir wolten uns gern auch zum Herren legen nun.
Die Bäurin mag darzu saur sehen oder süsse.
ich kan / gefällts ihr nicht / mich machen auf die Füsse /
und meiner Wege gehn. ja wol / das ist für sie /
Ich laß sie auch den Stall versehen und das Vieh.
Mein Arbeit ist / daß ich ümlauffe nach den Buben /
bey Tag zum Dantz / bey Nacht dort in die Rockenstuben /
dahin ich aber wol komm Spinnens halber auf /
nein Hansel mir daselbst ein andern Faden zieht /
der lang und dick genug. Das muß ich nur leiden.
Zwar grasen laß ich mich gern schiken auf die Heyden /
weil Hanseln sie alsdann bestellen kan zu mir.
Wie dünckt euch / schick ich mich zu euch / ihr Schwestern Vier.
So sagten diese fünf / in aller Mägde Nahmen.
Die Bösen sind gemeynt / die Frommen und die Zahmen
behüte Gott für Leid / dann deren sind zu viel.
Itzt wollen sie die Sach / und ich will nit verrahten ihren Raht / in ein Dietrei verfassen
zu Meg und Magdeburg ein Mandat stellen lassen /
Inhalts / es sollen nun die Mägde Frauen seyn /
die Frauen aber Mägd. O Juno / sih darein /
du höchste Himmelsfrau: und laß dich das erbarmen.
verlassen sind so gar die Frommen und die Armen /
Ihr Rächengötter ihr / rächt dieser Frevel recht /
gebt jeder solcher Magd einen starcken Knecht /
der sie deß Werektags zwier / deß Sonntags dreymal puffe /
biß sie halb tod üm Hülf zu Gottes Mutter ruffe.
So / rieth ich / werden los / im fall ich würd gefragt /
der Mann des bösen Thiers / die Frau der bösen Magd.

Zu finden bey Paulus Fürsten / Kunsthändlern in Nürnberg. 1652.

BRINGING UP GIRLS—
EDUCATING WOMEN

THE "noble and fair sex" is not given the chance to use her God-given intellect. She is left to "crawl around with the blind moles." These sentiments appeared in 1715 in *Teutschlands galanten Poetinnen* (Germany's gallant poetesses). On the other hand, in the preface to his *Frauenzimmer-Gesprächsspielen* (Women's talk plays) Georg Philipp Harsdörffer wrote of German women in 1644 that "you must consider all the excellent and virtuous women who have been praised throughout history and can still be found in many a place today."

Was one of the two authors not properly informed?

Harsdörffer cites a number of names to substantiate his claim, and although he adds that there are many more, one is struck by how often the same few women are mentioned in these writings. Learned women were viewed with equal amounts of amusement and suspicion; they were marveled at as if they were child prodigies or exotic curiosities. There was, for example, Anna Maria van Schurman in Utrecht (1607–1678) who was typically called "miracle of the century" because of her command of foreign languages, including Greek and Hebrew, and her knowledge of history and the natural sciences. Another was Dorothea Erxleben, née Leporin, Germany's first female doctor of medicine, only accepted to take her degree at Halle in 1754 because she had a letter of recommendation from the King himself. And there was Dorothea Schlözer so well prepared (by her father) that in 1787 at age seventeen, she could cope with an oral doctoral examination lasting several hours, with questions ranging from Horace to metallurgy. Her examiners showed obvious delight in dealing with an exotic case. Earlier, when Laura Bassi received her doctorate in Bologna in 1732, the whole of Europe was stirred to excited comment on the merits (or lack thereof) of this event.

These women were so exceptional, such "peculiar and heroic examples" in the understanding words of Hohberg, that they can barely be included under the heading of women's education. What we can regard as the normal state of affairs was described by Margaret Duchess of Newcastle in the preface to her book *Poems and Fancies*, published in London in 1653: ". . . Men will cast a smile of scorne upon my Book, because they think thereby, women incroach to much upon their Prerogatives; for they hold Books as their crowne, and the Sword as their Scepter, by which they rule and governe."

Fourteen years later, in *The Life of William Duke of Newcastle*, she went on to say that books and the sword were the power symbols of men who ruled by knowledge and strength. Women, however, could "grow irrational as idiots, by the dejectedness of our spirits, through the careless neglects and despisements of the masculine sex to the female, thinking it impossible we should have either learning or understanding, wit or judgement, as if we had not rational souls as well as men, and we out of custom of dejectedness think so too . . . so as we are become like worms that only live in the dull earth of ignorance, . . ."

In England women were strictly assigned their specific position in society, and the situation in other countries was not much different. What Lord Chesterfield described in his letters to his son was not limited to English aristocratic circles: "[Women] have an entertaining tattle and sometimes wit; but for solid, reasoning good sense, I never in my life knew one that had it, or who reasoned or acted consequentially for four-and-twenty hours together A man of sense only trifles with them, plays with them, humours and flatters them . . .; but he neither consults them about, nor trusts them with, serious matters." Most daughters of aristocratic families were educated in such a way that this description was not inapt. Instruction was either given by governesses in the home or in convent schools, but in both cases only two subjects were emphasized—religion and the social skills required by high society. The latter subject did in fact include a fleeting knowledge of as many different areas as possible, a superficial general knowledge which could be used to fuel the various conversations that formed the basis for the amusement of the aristocracy. Beauty care and etiquette also were important in the education of young ladies. Dancing lessons were regarded as indispensable for the development of a graceful manner and general appearance. A

favorite theme for painters of the Rococo was the picture of a tiny girl moving, under the watchful eye of her dancing instructor, with all the ceremonious grace and elaborate dress of the perfect aristocratic lady. Music lessons were also provided and, in some boarding schools, amateur dramatics was allowed.

Since aristocratic women did not have to bother themselves with domestic matters, including child rearing, they were only given superficial instruction in the affairs of the household. This was not the case with middle-class girls—in this area their education was quite different from that provided for upper-class girls—nor with the daughters of the landed gentry if they managed their estates themselves. The mistress of the house in Wolf Helmhard von Hohberg's *Georgica curiosa aucta* (Revised curious *Georgics*) of 1687 was supposed to urge her daughters to be God-fearing and virtuous and to avoid "impolite behavior and unsuitable habits" such as "noisiness" and "foolish laughter and shrieking." Above all they were not to get hold of any "tiresome frivolous tales, novels or stories." This could be achieved, if they "were never idle, but always busy doing some useful activity—bottling . . ., cooking or engaged in some other skill worthy of the female sex such as knitting, drawing, embroidery, sewing, spinning, so that not only do they avoid idleness but also through daily practice gain useful experience in housekeeping (which will be of great value to them in their future homes)." This important educational objective is discussed further in the next chapter, for "a well-brought up girl, instructed in the arts of housekeeping, will be much more desirable [for marriage] than one who can only talk about ruffles, finery and adornments."

(Hohberg considered it permissible for women to have a thorough scientific education, by the way, but only because they could then dispense with the services of often useless teachers and teach their children themselves.)

What was good for the landed gentry of Austria was also right for the North German patricians. We see distinct similarities in Hamburg senator Hudtwalcker's description of his mother, who got married in 1746.

Although my grandfather (a well-to-do sugar refiner) was a highly educated man, his wife and grown-up daughters could only do the writing and arithmetic that was necessary for them in the household.

My mother had learnt the catechism and had been confirmed, could dance a little and play the piano, though she made little use of these skills later. But she did know how to do plain needlework, embroider and see to the kitchen without ever worrying about what was happening or had happened outside Hamburg in the world at large. She did not know what passionate love was; but her virtue, loyalty and devotion made her an excellent wife and my parents' marriage was very happy.

But the views on the education of middle-class girls, in particular, were strangely uncertain and insecure, as seen in August Hermann Francke's plan for an "institute for the daughters of gentlemen, noblemen and other distinguished persons." Greek and Hebrew could be taught at special request "as the basic languages of the Old and New Testament," but was not included in the normal curriculum. On the other hand, all the girls were expected to attend lessons on housekeeping and gardening, although they could be excused if they so desired. The only compulsory subjects, besides French and deportment, were reading, writing, arithmetic, and the fundamental principles of Christianity.

There was no uncertainty about the education of orphaned girls, however. Francke was quite confident that the children who would later become servant girls, only needed a thorough grounding in religion and the female handicrafts, and a basic knowledge of reading, writing, and arithmetic. It was important that they develop a serious and strict attitude toward work, and to this end their leisure time was filled with washing, fetching water, and sawing wood. The widespread convent schools for the poor, especially in France, had—apart from religious instruction—no educational aims other than strict training for work. The catechism, prayer, and hymn singing made up the core of the curriculum at the free schools run by the Augustinian canonesses and the Ursulines. Their teaching was aimed at strengthening the faith, imbuing the girls with modesty, gentleness, obedience, and submission to their fate as well as to their husband or lord. Nonetheless they must have provided these lower-class girls with an indispensable minimum of knowledge and a certain amount of discipline as well, otherwise the establishment of new convents in a large number of towns would not have been so openly welcomed. Reading and handicrafts were everywhere regarded as a necessary supplement to religious instruction, but it took a long time for writing to be given the same priority. A German school regulation of 1610 emphasizes that the express permission of the parents was necessary for children to attend writing lessons. A century later, there were still parents who refused to give this permission.

The education of girls was fundamentally different from that of boys. Apart from equipping boys for their future occupations, their education was aimed at developing their personalities much more fully. There was of course no need to justify their education. When the subject of "education" came up in those days it always meant "boys' education." Education for girls was always clearly labeled as such, and its whys and wherefores, pros and cons were constantly debated. Even the great Comenius was referring to the education of males in his large-scale work on general education, although the schools of the time were supposed to teach that which "made men into men, Christians into Christians and scholars into scholars." We are well into his treatise when we come across his remark that girls are only to be included in nursery schools and primary schools, and excluded from grammar schools where the real work was done. The education of girls had its unusual features which stemmed from the girls' future activities, but to provide girls with an education that

helped them develop their own personalities would have been incomprehensible to the society of the day.

Protests against the degrading exclusion of women from serious education and its application were made throughout the epoch and were accompanied by a wide range of literature which seriously debated the age-old question of "whether women were also human beings." They argued that women's intellectual abilities were on principle equal to those of men and that they therefore had an equal right to education. There were a number of women among the advocates of this rather modest form of equal rights. On reading the 1601 polemic of thirty-year-old Lucrezia Marinelli entitled *La Nobilità e l'eccelenza della donne, co' diffetti e mancamenti degli Uomini* (The nobility and excellence of women against the shortcomings and inadequacies of men), one is immediately reminded of the Renaissance with its humanist ideals of education. The tradition was continued in France by Marie des Jars (1565–1645), whose intelligence so delighted Montaigne that he called her his *fille d'alliance*. In 1622 she published a work entitled *L'Egalité des hommes et des femmes*, and in order to emphasize the point even further, she dedicated the book to Queen Anne. Anna Maria van Schurman's 1641 Latin treatise *De ingenii muliebris ad doctrinam et meliores litteras aptitudine* (On the suitability of the female intellect for learning and for the higher sciences) was presented with scholarly precision and clarity. Reflections on this theme were by no means superfluous a century later. In 1742 Dorothea Erxleben summarized her own bitter experience in a work entitled *Gründliche Untersuchung der Ursachen, die das weibliche Geschlecht vom Studieren abhalten, darin deren Unerheblichkeit gezeiget, und wie möglich, nöthig und nützlich es sey, dass dieses Geschlecht der Gelahrheit sich befleisse* (A thorough investigation of the reasons why the female sex is prevented from studying, showing how these reasons are insignificant as well as how it is feasible, necessary, and useful for women to engage in learned work).

There were also a few men, especially in France, who wrote in the same vein. In *L'Honneste Femme* (1632–1636) Jacques du Bosc clearly called for comprehensive education for noblewomen in the interest of high intellectual and cultural standards at court. In 1673 François Poulain de la Barre (1647–1723) published a sensational work entitled *De l'égalité des deux sexes, discours, physique et moral où l'on voit l'importance de se défaire des préjugés*. In it he refuted all the arguments against women gaining a university education and using their skills as doctors, judges, clergy, politicians, and military commanders. According to him these arguments were based only on prejudice. The reflections of these two authors went far beyond reality and thus led to the suspicion that they were only interested in abstract logical rhetoric with an amusing edge to it. This can indeed be said of all the writings of this nature in defense of women. The works by learned women were well known, and triggered off widespread literary debates. But their learned and rhetorical character and lack of reference to practical results cannot be overlooked.

Practical, effective, and far-reaching impetus to publicize the injustice of existing conditions and to effect change came from two quarters. One was through the Enlightenment, in the form of bourgeois opposition to the life-style and principles of the aristocracy; the other was through religious zeal for reform. A few supporters of the Enlightenment realized that all the efforts undertaken to achieve moral and intellectual education of the human mind through the development of "reason" had only been applied to the male half of mankind. The fact that "precisely half of the human race" were kept in ignorance could not easily be reconciled with their principles. And on top of that, they rejected the life of luxury led by high society, where women played a purely decorative role. The first systematic advocates of women's education (as we will shortly see) did not simply demand that women should be educated—they were, after all, prepared by the convents for their future life in society—but that the nature and aims of their education should be changed. Its objectives should be preparation, not for aristocratic leisure, but for running a household and caring for a husband and family, which required a sound education.

The various anti-orthodox religious movements—such as Quietism and Jansenism in France, Puritanism in England, and Pietism in Germany—seem to have similar intentions and motivation where the education of women was concerned. They shared the same view that women had on principle an equal right to education; but they argued in the same breath that women's education should have a specific slant to it—which made it less comprehensive than that of men—for reasons of practicality and usefulness inherent to the bourgeois sense of duty.

Two works from France—which, for the first time since the Renaissance, approached the question of women's education in a systematic way and with guidelines for the future—had an enormous impact, even though there were initially few practical consequences. They were probably written at about the same time though independently of one another. Both authors were members of the clergy and therefore highly educated, and both had spent some time working as tutors for high-ranking families and thus were writing from their own practical experience. Their names were Claude Fleury (1640–1723) and François Fénelon (1651–1715). Fleury wrote his *Traité du choix et de la méthode des études* in 1675 but did not publish it until 1686. In it he discusses the education of children from a general point of view as well as with reference to each individual branch of instruction and education. In thirty-five chapters, he argues for a practical approach that has the child's future (together with his moral development) in mind. It only becomes clear from the thirty-sixth chapter onward that these carefully thought out educational considerations and rules of behavior apply to boys only. The last four chapters of the book are concerned with social groups that appear to require a special type of education: women, clerics, army personnel,

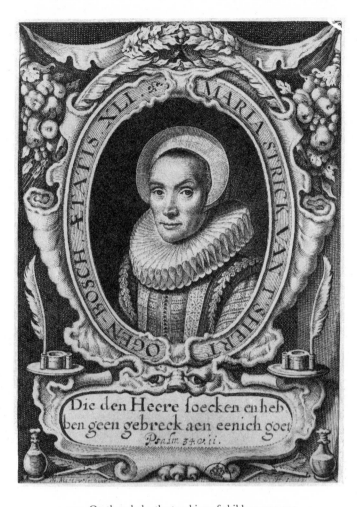

‹75› On the whole, the teaching of children was one
of the few professions that impoverished noblewomen
or middle-class women without financial means could take up.
In Holland there were semipublic elementary schools for boys
and girls in all towns and many villages.
Maria Strick from 's Hertogenbosch, who commissioned
a portrait and wielded a pen like a weapon,
must have been a respected personality.
Willem Jacobsz Delff after Michiel van Mierevelt, *Dutch Schoolmistress*,
early 17th century.
Copperplate engraving, 16.8 × 11.7 cm.
Staatliche Kunstsammlungen, Kupferstichkabinett, Dresden

and judges. This rather odd inclusion of women among professional groups shows that Fleury defines their position in society from the point of view of their "profession," in the sense of their "purpose" (the term more commonly later). What set the women apart from the other three groups was that they could not *choose* their purpose in life; they were automatically so destined by birth. In the seventeenth and eighteenth centuries the bourgeois struggle for the individual freedom to find one's own meaning to life—according to one's abilities

and needs, irrespective of the class barriers imposed by birth—was waged only on behalf of men. Nevertheless Fleury's view, as he is well aware, goes beyond the conventions of the day.

It would without doubt be quite inconsistent to expect women to learn anything other than the catechism, sewing and various other handicrafts, singing, dancing and dressing fashionably, curtseying prettily and talking politely—because that is all their education generally consists of. It is true that they do not need most of the knowledge that comes nowadays under the heading of studies. There is no value for them in Latin or Greek, rhetoric or theology. If some women, who thirst for knowledge, learn these subjects, it is mostly for their own vanity's sake, and they become hated by other women and despised by men. However, this led to the belief, as if from irrefutable experience, that women are not capable of studying—as if their soul was any different from that of men, as if they did not also, like us, have to be governed by reason, to determine their will, suppress their passions, preserve their health and administer their wealth, or as if it were easier for them than for us to fulfill these obligations without learning anything. Admittedly women have, as a rule, less application and patience for advanced intellectual work, they are less courageous and steadfast than men and their physical constitution does not help them either, although the poor education they receive is more to blame. On the other hand, however, they have a livelier and more penetrating intellect, a gentler and more modest spirit. And if they are destined for positions which are not as high as those of men, it must be said that they have more leisure which turns to great moral depravity if it is not given stimulation through studying.

(Quoted from Ernst von Sallwürk)

This in fact outlines all the problems, which in the centuries following were merely expanded from various standpoints and given a progressive or reactionary slant. These problems appeared in the conflict between the incorporation of women into society's framework according to the bourgeois "reasonable" and "natural" differentiation between the sexes and women's specified spheres of activity. Thus the right to education—which they had just been granted—was immediately limited.

Nevertheless one must not overlook the fact that this constituted pioneering work for the education of girls and women. In *Éducation des filles*, François Fénelon sets out in great detail what Fleury only hinted at. This work appeared originally in 1681 as a more concise manual for Marquise de Beauvillier, who had eight daughters. It was not until 1687 that Fénelon published an expanded version of his book. He comments on the basis for his educational method in Chapter 1. Women's duties consisted of presiding over a household, making their husbands happy, and bringing up their children well. These activities were no less important for the common good than those pursued by men. The aim of a girl's education, therefore, was to help her develop into a "sensible, hard-working and godly woman" who could be the "soul of an entire household." Later, in the large section on religious education, he is clearly concerned with the principle of

achieving the necessary qualities through moral development rather than mechanical learning. Of course "their spirit" must be kept "within reasonable limits" and they must understand that "as regards learning, their sex should show a restraint which must be almost as delicate as that which inspires a horror of vice." He recommends that girls should be encouraged to read the Gospel, especially because of the section in St. Paul's letter to Timothy where he demands sober and moderate wisdom of women. Fénelon's basic principles for the education of girls are totally in keeping with St. Paul's standpoint: "Let the woman learn in silence with all subjection. But I suffer not a woman to teach, nor to usurp authority over the man, but to be in silence." (1 Tim. 2; 11–12)

For this reason a declared aim of his method was to keep girls away from aestheticism.

If one is not careful and the girls are to any extent vivacious, they will always be meddling and ready to talk about anything. They lay down the law on matters quite beyond their capacity and pretend to be bored by exactness. A girl ought not to speak unless it is really necessary, and even then with an air of hesitance and diffidence. She ought not to speak about matters which are above the ordinary reach of girls, even though she has had some instruction on the subject. Although she may have a good memory, vivaciousness, tricks of speech and the ability to talk pleasantly as much as she would like, she shares all these qualities with a large number of other women who have little sense and are very contemptible. But her behavior should be well regulated; she should have a well-balanced and steadfast disposition; she should know when to keep silent and how to manage things—a quality so rare that it will mark her out among the numbers of her sex.

In his educational program for girls, Fénelon maintained that girls should be competent in reading and writing and should know the grammar of their mother tongue well enough to speak correctly. They should be familiar with basic arithmetic and with the essentials of the legal system. These were regarded as compulsory subjects, together with the knowledge and skills which were directly relevant to housekeeping, such as dealing with tenant farmers and servants, supervising purchases and expenditure, creating order and maintaining cleanliness. In addition, if a lively child had some spare time and wanted to read, then secular literature—such as books on Greek or Roman and above all French history—was permitted, but under no circumstances were comedies or novels to be read. Great caution was advised where the arts were concerned. Poetry, music, and painting were pastimes of the idle rich and superfluous for "sensible and hardworking" women.

On this point Fénelon and Fleury were unanimous with John Locke, who made it quite plain in *Some Thoughts Concerning Education* (1693) that little emphasis should be placed on the arts, even in the education of young men. This illustrates how the middle classes cut themselves off from the aristocratic way of life. In the same way they refused to instruct their girls on fashion and entertaining. Fleury and

Fénelon made a positive contribution to women's education precisely because of the distance from the role assigned to women in high society that their educational theories promulgated. They assigned to women a serious sphere of activity which was necessary for the community and which required an education so that they could fulfill their role knowledgeably and responsibly.

Fénelon aimed his educational program at girls brought up at home under their mother's supervision. He often revealed his dislike of convent education, which he disapproved of mainly because of the way it was carried out at the time. His ideal institution was not to be found in the convent schools adapted to the requirements of high society nor in the few schools where a strict religious education was provided. The "glittering and noisy nursery schools" of the large towns, as well as the exclusive educational establishments for the rich (such as Remiremont in Alsace, and Fontevrault and Panthémont), prepared young ladies for their entry into upper-class society. The organization of daily affairs and classroom instruction played a much more subordinate role. Apart from a thorough grounding in the catechism there was little importance attached to a general education as such. And the discipline generally associated with convents was appreciably relaxed. Their distinguished pupils lived in their own rooms and had their own maids. It was quite normal for the young ladies to have male visitors coming to speak to them at lattice grilles and to hold parties in their apartments. Fashionable luxury abounded, and even city tradesmen selling fashion goods were received. All of this was allowed in order to cultivate fine manners and the conduct appropriate for high society. In this aspect the convents achieved exactly what was expected of them by the parents. Many a lady of leisure would later reminisce warmly about her entertaining preparation for a life of entertainment.

There were some convents, however, which kept their young pupils in the strictest seclusion, with each day like the next; no hustle and bustle from the outside world was allowed to penetrate their lives. Since they were starved of intellectual stimulation—most of their time was taken up by religious exercises—they were badly equipped for their entry into the bewildering world of high society. The strictest institution of this kind was the Jansenist convent school at Port-Royal run by Angélique Arnauld. The girls who boarded here were subject to conditions scarcely less harsh than those endured by the nuns. The permanent vow of silence could only be broken to whisper the most urgent of messages. The watchful eye of the nuns prevented any contact between the children; they all had to work on their own. Their education was limited to religious exercises, elementary reading, writing, arithmetic, and handicrafts. The daily schedule did not include periods of rest and recreation. Both learning and handiwork activities were devoid of pleasant stimulation or personal fulfillment. The aim of this education was moral perfection, which was to be achieved through humility (the only way to

‹76› Little girls were encouraged at an early age
to prepare themselves for their future roles as housewives.

Jan Woutersz, known as Stap (1599–1663?), *Girl Baking a Pancake*, 17th century.
Wood, 44 × 33 cm. Museum der bildenden Künste, Leipzig

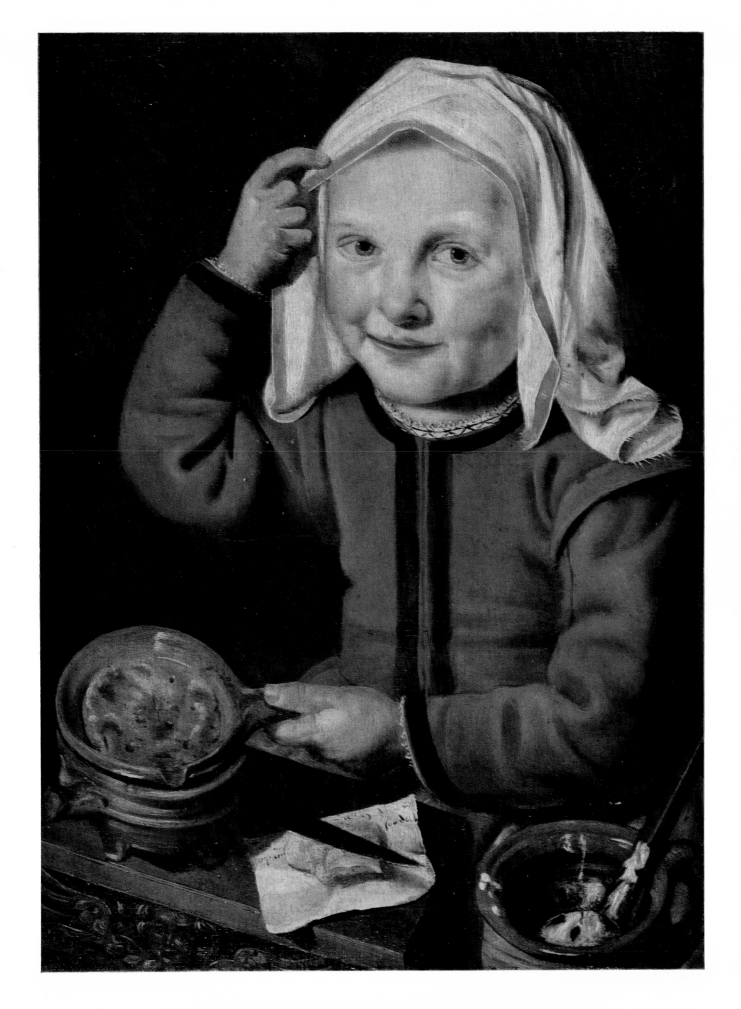

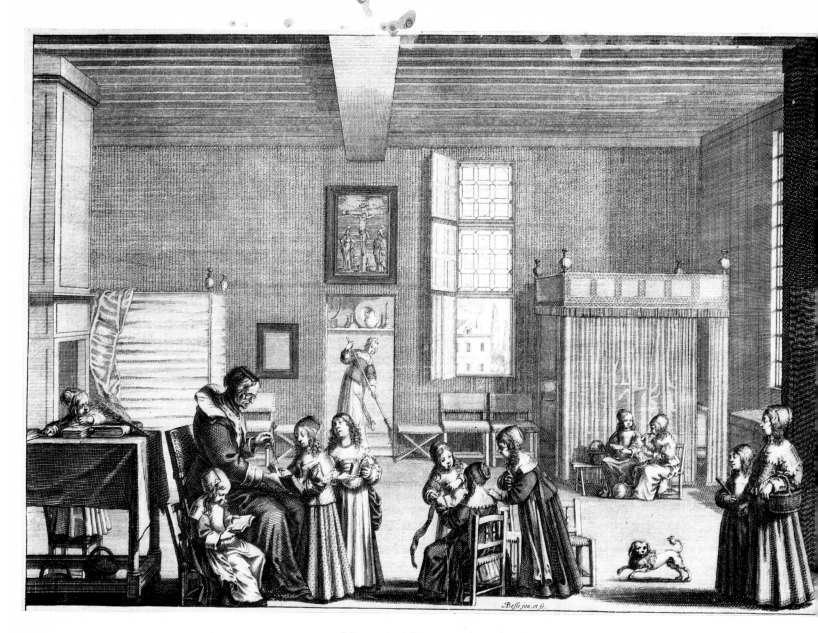

‹77› Primary school classes were often held in the
teacher's home. Girls were generally instructed by women,
who taught them all they knew in reading, writing, and arithmetic.
The girls' clothing and the orderly state of the room indicate that
this was a school for children from well-to-do families.

Abraham de Bosse, *The Schoolmistress, c.* 1630.
Copperplate engraving, 26.4 × 32.9 cm.
Staatliche Kunstsammlungen, Kupferstichkabinett, Dresden

‹78› The fundamentally middle-class idea of the emotional bond
between mother and daughter serving as a basis for education in female virtues
was portrayed by Chardin as an ideal of "good education."
Here the mother's loving efforts are met by
a willing readiness to learn on the part of her little girl.

Jacques Philipp le Bas after Jean-Siméon Baptiste Chardin, *The Good Education, c.* 1749 (original),
engraved after 1753. Copperplate engraving, 29.4 × 33 cm.
Staatliche Kunstsammlungen, Kupferstichkabinett, Dresden

‹79› Scenes from convent life, including a convent school, can be found
in the toy-town "Mon Plaisir." The Ursulines regarded the education of girls as one of their main tasks.
They taught them Christian obedience above all and female handicrafts.

Toy-town "Mon Plaisir." Room 33: Handicrafts
lesson for middle-class girls in an Ursuline Convent, *c.* 1720–1751. Schlossmuseum, Arnstadt

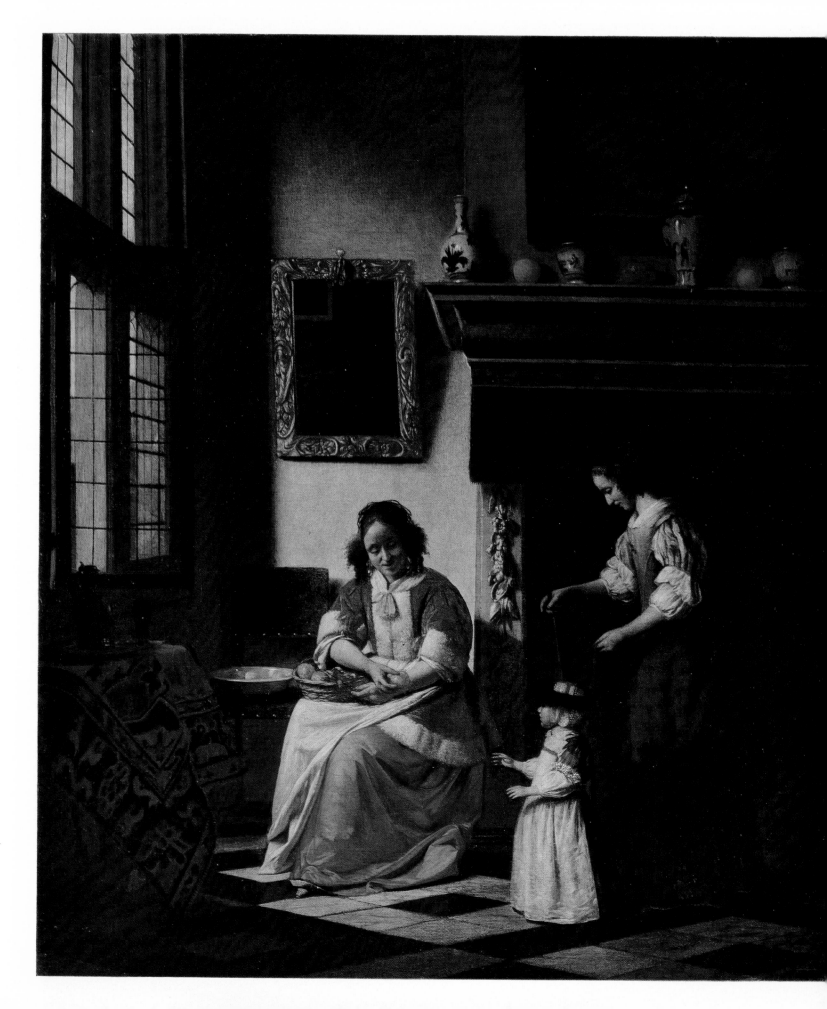

‹80› In Dutch families both mothers and nannies
concerned themselves with the children's education.

Pieter de Hooch, *Learning How to Walk*, 1660s.
Oil on canvas, 67.5 × 59 cm. Museum der bildenden Künste, Leipzig

‹81› The old schoolmistress holds classes
in her simple living room. While she is testing a little girl's reading with
another one waiting patiently for her turn, the other children
are up to their little tricks in the background.

John Coles after Francis Wheatley, *The Schoolmistress*, 1794.
Engraving, 43 × 50.2 cm. Staatliche Museen, Kupferstichkabinett, Berlin

gain divine grace). But most of these girls were destined to enter high society. Fénelon wrote that they emerged from the convents "like someone who had been brought up in the darkness of a deep cave and was suddenly brought into the brightness of daylight. Nothing is more blinding than such an unforeseen transition . . ."

In between these two extreme forms of convent education for aristocratic girls was an experimental school led by Madame de Maintenon at the convent of Saint-Cyr. She had been governess to the children of the royal family and was later the secret wife of Louis XIV. She based her educational aims on the teaching of Fénelon, which were fundamentally bourgeois ideals. She had good reasons for basing her work on bourgeois principles: the institute was intended for the daughters of impoverished noblemen who could not guarantee their offspring a proper education or position in society. Consequently, the education provided was simple, practical, and useful to prepare the pupils for a life without the added comforts that go hand in hand with wealth. In 1686 Madame de Maintenon received a royal endowment to found her institute for 300 pupils and 36 instructresses. The girls were taught in separate classes, and attended the school between the ages of seven and seventeen. Religion, of course, stood at the center of their education. But in addition to reading, writing, and arithmetic they did at least gain an elementary knowledge of history, geography, mythology and, in the upper forms, poetry and music, as well as dancing. The fear arose that the pupils, and even the founder, might develop "a feeling for aestheticism." So their productions of plays by Racine were ended rapidly, even though they had given great pleasure both to the young performers and their aristocratic visitors headed by the King. And in order to prevent any further slackening of morals, Saint-Cyr was turned into a convent in 1694. Its educational principles remained the same, with perhaps greater importance attached to learning about housekeeping and cultivating a positive attitude toward work. At the end of the century Madame de Genlis characterized this attitude as "not regarding any work as being too low that might be useful to a thrifty woman, and thus these girls make all their own clothes themselves." The girls in the top form were called upon to assist the nuns in the teaching of the lower forms, and were thus trained as teachers. When they left the institute they were competent as housewives in a suitable marriage or as governesses for a high-ranking family. Although encumbered with many compromises, the school at Saint-Cyr was the one and, for a long time, only institute which implemented the ideas which the French philosophers of the Enlightenment had developed concerning women's education.

These ideas gained ground relatively quickly in Germany, typically enough through the moral demands of Pietism. The approach fitted in very well with the interests of the middle classes, since it preached practical orientation on the one hand and a strengthening of religious feeling on the other. In 1698 August Hermann Francke

published the first German translation of Fénelon's *Education of Girls*. The preface contains a sharp attack on conditions in Germany, especially in terms of women's education. According to him the blame lay on the shoulders of the government:

We do the very least when it comes to educating our girls. If you look at the common people, then who looks after the girls' schools, who sees that they are properly equipped and maintained in such a way that we can expect really good results from them? Because the authorities and the preachers do not carry out their duties here as they should, it is no wonder that these girls generally grow up in sin, disgrace and vice. If then one of these badly brought up women turns to whoring and murders a child or commits some other terrible deed, her head is torn off. Is that enough? Will not God on that day demand blood from those whose duty it was to provide young people with an education? The ruling classes and the teaching profession are sullying their hands with blood by not ensuring that the people are given a proper Christian education.

The same moral and religious prerequisites formed the basis of *Christen-Staat* by Veit Ludwig von Seckendorff, published in 1693. In it he includes a chapter entitled, "On better education for the female sex and in their schools, proposed during the Reformation but never implemented." He also felt that there had been "gross and irresponsible neglect in the instruction and education of the female sex. There is very little taught in girls' schools, usually just the very fundamentals of the catechism." Seckendorff was referring here to the public schools, which were dependent on the specifications of each provincial ruler. They decided whether girls' schools would be established at all and whether school attendance was compulsory. The quality of the teachers was also determined by them. For example, Duke Ernst of Gotha was the first to introduce compulsory school attendance for all boys and girls in 1642; in 1609 Duke Christian of Saxony turned down an application to establish just one school for girls and recommended that the head of the house should educate his daughters at home. In such circumstances, A.H. Francke's plan for education must be regarded as a great and courageous achievement. The tenacity with which he pursued his aim was quite admirable. Francke's educational establishments for girls could easily be compared in their aims and methods with the French model school at Saint-Cyr. He also aspired toward a practical and useful education, aimed at the girls' future position, and he too placed great emphasis on moral instruction. Francke's plans were highly complex but, at the same time, his authority and financial resources were much more limited than those of Madame de Maintenon. So in the end little remained of his plans. As far as the education of girls was concerned, his only real success was his orphanage, which produced competent servant girls. This was a truly useful institution, and was never challenged (it took in girls who would have otherwise gone to the poorhouse). But his school for middle-class girls, opened in 1698, lasted only five years. This was due both to the hostility shown toward Francke because of his anti-orthodox attitude to the Church and to a

‹82› Dancing lessons were an integral part of the education of aristocratic girls. Dancing taught
them the skills of good conduct and how to move with confidence and grace among the company of the salon.

Pietro Longhi, *The Dancing Master*, 18th century.
Oil on canvas, 47 × 57 cm. Casa Rezzonico, Venice

‹83› The *Hausbücher* (house books) provided instructions
on how to educate girls to become good wives and housekeepers.

Wolf Helmhard von Hohberg: *Georgica curiosa aucta*, p. 276. Nuremberg: 1687

low demand. His *Gynäceum*, a school for the daughters of the wealthy, was opened in 1709 after lengthy preparations involving major—and in Francke's opinion, indefensible—compromises to accommodate the wishes of the upper classes. As early as 1732 it had to be closed through lack of pupils and teachers.

But perhaps all these efforts were unnecessary and women were sufficiently educated without regular schooling? This question is posed by a certain category of German literature. One of the numerous associations for the cultivation of the German language and customs, the Pegnitzschäfer Order in Nuremberg, published a rather strange book. Christian Franz Paullini, a prominent member of the Order, produced a comprehensive collection of tributes, in alphabetical order, to "learned" women throughout the ages, *Hoch und Wohl gelahrtes Teutsches Frauenzimmer* (Very learned German women). The aim was ostensibly to honor the poetesses within the Pegnitzschäfer association, but the real reason behind it was clearly expressed by Paullini in his preface to the second edition of 1704. The reader would be able to see from the book "that our beloved Germany does not need to bow down before noisy Spaniards, arrogant Italians or conceited Frenchmen . . . The languages of Europe must willingly yield to our beautiful, graceful and majestic mother tongue and melodious, divine poetry . . ." The foolish patriotic arrogance of such statements, which could only be understood as bourgeois opposition

to the Francomania of the boastful little German courts, detracted from the real value of the literary work produced by these diligent poetesses and from the soundness of their education, without which they could not have written as they did. Nevertheless, Paullini had exposed a major need, as can be seen by the large number of other works on the same subject. In *Eröffnetes Cabinet des gelehrten Frauenzimmers* (A look into the study of a learned woman), published in 1706, Johann Caspar Eberti was also at pains to reveal the learned ladies of his homeland Silesia to all the world. He was so resolute in this that even the goddess Minerva as a "Greek woman" was used as evidence of female intelligence. Johann Gerhard Meuschen established a kind of ancestral portrait gallery as homage to the electoral princess Sophie of Brunswick, who appeared to him to be the culmination of the *Curiösen Schaubühne durchlauchtigster gelehrter Damen als Kaiser-, König-, Chur- und Fürstinnen, auch anderer durchlauchtiger Seelen aus Asia, Africa und Europa, voriger und itziger Zeit* (Curious display of the most royal learned ladies as empresses, queens, electoral princesses and duchesses, as well as other royal intellects from Asia, Africa and Europe from bygone and present times). Lehms' *Teutschlands galante Poetinnen*, quoted at the start of the chapter, should also be included among this rather grotesque form of "defense" of women's education. All these remarkable writings are certainly proof of the fact that many women desired mental stimulation. But their enthusiastic tone—es-

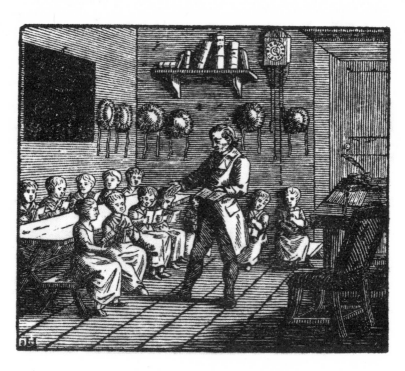

‹84› An unknown eighteenth-century illustrator
produced this picture of a school for girls.

Woodcut, 7.1 × 8.3 cm. Staatliche Museen, Kupferstichkabinett, Berlin

pecially with the reasons behind the euphoria quite transparent in every case—cannot conceal the fact that these women were the exception. The education of the day could scarcely be called education, and the "intellects" these books made so much of were clearly all products of chance and favorable conditions in the home.

Greater influence on a wider audience was gained by the *Moralische Wochenschriften*. These were in fact directed only at the educated circles among the upper classes, but within this sphere they disseminated bourgeois educational ideals and principles, and encouraged a bourgeois class consciousness. They were aggressive in their treatment of those things in particular which concerned the position of women in society, and with harsh criticism they drew a sharp distinction between older feudal and patrician conventions and the new bourgeois attitudes based on reason. These journals were guaranteed popularity by their rather glib and entertaining style and by the fact that their subject matter was always up to date and reflected everyday life with the aim of informing the public. They first appeared in England and soon became widespread. *The Tatler* (1709–1711) came first, then *The Spectator* (1711–1712, 1714) and *The Guardian* (1713). The question of women played an important role in these journals. Of the 1,081 essays contained in these three journals, written mainly by the editors Richard Steele and Joseph Addison, 420 are on this subject. The authors discuss the general assessment of women in re-

lation to men, and they conclude that a sound education based on virtue and reason is the only means of changing the low opinion of women widely held in England. This contempt was based on their mindless and pointless way of life, their foolish fashions, superficiality, and moral thoughtlessness. According to Steele and Addison, this was all the result of a badly organized society which, though still suffering from the culture of the court, was already ruined by the new classes that had bought their way into the nobility. They held the utopian belief that this terrible state of affairs could be rectified through enlightenment, and they urged that the education of women should be regarded as priority. Wherever possible, girls should be educated by their mothers at home. (We saw this same bourgeois viewpoint in France, where it so clearly contrasted with the convent education of the aristocracy.) Boarding schools ranked second in their order of preference. And the editors allowed a number of headmistresses to publicize their institutes in these weeklies. Poor families were also encouraged to send not only their sons but also their daughters to the charity schools, and Steele and Addison were always calling for donations to support these schools. The girls were given instruction in the usual range of subjects. These were reading, writing (with emphasis on correct spelling and grammar wherever possible), basic arithmetic (so that they would be able to keep the books later, as housewives), foreign languages, especially French

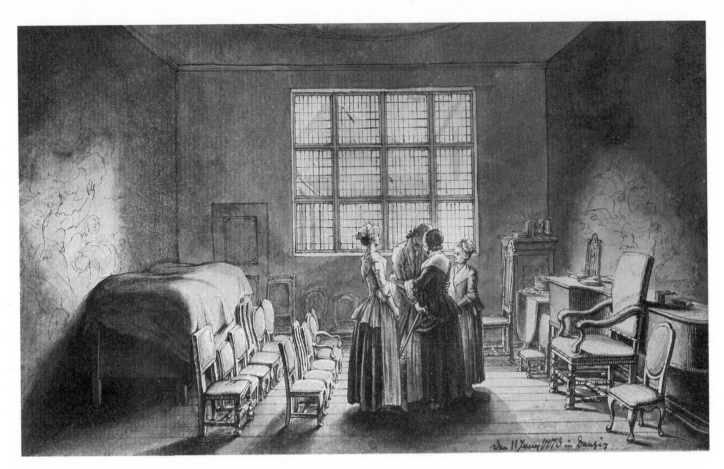

‹85› Daniel Chodowiecki's mother and sisters ran a school for young children in Danzig.
It was probably intended for 3 to 6 year olds and was therefore really a kindergarten.

Daniel Chodowiecki, *Journey from Berlin to Danzig: Greeting His Mother*, 1773.
Wash drawing, 11.3 × 18.4 cm. Staatliche Museen, Kupferstichkabinett, Berlin

and Italian (so they could use the literature of these countries to cultivate their intellect and taste). Music and painting again were regarded as superfluous.

The German moral weeklies took up the cause of spreading enlightened ideas. The Hamburg *Patriot* (1724–1727) presented an ideal image of the educated woman—she had firm morals and a God-fearing nature. Her general knowledge was supposed to be adequate for her to bring up her children in the same moral way.

Gottsched's *Die Vernünftigen Tadlerinnen* (The sober-minded criticizers) (1725–1726) stands out among the journals because it was aimed directly at women, not only providing good advice but also trying to set an example and develop an independent and critical capacity for judgment among women with regard to conditions in society. "In order to achieve this aim," wrote Gottsched in the preface to the second edition, "[the writers] used the harmless device of pretending to be women themselves." The fictitious female authors

were, by their example, supposed to give their female readers the courage and self-confidence to undertake their own intellectual work. "Examples have more force than rules alone . . ." It was particularly important for him to reach those "persons who were not learned or had at the most an average education," and he felt that inventing what we would now call "positive role models" was the most appropriate way to do this.

By pretending that women were the authors of the somewhat daring criticisms of society and traditions expressed in his journal, Gottsched presented a view of women which was quite different to that commonly held. He wanted women to use their minds independently and become mature and responsible persons. The other moral weeklies, with all their good intentions, proceeded quite differently. The listing of special books "suitable" for women was published, for example, by Steele and Addison and in the Hamburg *Patriot*, too, and was based, one must assume, on the presumption that

women were spineless entities who needed to be shaped by men. Women who considered themselves virtuous were expected to stick to the lists of books that men hoped would bring them closer to the desired ideal of moral perfection and intellectual mediocrity.

Nevertheless, this brief survey gives an idea of the various efforts that were undertaken to raise the intellectual standard of women. But there is no question of the fact that there were only isolated successes in the schoolroom and a few more among those educated in the home. This could hardly have been otherwise, and certain writers of the day gave quite blunt explanations for the situation. Let us look at the views of two Frenchmen, an Englishman, and a German.

Jean de la Bruyère in *Les caractères ou les mœurs de ce siècle* (1688) wrote the following: "One regards a learned woman in the same way as one looks at a beautiful weapon—as an elaborate piece of craftsmanship, artistically engraved and magnificently polished, which is displayed to visitors but which is fit for use neither in war nor for hunting, no less than a school pony, even if it is the best behaved pony in the world."

Théodore Agrippa d'Aubigné wrote in a letter to his daughters: *I would now like to give you my opinion on the benefit what women can gain from such outstanding knowledge. I have nearly always found it to be of no use for girls of the middle classes like you. Those who were less lucky used it badly rather than well. Others found the efforts of little value, as they discovered, as the saying goes, that the nightingale no longer sings when she has her young. I would like to add that an unusual raising of the mind increases one's boldness too. I have seen two evils come of this, one a contempt for thrift and poverty and for men who do not know as much, and two disagreement.*

In *Georgica curiosa aucta*, mentioned earlier, Hohberg said: "I could not advise noble women to pursue learned studies because there is barely one man in a hundred who would not prefer a wife that could run the household loyally and sensibly and on whose diligence and supervision he could rely, than choose a woman who can translate 100 madrigals, canzonets or sonnets by Desportes, Ronsard, Petrarch, or Marini or write them herself."

Daniel Defoe, in "An Essay on Projects" (1697), a collection of practical suggestions for the improvement of social institutions, including a proposal to found women's academies, said:

A Woman well Bred and well Taught, furnish'd with the additional Accomplishments of Knowledge and Behaviour, is a Creature without comparison; her Society is the Emblem of sublimer Enjoyments; her Person is Angelick, and her Conversation heavenly; she is all Softness and Sweetness, Peace, Love, Wit, and Delight: She is every way suitable to the sublimest Wish; and the man that has such a one to his Portion, has nothing to do but to rejoice in her, and be thankful.

On the other hand, Suppose her to be the very same woman, and rob her of the Benefit of Education, and it follows thus;

If her temper be Good, want of Education makes her Soft and Easy.

Her Wit, for want of Teaching, makes her Impertinent and Talkative.

Her Knowledge, for want of Judgement and Experience, makes her Fanciful and Whimsical.

If her Temper be bad, want of Breeding makes her worse, and she grows haughty, Insolent, and Loud.

If she be Passionate, want of Manners makes her Termagant, and a Scold, which is much at one with Lunatick.

If she be Proud, want of Discretion (which still is Breeding) makes her Conceited, Fantastic, and Ridiculous.

And from these she degenerates to be Turbulent, Clamorous, Noisy, Nasty, and the Devil.

These four prominent representatives of their epoch are remarkably unanimous in their views. They played an active role in practical life of their society, and were sufficiently experienced to be regarded as typical proponents of the prevailing opinion that knowledge was unnecessary for women. After all, they could not make use of it, and it made them appear ridiculous, as Molière showed once and for all. It was even dangerous, as it prevented them from being good housekeepers, wives, and mothers. Many a wife eventually rebelled against her husband, who was "the head of the other sex which was made for him" (John Milton, 1643).

Hindsight makes it clear that, as long as women were excluded from professional work and had no part in the public life of society, it was in fact not feasible to achieve fundamental changes in their education.

WITCHES
AND SAINTS

IN the troubled history of seventeenth-century Europe two phenomena of spectacular character still fascinate us today. They appeared as complete opposites, and yet both were based on the same sociopsychological features prevalent at the time. These were the nun, who believed that through meditation she gained unity with Christ, and the witch, who believed she could make a pact with the devil. They emerged as central figures, in part because society, which was unsettled in its own self-image—from the philosophical, economic, and moral point of view—needed to gain control of this uncertainty. The attempts to control its fragmented image, conducted by various means at all levels of society and thought, determined the dramatic course of the process of stabilization. Both violence and emotional manipulation were used with the utmost consistency. "Witches" and "saints" were brought into the arsenal of the great struggle for a new order in European society. The former represented all that was evil, horrifying, and frightening in the world, and the latter provided a worthy example to emulate.

For centuries witches had caused concern to Christendom. The *canon episcopi* of the early ninth century declared, with all the authority of official Church law, that it was heretical to believe in witches and their ability to fly through the air. Only pagan beliefs were punishable; superstition was not, as this was usually based on hallucinations. Initially this doctrine was adequate to combat the last traces of paganism. It was not until the campaigns of the twelfth and thirteenth centuries against the heresies of the Cathars and Waldenses that the newly founded Dominican Inquisition discovered a dangerous, "special" kind of heresy in witchcraft, that is in the superstitions and rural customs of mountain peasants. But the *canon episcopi* stood in the way of systematic persecution. By the fifteenth century, however, the Dominicans succeeded in having witchcraft added to the list of heresies, circumventing the awkward rule and clearing the way for the Inquisition.

The German Dominican fathers Henricus Institoris and Jakob Sprenger recorded their experiences of peasant superstition in a book published in 1486 already under the title of *Malleus maleficarum* (Witches' hammer). This book served as a basic reference work for judges involved in witch trials and was soon widely available in translation throughout Europe. It contained a thorough and meticulous account of all the information one needed about witches, of the crimes they usually committed, how they could be recognized, and what questions should be asked when interrogating them. Throughout the sixteenth and seventeenth centuries theologians and lawyers were zealous in their eagerness to supplement and expand on the Dominican fathers' belief in sorcery. They approached the issue from all angles, even debating the existence of witches, and attempted to determine how they should best be examined and judged.

It was commonly believed at the end of the sixteenth century that witches were people who had made a contract with the devil, receiving therefrom supernatural powers used mostly for evil. It was believed that witches cast spells producing illness or death among children, causing nursing mothers to lose their milk, and making men impotent; they were blamed for deaths among livestock, failed harvests, foul weather, hailstorms, and fires. Of course they could help and heal, too; they could soothe labor pains and bring down a fever. But this benevolent witchcraft was just as harmful as their evil actions because it was based on a pact with the devil. He appeared to them in person and was often their lover, sometimes over a period of several years. At any rate, they regularly attended large assemblies called witches' sabbaths. To get there they rode through the air on broomsticks or on various animals, usually leaving their homes through the chimney, or even through closed windows if other avenues of escape were closed off. There were hundreds of witches meeting at these assembly points, thousands at the large international meetings. The Blocksberg in the Harz mountains, the meadow Blåkulla in Sweden, and l'Aquelarre in southwest France were the largest and best known of these meeting places. The main activities at these witches' assemblies were banquets that no one liked and

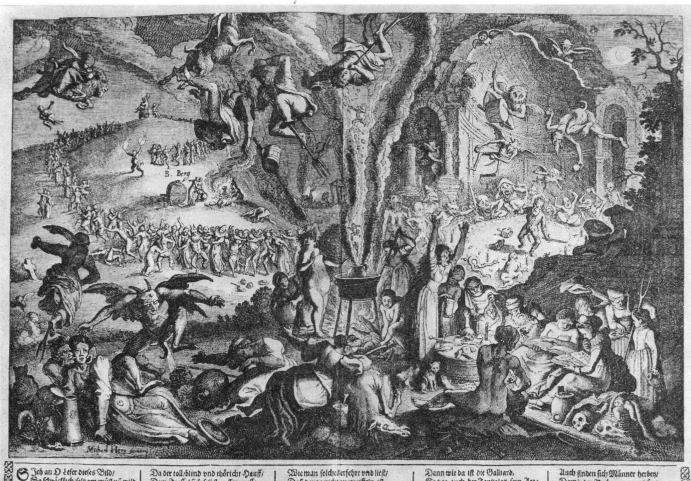

The text within the engraving reads (Old German):

‹86› Michael Herz, *Witches' Sabbath on Walpurgis Night on the Blocksberg Mountain*,
17th century. Copperplate engraving.

sexual orgies that no one enjoyed. There was also wild dancing and adoration of the devil. He led the gathering, appearing not as a lover but in the shape of a goat or toad. Finally, everyone had to give an account of "what she had been doing since the last meeting and what she had used her powders for. One would say that she had killed a child, another a horse, a third had made a tree die. When they discovered one who had not achieved anything since the last assembly, she was beaten several times with a stick across the soles of her feet, she was mocked and ridiculed by everyone present and she would say that one often needed new powders."[17]

All this was really believed. Not only by witch hunters of the theoretical and practical kind and not only by the ordinary people who saw in this a reason for all their fears of the incomprehensible horrors of disease and natural disasters. Even the witches themselves believed it to some extent. The foundation was laid through pathological states of excitement, hysteria, and the effect of drugs taken unwittingly, and all this was compounded by centuries of deeply rooted popular belief. Thus, there seem to have been numerous cases of women (with the right predisposition) who actually did experience what the majority of the population believed of witches.

Jean Bodin, a precursor of modern scientific thought as well as the greatest authority in France on witchcraft, in his book *De la démono-manie des sorciers* (1580), wrote of a woman who, *"sans question ni torture,"* described her love affair with the devil, her journeys to the witches' sabbath, as well as her fatal spells on people and animals. She even went into detail. The devil would appear to her "as a tall, black man of superhuman proportions, dressed in black"; he was "wearing boots with spurs and had a dagger at his side." The devil promised "to treat her well and make her happy." She then denied God and served the devil. From then on she had a physical relationship with the devil that lasted from her twelfth to her fifteenth birthday, "and the devil always endeavored to appear to her whenever she wished him to."[17]

We can imagine how these situations occurred. The examining magistrates had the general theme at the ready, and could direct their questions quite precisely. The persons being interrogated only had to agree—there was no need to invent all the grotesque details themselves. Unexplained states of fear, sexual excitement, and feverish dreams took on concrete form under the judge's questioning. And as soon as there were some sensational reports available giving convincing accounts of witches' experiences, current theories of witchcraft were consolidated and expanded. If there were women who, of their own free will, described witches' dancing grounds, journeys through the air, and visits from the devil—and were quite convinced that this really happened—then theologians and lawyers could conclude that witches really did exist. What had been handed down through the generations about them was therefore true, and the witches who denied any knowledge of this were lying and had to be forced to admit the truth.

This line of argument was the start of systematic persecution ending in cruel tragedy for thousands of people throughout two centuries. Those witches who freely admitted their guilt were not only exceptional but also harmless, as they were known and could be destroyed. It was much more difficult and important, however, to find, expose, and exterminate the obviously vast number of witches who were not prepared to confess. There were plenty of clues in the manuals on witches to help the witch hunters with their work. Fear of being harmed by witches also led to denunciation, but it was more often through spite or petty revenge that women were denounced. The slightest suspicion or ugly appearance, inexplicable behavior, or just a desire for solitude could be enough. Torture could be used on witches who were persistently stubborn in their denials. Records of court proceedings provide detailed, accurate, and uninhibited descriptions of the methods used and the reactions of the accused. They state how completely unconnected utterances without any matching evidence could be regarded as a confession, and they were never tested for truthful information but were taken as confirmation of what had long been known.

The heresies of the twelfth and thirteenth centuries are connected with sixteenth- and seventeenth-century witchcraft from more than just theological points of view. The Albigensian heresies were, initially at least, social, antifeudal, and anti-Church opposition by peasant and plebeian classes. The bloody wars conducted by the Catholic Church against these socially dangerous trends were successful: the Albigenses were exterminated. However, it was discovered in the course of the Dominicans' missionary expeditions that there were pockets of resistance against or indifference to religious orthodoxy everywhere. The peasant inhabitants of isolated mountain areas were by no means won over to the Christian religion and the rule of feudalism. Since the missionaries' efforts were to little avail, the Church quickly found traces of old heresies in these groups, which were not fully integrated into medieval society. These heresies were obviously in the process of spreading dangerously. Between 1628 and 1630 in Franche-Comté there was an *épidémie démoniaque,* and the Dôle authorities reported that the evil was growing from day to day and that "this seed of disaster was spreading rapidly all over the provence." There had always been old women in the villages who gathered herbs, treated illnesses with magic spells, brewed love potions and healing drinks. They had always been quietly tolerated by the Church. But from the fifteenth century, when social and political tensions had heightened in Europe, the secular and religious authorities began to feel threatened and therefore watched such people more closely. They connected them with unrest and concluded that there was a system of resistance here that had to be ruthlessly suppressed. Pierre de L'Ancre, royal counselor in Bordeaux, realized with horror that witches and sorcerers used to be "ordinary people and madmen who had grown up among the mists and bracken of the countryside." But in his day and age many witches had admitted that "a vast number of high-ranking people, veiled and disguised by Satan, so that they are not recognized" are witches, too.[76] If witchcraft had penetrated the upper classes, sweeping measures were necessary.

The systematic spread of the belief in witchcraft was not without its advantages. It could be manipulated by the authorities to put a violent end to all sorts of opposition. But this would not have been possible with the power of the institutions alone. Theorists from the Catholic Church (and later from the Protestant churches) provided a complete picture of the danger, power, and widespread distribution of witches. This picture was based, however, on a general sense of fear and instability that sprang from social tensions. The "witch" became the stereotyped object of hate—the cause of the people's little-understood needs, dissatisfaction, and agitation. She became the scapegoat: tangible and available for persecution and destruction, she stood in for the intangible social conditions that were the real root of the people's fear and poverty. The disciplinary measures of the authorities coincided with the people's need to find relief from all the things that tormented and oppressed them. Thus it was possible

‹87› By the eighteenth century fortunetelling had lost its demonic aura.
It is presented here as an artistically produced game with two women dressed as a shepherdess and fortuneteller.
Giovanni Battista Piazetta, *The Fortuneteller*, 1740.
Oil on canvas, 154 × 114 cm. Galleria dell' Accademia, Venice

12.

‹88› A story from the book of Samuel in the Old Testament was turned into
this uncanny scene of nocturnal sorcery.

Johann Heinrich Schönfeld, *Saul with the Witch of Endor*, 1660s.
Copperplate engraving, pen and ink, 42.7 × 31.4 cm. Staatsgalerie, Graphische Sammlung, Stuttgart

‹89› In the seventeenth century, fortunetelling was counted among the dangerous
arts of witchcraft and was banned. Here, the deceitful prediction of the future is compounded
by robbery. But the cavalier pays with a counterfeit coin. The whole of
life is thus deception and illusion.

Georges de la Tour, *The Fortuneteller*, 1632–1635.
Oil on canvas, 102 × 123 cm. Metropolitan Museum of Art, New York

‹90› There are surprisingly few portrayals
of the witches' gatherings
that were described in detail in reports on witches.
Here it was just as important to depict
the visions of the women who were taken
for witches as it was to show the practice of
their secret love.

Frans Francken, *Witches' Sabbath*, 1607.
Oak, 56 × 83.5 cm. Kunsthistorisches Museum, Vienna

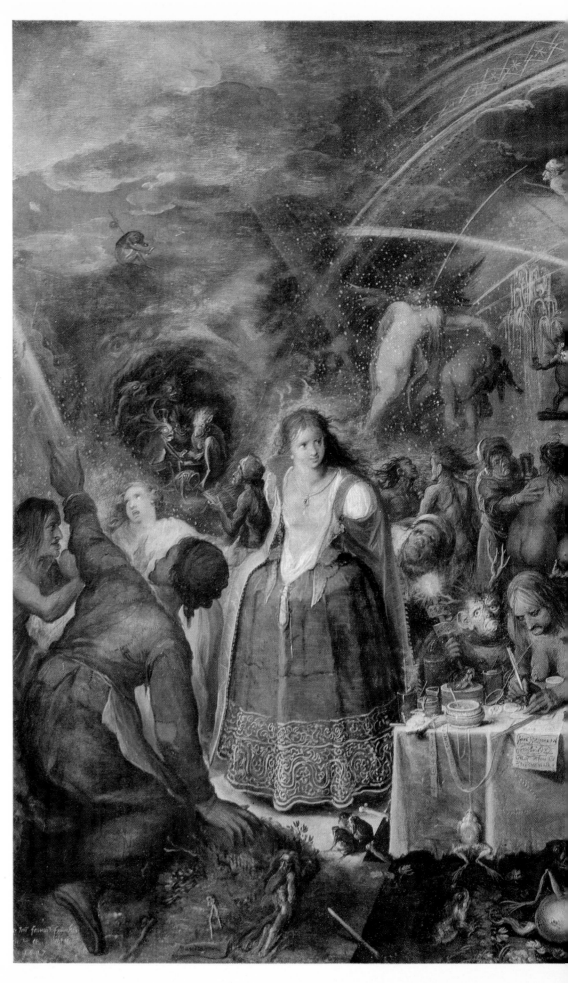

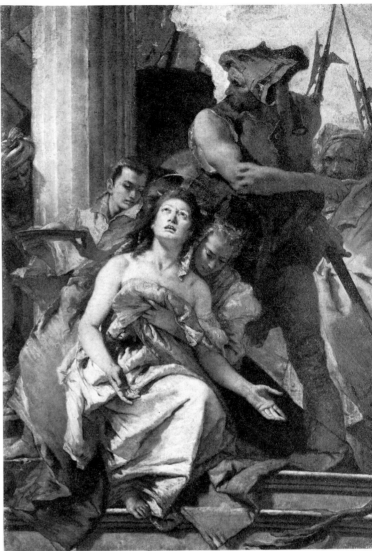

‹91› The picture of the penitent Magdalen is imbued with melancholy.
She renounces the transitory life of the world and abandons herself to meditation
on death and eternity.

Domenico Feti, *Melancholy, c.* 1613.
Oil on canvas, 168 × 128 cm. Louvre, Paris

‹92› Dramatic depiction of martyrdom showed how
the saints could withstand all temptation. True faith endowed them
with superhuman powers. Her upward gaze and her arms stretched out in self-sacrifice
reveal a state of rapture in which the soul rises above all that is earthly.

Giovanni Battista Tiepolo, *Martyrdom of St. Agatha, c.* 1756.
Oil on canvas, 184 × 131 cm.
Staatliche Museen Preussischer Kulturbesitz, Gemäldegalerie, Berlin (West)

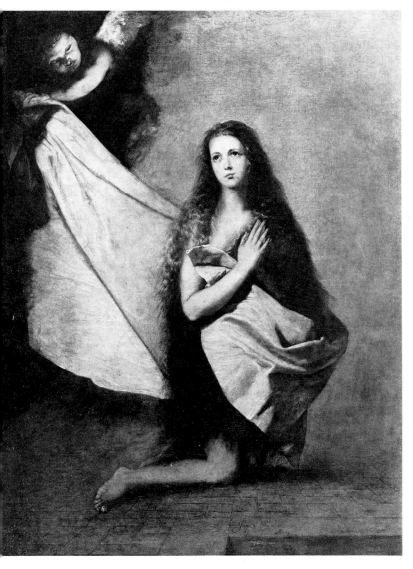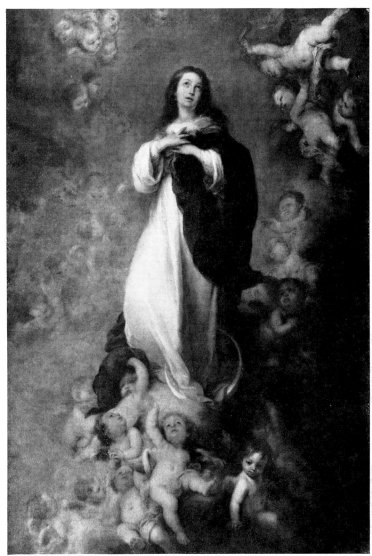

‹93› St. Agnes the martyr is dressed by an angel
as her persecutors have revealed her naked body for all to see. A bright stream of light
raises this soberly portrayed act into the realm of wonder.
The girl's expressive attitude challenges the onlooker to join in with her experience,
so that he or she would also be honored with the same kind of trust from God.

Jusepe de Ribera, *St. Agnes in Prison*, 1641.
Oil on canvas, 203 × 152 cm. Staatliche Kunstsammlungen, Gemäldegalerie Alte Meister, Dresden

‹94› Many mystics believed that they were lifted up into the air during
their spiritual ecstasies. Painters depicted a rare kind of religious perfection
with figures floating in the heavens. Most perfect of all
was Mary whose Immaculate Conception is shown as a state of rapture in the skies.

Bartolomé Esteban Murillo, *The Immaculate Conception*, 1665–1670.
Oil on canvas, 206 × 144 cm. Prado, Madrid

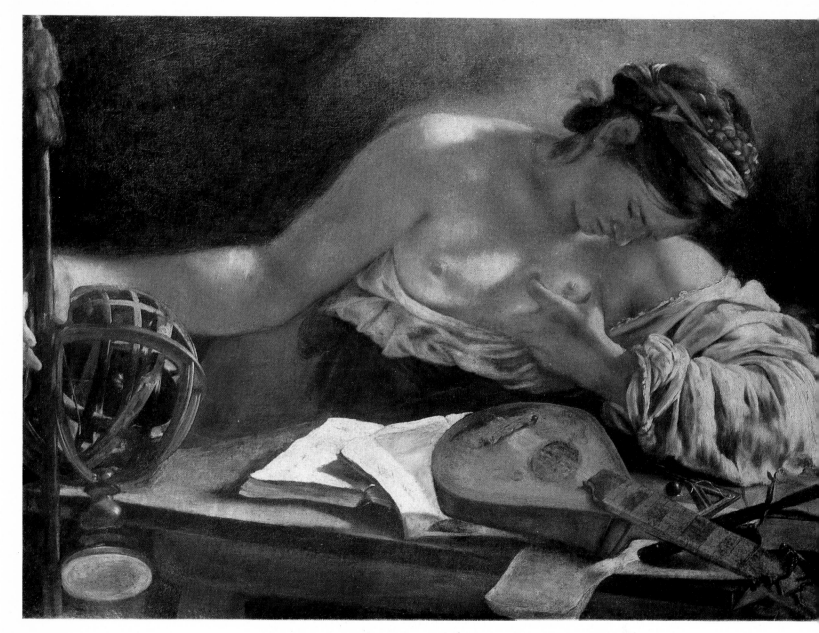

‹95› Books, measuring instruments, musical instruments, and a globe all strewn about
the table mean that art and science is a heathen and profane folly.
The bacchante's enthusiasm has run dry and she mourns the barrenness of her arts.
This signifies the rejection by the Counter-Reformation of the
spirit of the Renaissance.

Giovanni Serodine, *Mourning Bacchante*, first quarter of the 17th century.
Oil on canvas. Ambrosiana, Milan

‹96› To the accompaniment of ecstatic prayer the nuns eat their meal in ghostly,
eerie rooms. The sombre atmosphere of religious fanaticism comes uncomfortably close to
the demonic element of witchcraft.

Allessandro Magnasco, *The Nuns' Meal*, 18th century.
Oil on canvas, 76 × 94 cm. Pushkin Museum of Fine Arts, Moscow

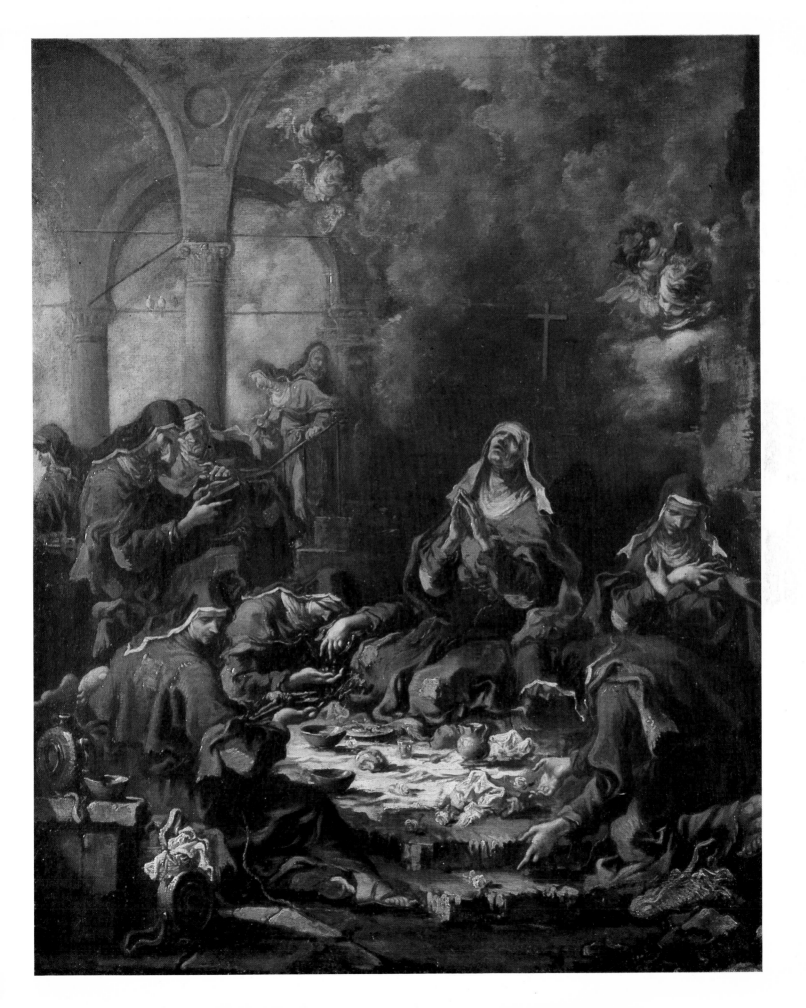

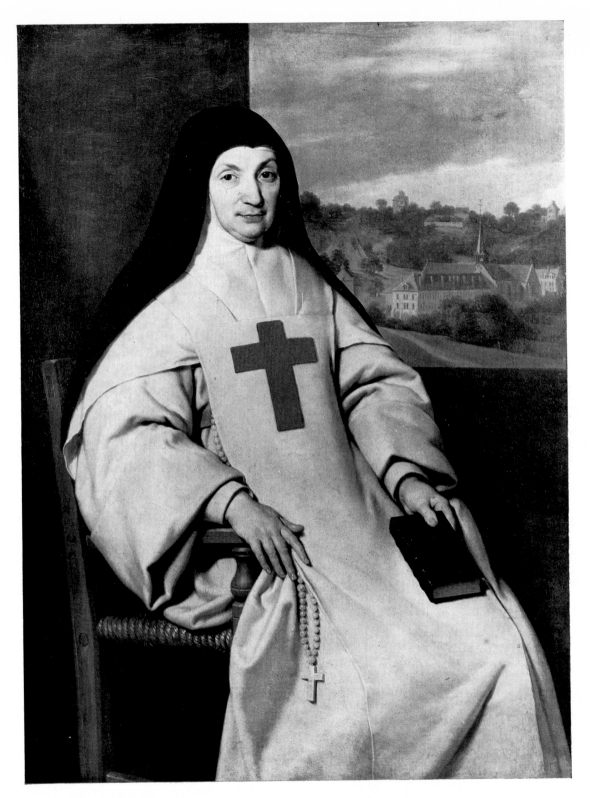

‹97› Angélique Arnauld, abbess of Porte-Royale, made her convent
into a center for reformed Catholicism and a rallying point for the intellectual elite of France.
The severe clarity of her portrait illustrates the high morals of this important personality.

Philipp de Champaigne, *Mère Angélique Arnauld*, 1654.
Oil on canvas, 130 × 98 cm. Louvre, Paris

‹98› and ‹99› The Cistercian convent of Marienthal near Ostritz,
founded in the thirteenth century, was provided in the seventeenth and eighteenth centuries with splendid
new buildings for the church and cloisters. The chapter, the convent's prayer room and meeting room,
was kept simple in contrast to several other rooms which were decorated with
magnificent ceiling paintings and murals.

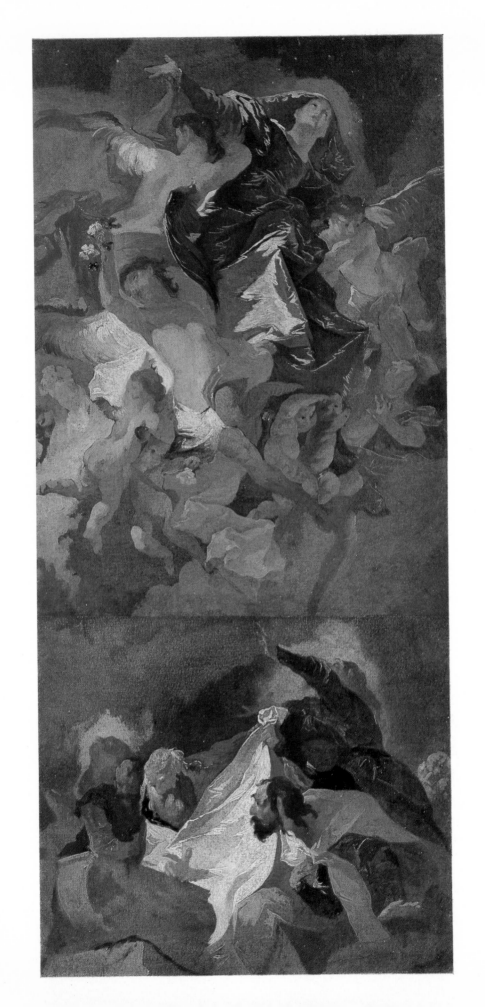

for witches to be persecuted to such an extent that in some villages and towns a substantial part of the population was exterminated.

Even with all the explanations we have for the rise and widespread belief in sorcery, we are still faced with the amazing fact that people had absolutely uniform ideas about this bizarre craft. We are talking here about hundreds and thousands of cases where distraught women, scarcely conscious because of fear and pain, would confess, under sophisticated methods of torture, to anything that was suggested to them. It was quite normal for judges to interpret anything—a woman's pallor or blushing, her inability to cry or uncontrollable weeping, her stony silence or voluble denials—as a confession to all the deeds and experiences of which she had been accused, *which were accepted as fact right from the start* and which the judges firmly believed to be true. But this is only one aspect. Countless meticulously detailed, clear confessions by "witches" invariably reveal the same facts. The devil, for example, always appeared in the shape "of a tall man, completely dressed in black, with a full black beard and terrifying, gleaming eyes," as Françoise Fontaine from Normandy described of her own free will to Henry IV's provost; there were journeys through the air to the great assemblies and unrestrained sexual intercourse with demons. Some of the accused would insist on having really experienced everything themselves. This is borne out by Pierre de L'Ancre in his description of twenty-eight year old Marie de la Ralde, who maintained that she had taken part in witches' sabbaths from the age of ten and that she had traveled there and back with women neighbors "on her very own two feet, without sleeping, not in a dream nor an illusion. They walked so quickly, as if flying through the air, and were there in a flash." [76]

The various reports were so astoundingly alike that William Perkins, the English expert on witchcraft, wrote in 1608 in his *Discourse of the Damned Art of Witchcraft so farre as it is Revealed* that the similar reactions to questioning made by all the witches in Europe not only proved that the statements were true, but also pointed to a centrally run and strictly coordinated witches' organization on an international scale. The idea of an organized opposition movement only came up after certain theologians had drawn a connection between witches and heretics. It was felt that vigorous action had to be taken and that any means adopted to hunt them down were justified. Witches were not the victims of any particular religion, they were the victims of the struggle for a transformation of European society and redistribution of international positions of power—a struggle in which the churches had a role to play. The Catholic Church justified its persecution of witches in the 1480s by maintaining that it had to eliminate the last traces of medieval paganism. The Protestants spread the belief in witches into the countries of northern Europe, and in the 1560s they instigated a rebirth of this mania in a far more fanatical form. Whereas Charles V's *Constitutio Criminalis Carolina* of 1532 still maintained the distinction between "good" and "evil"

witches and exacted punishment only where evil spells were concerned, the Lutherans and Calvinists also insisted on the elimination of the witches who did good deeds. According to them, the pact with the devil was punishable irrespective of the results it brought. In 1635 Benedikt Carpzow, the Lutheran scholar, insisted in his major work on witches and the law, *Praktica rerum criminalium*, that all the women who believed that they had attended a witches' sabbath had to be executed as they had thus testified to their desire to be linked with the devil.

The Protestants, with their close reference to the Bible and rejection of everything that the Popes added to its teachings, found an irrefutable justification for their witch hunting in the Book of Exodus (22:18). Among the laws given to Moses by God on Sinai there are the succinct words: "Thou shalt not suffer a witch to live." This clear biblical message allowed the law of God to be set against the law of the Emperor, and provided a decisive argument for the Protestants to carry out a ruthless campaign against witches. Lawyers and theologians in Wittenberg during Luther's time managed to have a law incorporated into the *Consultationes Saxonicae* of 1572, the penal code of the Saxon Elector Augustus the Pious: it stated that "good" witches also had to be burned. Wherever Protestant preachers spread the word they came upon the problem of sorcery, which in their eyes had to be rooted out through torture, the sword, and burning at the stake. With the Reformation the persecution of witches spread to Denmark, Scotland, Transylvania, Brandenburg, Württemberg, Baden, and Bavaria. After the local princes had been converted, resistance to Protestantism was viewed as rebellion against the authorities, and there was no better way of combatting this than by stirring up the inevitable hatred of witches.

The Catholics acted no differently when they set about to regain northern Europe after 1580. Béarn's return to the Catholic faith in 1609 triggered off a vehement witch hunt; the same happened from 1600 in Franche-Comté. Maximilian I, Duke of Bavaria, who formed the Catholic League of German princes, gained his position of leadership through an extremely successful crusade against witches in Bavaria. Pierre de L'Ancre, the most fanatic judge of witches in southwest France, said in 1609 that the entire Protestant population of Navarre consisted of witches ond sorcerers, in other words, that they should all be destroyed. A veritable fever of destruction broke out in Germany in the 1620s. It was provoked by the Catholic princes, especially the prince-bishops who had only just had their power restored and were taking steps to preempt any potential resistance. The prince-bishop of Würzburg had 900 people burned during his period of office from 1623 to 1632. In 1629, in the bishopric of Eichstätt, 274 witches came up for trial, and in the same year 24 witches were burned in Koblenz, the residence of the Elector of Trier. Between 1609 and 1633, Bamberg witnessed several hundred deaths by burning at the stake.

‹100› The profusion of color and dramatic movement
of the late Baroque shows triumphant faith at a theatrical peak.

Anton Franz Maulbertsch, *Assumption of the Virgin Mary*, 1762–64.
Oil sketch on card, 68 × 33 cm. Österreichische Galerie, Vienna

Right from the beginning, however, there had been people who called for reason. Although the belief in the world of demons and witches was quite "normal," when it started to border on the fanatic there were more critical voices to be heard. In 1563 Johann Weyer wrote *De praestigiis daemonum* (About the delusion of devils) in support of the Düsseldorf court of Jülich-Kleve-Berg to which he had been summoned by Duke Wilhelm IV in 1550. He believed in the existence of devils, but argued that the so-called witches were nothing more than "melancholic, pitiful women"—that is, emotionally disturbed—and that the experiences they described and for which they were burned were based on hallucinations. The Bible did not mean the mentally deranged when it called for the death of sorceresses. Weyer's thoughts and his earnest plea for an end to this inhuman madness were repeated often enough but without success. Even the much harsher criticism made by Jesuit Friedrich von Spee nearly one hundred years later in the *Cautio criminalis* (1631) had little initial effect, apart from a fanatical refutation by Benedikt Carpzow, the Protestant theologian. (Spee's book prompted Carpzow to review and uphold the doctrine on witches in all its grotesque entirety with reference to eminent Catholic sources. He insisted that torture should be used on those who appeared to be innocent, and that the women who had made a pact with the devil merely in their imaginations also had to be killed. Thus were Spee's arguments dismissed, unfortunately, from the sphere of theoretical discussion.)

During the great witch hunt in Würzburg Spee was confessor to the condemned. What he saw there greatly distressed him, and he was convinced that all the women he had to lead to the stake were, without exception, innocent and that they were there only because they had been tortured. "The fact that we have not all confessed to being witches is merely because we have not all been tortured." Like his predecessors, Friedrich von Spee did not attack the belief in witches as such. He objected to the way in which witches' trials were conducted, in particular to the fact that false confessions were extracted by force, that the judges behaved deceitfully, and that they were seeking to profit from the situation. He was only interested in the way witches were identified and condemned and did not touch on the foundations of the myth itself. For this reason the witch hunters restrained themselves in their attacks on Spee. It was obviously difficult for him to make a real stand against the deep-rooted belief in witchcraft.

Christian Thomasius later assumed that Spee believed more than he dared say. Thomasius, a lawyer at the University of Halle, was involved in witches' trials from 1694 until his death in 1728. He summed up his observations in two important works.[122] In an atmosphere of general scepticism, he was able to construct a line of logical reasoning against the persecution of witches, although he experienced massive resistance from theologians who believed in sorcery, even in the early eighteenth century. He reproached Carpzow, that great authority on witches, for "always confusing the question of how witchcraft should be punished with the question of whether it existed and always taking for true what still had to be proved." The devil, which even Thomasius could not afford to deny, was able to do "his work in the godless by hidden, invisible means." He maintained, however, that "the devil had never taken on a physical form; it was not possible for him to do so, and he was thus not capable of making a bond in a physical way, neither had he ever done so. It was even less likely that he had used witches or sorcerers for that purpose, or that he, in the shape of a goat, had led the same up the well-known Blocksberg mountain, etc." His detailed and factual analysis of doctrines that he considered nothing more than old wives' tales shows how deeply embedded and widespread the belief in witches still was. In order to substantiate his arguments he looked for like-minded allies from the past and came across the *Cautio criminalis*. He was certain that its author "only pretended that he believed in the existence of witches and their bond with Satan."

Thomasius found some allies among English authors who launched a strong protest movement during the period of the civil war in England after witch hunting had passed its peak. In 1656 Francis Osborn wrote in *Advice to a Son* that so many witches were being discovered now that he was beginning to think that most of the sorcery was in the judges' ignorance, malice of the witnesses or in the stupidity of the wretched defendants (published by Edward A. Parry, London: 1896). Thomasius also commissioned a number of German editions of English writings against witches' trials in the hope that this would lend support to his own struggle. A German version of John Wagstaff's *The Question of Witchcraft Debated: or a Discourse against their Opinion that Affirm Witches* was published in Halle in 1711. John Webster's *The Displaying of Supposed Witchcraft*, which appeared in London in 1763, was published in translation by Thomasius in Halle in 1719. Finally a German translation of *An Historical Essay Concerning Witchcraft* by Francis Hutchinson (London: 1718) was published in Halle in 1726. There was no end to the literary attacks on Thomasius nor to the attempts to refute him. Far more important was the success that was achieved in the practice of the law. In 1714, Frederick William I issued an edict "to stop abuse in witches' trials." This greatly restricted the judges' arbitrariness, as every decision in matters concerning witches had from then on to be confirmed by the King. Prussian law of 1721 prohibited the belief in pacts with the devil, journeys through the air to witches' sabbaths, intercourse with demons, and so on.

It was not just his better arguments that made Thomasius's efforts more successful than those of his predecessors. With the end of the Thirty Years' War the extreme fanaticism in the persecution of witches had eased. New boundaries were emerging in the bitter struggle for a redistribution of power among the nations and rulers of Europe, and a general calm set in. There were, of course, a few

<101> As a piece of propaganda this pamphlet
was intended to provide information on the danger of witches and the need to punish them.

The Crime, Trial and Execution of a Witch.
Woodcut, 36.3 × 27 cm. Augsburg, 1669. Staatliche Galerie Moritzburg, Halle

Oder Beschreibung so Anno 1669. den 23. Martij in der Römischen Reichs=Statt Augspurg ge=
schehen/ von einer Weibs=Person/ welche ob grausamer vnd erschröcklicher Hexerey vnd Verkreissungen der Menschen/ wie auch
wegen anderer verübten Vbelthaten durch ein ertheiltes gnädiges Vrthail von ein gantzen Ehrsamen Rath/ zuvor mit
glüenden Zangen gerissen/ hernach aber mit dem Schwerdt gericht/ der Leib zu Aschen verbrennt
ist worden.

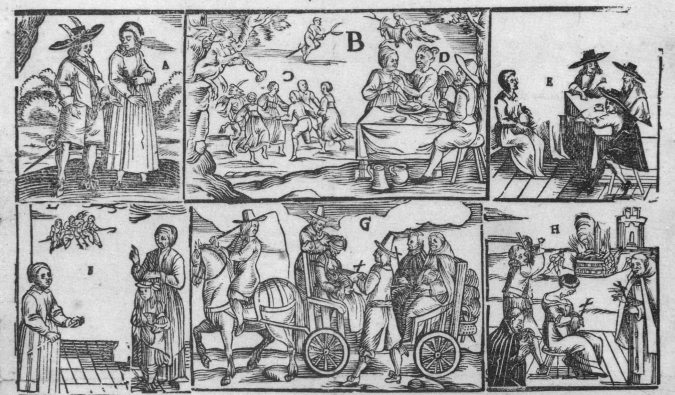

Erstlich hat Anna mit Namen Eberlehrin/ geweste Kindtbeth=Kellerin von Augspurg gebürtig/ gut vnd betrohlich auffgesagt vnd bekändt/ daß sie vor vngefähr 13. oder vierzehen Jahren/ sich mit dem bösen Geist/ als er damahlen bey einer Hochzeit in Manns=Gestalt zu jhr auff den Tantz/ vnd hernach in jhr Hauß kommen/ der gestalt in ein heimlichen Pact vnd Verbündtnuß eingelassen/ das sie nit allein demselben sich gantz vnd gar ergeben/ sondern auch der Allerheyligisten Dreyfaltigkeit abgesagt/ dieselbe verlaugnet/ vnd dise zuevor Mündtliche gethane all zuegrausame vnd höchst Gottslästerliche Absag vnd Verlaugnung/ auff begehren deß bösen Feinds/ nach dem er selbige selbst zu Papier gebracht/ vnd jhr die Hand geführt/ auch so gar mit jhrem Blut vnderschriben vnd bekräfftiget/ von welcher Zeit an sie mit dem laidigen Sathan auch manches mahlen Vnzucht getriben: Deßgleichen auß antrib desselben durch eine von jhme empfangnes weisses Pülverleins wenigist 5. Personen/ vnd darunder 4. vnschuldige vnmündige Kinder elendiglich hingerichtet/ vnd vmbs Leben gebracht/ nit weniger habe sie jhren leibeignen Bruder durch ein dergleichen jhme inn Trunck beygebrachtes Pülverleins verkrümbt/ vnd dardurch sowol demselben als andern Menschen mehr/ die/ eintweders an jhren Leibern Knipffel oder sonsten grosses Kopffwehe bekommen/ zu mahlen dem Vieh durch Hexerey vnd zauberische Mittel geschadet/ auch darunder zwey Pferdt gar zu schanden gemacht/ Ferners habe sie auch nit allein durch grausam fluchen vnd schwören mit zuthun deß bösen Feindts etliche Wetter gemacht/ darunder eines zu Güntzburg eingeschlagen/ vnd grossen Schaden gethan/ sondern auch vermittelst Nächtlicher Auffahrens zu vnderschidenen mahlen bey den Hexen=Täntzen vnd Ver-

samblungen sich eingefunden/ vñ darbey dem bösen Geist mit Kniebiegen vnd dergleichen solche Ehr bewisen die sonsten GOtt dem Allmächtigen allein gebühre. So hat sie auch über daß noch weiters auffgesagt vñ bekändt/ daß sie in Zeit diser jhrer mit dem bösen Feind gehabten gemein vnd Kundtschafft einsmahls vngebeichtet das Hochwürdige heylige Sacrament deß Altars empfangen vñ genossen/ auch sich vnderstanden/ nit allein durch jhr vergifftes Teufflisches Pulver vñ anders/ zwey Weibs=Personen vnfruchtbar zumachen/ bey deme es aber ausser einer nit angangen seye/ sondern auch ein Mägdtlein vnd einen jungen Knaben zu den Hexen=Täntzen mit genommen vnd verführt.

Ob welcher vnd anderer verübter vilfältiger schwerer vnd grausamer Vnthaten/ vnd Verbrechen halber ein Ehrsamer Rath mit Vrtheil zu Recht erkandt/ daß jhr Eberlehrin obwolen sie denen Rechten nach lebendig verbrennt zu werden verdient hette/ dannoch auß Gnaden allein mit glüenden Zangen am Außführen drey Griff gegeben/ vnd sie bey der Richtstatt mit dem Schwerdt vnd blutiger Hand vom Leben zum Todt hingerichtet/ auch der Cörper zu Aschen verbrandt solle werden.

A Die Abführung ab dem Tantz/ vnd in Anna Eberlehrin Behausung Einführung von dem Teuffel.
B Die Außfahrung Nächtlicher weil mit dem bösen Feindt.
C Die Beywohnungen der Hexen=Täntzen.
D Die Hexischen Zamenkunsften vnd Teufflische Malzeiten.
E Verhörung vnd Außsag wegen jhrer verübten Hexereyen.
F Verführung zweyer jungen vnschuldigen Kinder/ als eines Knaben vnd Mägdlein.
G Anna Eberlehrin Außführung zu dem Gericht/ vnd wie sie mit glüenden Zangen gerissen wird.
H Die Hinrichtung vnd Verbrennung zu Aschen jhres Leibs.

Zu Augspurg/ bey Elias Wellhöffer Brieffmaler/ bey vnser L. Frawen Thor.

localized outbreaks of witch hunting, for instance in Sweden from 1668 to 1677, in Mecklenburg after 1690, and in Salzburg between 1677 and 1681. From the middle of the century the belief in witches grew generally and visibly weaker—governments were occupied with other problems. In France, for example, Colbert, who was busy reorganizing finance because of the expansion of the factories, repealed the law against *sorcellerie sabbatique* as early as 1672. Holland was the first country to abolish witches' trials, which it did in 1610. By the beginning of the seventeenth century it had achieved a leading position as a European trading power and had emerged successful from its battle against foreign domination and the imposition of an alien religion. The last executions of witches that took place—in England in 1684, in Bavaria in 1775, in the Swiss canton of Glarus in 1782, and in Poland in 1793—were exceptional and, in some cases, illegal.

The biographies of pious women, however, reveal an entirely different world. Few of them became as famous as the Spanish nun Theresa, but the Church canonized an unusually large number of nuns at this time or at least gave them the title of "Blessed," and hundreds were found worthy of having their life and work recorded for posterity in the various orders' chronicles and in devotional books. And there were many thousands more who lived like the saints but remained anonymous.

The period around 1600 can be regarded as the peak period for convent life. New congregations and religious societies formed in rapid succession, soon followed by the Pope's bull of confirmation. Even in the old convents, where the strict rules of the order had long since been relaxed, there were successful calls for reform in order to lay down the original rules of the order for the monastic life.

This reform movement began in Italy and Spain and reached its climax in France. The story of the Ursulines typifies the inner logic of this development, which was clearly based on widespread needs. In 1535, in Brescia, Angela Merici (of obscure origin) founded the Society of St. Ursula. After a life of the strictest piety and asceticism, she felt the need to ensure that her own godliness would continue to inspire others. Thus at the age of fifty-six, five years before her death, she gathered around her a group of young girls from the aristocracy and the upper, rich strata of the bourgeoisie to practice Christian charity. Their duties included teaching poor children, caring for the sick and the poor and above all, of course, instructing them in the faith. These girls did not become nuns. They carried on living with their families, but they followed a daily routine that Angela had laid down for the society. They had specific periods for prayer, daily mass, and fasts which were harsher than those intended for ordinary believers.

It was after her death that Carlo Borromeo, the enthusiastic reformer of the Italian Church, recognized the potential of the pious energy of these women. In 1568 he invited the Society of St. Ursula to Milan and persuaded them to live in community as a congregation. Four years later he received papal confirmation of this new congregation. According to this saint (canonization in 1610), who had a talent for organization, there was no better way of strengthening piety and religious discipline among the people, especially in the towns, than through the example of the gentle, patient, and steadfast Ursulines. When he died in 1584 there were already eighteen convents in his diocese, housing several hundred Ursulines, and they had already established themselves in other parts of Italy.

What usually happened was that women provided the impulse for and then founded a new Ursuline society, and when it was recognized as being potentially stable their religious superiors or "spiritual advisors" would intervene. They would then unite and organize the separate groups, which had started off on an individual basis, and provide them with the officially sanctioned guidelines. The combination of individual desire for action and Church benevolence led to a growth in the popularity of the Ursulines, especially in France. In Avignon the daughter of the royal treasurer of Provence, Françoise de Bermond, began to withdraw from life at court to devote herself to the worship of God and to instruct ordinary girls in the Christian doctrine. Her decision was not due to any external cause and was made at a time when she was very successful in society. This young woman is portrayed as attractive from every point of view. Educated, interested in poetry, and a creative writer, she was the focal point around which the distinguished people of Avignon and its surroundings would rally. The chronicle of the order reports with emotion the distress felt by her friends because they were losing her to a convent. Their attempts to make her stay had the opposite result: Françoise persuaded "these vain creatures of the world" to join her in "conquering the heavenly kingdom." The chronicle's didactic aims in the story are quite unmistakable, but they also show that it was no terrible misfortune or abrupt change in their lives that caused the sudden change of heart. Two years later more than twenty women had come together to live according to the Italian model. Since they were all, without exception, daughters of the leading families of Avignon, they were sure of receiving substantial support. They were presented with a country house where about twenty-five young aristocratic ladies lived from 1596 with the permission of the Archbishop of Avignon as members of the first Ursuline convent in France. Any resistance from the girls' families, some of whom instigated court proceedings against the founders, only strengthened their resolve.

Anne de Xaintonge, daughter of a counsellor in Dijon, fought her father for thirteen years before she was officially granted permission in 1606 by the Church to set up an Ursuline community in Dôle. In Toulouse, "God filled a virtuous young woman with the desire"—in the words of the order's annals—to start up an Ursuline convent according to the model set by Françoise de Bermond. Formal confirmation of the Toulouse congregation came in 1615, and in the course

‹102› and ‹103› Girl escaping death by burning by confessing after the judgment.
Woman condemned by the Inquisition to being burned alive.

Bernard Picart (1673–1733), copperplate engravings, 1722, 15.3 × 10.5 cm.

of the seventeenth century over twenty convents were established. According to a papal bull issued by Paul V on 5 February 1618 there were also some "clever young women" who had come together and

> *founded, out of deep devotion, a society under the patronage of St. Ursula and with permission from the Cardinal of Sourdis. They had resolved to preserve their order, which was pleasing to the Lord, and at the same time make the education of young girls and their instruction in the Christian faith the principal task of their institute. Not long afterwards and through the inspiration of the Holy Ghost, they concluded that free association with men and the meals, which according to French custom are always taken in the houses both of men and of women, was preventing them from preserving their purity and from leading a spiritual way of life. For that reason they all moved into one house, in order thus to protect better the virtue of virgin innocence and lead a monastic life by cutting off their contacts with the world, united in a closed community. After a trial period of two years, they have, with the permission of the Papal See, taken their views of eternal chastity, obedience, poverty, and perseverance in this society.*

Paris became another center of organized religion for women. A number of women from the aristocracy were renowned for their work, and interest was shown for women's orders even in the Queen's circles. In order for the founders to be effective, they had to possess riches, an education, and fervent piety. Madame Barbe Acarie, mother of six children and an accomplished society lady with all the right connections (Bérulle, who later became cardinal, used to frequent her house)—had a vision (between 1601 and 1604) telling her that she should introduce the barefooted Carmelite order into France.

In 1601 *La vie de la Mère Térèse de Jésus* was published in Paris and stirred the susceptible hearts, mainly of women. Just three years later, in 1604, a few Spanish nuns came to Paris to open the first Carmelite convent there. They had, under Theresa's guidance, worked toward reforming the Carmelite order to establish the original rules. They became extremely harsh, but this did not deter the many young ladies who wanted to join it, and about forty convents had been founded by the middle of the seventeenth century. Madame Acarie herself ended her days as a Carmelite nun, after playing an active role in establishing the new order. She opened a boarding school where she prepared young girls for their entry into the order. Although not all of the candidates felt at the end of their training, that they could cope with the rigorous code of the Carmelites, they didn't want to give up the idea of monastic life. At this point news of the Ursulines of Provence arrived in Paris, and this seemed to offer an ideal solution. Another influential society lady, Madeleine de St. Beuve,

decided to found and furnish a new convent. She asked the Ursulines in Avignon for support, and in 1608 Françoise de Bermond herself arrived in Paris to set up a community there. Religious young women of Paris flocked to her side. Mother Françoise exerted a great appeal, apparently by combining education and refinement with ardent religious fervor. The daughters of distinguished families still thronged to the Ursulines after the decision was taken to transform the order from a simple congregation (allowing a certain amount of freedom) to an order of strict seclusion and solemn vows—for which permission had been benevolently granted by the Pope in 1612. This rigid organization was new in comparison to that of the Ursulines in Provence, who initially expressed some misgivings about the changes. Nevertheless, the changes were soon accepted in Provence, too.

By 1610 when the first stage of their foundation was over, there were already over 300 Ursuline communities in France. This is just one of several orders with a similar history. In Bordeaux, a Benedictine congregation of Our Lady was set up in 1606 by Jeanne de Lestonnac, daughter of a parliamentary counselor. By her death in 1640, she had established thirty Benedictine convents in France alone. In Orléans the Duchess Antoinette d'Orléans-Longueville, who lost her husband and took the veil at the age of 24, was instructed by the Pope to found a seminary to train nuns. This led to a new Benedictine congregation emerging in 1617 under the name of Our Lady of Mount Calvary. In 1602, the lawyer Anton Arnauld obtained a royal patent in Paris which allowed his daughters, one eight years old, the other eleven, to become abbesses. The older of the two, Angélique, began at the age of seventeen to reform the Cistercian convent of Port Royal des Champs. Women flocked to her in such large numbers—over seventy in her convent—that she soon had to open a second convent in Paris. Arnauld's contacts with influential clergymen who were supporters of Jansen of Ypres made her convent the spiritual center of French Jansenism. Its reforming zeal, its mission to renew the Catholic Church, and its absolute intolerance towards any trivialization was very close to their hearts. The sparse and succinct character of Philipp Champaigne's painting of Angélique Arnauld provides us with an impressive portrayal of the position of these women in the religious life of their society.

The women's orders were almost invariably drawn to the strictest religious views and harshest rules. Most of the newly established congregations went back to the rigorous original rules of the order and enforced them very strictly. This strictness applied to the spiritual life of cloistered nuns as well as to dedicating their lives to "good works." The order of St. Clare, founded in Italy in the sixteenth century, regarded the care of the sick as its main task, but also included a body of nuns dedicated to extreme spiritual devotion. The women of the Alcántara order, founded in Farfa in 1676, spent their lives in uninterrupted prayer and meditation in absolute silence. But even this apparently introverted behavior was intended to serve the commu-

nity. The Benedictine community of the Blessed Sacrament of the Altar arose through the combined wishes of the French Regent, Anna of Austria, and an ecstatic nun called Mechtild. They believed they could persuade God to turn His wrath away from France if they only made enough effort. Mechtild devoted herself to this task by gathering a small group of women around her who took turns in keeping up an unbroken vigil of prayer at the altar. This community, too, expanded.

Not surprisingly, the congregations given most support were those, like the Ursulines, whose work directly affected the public through teaching and through nursing the sick. The duties of their cloistered life were far less rigorous, although they by no means dispensed with the ascetic practices of scourging, fasting, and nightly prayer. But one should not underestimate the self-denial involved in their work in schools and hospitals. These nuns were dealing with sections of the population which, because of their background, were totally alien to them. The most established orders in this field, such as the Salesian women and the sisters of St. Augustine recruited their members from the upper classes—including the most distinguished circles of the aristocracy.

The unusually prominent role played by religious organizations for women at the end of the sixteenth and beginning of the seventeenth centuries is often given great emphasis. What were the reasons for this movement? The reasons certainly do not lie purely in the Church's efforts toward the Counter-Reformation, as we have already indicated. The Church's administration could never have triggered off a movement on such a scale. A number of causes seem to coincide at this point in history. It is interesting to note that France, that "bloody scene of the European battle between the denominations," was the center of women's religious zeal. Religion and religious communities offered women a refuge from the misery surrounding them in the outside world. They provided an escape, even if illusory, by giving the women hope in the next world. Perhaps the most important reason was that these communities offered an outlet for women's desire to be active, to have a purpose in their lives, and to be engaged in productive work—all while filling their need to take part in the spiritual movements of their time. The last point is clearly connected with the post-Renaissance trend of excluding women from public life. At the same time the tradition of providing upper-class girls with a sound education was still largely continued. Thus although women were informed about spiritual and social conflicts and movements and were capable of expressing an opinion about them, they were allowed no public role.

It was this psychological pressure that gave rise to much of the missionary zeal of the time, fed by hate of the Huguenots and the desire to strengthen the Catholic Church. Caring for the souls of the people and educating children were felt to be the most suitable activities for women. The missionary element, which was most clearly

visible in the women's orders of France, was obviously directed by the intense feeling and fanaticism among both Catholics and Protestants, which was aggravated after the Massacre of St. Bartholomew of 1572. Moreover, it was possible for talented women to develop their personalities to the full in the leading positions of the order, something unthinkable in secular life. The information contained in the chronicles about outstanding abbesses and especially about the orders' founders reveals first-class qualities of leadership, stamina, talent for organization, and general efficiency. If one removes the religious padding from these stories one can sense how the excessive demands on their strength, the devoted attention to the needs of others, the untiring and often practical and profitable work for the convent or the order functioned to fill the emptiness in their lives. Many of these women entered or founded a convent because the eternal wars had taken their husbands away from them while they were still young women or had later robbed them of their sons. In the outside world it was not possible for them to overcome their loss through meaningful activity.

We must remember that most women, in the upper classes, too, had to live day after day right from their childhood with the misery and devastation of the religious wars, and stand by and watch all the resulting starvation, plague, pillaging, plunder, persecution of heretics, burning of witches, and political executions. For them the systematic "destruction" of all that was "earthly," the denial of their desire for personal happiness and fulfillment, must have been an escape from an unbearable reality. At the same time, they were firmly convinced that they could help to avert God's "wrath" by their own perfection and godliness. Many women were capable of contemplative meditation, which would sometimes develop into ecstasies, visions, revelations, and total spiritual rapture. When they were deep in prayer, they would see a wooden crucifix move and give them a sign, they would hear voices telling them of divine will, and they had hallucinatory visions, mostly of Mary and of Christ, assuring them of His special affection. Margaret Mary Alacoque, a Salesian nun, had a vision of the Sacred Heart of Jesus in 1675 in the convent at Paray-le-Monial. She was instructed by the vision to introduce the Feast of the Sacred Heart. She accomplished this successfully with the full support of her Jesuit confessor, who quickly recognized the popular potential of this feast.

The Spanish Carmelite nun Theresa (1515–1582) was the idol of the many religious ecstatics who lived in convents. In 1563 she founded the convent of San José in Avila for barefoot Carmelite nuns, beginning a strict reform of this order, which had been established about a hundred years previously. From her base in Avila she personally reformed another seventeen convents. Her canonization in 1622 was a reflection of the international renown that her reforms and writings had achieved. In her autobiography (written in 1562) she gives a detailed account of her physical and spiritual experiences when in a mystic trance. She would on occasion induce such a state through excessive asceticism and concentrated meditation and through her own physical constitution. She clearly states that her visions were not dependent on her will, that she did not wish them onto herself, and that she was often haunted by them against her will. She describes the course of her ecstasies suggestively, vividly and with a lively form of expression. These ranged from sensations of peace, doubt, exhaustion, and enthusiasm right up to the climactic "mystical union," together with the physical state accompanying them.

In Chapter 18 of her autobiography she writes:

The soul, while thus seeking after God, is conscious, with a joy excessive and sweet, that it is, as it were, utterly fainting away in a kind of trance: breathing, and all the bodily strength, fail it, so that the eyes close involuntarily, and if they are open, they are as if they saw nothing; … The ear hears; but what is heard is not comprehended…. It is useless to try to speak, because it is not possible to conceive a word; nor, if it were conceived, is there strength sufficient to utter it…

She is very convincing in her factual and detailed observation of herself, to the extent that the reader also finds the statements on rapture quite natural.

In Chapter 20 we find the following: "During rapture, the soul does not seem to animate the body, the natural heat of which is perceptibly lessened; the coldness increases, though accompanied with exceeding joy and sweetness."

Two pages later she adds: "My soul was carried away, and almost always my head with it—I had no power over it—and now and then the whole body as well, so that it was lifted up from the ground." And again: "It seemed to me, when I tried to make some resistance, as if a great force beneath my feet lifted me up. I know of nothing with which to compare it."

The French rationalists mocked at the book, calling it "a bible for the sactimonious," but its precise description as well as effusive praises to God's love made it into a kind of guide for nuns of all orders who were less talented in mystical contemplation. It provided their religious fantasy with instructions in the form of comprehensible pictures for their own meditation. They in turn produced a flood of treatises and devotional literature to inform the public of their mystical raptures, and thus this religious fervor spread among lay people too.

Theresa herself was not just a fervent mystic. Her writings reveal a person who is energetic, efficient, and versatile. Although she never left the convent walls, she was at the hub of public life, always fully informed about the daily affairs of the Church and always ready to intervene. As the spiritual head of the order, she carried through its reform with energy, intelligence and prudence.

Theresa's mysticism had a lot in common with the spiritual exercises of the Jesuits. Ignatius of Loyola also felt that the path of perfect faith should be taken by means of the senses. This embodied a men-

tal picture of Christ's sufferings, His resurrection, of paradise and hell, and culminated in a spiritual union with God. For the Jesuits, however, this religious experience was not an end in itself. Personal piety was supposed to be incorporated into the organized life of the Church, wholly in the spirit and in the service of the Counter-Reformation. Theresa and her followers, on the other hand, kept an element of the old medieval mysticism alive. It was the embodiment of fettered individuality breaking out and escaping and ending up as the consciousness of subjectivity of the Renaissance. The Society of Jesus aspired toward a new bond between the individual and the centrally organized community. This was the exact opposite of the ecstatic raptures of the mystics, who attained divine grace personally through their own efforts and without the mediation of the Church. But the price of this mystical uplifting of the soul to God was "mortification" or "deadening" and thus a pessimistic and passive attitude to the course of earthly life. This is vividly expressed by a subject which can almost be regarded as a classical theme of Baroque art. The figure of the penitent Mary Magdalen, who has turned away from her careless way of life to dedicate herself to strict asceticism, is depicted over and over again. She is shown as a solitary figure out in the wild, lost in melancholy contemplation of death and the senselessness of the world. This scene was extremely popular among people of the day, not only because of the sentimental, erotic effect produced by her half-naked body, but because of the scepticism that emanated from her free decision to withdraw from participation in the affairs of the world.

Men who dedicated their lives to the Church had the choice of a life of seclusion and privation or one of active Jesuit campaigning.

Women, on the other hand, apart from engaging in charitable work, could only really make a free decision to withdraw into ecstasy and vision, in other words, to cultivate their inner life. This explains why there was a preponderance of women among mystics in the seventeenth century.

We must not forget that there were also other, quite different factors that determined the importance of convents in women's lives. These were present right from the beginning of the movement but only gained great significance in the eighteenth century. This is very aptly portrayed by the Goncourt brothers in their description of French women in the late Baroque[44]:

Convents were then very much in fashion. They met all kinds of social needs and in many instances provided all the necessary comforts. In a large number of cases they were refuges and sanctuaries for women. Widows who wanted to pay off their husband's debts would go there; mothers who wanted to build up a fortune for their children would go there to save. Convents provided a refuge and a place of residence. They hid away mistresses of princes who wanted to get married. Women who were separated from their husbands came to live there.

Convents were "almost a compulsory place of refuge for (aristocratic) women who had suffered from smallpox," since they would have no chance of surviving in their own circles because of their disfigurement. In short, convents were "a refuge for all broken lives"; that is, of those who could not meet the demands of the aristocratic way of life. This was by no means a necessarily sad refuge; the comforts and customs of convent life were a miniature replica of high society outside. It was in this respect that convents of the late Baroque differed from those of the seventeenth century.

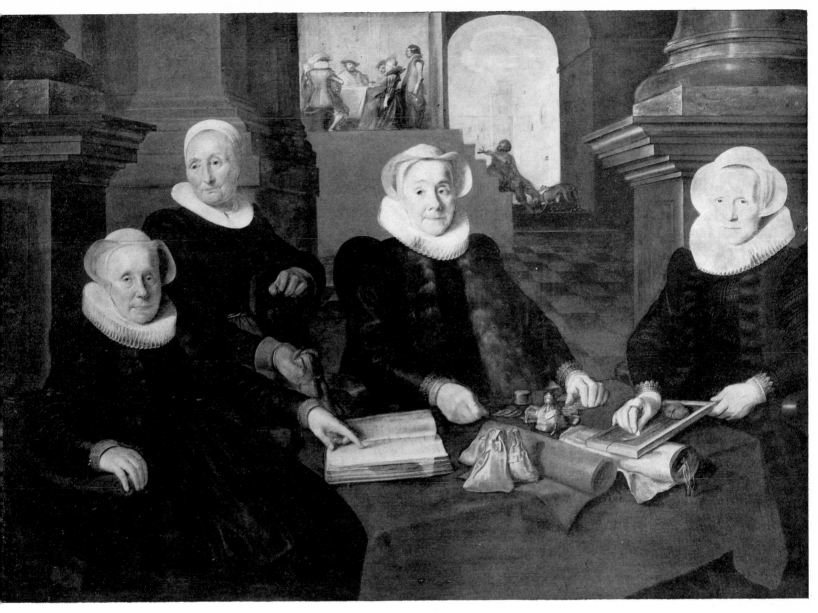

‹104› Public welfare establishments in
Dutch towns were run by "regents," members of patrician families.
Patricians' wives were also entrusted with this honorable position and could thus participate
in the exercise of power. The character portraits of these women regents indicate
a calculating and authoritarian attitude rather than one of charity.

Werner van der Valckert, *The Directors of the Amsterdam Hospital for Lepers*, 1624.

Oil on canvas, 134 × 192 cm. Rijksmuseum, Amsterdam

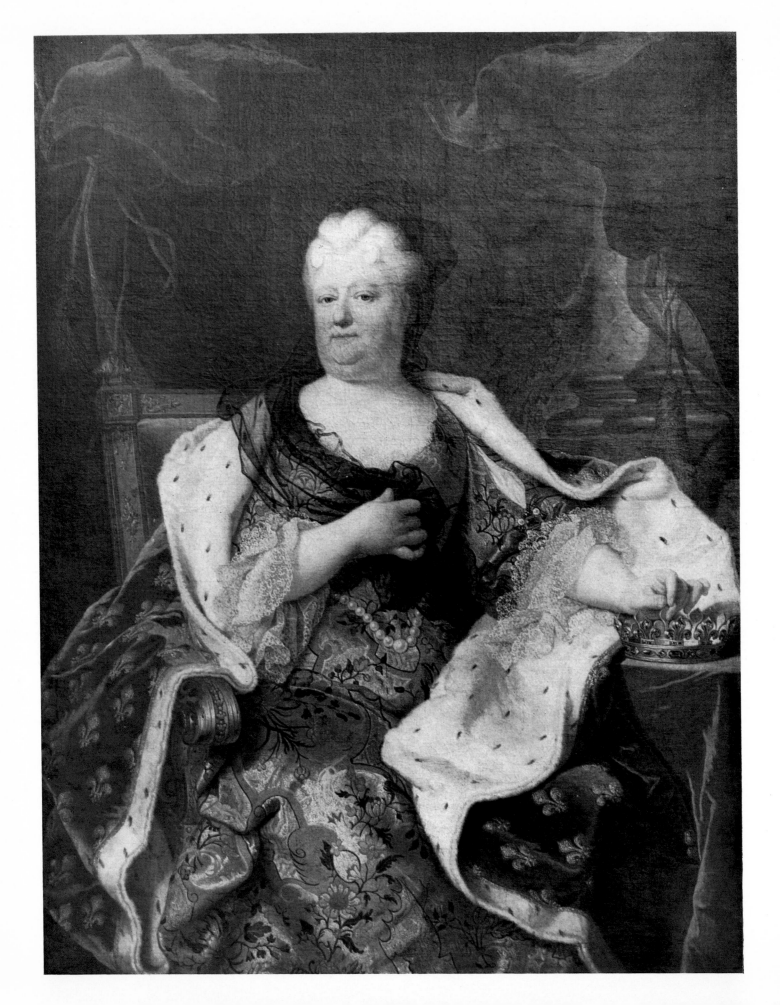

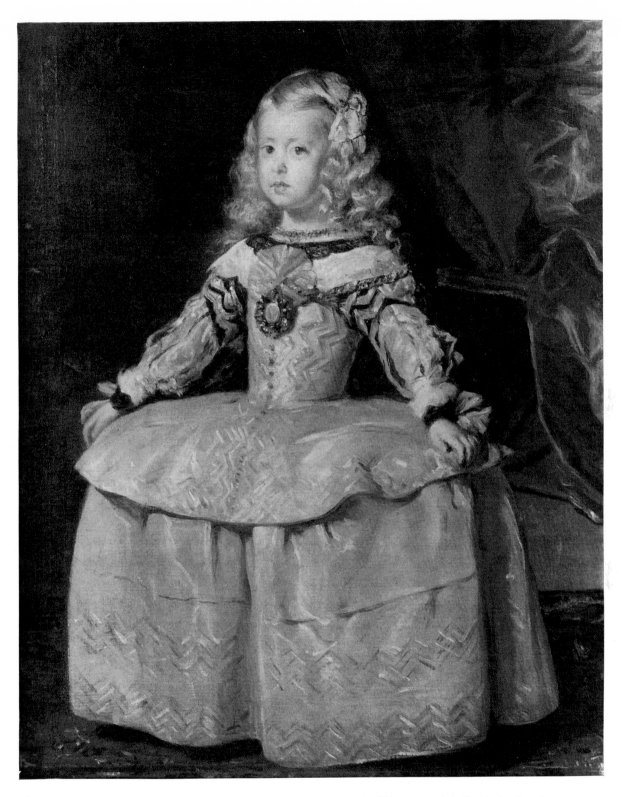

‹105› At the age of eighteen, in 1671, Elisabeth Charlotte von der Pfalz was married off to the brother of
Louis XIV. When her son became regent in 1715 the court painter painted her portrait showing
her draped in an ermine cloak bearing the lilies of the French kings.

Hyacinthe Rigaud, *Liselotte von der Pfalz, Duchess of Orléans*, c. 1713.
Oil on canvas, 148 × 112 cm. Museum of Fine Arts, Budapest

‹106› When the Spanish infanta Margarita Teresa was still a baby she was engaged to the future Emperor Leopold I.
From then on Velázquez, as the court painter, had to make several portraits of her for her Austrian relatives until she was fifteen,
when she took up residence in Vienna as the Empress. The painting of the five-year-old child had to do justice to the rank
of infanta. However, it cleverly managed to retain a childlike charm about it.

Diego Velázquez, *The Infanta Margarita Teresa in White*, c. 1656.
Oil on canvas, 105 × 88 cm. Kunsthistorisches Museum, Vienna

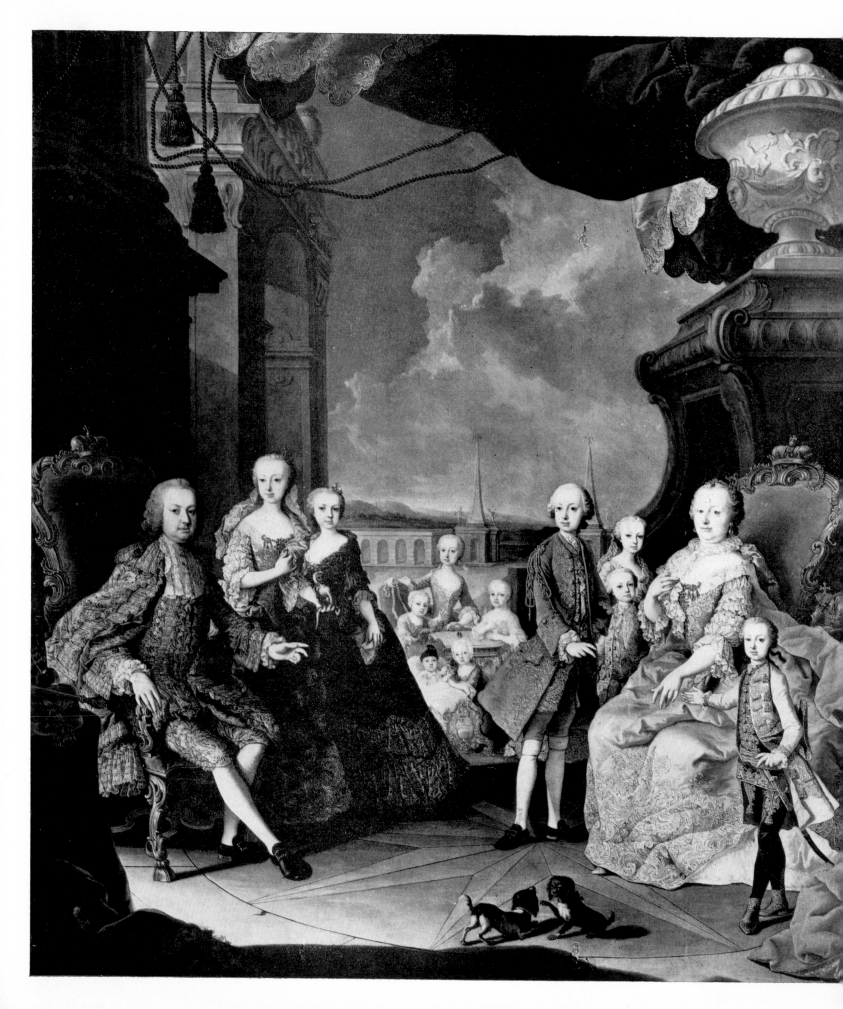

‹107› Francis I is clearly portrayed as the crowned emperor by the imperial insignia at the edge
of the picture on the left. The more majestic place, however, is held by Empress Maria Theresa of Austria.

Martin van Meytens, *Maria Theresa and Francis I with Eleven Children, c. 1754.*
Oil on canvas, 200 × 184 cm. Kunsthistorisches Museum, Vienna

‹108› The *Millionenzimmer* (million-dollar room) in Schönbrunn Palace served as a salon
for Maria Theresa's more intimate gatherings. It was decorated around 1760 and received its nickname because
of the high costs involved, which even Maria Theresa regarded as extravagant. Gilded rocaille
ornamentation containing 260 seventeenth-century Indo-Persian miniatures
was set off by the brown wooden paneling.

Photograph of the *Millionenzimmer* in Schönbrunn Palace, Vienna.

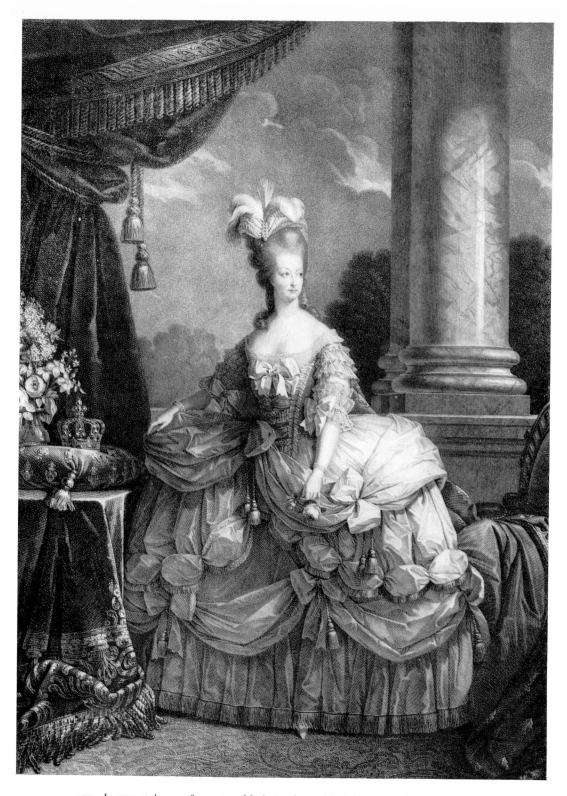

‹109› In 1770 at the age of seventeen, Marie Antoinette, Maria Theresa's youngest daughter,
was married to the future Louis XVI. The lavish background and her dress indicate
her official position as Queen.

Barthélemy Roger after Alexander Roslin, *Marie Antoinette, Queen of France*, 18th century.
Copperplate engraving, 68.6 × 50cm. Staatliche Museen, Kupferstichkabinett, Berlin

‹110› A number of people have come together for their amusement
in Marie Antoinette's bedroom. In the hustle and bustle of the *levée* there is still a respectful distance
granted to the Queen. The visitors are only background figures lending emphasis to the main character.

Jean Baptiste André Gautier d'Agoty, *Marie Antoinette in Her Bedroom at Versailles*, c. 1776.
Gouache, 67 × 54 cm. Musée de Versailles

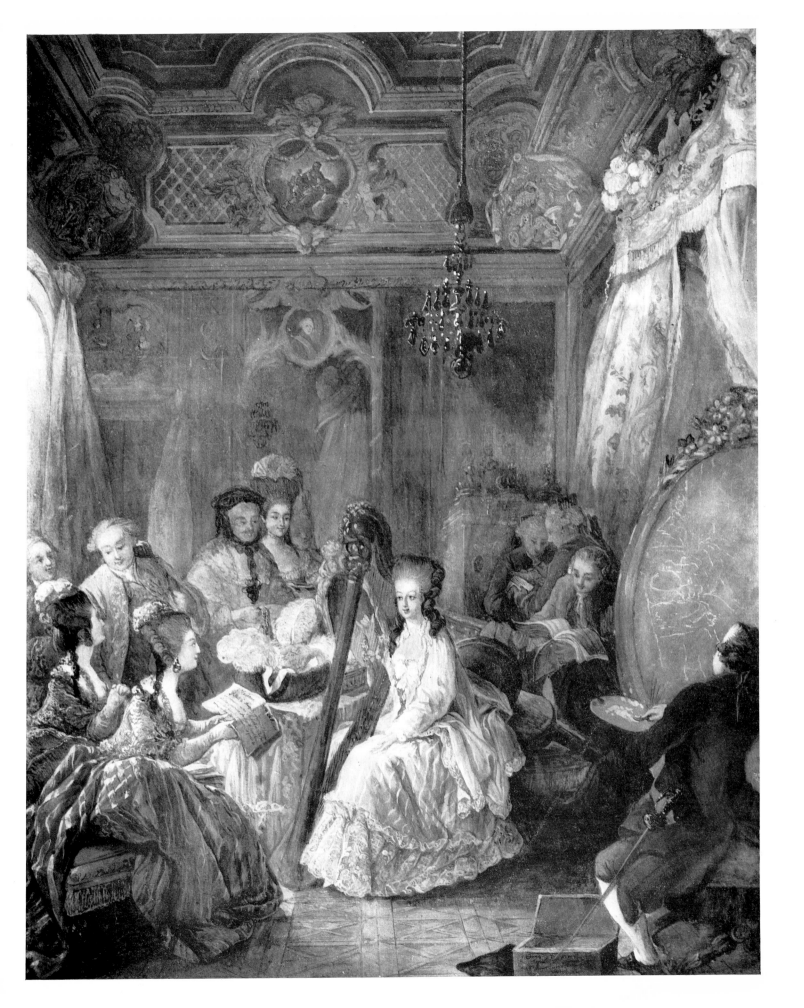

‹111› Madame de Pompadour sometimes liked to emphasize her bourgeois background. This beautiful drawing depicts her without the fuss of a royal spectacle in an intimate atmosphere showing her close relationship with her little girl.

François Guérin, *Madame de Pompadour with Her Daughter, c.* 1750.
Colored chalk and pastel drawing, 25.2 × 29 cm. Albertina, Vienna

‹112› This majestic portrait bestows the rank of real ruler on Madame de Pompadour, Louis XV's mistress. The painting also flatters her by showing her as a sympathetic patroness of the arts and sciences.

Maurice Quentin de la Tour, *Madame de Pompadour,* 1755.
Pastel, 175 × 128 cm. Louvre, Paris

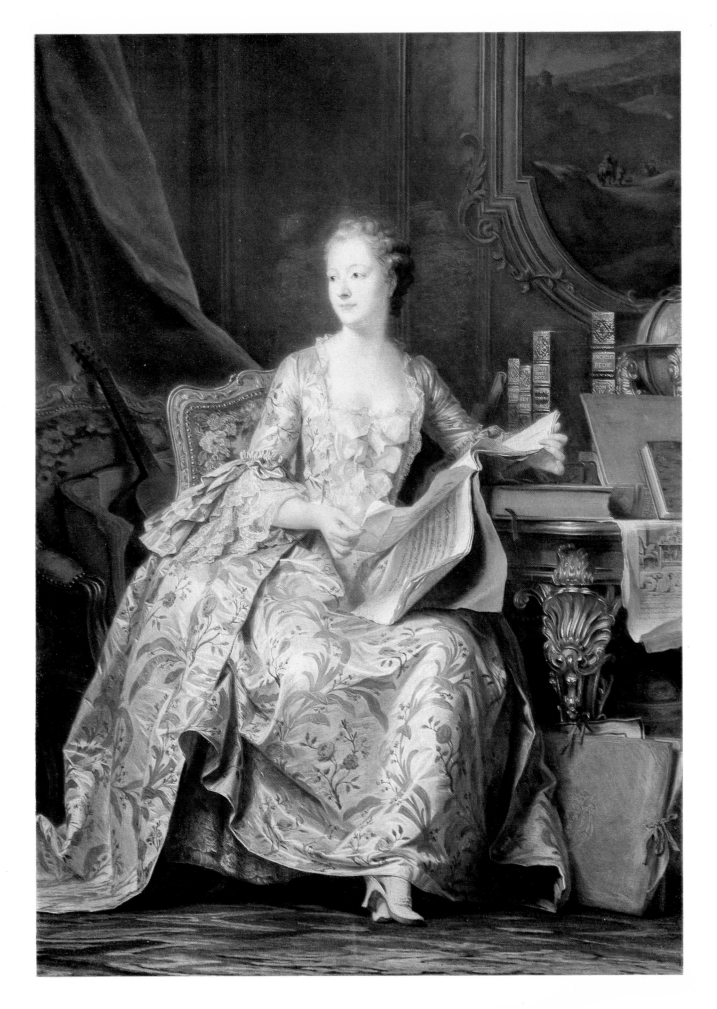

‹113› Catherine II with her royal household.
Central section of the centerpiece belonging to a dessert service for Catherine II.

Model by F. E. and W. C. Meyer, 1770–72.
Height of the throne 93 cm., width 79 cm. Hermitage, Leningrad

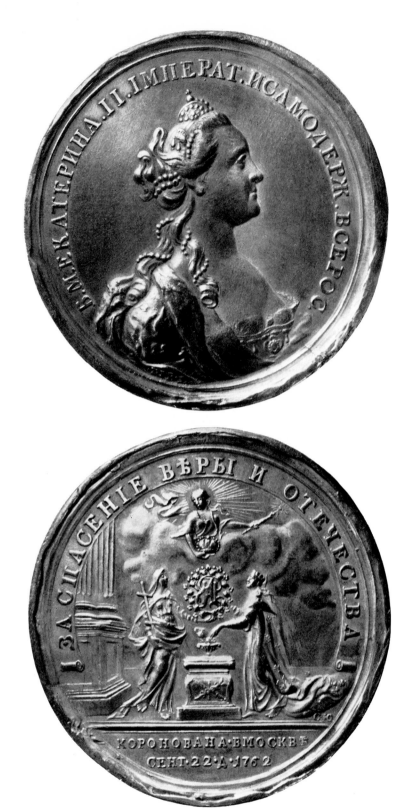

‹114› and ‹115› The head of the silver medal depicts a bust of
Tsarina Catherine II in royal attire. The Russian inscription bears her name
and the title of empress and ruler of Russia.
The reverse of the medal shows the tsarina standing beside an altar, being crowned by an angel.
This altar scene is an allegory of the Russian Orthodox Church
and is meant to indicate Catherine's orthodox faith, as does the inscription around it.
The date of her coronation is given below the allegorical picture.

Silver embossed medal (between 1760 and 1790) by Timofey Ivanov (reverse by a different artist).
Diameter 5.08 cm., weight 51.0819 gm. Kulturhistorisches Museum, Magdeburg

‹116› Catherine II's magnificent coach was built in 1769 in England
by Master Bockindale. It was not designed merely with grandeur in mind,
but incorporated a number of improvements to make traveling more comfortable.
It was very stable and both vertical and horizontal suspension
made the otherwise bumpy ride on bad roads smoother.
The body of the coach was decorated with gilded wooden carvings—interlacing
flowers and bouquets—and paintings by pupils of Watteau.

Coach of Catherine II built by Master Bockindale in 1769.
Museums of the Kremlin, Moscow

POWERFUL WOMEN

NY doubts about "whether women were human beings, too" instantly vanished if the women in question had achieved positions of power either by birth or marriage. All of a sudden there was no truth in the allegation that women's intellect was deficient, nor was it suggested that their God-given role in life was to be subordinate to male "superiority and perfection." The power of the absolute monarchy stood safely apart from the complex society it controlled. It was not affected by the dogmas on the difference between the sexes, even though these prevailed in all other areas of life. In fact, women rulers became popular legendary figures, although little attention was paid to their real achievements. There were instead endless stories of scandal spread about them, or they were glorified beyond reason. They were exempted from contemporary debates on the advantages and disadvantages of men and women because they had come to the throne. There should never have been any female monarchs if you go by the conventions of the time, which banned all women from holding public office or practicing a profession, but the sensitive institution of the monarchy did not tolerate such interference. (There were other interests and pressures at work at this level of society.)

Women rulers in Europe during the Baroque era were far more numerous than we are led to believe in the wide-ranging, though one-sided, literature on Maria Theresa (1717–1780), Archduchess of Austria, and Catherine II of Russia (1729–1796). The superior skills of government displayed by Elizabeth I in sixteenth-century England were not manifested by Queen Anne (1702–1714). And of the French regents who ruled in the name of their dependent sons, the strongest personality can also be found in the sixteenth century. She was Catherine de Médicis, an active, albeit inglorious, force in the wars against the Huguenots. But the destiny of France was also shaped by Marie de Médicis, Henry IV's widow, who ruled (capriciously, it must be said) during the minority of her son, Louis XIII. After his death in 1643, his wife, Anne of Austria, was regent for eight years for her son Louis XIV, the Sun King. The Spanish infanta Isa-

bella ruled over the Spanish Netherlands as governor (from 1621 to 1633) after the death of her husband.

In Russia, too, a number of women seized power as a matter of course and remained on the throne with the same power-consciousness, skills, and deficiencies that were shown by men. Catherine I, the widow of Peter the Great, might have been manipulated by Menzhikov, her favorite, but Anna Ivanovna, who ruled from 1730 to 1740, after the death of Peter II (1727–1730), was quick to put the Russian court back on the West European course that had been set by Peter the Great, and her autocratic rule was strengthened by the Supreme Privy Council. She consolidated the foreign element in the Russian ruling class as she was descended from a German line. When Elizabeth, daughter of Peter I, came to power in 1741 by a *coup d'état*, her action was regarded as a breakthrough for Russian nationalism and had great support from the old Muscovite nobility. Despite the various individual qualities of the tsarinas of the eighteenth century, they appeared only as pawns in the hands of rival forces in the Russian empire. In contrast, the important position of Catherine II, which we will look at in some depth later in the text, stood out quite clearly against the rest.

Since we do not share the inhibitions of the people of the day in their respect for the monarchy, it might be interesting for us to examine how these women in positions of power reconciled their "womanliness" with the business of government. It would seem that if women really exercised power themselves and governed well they developed a rigorous approach, which was regarded as a "male" trait. If, however, they revealed qualities that were considered to be typically female, then they proved to be ill-suited for government.

Maria Theresa's attempt to combine both qualities brought her justified fame. The nickname "Her Motherly Majesty" expresses a judgment of her that we find questionable when we look at many of the decisions she made, which were anything but motherly. It clearly reveals, however, how difficult, if not impossible, it was to reconcile personal moral views with the requirements of government, especial-

ly in an absolutist state. Her perseverance in doing so, even against such odds, makes her unique. Maria Theresa was a deeply religious woman, and her moral principles on legality and honesty were often in conflict with the reasoning of the state. The prime example can be seen in the issue of partitioning Poland among Prussia, Russia, and Austria in 1772. She fought hard, albeit unsuccessfully against her country taking part in that rapacious treaty. She did not want to gain territory at the expense of honesty, by "violating everything that had hitherto been holy and just." There is no doubt, on the other hand, that she could be quite ruthless where the security and welfare of the state was concerned.

She was a loving mother and very close to the twelve (of sixteen) children who at least survived of their youth, and she felt keenly responsible for their character development. But in a cool and calculated manner (and at times against their wishes), she married off her seven daughters—while they were still children—into a variety of European courts, thereby establishing a system of support for the power of Austria through this clever policy of marriage. She kept in touch with these "outposts" of her realm and retained her influence over them through countless letters. It is difficult to distinguish here between maternal concern for the proper conduct of her children and her efforts to direct their actions to her political advantage. She always described herself in her writings as a solicitous *Landesmutter* (mother of the country), and probably genuinely regarded herself as such. But even she had to strike a delicate balance between maintaining her position of power and working for the good of the people entrusted to her care. In the difficult period at the beginning of her reign, she wrote in 1741 in connection with the defense of Bohemia: "Do not spare the country, in order to keep it; assist in seeing that the soldier is satisfied and has all he needs . . . What one cannot get freely from the country must be taken from it. You will say that I am cruel. It is true; but I also know that I will be able to compensate a hundredfold for all the atrocities that I have sanctioned. And I will do so; but now I will steel my heart to any compassion." It was only this remarkable tenacity that saw her through the seemingly hopeless situation after the death of the last Austrian emperor. She insisted on her right to the Austrian succession and was eventually successful—against all predictions—in the fight against all the contenders who claimed the Habsburg inheritance.

When she ascended to the throne in 1740 at the age of twenty-two, Austria was greatly harried by external enemies and was internally in a state of crisis. No one, least of all Austrian statesmen, believed that this young sovereign could achieve stability. Moreover, Maria Theresa had not been instructed in government by her father, Charles VI, although it was clear that, as there was no son, she would succeed as the eldest daughter. She outlined her position in a major statement in 1751, the so-called political testament. "I believe no one would disagree that there have been few instances in history of a mon-

arch coming to the throne in circumstances more difficult and precarious than those I find myself in . . . without money, without credit, without an army, without experience and knowledge and lastly without any counsel, because everyone . . . wants to wait and see how events will turn." Above all her ministers wanted to leave their options open, and proved to be incapable of mastering the situation. She alone "without falling prey to vanity, was the only one who kept up her courage through all these trials and tribulations." By 1745 she had "acted valiantly, risked everything, and strained all her abilities." She obtained the imperial German crown for her husband Francis Stephen of Lorraine, to ensure that the emperorship would remain in Austria. She herself relinquished any claim to the German crown, but retained all the power in the country in her own hands.

The second major event of 1745 was the final loss of Silesia to Prussia. This was most certainly a heavy blow for the Austrian monarchy, but it helped to speed up domestic reforms, especially since the superiority of Prussia highlighted the shortcomings within the organization of the state. "And seeing how we had to reach out for the Dresden Peace, my thoughts changed and turned solely to the internal matters of our countries." Count Haugwitz, who had already contemplated reform while governor of Silesia, was assigned the huge task of reforming the Austrian empire. It was imperative to weaken the power of the ruling classes with their particularist privileges and to strengthen the authority of central government. Up till then the ruling elites had, without restriction in their own provinces, looked after their own interests, not those of the empire. From 1748, through the reforms of Haugwitz, Austria was transformed into an absolute state run by a monarch.

Greater headway was made in the second period of reform after 1761. Chancellor Kaunitz introduced the principle of modern government through his reform of the regional administration system. Maria Theresa's "enlightened absolutism" paved the way for modern development, especially in economic policy. She started industrialization, encouraged trade and transport, and eased the restrictions in the guilds. She was personally involved in all the administrative and economic measures. She kept herself well informed about domestic and foreign economic matters and frequently made important decisions which displayed an astounding knowledge of the facts. As the mother of the country she considered it her duty to take charge of the affairs of the state herself, and her style of governing had a family touch about it. Admittedly her "motherliness" in no way prevented her from sending ten-year-old orphan boys into the mines and eight-year-old orphan girls into the spinning mills. But even these measures were intended to improve the general lot of the people.

It was in this aspect that she differed most from the other great female ruler of the eighteenth century, Catherine II, whose ambitious reign did not change the conditions in which the Russian people had to live, at least not for the better. Catherine's story ran like this. A shy

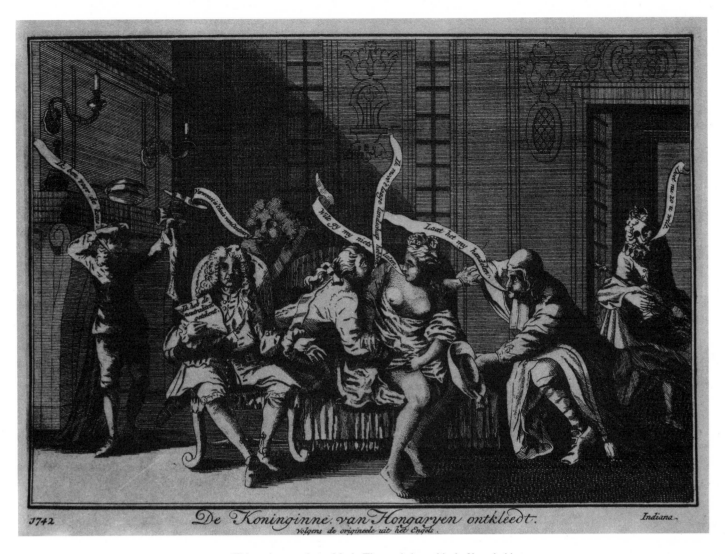

1742 De Koninginne van Hongaryen ontkleedt. Indiana
volgens de origineele uit het Engels.

‹117› This caricature shows Maria Theresa being robbed of her clothing—
a representation of the Austrian Wars of Succession.

Unknown artist, *The Queen of Hungary being Undressed*, 1742.
Copperplate engraving, 21.3 × 30.1 cm. Albertina, Vienna

German princess, she came to Petersburg at the age of fifteen as the fiancée of the heir to the throne and married him a year later. She had seventeen years in which to prepare herself for her role. During this period she obtained an excellent education, especially in the literature and philosophy of the French Enlightenment. Her keen intellect coupled with natural diplomatic talents helped her to prepare a successful *coup d'état*—six months after her husband, Peter III, ascended to the throne she seized power for herself with no real claim other than the general dissatisfaction that people felt for this somewhat retarded, unattractive tsar, who gave to Prussia all the lands Russia had wrested from Frederick II in the past five years. Certainly his subjects perceived him as anti-Russian. She, too, was a foreigner, but

she had quickly realized that she could only gain power in the Russian empire by stressing the importance of Russian culture and making it her own. She had no difficulty in reconciling her enlightened, rational education with ancient Russian culture and religion. This was not all pretense. She was as shrewd as she was unscrupulous in her expansionist foreign policy. This revealed both an awareness of the total power of an autocrat and her complete identification with the interests of the Russian empire.

Without doubt Catherine's reign made an immediate impact on Russia's standing in the game of power politics in Europe. Her statement in 1766 that "Russia is a European power" expressed her desires more than reality, but she soon made the statement come true.

The extension of the Russian border to the west at the expense of Poland, and to the south at the expense of the Ottoman Empire, was no mean contribution to her aims. Catherine supplemented by conquest her brilliant, influential foreign policy, and she continued Peter the Great's concept of westernization at home. French culture and education, a comprehensive promotion of science and the arts, and especially her own enthusiastic pursuits soon made Petersburg a center of European culture. Furthermore, the enlightened ideas which Catherine supported at the beginning of her reign paved the way for a flowering of intellectual life and for humanist ideals.

In the fourth year of her reign, the hopes of many for an enlightened form of absolute rule seemed at first to be confirmed by an action which caused a ripple of excitement throughout Europe. In 1766, Catherine summoned a legislative body in which all classes (apart from serfs) were to be represented. This assembly by 564 deputies was supposed to draw up a modern, comprehensive code of laws, on the basis of an explanation of "general needs and social evils." In her *Instructions*, all the deputies were expressly enjoined to commit themselves to this humanistic position. Indeed the entire position of society in the empire was discussed in a surprisingly open way. Legal relationships, economic interests, and the needs and demands of various classes were all brought up. For a year, it seemed that Catherine wanted to rule with the aid of a parliament. However, the assembly did not, in fact, draft or pass any laws. It only passed one resolution, confirming Catherine in her position and title of tsarina. After she had achieved the urgent legal recognition of her usurped rule she dissolved the assembly at the end of 1768, using the outbreak of the first Turkish War as a very plausible pretext. She did later undertake various social, administrative, and economic reforms, but never achieved a profound restructuring of society: her autocratic method of government prevented her from turning her intentions into reality. Even her many lovers, particularly Orlov and Potemkin (on whom she greatly depended), had no influence on her political decisions.

But for all her despotic, absolute power she could not get the nobles under her control. Thus her theories and ideas, which were originally highly promising, were completely reversed, because she was not sufficiently interested in the real position of the Russian people. Her idea of liberating the peasants was transformed in the course of her government into a total deprivation of their rights, with estate owners having limitless authority over them. Catherine's reign, which started out in such a splendid, enlightened way under the banner of liberalism and rationalism, widened the gulf which had sprung up under Peter I between a tiny, highly cultured upper class and the mass of the people. The empress reserved her great energy to increase the power and influence of Russia, but in so doing damaged the vital interests of the vast majority of the peasant population. Eliminating their social, political, and cultural backwardness was of little significance to her.

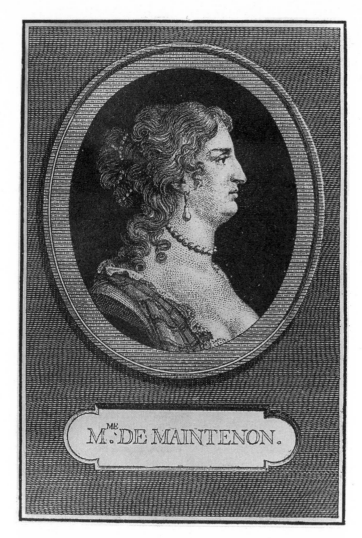

‹118› Augustin de Saint-Aubin, *Madame de Maintenon.*
Etching

The two most important female rulers of the Baroque held diametrically opposed views on the art of government. One believed in moderation, fully understanding the value of and always acting for the benefit of the country and the people; the other strove unconditionally and ruthlessly to establish the power and prestige of her empire. They were both quite steadfast in putting their ideas into practice right to the very end. There was a third queen in Europe who had the whole of the Continent watching her. Christina of Sweden (1626–1689) was six years old when her father, Gustavus II Adolphus, fell at the Battle of Lützen. Six months later the Swedish parliament proclaimed her Queen and took their oath of allegiance to her. The chancellor Axel Oxenstierna headed the team of regents who ruled for the Queen-elect. Christina was prepared thoroughly for taking over the crown and was given an education normally reserved for

princes, as her father had wanted. She was soon fluent in several foreign languages, read and spoke Latin effortlessly, was well versed in the literature, philosophy, and history of the ancients as well as of modern Europe. The chancellor himself gave her instruction in government and politics and always kept her informed about the state of the country and everyday political affairs. Christina was an enthusiastic student and extremely self-disciplined. She neglected her sleep, food and appearance, and never showed the slightest interest in the usual female occupations.

As a child she stood out for her unusual mental and physical stamina and strength of mind. Her thinking displayed remarkable maturity for one so young, and her serious attitude toward work was quite untypical of children. When she was sixteen she was regularly attending the meetings of the Council, which did not make any decisions without her knowledge. From the point of view of her intellect and character, learning and knowledge, she seemed quite ready to take over the government of the country when she came of age. In 1644 she was crowned Queen of Sweden. "The clarity and keenness of her intellect, which allowed her to grasp easily and judge the most difficult of questions, her precise knowledge of government and administration, the eloquence and beautiful manner in which she expressed her views and at the same time the resolute will which she displayed in the Senate"[45] gave her authority as the real head of the Swedish state. Christina soon gained international renown, especially for treating scholars and philosophers from a number of countries as her equal and for the fact that they, too, regarded her as an equal. She was lavish in her passion for gathering art treasures, particularly books and manuscripts, from all over the world. She had one of the most notable collections in Europe. She did not even shrink from large-scale plundering if it meant that she would gain more treasures. Immediately before the end of the Thirty Years' War, the Swedish army occupied Prague. It would appear that the campaign was aimed purely at stealing Emperor Rudolf's art collection, as Prague had no military value.

Her fame as a royal patron of the arts and sciences was at its height when she suddenly lost all interest in government. All her time was taken up by glittering parties and costly amusements. She had been almost notorious for her manly military life-style and for the way she played no part in the frivolous life of the court, but now she seemed to want to catch up on all she had missed. But this did not last very long either. She abdicated in 1654 and, freed from her burdensome responsibilities, went to live in Italy, where she could dedicate herself to the arts and sciences. This was not really the sudden development it might seem. Although she had proved her diplomatic ability and political foresight in supporting the treaties with France and England and in the Peace of Westphalia, she could not master the problems in her own country. The state of the economy was becoming more and more desperate, the peasants were becoming impover-

ished, the army was going to seed, and the people were generally becoming increasingly dissatisfied with the extravagances of the court and the privileges of the aristocracy. Moreover, the Queen lost a lot of popularity because she was surrounded by foreigners, some of whom were Catholic to boot. She did not have enough strength to confront these difficulties and chose to abandon her responsibilities.

Certain people regarded her failure to govern Sweden as being to her credit. Under the influence of French and Spanish diplomats she had become interested in the Catholic Church, and on her way to Rome, immediately after her abdication, she announced her conversion to Catholicism. She therefore became a most interesting figure for the supporters of the Counter-Reformation. She was received in splendor by the Pope, who put a truly royal residence, the Palazzo Farnese, at her disposal, provided her with ample funds, and assigned one of his cardinals to her as personal advisor. Christina closely followed events in Sweden, and she traveled to her homeland on two occasions to be present at possible accessions to the throne—one could hardly say that she had withdrawn from public life. The Roman Catholic Church obviously hoped to penetrate Protestant Sweden with her help, but Christina of Sweden was not the right person for a long-term strategy.

Unlike Maria Theresa and Catherine II, who were constant in their principles and practices, Christina's life was full of abrupt and quite spontaneous changes governed by her emotions. They brought with them in each case a complete reversal of her interests and principles. Being calculating and clever and good at compromise was alien to her nature. Although she had been a sovereign of little standing, her personality had unique significance. Her manner was free from prejudice and the constraints of conventions. Her refusal to accept all social norms and obligations revealed a level of emancipation unique in the seventeenth century.

Apart from the few female heads of state, women's economic powerlessness condemned them to a passive role in politics. Certain public offices such as those of the Dutch "regents"—women who ran municipal welfare establishments—were aimed at acknowledging class privileges rather than allowing women to intervene in public matters. It was the upper-class women of England who found it hardest to reconcile themselves to their deprivation of rights. This was because until the beginning of the eighteenth century women from the upper classes were not excluded by right from voting, and women who owned large estates as well as those who were wealthy city dwellers had the right of representation in parliament. Women could also take up public office, for example as justices of the peace. All these opportunities, which had never existed in other countries, were swept away without trace by a development that aimed at the ejection of women from all political decisions.

Intelligent and enterprising women in this era could only gain influence by roundabout routes. The chronicles of court and salon in-

trigues provide ample proof of these attempts. A King's mistress, however, came closest to power. This rather remarkable institution of mistress *en titre*—a position that officially commanded honor and dignity—cannot be understood without bearing in mind that monarchs were treated almost like God. Their favorite mistresses were raised, irrespective of their backgrounds and means, to a very high position, equal to the Queen. This was quite a common occurrence for the people of the day. Even an enlightened philosopher like Christian Thomasius maintained that the contempt in which concubines were justifiably held did not apply to great princes and lords "as they were accountable only to God for their actions and because the concubine seemed to take on some of her lover's splendor."

There was hardly an absolutist court without a mistress *en titre*, even though not all of them were quite as open about it as the French and Saxon courts. The mistresses of Louis XIV and even more so those of Louis XV held what amounted to official positions at court. They accompanied the King wherever he went, they had their own suite of rooms in the royal palace and, one could say they served the state by mediating between the King and the people around him on a variety of issues. They were treated as equals by members of the aristocracy. Sovereigns such as Frederick of Prussia, Catherine of Russia, and even the highly principled Maria Theresa did not disdain to correspond with Madame de Pompadour (admittedly, a highly exceptional woman). Earlier, Louis XIV's mistresses certainly left their mark on the fashions and fancies of life at court, and Maintenon most definitely controlled the King's personal life when he was older. But she had just as little influence on his political decisions as her predecessors Montespan, La Vallière, and Fontange.

Pompadour was different. She came from a simple bourgeois background but was well educated, and utterly captivated Louis XV with her intelligence and tact. Le Normant de Tournehem, an aristocratic patron, paid and instigated her education and prepared her for her future role as mistress. Her lively interest in government, her power of judgment, and her practical and resolute mind often pro-

vided this insecure, reluctant king with direct advice about decisions. In foreign policy she supported the alliance France–Austria, a turning point in the foreign policy of France. She had a decisive concern in the occupation of the ministers by her intrigues and influence on the King. In the conflict between the King and the Parliament (1756) she brought her influence to bear on the King for the deprivation of the Parliament.

She also relieved him of burdensome duties such as meetings with ministers or receiving ambassadors. This middle-class woman, who was ennobled with the title of Marquise and whose life-style was that of a distinguished aristocrat like the Queen herself, retained her bourgeois, rational way of thinking throughout her life. It is true that she spent public funds prodigally on herself, but one must not overlook the fact that she gave all the support she could to the *tiers état*, that of professional people and the wealthy bourgeoisie, against the aristocracy. She was quite aware of their future importance. She retained her influential position for nineteen years, right up to her death in 1764, even though her sexual relationship with Louis XV had long since turned into a platonic friendship. A successor, Countess Du Barry, could hardly be compared with her as a personality. The Parisian prostitute was not capable of catching up on her education to the extent that she could intervene decisively in French politics. One of her lovers prepared her roughly for the role she was expected to play at court, but to all intents and purposes she always remained the tool of the courtiers who launched her into this society. She was used by them to provide support for the conservative clique at the court, whereas Pompadour had, from her own convictions, always worked with deputies to the parliament. Du Barry, like all the royal mistresses, played a part in the rise and fall of courtiers and officials, and in this way certainly exerted some influence on public affairs. This was charmingly and precisely summed up by Madame de Lafayette in her novel *La Princesse de Clève*: "There were so many interests, so many intrigues and the ladies were so deeply involved that love was constantly interwoven with politics, as was politics with love."

WOMEN ARTISTS

WITHOUT doubt, female activity pervaded the arts much more than any other area of society. Countless dilettantes devoted themselves to literature, music, fine arts, and visual arts as a pastime. We must take a closer look at this expression "pastime" in order to assess the importance of women's nonprofessional work in the arts in the era of absolutism. The preconditions, of course, were material independence and membership in the upper classes (hence "dilettantes"). The natural desire of men and women to be creative, to be active, to achieve something of value (and perhaps to gain some recognition), and to observe the results of their work could only be satisfied, as far as women were concerned, in the arts—unless it was directed into religion or serious and dedicated teaching. There were, typically, no other outlets (certainly no "gainful employment") for women in this era. The widespread dilettantism, or amateur art, that we see in the Baroque, allowed real creativity to be combined with a light, playful form of amusing entertainment—the only form permitted of aristocratic women. Certainly not all the results can be regarded as works of art. There are countless shades of artistic ability between someone like Marie-Madeleine de Lafayette and all the many women who were engaged in writing, drawing, and acting and whose names have been forgotten or were never well known.

It would seem that creative abilities were best employed in writing where no special training was required. Letter writing best fit the bill. This form, by no means insignificant, developed out of its original purpose. Letter writing as a *literary* form, reached its peak in the seventeenth and above all eighteenth centuries. It produced some excellent pieces of great cultural, historical, and literary value. The letter provided a welcome excuse to express oneself informally, unconstricted by the thematic and compositional structure of a plot, and seemingly unconstricted by the expectation of becoming famous. The impression of improvisation which produces an element of freshness, immediacy of feeling and carefree expression is in reality achieved with the utmost care. In these letters, this confidential form of communication with a distant partner, women provided a great deal of information about themselves, their way of life, and their philosophical outlook. The letters reveal how knowledgeable and interested these women were in the intellectual movements and controversies of their time, and how very capable they were of critical judgment. They wrote openly about their moral principles, their doubts about religion and their beliefs about their maxims and their values in life. A shrewd sense of reality alternated with a totally unsystematic, emotional, and disconnected philosophizing, which clearly indicated the potential powers of intelligence that remained untapped. The letters of the Marquise de Sévigné exquisitely combined a talent for observation, a warm, natural sensitivity and harmonious, refined creative skills. Widowed at twenty-five, she dismissed the idea of remarrying and devoted herself to the education of her two children. When her beloved daughter Françoise went with her husband to the south of France, she, now alone, regularly corresponded with her daughter in what are considered her most beautiful letters. The following extract, taken from one of the roughly fifteen hundred surviving letters by Sévigné, reveals only a small portion of her writing ability, as it illustrates merely one of the many different facets of her ingeniously versatile prose style.

Thank God for this wonderful weather! I have worked so hard that Spring has arrived. Everything is green. It was by no means easy to make these buds open up, for the red to turn into green. When I had finished with all the white beeches I had to go to the copper beeches and then to the oaks. That caused me the greatest trouble. I worked for another eight days before I felt satisfied with myself. I am beginning to see the fruits of my efforts, and I honestly believe that not only have I not damaged these beautiful things but have in fact been able to make the Spring appear very attractive. For I really devoted my attention to it, observed and criticized it, something which I had never done before with such exactness. I am indebted to my abundant free time for this ability, and indeed, my dear, it is the finest occupation in the world. It is a pity that there is none of the lovely freshness in which I have become so immersed left in me.

It is very interesting to study the various temperaments and attitudes toward life as presented in the letters of the period. In each case the personality of the writer determined literary style. We have, for instance, letters by Maintenon, the semilegitimate wife of Louis XIV, the tone of which was moralizing, careworn, and often pessimistically self-tormenting. She wanted to demonstrate clearly that she found it difficult to cope with the external conditions of life at court, that she felt drawn to a life of seclusion, and that she sought refuge in her responsibility for the girls' school at Saint-Cyr, which she founded. The famous letters by the Duchess of Orléans, Liselotte von der Pfalz, portray the French court from the position of someone who was not fully accepted by it, unmasking all that was unnatural and ridiculous in it with the critical attention produced by aversion. A profound uneasiness in the life-style of the court is concealed beneath the rough joviality of her perpetual chiding. Liselotte's vivid and powerful language—she refers to Maintenon as the "old hag," for example—was in marked contrast to the usual French style. A very characteristic example of the latter can be found in the letters of Madame de Staël (1766–1817), in which she endeavors to come to terms with the inadequacies of aristocratic life by using irony in a very light, by-the-way fashion. Her comments pour scorn aptly and accurately on her surroundings.

Some women of the aristocracy, however, also took up the highest of all literary forms, novel writing. Madeleine de Scudéry (1607–1701) and Marie-Madeleine de Lafayette (1634–1693) occupy an important place in the history of the French novel of the seventeenth century. In Scudéry's monster novels the plots branch off into endless adventures, confusions and complications, separations and reunions of the fictitious, historical heroes. The most remarkable thing about her heroes is that they combine historical distance and ideal flawless virtue with quite concrete figures. All Scudéry's characters from antiquity are in fact literary portraits of her friends. Between 1649 and 1653 *Artamène ou le grand Cyrus* was published in ten volumes, and between 1656 and 1660 *Clélie* was published, also in ten volumes. Mlle. de Scudéry also wrote a number of smaller works. Her major works were the subject of literary conversations in her own salon and in that of the Marquise de Rambouillet, where she was a permanent guest, while they were still being written. And her brother, Georges, as well as perhaps a few of her close friends, were involved in their development. The basic outlook of the novels was definitely the product of the commonly held view of life shared by the *précieuses*. That self-selected name came from their conscious attempts to discard all that was mean and low in their everyday lives. It was essentially a revolt against the emptiness of aristocratic life, sublimated in literature—and thoroughly ineffective. With the heroes of her novels always saving true love through all the mental and physical turmoils of life, the author constructed a picture which was the exact, though abstract, opposite of the reality she experienced daily in society.

Much greater importance has been attributed to the novels of the Comtesse de Lafayette, especially to the *Histoire de la Princesse de Clèves*, which appeared in 1678. This book constituted a turning point in the development of the novel because of the classical simplicity of its plot and the fact that it did away with intricacies and embellishments in the form of turbulent action. The plot is set in the sixteenth century, depicted with historical accuracy, and takes the form of an eternal triangle. What is new, though, is the psychological perceptiveness with which she portrays inner experience, thus creating real characters. The interesting element of the story is not in the plot itself, but in the explanation given for the actions of the heroine, who forgoes personal fulfillment out of a feeling of moral obligation toward her class, the aristocracy. The novel presents, in a highly informative way, the increasingly obvious contradictions between the moral norms of society and individual goals for happiness.

In England, too, there were many noblewomen eagerly engaged in writing. The philosophical ambitions, in particular, of Margaret Duchess of Newcastle aroused the displeasure of her contemporaries. It was flatly denied that a woman could have written books like *Philosophical Fancies* (1653) and *Observations Upon Experimental Philosophy* (1668), and her critics maintained that her husband was the real author. High society only tolerated such extravagances because she was a duchess. Women might be allowed to "indulge in" poetry, but they had to keep well away from philosophy. Many other women, who were drawn to literary work, such as Lady Mary Wortley Montagu, chose to concentrate on letter writing in order to escape society's contempt. In 1733 the faculty of philosophy at the University of Wittenberg bestowed the great honor of *laurea poetica* on a woman writer. Christiana Mariana Ziegler, the poetess laureate, was the daughter of the mayor of Leipzig. By the age of twenty-seven she had been twice widowed. She did not remarry and, since she was rich and had no other obligations, she could devote all her time to "culture." She supported young people who were musically gifted and attracted the great intellectuals of Leipzig to her side. They included Gottsched, the literary scholar who presumably encouraged her to contribute to his women's journal *Die vernünftigen Tadlerinnen* as well as write her own poetry. After she had published two slim volumes of poetry and a collection of letters, Gottsched had her admitted, in 1731, into the *Deutsche Gesellschaft* as the first female member of this Leipzig society for the cultivation of German language and literature. The very fact that she wrote her letters in German was justification for this honor, as up till then only French had been regarded as suitable for this form of literature at which French women excelled. The "moral and miscellaneous writings" of von Ziegler, however, by no means matched the intellectual charm of the French works. Nevertheless, her inaugural speech to the *Deutsche Gesellschaft* was infused with an incredible pride and awareness of her exceptional position as a woman writer. Her speech was a pretty piece of flowery Baroque prose. Von Ziegler

‹119› This skilfully presented self-portrait reveals the high standards and self-assurance
of the great women painters of the French Rococo.

Adélaïde Labille-Guiard, *Self-Portrait with Two Pupils*, 1785.
Oil on canvas, 210.8 × 151.1 cm. Metropolitan Museum of Art, New York, gift of Julia Berwind 1953.

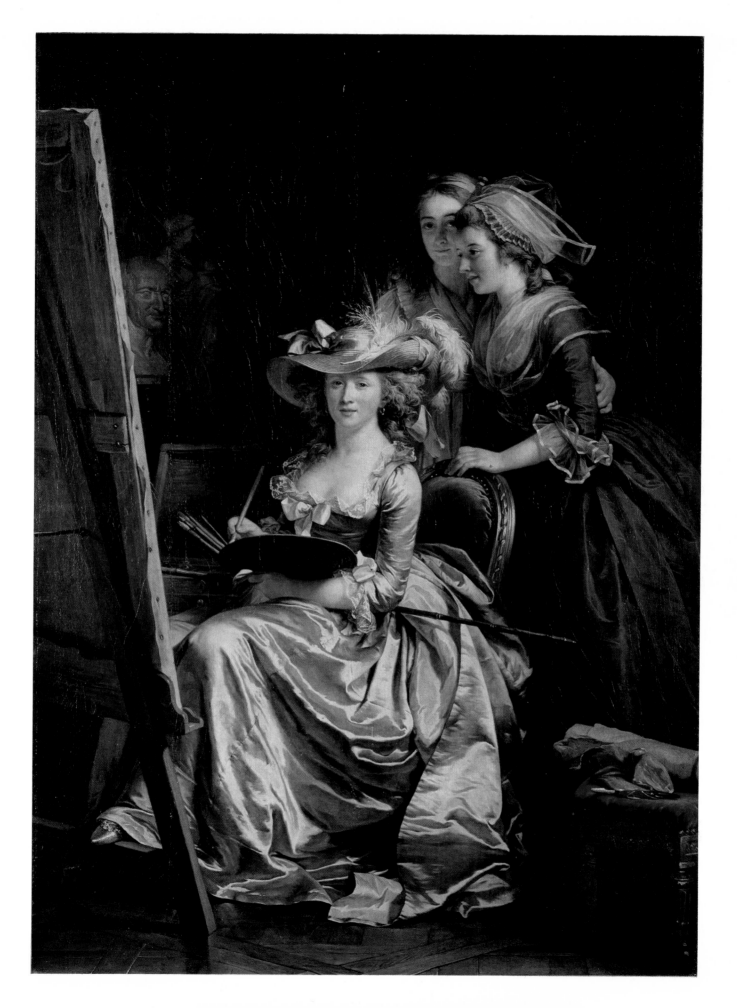

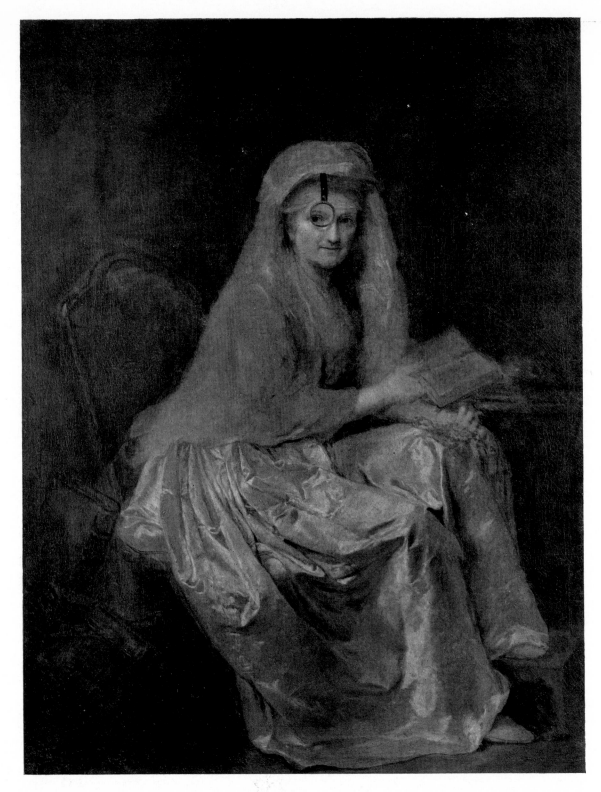

‹120› This self-portrait is full of character and is one of the most interesting works
of a woman painter who enjoyed a high reputation for her portraits. They displayed a degree of
observation which was unusually truthful and containing great psychological depth.

Anna Dorothea Therbusch, *Self-Portrait*, 1775.
Oil on canvas, 151 × 115 cm. Staatliche Museen, Gemäldegalerie, Berlin

‹121› Jean-Honoré Fragonard observed this charming scene, in
which his sister-in-law Marguerite Gérard was drawing a model group.
Marguerite Gérard (1761–1837) was a successful painter
of family scenes from the upper middle classes.

Jean-Honoré Fragonard, *The Artist (The Painter Marguerite Gérard)*, 1770s.
Pen drawing, 45.1 × 38.8 cm. Albertina, Vienna

‹122› Maria Sibylla Merian, the most outstanding illustrator of flowers and insects
in seventeenth-century Germany, combined scientific accuracy with artistic prowess in her
studies of nature. The picture shows a caper from Surinam with butterflies.

Maria Sibylla Merian, untitled, 1700–02.
Watercolor and opaque, 33.8 × 28.7 cm. Botanical Institute Library, Leningrad

‹123› At the age of fifty-five the celebrated portrait painter, Rosalba Carriera, painted her
own portrait as an allegory of the seasons. Her fur hat and collar lend a quality of fantasy
to her facial features, which are less idealized than usual.

Rosalba Carriera, *Self-Portrait as "Winter,"* 1731.
Pastel on paper, 46.5 × 34 cm. Staatliche Kunstsammlungen, Gemäldegalerie Alte Meister, Dresden

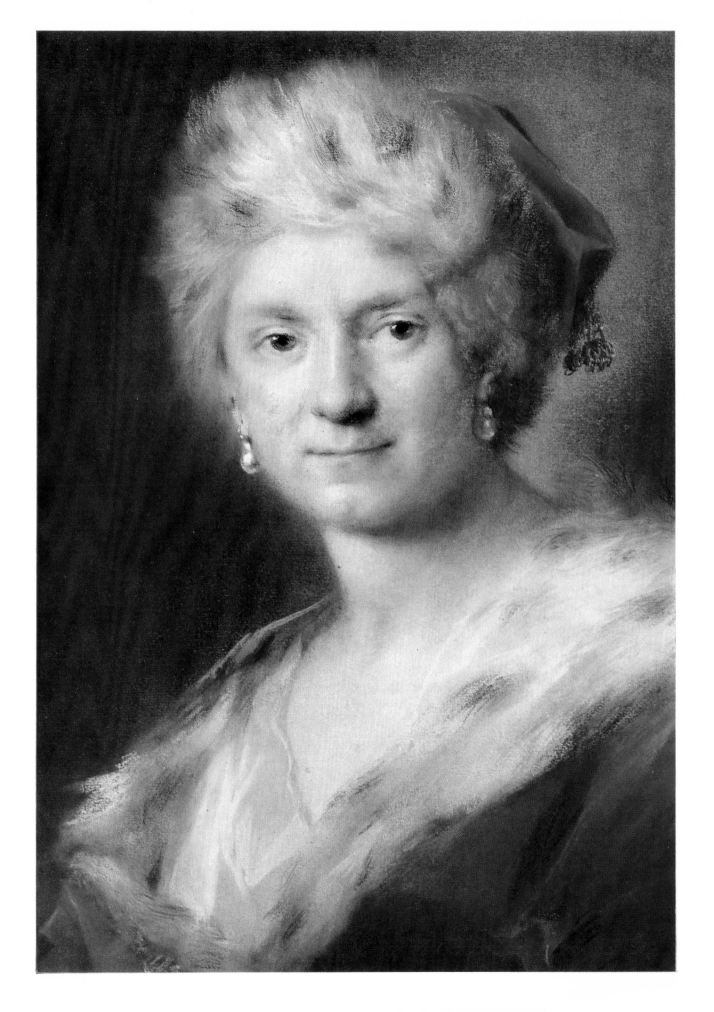

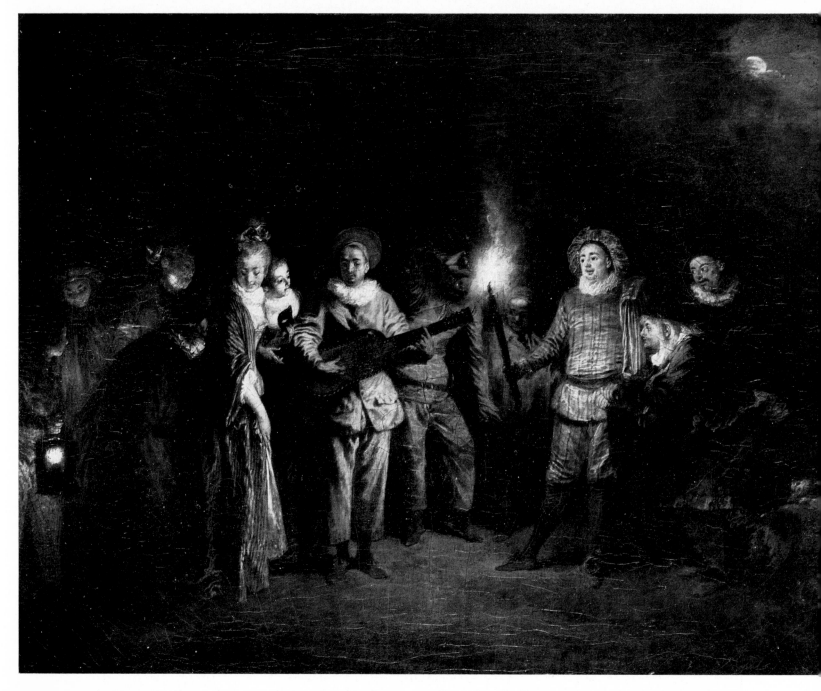

‹124› Women did not only perform in amateur theater. There were actresses
among traveling players, mainly in the role of Columbine.
Watteau shows the scene of a performance where she and Pierrot
are caught by surprise in a rendezvous at night.

Antoine Watteau, *Love in the Italian Theater*, c. 1716.
Oil on canvas, 37 × 48 cm. Staatliche Museen Preussischer Kulturbesitz, Gemäldegalerie, Berlin (West)

‹125› Barberina Campanini was a great ballet star of international fame.
She was the prima ballerina of the Berlin Opera between 1744 and 1748. She was also the mistress
of Frederick the Great, who commissioned this portrait for his study.

Antoine Pesne, *Barberina Campanini*, c. 1745.
Oil on canvas, 221 × 140 cm. Schloss Charlottenburg, Berlin (West)

‹126› Actors and especially actresses had a bad reputation.
The difficult conditions of their itinerant way of life led to habits which shocked honest citizens.
A dilapidated barn serves as their changing room. They push each
other as they prepare for the performance.

William Hogarth, *Strolling Actresses Dressing in a Barn*, 1738.
Copperplate engraving, 41.9 × 53.3 cm. Staatliche Bücher- und Kupferstichsammlung, Greiz

challenged her male colleagues to think again about her "poor writings." She could not believe "that they were capable of giving you such a good impression that they deserve to be included among the laurels of your Temple of the Muses." With the same tone of affected humility she gave expression to the view that women's intellect was equal to that of men. She spoke of the kindness shown by scholars of the time toward women's works. "They flatter our literary efforts with polite approval and accept the meanest and most awful weeds that sprout forth on our fields in place of the most beautiful balsam trees."

Whether von Ziegler was merely coquettishly modest or whether (as feminists would claim) this was veiled sarcasm, cannot be known. What is clear, however, is that the "benevolence" shown to women's writing (and much attention certainly was paid to it at the time) only applied to those who remained within the constraints imposed upon them. Thus the female members of the Nuremberg order of the *Pegnitzschäfer* were showered with praises. These writers, the wives of merchants, pastors, court officials, and the gentry, were soon attributed with the titles of the "tenth muse of our time," the "sun over German soil," and "earthly goddesses and heavenly beings."

In England a similarly remarkable reputation was achieved by Katharine Philips (1631–1664). She was the daughter of a London merchant and married a country squire in 1648. In order to liven up the monotony of her life in the country she founded, together with a few of her friends, a "society of friendship." Its aim was to discuss "poetry, religion and matters of the heart." Her poetry was initially intended for this society and not for general publication. When it was finally published in 1662, the extreme modesty she presented in the preface definitely helped her to win over the hearts of the public. A comparison with Orpheus was one of the least effusive compliments paid to her by her male admirers.

It is often difficult to distinguish clearly between this aristocratic dilettantism and professional work in the arts. The only difference between Mlle. de Scudéry, who dedicated her whole life to literature, and the first professional women writers was that the latter earned their living by writing. It was in England that women first dared to take up writing as a career.

Aphra Behn (1640–1689) seemed to be destined for an unusual life right from her childhood. She spent her youth in Surinam, where she led a free and easy life. She returned to England married to the merchant Behn. When he died two years later she was apparently left without any money. After an unsuccessful spell in the diplomatic service, where she was engaged by Charles II in 1660 in the Dutch War, she began to support herself by writing, and continued to do so throughout her life. She mainly wrote plays, which were regularly performed with acclaim. The themes and characters of her plays met with public approval and her style was similar to that of male dramatists. She never discussed equality between the sexes and never demanded rights for women: she just practiced them. Nor did she consider it necessary to gain the sympathy and good will of the public through overmodest prefaces. Thus she was not showered with gushing praise; on the contrary, her name was associated with everything unbecoming to a lady. She enjoyed real success, however, as her plays were popular and her fiction much sought after.

She used her experience of the tropics in her novel *Oroonoko* (1688) and, without regard to conventional literary form, intermingled her own person in a romantic story. The story is about an ideal character, Oroonoko, who combines with utopian perfection a European education and background with the simplicity and moral purity of the "natural man." The novel reveled in nature but also contained a pronounced element of social criticism—long before Rousseau. Her criticism was pragmatic, drawn from her own personal experience, without generalizations, but this was nevertheless the first literary attack on British colonialism and slavery. She was systematic in presenting the British subjects in Surinam as thoroughly evil, brutal, and treacherous, in contrast to the natives, whom she presented in a glorified light as morally upright and flawless.

Aphra Behn's independent thought and action made her an outstanding phenomenon. It was precisely because she was so unusual that she was accepted without this heralding a general change in the position of women. It was, however, not just a coincidence that English society could guarantee a constant interest among its educated members; the English middle classes were rich and eager to learn, and the aristocracy were open-minded about economic matters. Consequently, Behn could flourish, and other women writers could take up the profession. Soon after Aphra Behn, another self-willed literary figure came to the public's attention (although she does not feature greatly in literary history). Her name was Mary de la Rivière Manley (1672–1724). She came from a good family, but had to move outside of conventional social circles when it was discovered that her marriage was bigamous. She worked at first as a lady companion and then as a playwright, but with little success. Finally she lived for a few years as a kept woman, a typical way for women of the theater to secure their livelihood. In 1705, she started to write again out of necessity, and continued to do so up to her death. But this time she wrote prose. Although her work was of little artistic merits, she was, without doubt, a very popular writer probably because of her subject matter: she made very transparent attacks on people in high places, exposing their morally dubious affairs. This led to her being imprisoned for scandal—although she denied vehemently "drawing on" real-life incidents. It would not be right, however, to label her merely a scandalmonger. As a journalist and lampoonist who contributed to Steele's and Addison's journals and who provided assistance for Swift, she was involved in political conflicts.

<127> to <130> Four women artists.
From Joachim von Sandrart, *Teutsche Academie der edlen Bau-,
Bild- und Mahlerey-Künste* (German academy of the noble arts of architecture,
sculpture and painting), Nuremberg, 1675

mentally different in one very important aspect. They were tolerated as writers but separated from literature in general as writing in a "female style"—a category on its own. This category was limited to minor works such as informal narrative, novels, letters, and diaries. This is what women were capable of achieving and this is what they were allowed to achieve. In fact, Behn, Manley, and Haywood had already made a decisive contribution to this personal form of literature. They had paved the way for the psychological novel and, to some extent, had created it. In the late eighteenth century, it had gained a position of prestige. As they were not emotionally restricted by male prejudices, they did not limit themselves to the novel but had a go at everything that male writers did.

The theater offered one of the few opportunities for independence and job satisfaction for women at quite an early stage and on a wide scale, and not only as dramatists, but as actresses, dancers, and chorus girls. Performers were not held in very high public esteem, they were considered hardly better than prostitutes. In 1790, Adolf von Knigge described them as "people without morals, education, principles or knowledge; adventurers; people from the lower classes, impudent paramours." If a performer managed to become the mistress of a good benefactor, she had a chance to lead a free life. This was, for many of them, the only reasonable option, but a great deal of talent must have fallen by the wayside. Nell Gwynne (once a street vendor of oranges) was an extremely attractive actress, who rose to fame as the mistress of King Charles II of England. Theater experts extolled

Eliza Haywood (1693–1756) was the next woman to become a professional writer. She also provoked the anger of good citizens by her barely concealed scandal stories and political satires. She, too, wrote novels in a way that would guarantee their popularity, and had little concern about their "literary" value. The first professional woman writers of England were brave pioneers who cleared the way for those to come. They were energetic rather than brilliant, flexible and versatile rather than creative, and were efficient organizers (journal editors, for example). Their approach to writing demanded more strength of mind and stamina than was necessary for the refined poetry produced by women of social and financial standing. Light fiction thus came about largely through financial necessity, and was widely read by the English middle classes. The upper classes did not regard the novel as literature. But apart from being entertaining, it also imparted certain moral norms and ideals to its readers.

A younger generation of women writers, the society of "bluestockings" around Richardson, had a much easier time in many ways. They were more numerous, and they did not have to hold their own as lone individuals in a man's world. And their situation was funda-

It was not until the middle of the seventeenth century that it became acceptable for women to appear on stage. Even before Nell Gwynne, the tragedienne Elizabeth Barry worked in London. She was acclaimed for her skill in depicting dignified passion. In 1655 she was taken on as the first woman to act at the Amsterdam Schouwburg. In 1654, Joris Jolliphus, an Englishman who led a company of strolling players in Germany, engaged some actresses for the stage. The courts sought out the most famous ones to be royal mistresses, and here the Spanish and Prussian courts were no exception. But the basic support for women as stage professionals came from public theater in England. The sort of striking personalities who were famous in England in the seventeenth century did not appear in France and Germany until the eighteenth century. The French ballet dancers Marie-Anne de Cupis de Camargo and Marie Sallé were not only known for their radiant female charm and beauty but for the creative originality of their art. They were not simply performers; both made an independent contribution to the development of ballet as well. Camargo introduced a new style of movement at a quick tempo that was characterized by graceful leaps. There was also great enthusiasm about the way characters and plots were portrayed in Sallé's ballet pantomimes, which she choreographed herself.

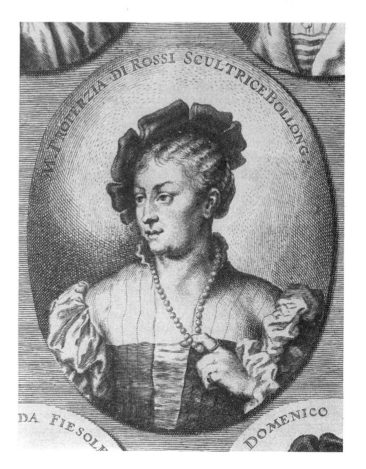

her skills. She performed at the London Drury Lane theater for only four years (1666–1670), and who knows what theatrical acclaim she might have achieved with her tomboyish charm had she not chosen a more attractive path?

Women first appeared on stage in the Italian *commedia dell'arte*. There were women among the touring players as early as the mid-sixteenth century. The great intellectuals of the day sang the praises of one such player, Isabella Andreini, not only for her acting skills and her work as a writer but for her virtue and honor as a wife and mother. It was also commonplace to see women on the stage in sixteenth-century Spain. Toward the end of that century the Church tried to ban women from the stage but this was prevented by the Spaniards' enthusiasm for the theater. The ban was reduced to a demand that actresses should be decently dressed on stage and should not cause offense in any other way. The Spanish maintained that it was even more immoral to allow men to appear on stage dressed in women's clothes than it was for women to perform themselves. What was rejected here was quite normal practice elsewhere in public professional theater. Women were always involved in the amateur theater of the aristocracy, but in Shakespeare's touring companies, for example, young actors still had to take over the female roles. Sometimes boys were used from the children's troupes; when they finished their apprenticeships they simply switched to playing parts for men.

The most impressive actress in German theater was Friederike Caroline Neuber (1697–1760). She was a very unusual person. As a young girl she revealed her resolute and active nature by twice trying to escape from her hostile and unloving father. The second time she ran off with the man who was to become her lifelong partner. She displayed the same resoluteness in 1727 when she took over the management of the theater company in which she worked as an actress from a man who was incompetent. She must have had the necessary management qualities as the company immediately expressed their confidence in her. She was energetic and self-confident, but also cared for the members of her ensemble, which she kept together like a family. She had substantial acting experience and was obsessed with her profession. Such a character could never be satisfied with being merely a director, and indeed she gradually began a thorough reform of the theater. Together with Gottsched she played a decisive part in raising the level of the theater, giving it artistic status as well as bestowing the rank of artist on the acting profession, now no longer mere "players." Her association with Gottsched and later with Lessing helped her to fill her repertoire with serious plays. Believing that the theater should be rid of noisy buffoonery, she drove out clowns and with them a large part of folk theater—and lost most of her audience. She came to realize this, but her break with Gottsched came too late. The character of Neuber is also of interest to us because, like the women writers of seventeenth-century England, she regarded her artistic work as a "job," in the bourgeois sense of the word. She got on with her work without wasting time questioning whether it was suitable for a woman. This totally independent attitude toward art was quite different from that practiced in the royal cities, where women artists often fell under the influence of a wealthy aristocrat.

Similar differences became apparent in the fine arts, though perhaps in a slightly different form. There were many women copperplate engravers as there had been in the textile craft trades. Women, either as wives or daughters, worked in the family business in a particular branch of the arts. They were generally restricted to the one field because of long family tradition. Copperplate engraving demanded stamina, skill, sensitivity, and the submission of one's own personality to the original work. To people of the day it must have appeared to be highly suitable artistic work for women. Indeed, a large number of women won acclaim and wealth through this art form. In France, for example, Claudine Bouzonnet (1636–1697), who came from a famous family of artists, enjoyed the privilege of an apartment in the Louvre. She was known, above all, for her engravings after Poussin. She also did some teaching, that is, she passed on the highly sought after art of copperplate engraving to her two sisters. In Germany the three Küsel sisters, daughters of an Augsburg engraver, made innovations in engraving techniques for illustrations. In the Netherlands Magdalena van der Passe (1600–1638) engraved the most coveted paintings by countless Dutch masters, including

⟨131⟩ Angelika Kauffmann, *Self-Portrait*, 1797.
Wash graphite drawing, 12.6 × 18.7 cm.
Staatliche Museen, Kupferstichkabinett, Berlin

Rubens and Rembrandt, for reproduction. The eighteenth century seemed to abound in prolific women engravers who produced prints, illustrations, decorative copper, and ornamental engravings.

The organization of the workshops of the copperplate engravers, illustrators, and publishers has an interesting parallel in sixteenth- and seventeenth-century Russia. Although the embroidery workshops that we will discuss were on a feudal-patriarchal basis—unlike the urban-bourgeois workshops of Western Europe—there was a number of similarities. Located in the households of the great princes and boyars, the embroideresses were held in high esteem. The rooms that were allocated to them were always in the best, the sunniest part of the house. The mistress of the house was entrusted with the running of the workshop. She herself had to be skilled at embroidery

(this applied even to the wife of the tsar). The workshops of the tsars comprised up to eighty embroiderers, with those of princes being about half as big. Although the preliminary designs were usually prepared by icon painters, the expressiveness, beauty, and effectiveness of the embroidered pictures—which often contained scenes with many figures—mainly depended on the skill of the embroiderers, who had "specialties." The work was split up, as in the icon workshops themselves, so that several women would work on one item, each contributing her own special skills and expert techniques. The demand for embroidery must have been very great if we just look at the ecclesiastical garments and textiles that have survived. But formal dress and household furnishings also needed a great deal of embroidery. Embroidery skills were regarded as a great virtue in women and were even said to be pleasing in the sight of God, especially where religious objects were concerned. This can be easily understood if we look at the sort of life that women had to lead in old Russia. In their isolated existence in the *terem* (the women's tower-chamber) they had very little freedom of movement, from both the spiritual and physical point of view. Their social contacts were very limited, and handicrafts became almost the sole opportunity for satisfying activity. It was for this reason that embroidery developed into such an exquisite art form in Russia.

The preference for specialized work, which is characteristic of female artworks of the seventeenth and eighteenth centuries, can be largely explained by the way artworks were produced in the workshops of masters, who were inundated with orders. The daughters of Tintoretto, for instance, were brought up in their father's studio. Two of them specialized in portrait painting, and the most talented one, Maria Robusti, was involved in his own works. The large numbers of Italian women painters at the turn of the seventeenth century received their training by virtue of working in their fathers' studios. This might explain their tendency toward conservative, stylistic attitudes, which is particularly striking in the work of, for example, Lavinia Fontana (1552–1614). She was one of the few women who carried out monumental painting in churches and palaces. Another example can be found in the work of Fede Galizia (1578–1630), whose religious paintings, portraits, and still lifes are highly reminiscent of the Cinquecento. Lucrina Fetti (1614–1651) was another such painter. Even today it is difficult to distinguish her work from that of her father, Domenico (1588/89–1624). Giovanna Garzoni (1600–1670) was honored with the membership of the Accademia di San Luca in Rome because of the meticulous detail and accuracy of her miniature portraits and still lifes. Spectacular fame was achieved by Elisabetta Siranni (1638–1665), who turned the model for her work, Guido Reni, into a favorite of the public. She met popular demand by mass-producing devotional paintings that were full of elegant slickness and fawning sentimentality. But the most original of all was Artemisia Gentileschi (1593–1652). Among Cara-vaggio followers, she was one of the greatest proponents of the artistic revolution against conventional style. This can be seen both in her flickering light and shadow contrasts and the aggressive severity of her composition, as well as in her frequent portrayal of the Judith theme. The violence of this murder scene, placed blatantly in the foreground, is unique in women's art in the Baroque era.

Women in Germany and Holland concentrated on specialist work to a far greater extent than elsewhere. A number of them was outstanding for their charming and polished craftsmanship. Among them was Maria Sibylla Merian (1647–1717), who was known for her independent character. In Frankfurt, the town of her birth, she was involved in the well-established tradition of scientific illustration, and made a significant contribution to that work in her drawings of plants and insects. Her work occupies an unusual position between art and research. The drawings were accurate and reliable but at the same time full of fascinating charm and animation. In 1699 she was sent by the city of Amsterdam to Surinam in order to make drawings of the insects there. Her style was especially popular among women, and she had a number of followers, above all in Nuremberg, where she lived for twenty years. These included her daughters, who continued their mother's unfinished work, as well as Clara Eimmart (1676–1707), who assisted her father in producing scientific illustrations of flowers, insects, and birds. Others were Barbara Regina Dietzsch (1706–1783) and the Fürst sisters (Magdalena, 1652–1717), daughters of the Nuremberg publisher Paul Fürst.

The women painters of Holland were also specialists whose work was revered and much sought after. Clara Peeters (1594–1657) made a name for herself in early Dutch still lifes. Her cool and sober but brilliantly composed arrangements of everyday objects seem to be full of life. Maria van Oosterwijk (1630–1693) was renowned for her paintings of flowers. The paintings are captivating in their luxurious splendor and delightful in their accurate detail. Several European courts commissioned work from her. There was also a great demand for the work of the somewhat younger Rachel Ruysch (1664–1750), the celebrated "princess of painters," as she was called in a portrait. Her still lifes depicting flowers in luxuriant abundance tended toward the less formal style of the Rococo. She was appointed court painter at Düsseldorf, where she spent a certain amount of time, even though she was the mother of ten children. As far as we know, the only woman painter who went further than just painting portraits and still lifes was Judith Leyster (1609–1660). She was a member of the painters' guild in Haarlem and had her own studio and pupils. Her vivacious genre scenes in the style of Frans Hals and her intimate society paintings with light effects typical of Gerrit van Honthorst were for a long time ascribed to these two masters. This testifies to the sensitive character of her art as well as to her expertise. As late as 1893 her signature was discovered on a painting which had been attributed up till then to Frans Hals.

Apart from the women painters involved in workshop production, there was a surprising number of women court painters, with their numbers growing from the eighteenth century onward. A court position required great artistic talent and a good education as well as social skills, as the princesses often regarded their court painters as companions and confidantes. Elisabeth Vigée-Lebrun (1755–1842) was very close to Queen Marie-Antoinette, whom she often painted, and Adélaïde Labille-Guiard (1749–1803) had a similar relationship with the French princesses, to whom she was court painter. At the Medici court in Florence, Maria Magdalena of Austria claimed the attention of Arcangela Paladini (1599–1622), and at the same court Guilia Vittoria Farnese sought the company of the painter Camilla Guerrieri (1628–1644). In 1721 the Saxon court appointed the miniature painter Anna Maria Werner-Haid (1688–1755) as court painter. In 1766, the one sculptress of repute, Marie-Anne Collot-Falconet (1748–1821), was invited, together with her father-in-law and teacher Etienne Maurice Falconet, by Catherine II to the court at St. Petersburg. The natural, classicist simplicity of her portrait busts (including one of Catherine herself) was warmly received there. It seems likely that she sculpted the head for Falconet's equestrian statue of Peter the Great, although this is not known for sure. Anna Dorothea Therbusch-Lisiewska (1721–1782) was frequently commissioned to make portraits at the Stuttgart and Mannheim courts, even though she unsparingly incorporated her keen psychological observations into her work.

All these women painters, who were very popular at court, were portrait painters (apart from those who specialized in flowers). This is no coincidence: portraits in the eighteenth century, especially those painted by women, met a variety of demands. This is best illustrated by the work of Vigée-Lebrun, who painted portraits of distinguished ladies almost exclusively. Her delicate style imbues all of them, regardless of their individual characters, with elegance, refined sensitivity, and soulful subjectivity. Labille-Guiard as well as other less talented artists were all skilled in producing this gentle,

attractive quality. The pastel drawings of Rosalba Carriera (1675–1757) came closest to the contemporary ideal. She was a celebrated artist (though vastly overrated) when she came to Paris in 1720, well known for the lightness of her technique and the flattering, gentle gestures that gave her models an air of unclouded felicity. But even the more strictly rational and serious portrait work of Therbusch-Lisiewska appealed to the sentiments of late eighteenth-century aristocratic circles.

Recognition by the court nearly always led to academic honors. Many women were members of art academies. In 1767, Therbusch-Lisiewska was appointed member of the Paris and Vienna academies. This was no longer exceptional at the Académie Française (founded in 1635), as it already had several women painters as its members in the seventeenth century. However, the work of Cathérine Duchemin (1630–1698), Anne Marie Renée Strésor (1651–1713), and Elisabeth Sophie Chéron (1648–1711) which brought them this honor is little known today. In 1783 Adélaïde Labille-Guiard was appointed to the academy on the same day as her rival, Elisabeth Vigée-Lebrun, and in 1790 she was further distinguished with a fellowship. At the age of twenty-one Angelika Kauffmann (1741–1807) was made a member of the Florentine academy, and she was a founding member of the London academy. In the eighteenth century nearly all the academies included women in their membership, though they were admittedly exceptions.

There are a number of valid assessments of women's artistic achievements in this era. It depends on whether one is judging from the viewpoint of art history or social history. Most art historians would note the sensitive and delicate nature of women's art, and they might mention its tendency to be faithful and conservative rather than bold and innovative. Few would suggest that among these women are any "great artists." But the very fact that women were engaged in artistic activity prepared the way for their emancipation: their involvement in the arts helped them create an awareness of their intellectual potential.

LADIES AND CLOTHES

FASHION made a considerable claim on the time and money of the upper classes. It had even wider-ranging effects on political and economic life of European nations. Diderot's *Encyclopédie* gives us a simple assessment of fashion. It is defined as having a dual purpose: to make oneself beautiful and to spur on the economy of a clever state. The author of the section of fashion talked of the "desire to be more attractive than others" and "to be more attractive than one actually is." He thus identified the two determining features of Baroque fashion: (1) the striking, unusual element, and (2) an artificial element ("artificial" in the sense of correcting the natural shape of the body). In the same sentence he also mentioned the word "luxury," which points to another basic feature, that of extravagance. Extravagance, in fact, was a goal in itself and not just something that had to be taken into account. The people living in the age of Baroque fashion had themselves identified their desire for the unusual and for superabundance as the main driving forces behind an era in fashion that brought forth some strange results.

A society which would go to any lengths to shape its entire environment—from its architecture and nature itself right up to the most trifling utensil—into a uniform artistic structure must have had difficulties with the human form. Man's natural appearance was in conflict with ideal Baroque forms. It could not be easily transformed into the display of magnificence that was possible in other areas of culture and art. Its perhaps most infuriating shortcoming was the fact that it gave no indication of social rank. Her Majesty the Queen was by no means guaranteed by nature to have a more splendid and distinguished appearance than any peasant woman. These unfortunate inadequacies of nature could be rectified, to some extent at least, by clothes and hair styles.

The fact that all human beings have the same basic shape must have been extremely irritating to people in the seventeenth and eighteenth centuries. At that time the division of society according to rank and class was reaching a peak that has never been surpassed.

The various regulations on who could or could not wear certain kinds of clothing reveal the persistence with which the upper classes fought against those members of the lower ranks who refused to conform to the rules of dress defining their class. Decrees on dress were common from the fourteenth century onward, but it was not until the seventeenth century that they frequently took on the form of complaints, abuse and polemics harshly criticizing the presumptuousness of the lower classes in encroaching on the privileges of fashion of their superiors. Prohibited, for example, were precious fabrics, like brocade, velvet, taffeta, as well as the farthingale, the décolleté, and lace. In 1680, for example, the city fathers of Leipzig were forced to admit "with regret and great displeasure" that their "salutory decrees" no longer had the right effect on those they were intended for. Thus new decrees were regularly issued by mayors, princes, and even by kings and emperors—and, it would appear, were just as regularly disregarded. Warnings were made again and again to craftsmen's wives and the daughters of the bourgeoisie because they were wearing dresses that were more exquisite than those of noblewomen. The punishments for wearing such dresses, for example fines of twenty to forty talers or the confiscation of the prohibited garment, were used only hesitantly and had therefore no effect. Ordinary women also dared to wear silver lace, something reserved for members of the court. How could the aristocracy possibly outdo the lower classes when they were spending so much on their attire! A Bavarian decree on dress dated 1683 mentions that many members of the upper classes would like to dress more modestly but dare not because they would then no longer be distinguishable from the lower classes.

That the upper and lower classes be immediately distinguishable was regarded as an obvious necessity and was therefore an important aim of the laws of dress. A Bavarian police regulation of 1599 stated that everyone had to dress according to rank "so that noblemen can be recognized and distinguished from commoners and likewise priests from lay people, townspeople from peasants, masters from servants and mistresses from maids." The law makers of Freiburg,

for example, were so convinced of their rights that in 1667 they went so far as to maintain that there would be a "divine punishment" for the unbearable arrogance and extravagance which eroded the distinction between middle-class girls and maids, and between noblemen and servants. Other law makers were not always so direct. They usually took pains to lend weight to their wishes with the aid of moral decrees. The city fathers pretended that they were worried about the welfare of their subjects, who were destroying family relations by spending too much on clothes. According to the decrees on dress, those who clothed themselves as was befitting to their ranks were paragons of virtue, respectability, and divine pleasure. Those, however, who overstepped the confines of their class were accused of arrogance, thoughtlessness, and immorality.

The moral arguments used to explain the necessity of following the rules on dress provided great scope for preachers. They were obviously pleased to have this inexhaustible source at their disposal for vociferous and, at times, coarse lectures and admonitions. They were as worried about moral standards being neglected or weakened as they were annoyed at senseless extravagance. It is even possible to discern at times some moral criticism of the life-style enjoyed by the privileged classes. This did not degenerate, of course, into subversive ideas; the "clerical thunderstorm" poured down on masters and servants alike. The sermons were aimed at making everyone behave according to his or her rank. Maids were to be modest, honest servants; mistresses were not to misuse their privileges. Nonetheless, Abraham a Santa Clara (1644–1709), preacher to the imperial court at Vienna, loudly deplored the "fashion mania among women," whether empress, archduchess, or their noble entourage. He, together with other famous preachers, fought against the dissipated, extravagant habits in dress at court and against certain trends in fashion which they thought indecent. Bourgeois principles of common sense and thrift and Christian ideas on morality, as expressed by the Reformation and interpreted more strictly in Dutch Calvinism, English Puritanism, and German Pietism, were combined with the renunciation of all external, worldly values to gain spiritual piety as preached by the Counter-Reformation of the Catholic Church.

If we look at portraits and court paintings of that era, it is clear that the mania for finery and fashion was no weaker among men than among women. All the sermons, essays, tracts, and contemptuous pamphlets, however, held women responsible for the neglect of thrift and virtue. It was they who encouraged their husbands to waste money. The idea that women were the origin of all sin, propagated by the Christian Church for centuries, was applied here too. The book *Neue alamodische Sittenschul* (The new alamode school of customs) published in 1713 said:

So many men would stay honest in their jewelry trade if it were not for the extravagance of their wives, who are ever obsessed with the devil of vanity! If I

only had the money which our tender voluptuous German ladies coax out of their husbands' purse and waste on pearls, rings, chains, necklaces, head covering which grows bigger from day to day, bonnets, fontanges, costly hats, lace, braid, galloons, balm, perfumed hair powder and toilet water: I would not only dare to wage a war against the Turks but also drive them out of Candia, Cyprus and even the Holy Land.

The emergence of rhetorical overstatement is unmistakable if we compare this tract on morals with a sermon by Archangelus a Sancto Georgio (1661–1718). In contrast to the rather petit bourgeois *Sittenschul*, he addressed the wealthier classes and cursed them for not giving alms any more. After all, "what with their beautiful estates, countless subjects, enormous incomes, appointments and favors" they had nothing left. He went on to say:

How is that possible? It is only too possible! . . . If one just takes a look at the pomp and majesty, pride and arrogance, haughtiness and abundance of everything in the world today, one can soon work out that the sums spent are great, sometimes two or three times greater, than the income received. If all the silver and gold, pearls, precious jewels, rings, bracelets, satin and silk, taffeta and linen, braid and lace, worn not as necessary or befitting attire but as an extravagant luxury, for pride and vanity, often indeed a thoughtless outrage, if all this was removed from just one of its foul, maggot-infested bearers and exchanged for gold, just think how many hungry bellies it could fill and how many naked bodies could be covered and clothed with it.

These social and moral criticisms of customs and fashions, with their indirect reference to the unjust distribution of goods as something incompatible with Christian brotherliness, were essentially restricted to tracts and sermons. There seemed to be little awareness of the enormous contrast between the life-style of the wealthiest and the poorest classes. There was also hardly any mention made of the fact that all the controversies surrounding the follies of fashion, all the statements about the huge variety of Baroque fashions in clothes only affected a relatively small section of the population. We can see from the occasional illustrations and paintings of other than wealthy bourgeois or upper-class subjects that fashion had no meaning for the vast majority of the population, for the hordes of beggars, vagrants, day laborers, and peasants. Their rags are portrayed in a sober and factual way.

In paintings, they were often given a picturesque quality and were sometimes even glorified. We must always bear in mind that the concept of "Baroque fashion" means the fashion of the upper classes and excludes the bulk of the population.

It was left to the churches to make tentative exhortations about the social injustice and immoral nature of the lavish extravagance displayed by the nobility and the wealthy middle classes. Ecclesiastical and secular authorities worked together to preserve virtue and responsibility.

In both 1653 and 1654, Maria Anna, a strict Catholic and widow of the Elector Maximilian of Bavaria, issued decrees to prevent coun-

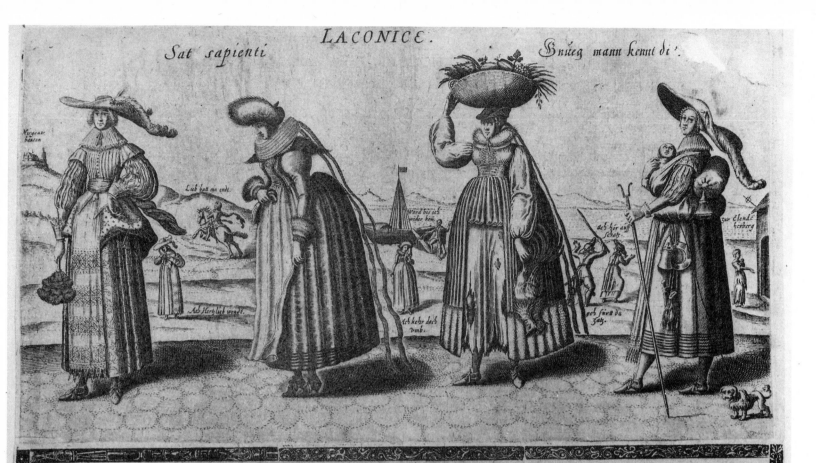

LACONICE.

Sat sapienti Gnueg mann kennt di.

1.	2.	3.	4.

‹132› Women of the aristocracy and the middle classes, maids, and prostitutes are reprimanded,
each according to their rank, for their vanity. This vice leads to impudence, extravagance, idleness, and finally to beggary.

Pamphlet against women's vanity.

Copperplate engraving, Strasbourg: 1630, Staatliche Galerie Moritzburg, Halle

try women from wearing shorter-length skirts or low-necked bodices. She appealed to their natural modesty and urged them to behave decently, especially at dances (where peasant girls were used to hitching up their skirts). Municipal authorities were also concerned about the respectability of their female citizens. The décolleté fashion from France aroused enormous indignation among the city fathers, but this was also fired by German nationalist sentiments. The Spanish fashions of the Counter-Reformation completely concealed the female body and hid its natural shape. They soon spread throughout the rest of Europe and became an indication of female respectability. The new French fashions seemed extremely indecent, as they exposed bosoms and shoulders or only veiled them with delicate tulle or lace. In 1667, the city of Freiburg prohibited this "indecent clothing" which "hides vulgar minds, thoughts and a dissolute way of life." In 1662, Brunswick banned its women from "shamefully and vexatiously exposing their breasts." In the 1630s Leipzig seems to have repeatedly prohibited this low-necked fashion, which would indicate that the bans had little effect. They might have delayed the introduction of the French style here and there, but they certainly could not stop it.

From the beginning of the seventeenth century, certain groups of people dedicated themselves to ensuring that women were chastely dressed. This is borne out by hundreds of polemics, mostly anonymous, on the subject of décolletage. With pedantically detailed arguments, they endeavored to persuade the women who had been led astray by this foreign fashion to revert to the good old tradition. The title of one of these publications (1687) is *Dass die blossen Brüste seyn ein gross Gerüste viel böser Lüste wird dem züchtigen Frauen-Zimmer zu Ehren und den unverschämten Weibs-Stücken zur Schande erwiesen* (Honest women can be respected for not exposing their breasts as a source of evil temptation, as do loose women). It is full of laborious arguments but at the same time clearly states the belief that freedom in dress could undermine public discipline. A short treatise of 1689 bore the title: *Die zu jetziger Zeit liederlich und leichtsinnig entblössten Brüste des Frauenzimmers und die darauf gehörige und hochnöthige Decke* (The current rash and dissolute exposure of women's breasts and the proper and urgent need to cover them). The table of contents aptly illustrates this disputatious literature, which nowadays makes most amusing reading—and which some no doubt found entertaining in those days, too, despite the pedantic detail of its moralizing arguments and the passionate tone of religious and moral indignation. Its forty-eight pages are divided up as follows:

Chapter 1: *Description of women's breasts and their commendations*
Chapter 2: *On the sins which are committed through women's breasts, especially through their disgraceful exposure*
Chapter 3: *That such exposure is a terrible sin, because it is (1) against God and his word*
Chapter 4: *Exposing one's breasts is (2) a satanic sin*
Chapter 5: *Exposing one's breasts is (3) vexatious*
Chapter 6: *Exposing one's breasts is (4) foolish and casts suspicion and disgrace on those who indulge in it*
Chapter 7: *Exposed breasts are (5) particularly damnable at a public religious service, turning it into idolatry and worship of Venus*
Chapter 8: *Exposing one's breasts provokes the wrath of God*
Chapter 9: *Refutation of the objections raised to excuse this vice*
Chapter 10: *A caution for women and men, together with some consolation and the conclusion*

The controversial issue of expenditure on clothing must, of course, be viewed from various angles. The preachers' campaign against unwarranted luxury is contrasted by a sober pronouncement made in 1771 by statesman and expert on financial matters Josef von Sonnenfels in *Grundsätze der Polizey-, Handlungs- und Finanzwissenschaft* (Principles of police, action, and finance sciences):

> All the rhetoric against splendour and luxury is . . . ill-advised . . . Luxury, on the one hand, increases demand and thus aggravates the livelihood of some. On the other hand, it creates work and therefore improves and increases the sustenance of others. Even if a citizen is ruined by wasting his fortune on luxury, he will have helped about ten working families by providing them with a wage. This argument dispels all the objections to luxury. There is only one exception. If the goods necessary for producing luxury items are not of domestic origin but come from abroad then the level of national employment is reduced and not raised.

A century had passed since priests of the Baroque age preached thrift, but the economic side of fashion assumed great importance and kept government ministers of finance and the economy busy, when, in the seventeenth century, consumption of expensive fashion goods spread among wider sections of the population. In France in the 1630s, Venetian lace became so popular that laws were repeatedly passed prohibiting the wearing of lace or limiting its use to the aristocracy so that French money would not flood into Italian coffers. If we take a look at some portraits of wealthy aristocrats of the day we will soon see what enormous sums of money were being spent on the abundance of lace decorating the clothes of both men and women. When Colbert took charge of the factories after Louis XIV had come to the throne, a fundamental change was set in motion. Colbert established efficient factories for the manufacture of lace, which at first copied the Venetian patterns but soon developed their own products with an unmistakably French character. This *point de France* quickly conquered the European market. Now it was the turn of other foreign governments to levy import controls on luxury goods from abroad and protect their still undeveloped industry against superior competition from France. In the 1720s and '30s Prussia was still involved in a prolonged struggle to maintain its wool mills, although they had neither sufficient labor nor the modern English spinning machines. Thus in 1731 a decree was issued that "no servant girls or other com-

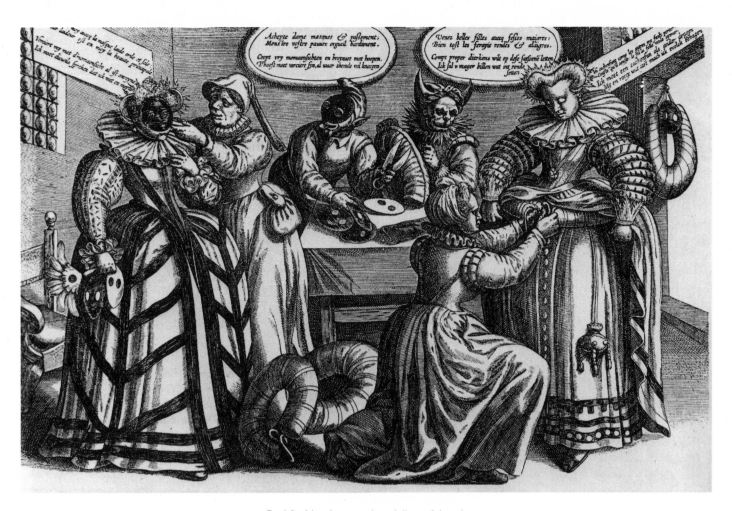

‹133› Real farthingales were the privilege of the aristocracy.
Middle-class women used thick pads to achieve the dimensions required of fashion.

Caricature on the follies of women's fashions, *c*. 1610.

Copperplate engraving, 32.4 × 30 cm.

mon women" were allowed "to wear silk camisoles, skirts or bibs." The argument that silk did not befit their rank was secondary here. King Frederick William was far more concerned that the use of imported silk would be "a hindrance to the wool mills" which were "so beneficial for the whole country."

In 1671, Leopold I prohibited all Austrians who were not of noble rank from wearing foreign articles of fashion. In 1659, without having bothered about questions of rank or morals, he had already banned all luxury goods "which are not produced in our country." This was above all directed at materials and ornaments from the Netherlands and materials and braid interlaced with gold and silver from France. In 1724, the ban on imports was lifted from those goods which could not be made in Austria. In 1749, an imperial decree allowed all Austrians—in stark contrast to the seventeenth-century

rules on dress!—to wear *domestically* produced braid trimmed with gold and silver. In such a situation it was possible for the politician Josef von Sonnenfels to dismiss the warnings against luxurious clothes as empty "rhetoric" and to argue for as much spending on fashion as possible. Since he knew that Austrian factories were capable of producing all the popular precious materials and fashion accessories, the economy would have been hampered by restrictions on clothes. Maria Theresa was highly vigilant where virtue was concerned, but even her persistent efforts to issue a new police regulation on dress, aimed particularly at the lower classes, were rejected by the royal chamber of commerce. What was the point of building up an efficient industry if it could not be used? Economic benefits triumphed over moral misgivings and even over the fear of inadequate discipline among the lower classes.

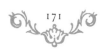

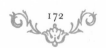

‹134› All the various little bits and pieces that contributed to fashionable dress could be obtained
in the elegant fashion shop in the gallery at the Palace of Justice—collars, cuffs, wigs, sashes, stockings, gloves, and stiff petticoats.

Jean Bérain, Fashion house "Mercure galant" in the Galerie du Palais in Paris, c. 1700. Copperplate engraving,
Bibliothèque Nationale, Paris

From the economic point of view this phenomenal extravagance, especially among the aristocracy and above all at the French court, was not totally senseless: it provided a powerful stimulus for the development of industry and foreign trade. As early as the seventeenth century French factories had concentrated on luxury goods. Many thousands of French people were provided with work and wages in the production of velvet, silk, gold and silver brocade, lace, ribbons, embroidery, and fashion accessories such as fans, wigs, and objects made with ostrich feathers. Toward the end of the seventeenth century, English cottons, which were cheap, light, and gaily printed, began to captivate middle-class as well as lower-class women, so they were promptly banned by both the French and Prussian governments. In order to market French fashions abroad and thus increase sales revenue for French goods, two life-size wax dolls were sent by Parisian couturiers on the King's instruction, first to London and later to other European capitals. One of the dolls displayed the latest in

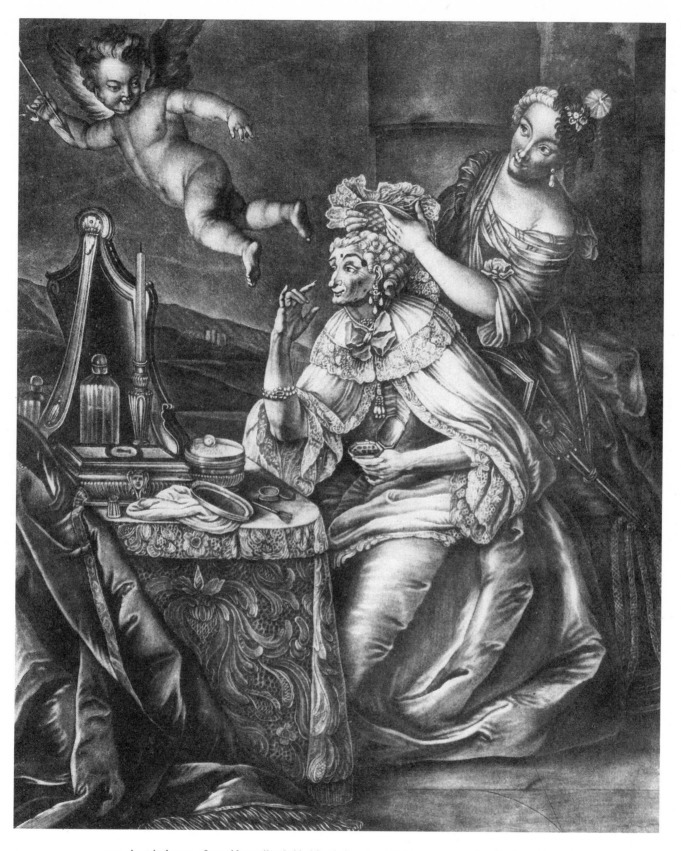

‹135› A typical scene of a maid standing behind her lady at her toilet is interpreted allegorically and is used
as a blunt warning: the old lady would be better off thinking about her grave than all this finery.

Johann Jakob Haid, *Old Age Adorned by Folly*, c. 1740.
Mezzotint. Staatliche Bücher- und Kupferstichsammlung, Greiz

J. M. Moreau inv. P. A. Martini Sculp 1777.

ceremonial dress and the other the so-called *negligé*, the more simple and comfortable informal wear. The dolls were not replaced by fashion magazines until the latter half of the eighteenth century. In 1672 *Mercure galant*, the first French fashion magazine, appeared.

Fashion and luxury goods were only used by a relatively small class of wealthy people, but they called on all their inventive powers to use as many precious materials as they could. This applied equally to the number of dresses and styles. It was not unusual, and is often mentioned in letters and memoirs, for a lady from the aristocracy to own several hundred dresses, some of which would only have been worn on one occasion. One of the most striking features of fashion creations of the seventeenth and eighteenth centuries is that they seemed to be designed with the express purpose of enlarging the surface area of the body. In this way huge quantities of the beautiful, costly materials could be shown off to their best advantage.

This led to the invention of a very peculiar fashion: the farthingale. It originated in Spain and immediately met with the approval of the Counter-Reformation. Soon it was an established part of Spanish fashion. It fitted in perfectly with the moral attitude of the Church in the Counter-Reformation as it not only completely covered up the lower part of a woman's body but also quite simply denied its natural shape. It provided extreme grandeur for state appearances, as it restrained movement and made the figure appear wide and powerful. And, finally, it used up a great deal of material. Because of these qualities it appealed to noblewomen in other absolutist states, especially in France, where it caught on very quickly. Its Spanish name *verdugado* referred to the metal hoops which gave it its conical shape. The French misinterpreted the word, changing it to *vertugadin*, meaning "virtue guardian" (which comes very close to its original purpose and inevitable effect). It was perfect as a symbol of rank, and was therefore prohibited to townswomen—who wore it anyhow if they could get hold of one. The most popular substitute was the *Weiberspeck* (female fat), thick leather-covered pads filled with horsehair placed on the hips, thus making the skirt stand out at right angles before the folds fell straight down. The effect was similar to the French barrellike version of the original crinoline. The custom of wearing hip pads provoked Hans-Michael Moscherosch, author of the *Gesichte Philanders von Sittewald* (Visions of Philander von Sittewald), to write an incensed, reproachful account (his *Straff-Schriften*) of the ridiculous fashions rampant in Germany around 1640: "What silly thing are your wives and daughters up to again with these huge padded and lined bulges? It is as if they wanted a better shape to their bodies and add on fat with such a bulge. No wonder they call these bulges and bulk fat, which often weigh up to 25 pounds. They must be really fat sows, and it is not surprising that an honest man is afraid of touching such a dirty old bag of lice."

The dictates of fashion, however, were not content to make a skirt bell out with a suitable frame. It found another dimension for displaying extravagance—placing layers of petticoats on top of each other. The farthingale itself remained hidden with at least three petticoats worn over it. The top layer was spread open at the front up to the waist, acting only as a wrap and clearly revealing the skirt underneath. Women could show off a third petticoat by gathering up the skirt in their hands. Spanish noblewomen were reputed to have worn twelve petticoats. Seven or eight were enough for French women. The imagination knew no bounds when it came to covering one dress with a variety of artistically decorated materials. Sleeves offered plenty of scope for decoration. When the farthingale went out of fashion for a while after 1620, sleeves were used to bestow breadth and grandeur on the female figure. First the shoulders were made to look much wider with stiff shoulder pads which went right round the edge of the sleeve. Then the enormously wide sleeves were puffed up into balls or were gathered and slit open in sections down the length of the arm, revealing a silk lining underneath. A century earlier there had been a craze for puffed trunk hose for men, and this same style was used to widen a woman's figure at the sleeve. This ostentatious fashion was not restricted to the court, and was extremely popular among women of the wealthy regent class in Holland.

Women certainly did not give up the farthingale to save money. Instead of using a stiff frame they gathered the uppermost skirt up to their hips so that it stood out around their hips like a huge roll (it consisted of heavy fabric) and thus matched the puffed sleeves. Even the relatively comfortable and natural costume of the mid-seventeenth century was majestic in its lavishness. French aristocratic ladies, for example, wore visible heavy velvets that fell in close pleats from the waist to the ground in a train behind them. The wives of Dutch merchants and city councilors positively rustled as they walked in their glistening robes of brocade and satin. These gowns were designed to endow the wearer with a rather solid but quite magnificent air of stateliness, and they used up vast quantities of beautiful materials. The *Vlieger* was a cape, which fell from the shoulders down to the ground but remained open at the front to display the dress underneath. Nicolaes Elias portrayed Catarina Hooft, wife of the mayor of Amsterdam, as the embodiment of dignity and wealth in this statuesque attire. It is all the more striking in comparison to the clothing of servant girls or market women seen in countless paintings by Dutch masters. Their clothes are by no means drab and they are indeed neat and clean, but their lack of embellishment, costly materials, and fashionable trimmings make them a perfect backdrop for the splendor of the regents.

From about 1670, in the reign of Louis XIV, the French court once again took the lead in discovering and establishing new fashions. There was a visible trend toward reviving the farthingale, although not right away. Metal supports were soon reintroduced to draw up the *manteau*, the heavy, usually velvet, top skirt at the back, letting it fall in a train that trailed behind for a few yards. It soon became quite

‹136› Farthingales of the Rococo impressively emphasized the tiny waist. Flowers and ostrich feathers were preferred as decoration for powdered hair.

Jean-Michel Moreau the Younger, *The Queen's Lady-in-Waiting*, 1777.
Copperplate engraving, 27.3 × 22.2 cm. Staatliche Kunstsammlungen, Kupferstichkabinett, Dresden

normal to pad out the natural curves of the hips again. It was not until the eighteenth century, after Louis XIV had died, that the farthingale came back in all its glory and remained at the height of fashion for a long time. This new version was in a far more charming and imaginative form than its Spanish predecessors. It was shorter, for instance, giving a glimpse of the feet and providing a little more freedom of movement. A more important change was that petticoats became a focal point, elegantly peeping out from below the top skirt, now open at the front or gathered up in several places and finally drawn up into large bustles padded out at the side and the back. The petticoat could now be embellished with garlands of imitation flowers, lace, flounces, bows, frills, braids, pompons, and embroidery— every imaginable kind of trimming, which made up the main attraction of the farthingale and, like it, cost a fortune.

The circumference of the farthingale increased in a frightening manner and to such an extent that it seriously hampered social intercourse. Of course, no lady could go without a farthingale of the latest fashionable size (some of them were four meters in circumference) as they were also worn, admittedly in smaller versions, by ordinary women. The formal gown of one of Marie Antoinette's ladies-in-waiting, as portrayed by J.M.Moreau the Younger in 1777, required a farthingale so wide that the lady could place her stretched out arms comfortably on top of it. It had an oval shape (that is, flatter at the back and front) and to compensate for this a huge bustle and train were attached at the back. The farthingale fashion had, without doubt, reached its peak here, but it was still not finished. Farthingales held on to their popularity until well into the nineteenth century. The women of the ruling bourgeoisie found it attractive and suitable for the same reasons that made it popular among the aristocracy.

So far we have spoken only of skirts, which were indeed an essential element of a noblewoman's attire. The magnificent appearance of the skirt was equally matched by the frame given to the head. Like the farthingale, the ruff also originated in Spain, and was likewise intended to restrict freedom of movement to a ceremonial minimum. In this way, and again by denying the natural shape of the body, it emphatically distanced the wearer from the common people. Furthermore, it was extremely expensive. A certain Frenchman is believed to have said that he wore nearly thirty acres of the best vine-growing land around his neck. This is not difficult to understand, as ruffs were made from the best linen, densely pleated or layered. Since the ruff encompassed the width of the shoulders and was up to ten centimeters thick, it was clearly impossible to skimp on the linen. Ruffs were even more expensive if the edges were trimmed with lace. Isabella Brant can be seen wearing this kind of ruff in Peter Paul Rubens' self-portrait with his wife (1610). It not only constituted a graceful frame for her face but was also a sign of the couple's wealth. By the beginning of the seventeenth century most men had stopped

wearing a ruff. In general, men tended to opt for more practical clothes because of their professional or military commitments. Women were not really affected by these considerations. Two decades passed before women in France abandoned this mark of rank which framed the head in a dignified and flattering manner, giving it the appearance of a precious object displayed on a ceremonial platter. The women regents of Holland found it particularly hard to part with the ruff, and continued to wear it well into the second half of the century. Until then, the large ruff remained a feature of conservative formal wear which was sure to create an aura of power, wealth, and everlasting security. After 1710, women in Holland and France who were young and less inhibited by the confines of their rank finally joined the new craze for lace. These delicate and costly creations still exuded an air of luxurious elegance and exclusiveness, even when in the latter half of the century they were used to decorate every bit of clothing worn by men and women, and were indispensable to people of high rank. Lace collars first enjoyed huge popularity when they were still imported from Italy. It was turned up at the back to surround the head like an open fan. It was a picture of splendor and grace and preferable to the ruff which, for all its refinement, was rather severe. When it became the fashion to wear them flat on the shoulders, lace collars became increasingly wide until they reached halfway down the arm, rather like a mantilla. This is illustrated in many French paintings of the 1630s and '40s, regardless of the ban on imported lace.

It was possible for the Dutch and the Flemish to decorate with lace their generally rather puritanical clothes so lavishly because the Netherlands had been able to use their own flax to produce lace several decades ahead of France. Dutch women were always refined and sparing in their use of lace, whereas the French abandoned themselves to this fashion to the point of idolizing lace and spending incredible sums of money on it. Even shoes were embellished with lace, complete dresses were made out of it, and yards and yards of it were used as trimmings. In such circumstances, it was inevitable that women finally started to include lace in their hair styles.

In the 1680s the fontange was created in France. This was a coiffure that was so uncomfortable (and so ugly in our eyes) that it is difficult to comprehend how it ever managed to remain fashionable for a good three decades. The hair was piled up high over a wire frame. Most people's hair was not usually long or thick enough for this style, so the hair stylist would use yards of ribbon and lace—as well as hairpieces—to bring this peculiar structure up to its usual height of about sixty centimeters. Apparently, coiffures which were a meter high were not impossible, although perhaps exceptional. An anonymous work dated 1690 called the current female hair styles a "storm-bonnet" and described it as a "great nest of all kinds of hair, lace, ribbon and frills piled up so high that it is twice the height of the wearer's head and looks as if two heads were standing on top of one anoth-

‹137› The spray of flowers indicates that the young woman is a bride wearing ceremonial dress.
This is shown by the costly lace material, the cuffs, and the wide ruff.

Cornelis de Vos (?), *Portrait of a Woman*, 1627.
Oil on canvas, 104 × 79.5 cm. Museum of Fine Arts, Budapest

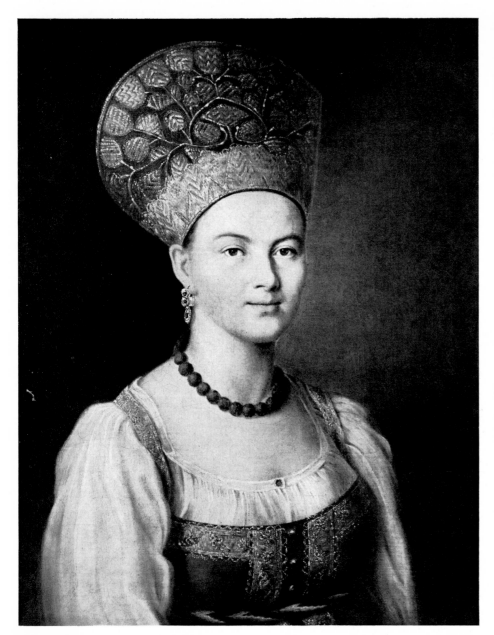

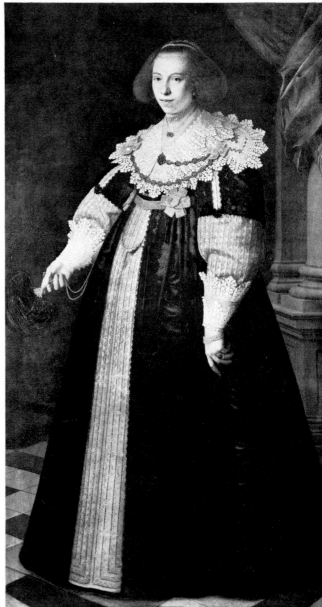

‹138› An unknown woman, not of peasant stock, shows off the
ceremonial dress of the peasants. The national headdress, the *kokozhnik*,
is beautifully embroidered and is extremely decorative.

Ivan P. Argunov, *Portrait of an Unknown Woman in Russian National Costume*, 1784.
Oil on canvas, 67 × 53.5 cm. Tretyakov Gallery, Moscow

‹139› Capes were open all the way down the front
to display the more brightly patterned dress underneath.
Both were made of heavy material and gave an air of importance to the wearer.
The double lace cuffs and wide lace collar indicate unusual luxury.

Nicolaes Elias, *Catarina Hooft, Wife of the Mayor of Amsterdam, Cornelis de Graeff*, before 1652.
Oil on canvas, 185.5 × 105 cm. Staatliche Kunstsammlungen, Gemäldegalerie, Berlin

‹140› to ‹145› The Bohemian artist and copperplate engraver Wenzel Hollar
produced a comprehensive series of engravings entitled *Aula Veneris—Theatrum
Mulierum* (Palace of Beauty—Women's arena) in which he depicted European
fashions from various classes. The illustrations show a Parisian matron,
a maid from Cologne, an English countrywoman, a woman of the French nobility,
a woman from Upper Austria, and a lady from Cologne.

Wenzel Hollar, from the series *Aula Veneris—Theatrum Mulierum*, 1640s.
Copperplate engravings, 9.3 × 6 cm. Staatliche Bücher- und Kupferstichsammlung, Greiz

a French Matron

Matrona Parisiensis.

a Servant Maid of Cologn

Ancilla Coloniensis.

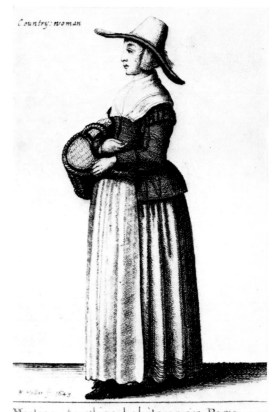

Country woman

Mulier Anglica habitans in Pago. 11

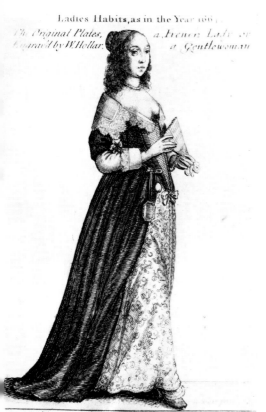

Ladies Habits, as in the Year 166

Th. Original Plates, *a French Lady or*
Engrav'd by W. Hollar. *a Gentlewoman*

Mulier Nobilis aut Generosa Gallica.
Printed for John Bowles, at N.º 13 in Cornhill.

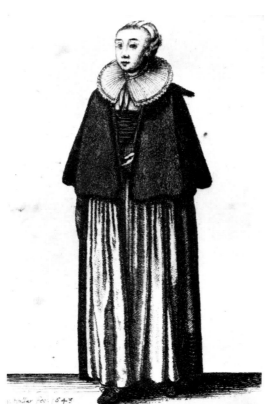

Mulier Austriæ superioris.

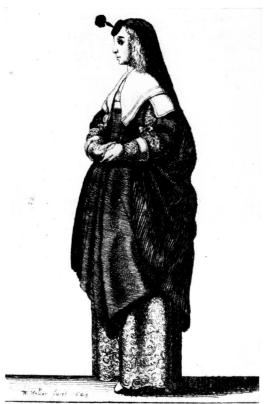

Mulier Generosa Coloniensis.

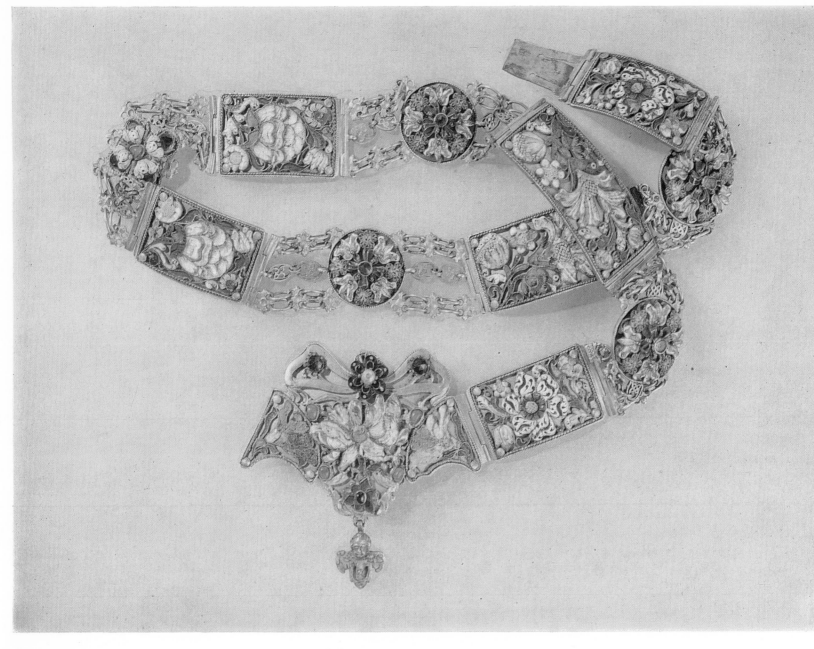

‹146› Delicate gold work on a woman's belt made from
silver links and Transylvanian enamel was just as important for the Hungarian national
dress as bracelets, chains, coat fasteners and hair decoration.

Woman's belt, silver and Transylvanian enamel, c. 1700.
Length 68 cm. Hungarian National Museum, Budapest

‹147› Anna Julianna Nádasdy, the wife of the Hungarian judge,
is wearing ceremonial robes of enormous value. She has several rows of pearls
on her bodice and around her arms and neck, a hair-band studded with jewels and
a wide band of pearl trimming around her collar.

Benjamin Block, *Portrait of the Countess Anna Julianna Nádasdy*, c. 1656.
Oil on canvas, 182 × 121 cm. Hungarian National Museum, Budapest

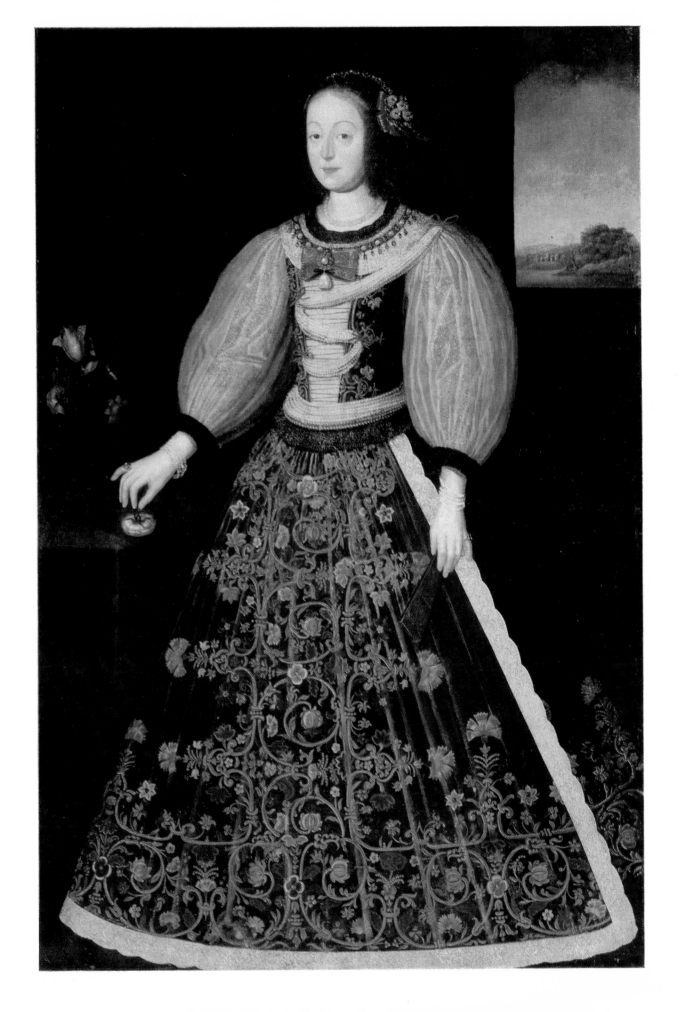

Mᵐᵉ la Duchesse
du Lude

‹148› A *levée* at the court of Versailles provides an opportunity
to demonstrate the fashion for aristocratic women in the time of Louis XIV.
The hair is swept up with only a few locks falling on the shoulder.
Little black beauty spots *(mouches)* are used to adorn the face and décolleté.
At least two layers of skirts are visible and the seated princess reveals three.
The top skirt, made from an especially heavy material, is gathered
up over the hips into a bustle (supported by pads or metal frames) which
falls into a train behind. The sleeves and collars are lavishly decorated with lace,
and the dresses are trimmed with precious stones. The gathers are
held in place by jeweled pins.
Nicolas Arnoult, *The Duke of Burgundy Visiting the Princess of Savoye During Her Toilet*, c. 1690
Copperplate engraving. Bibliothèque Nationale, Paris

‹149› A set of toilet articles trimmed with lapis lazuli.
Augsburg, *c.* 1730–1747, Staatliche Schlösser, Gärten und Seen,
Schloss Nymphenburg, Munich

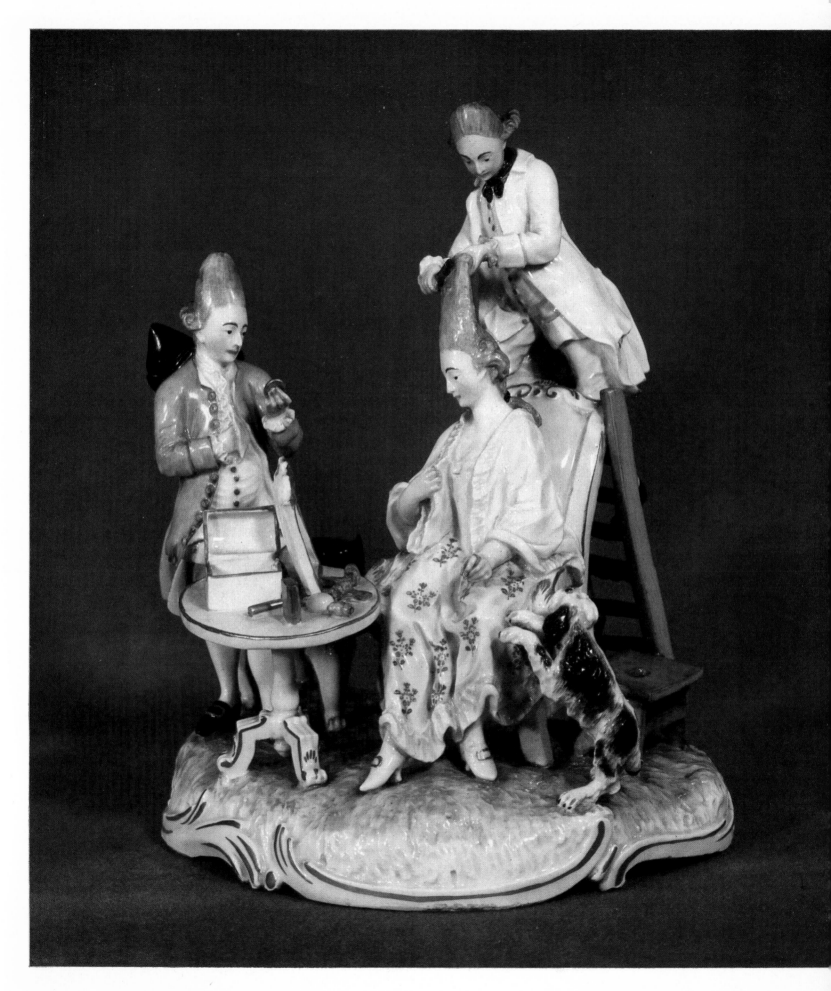

‹150› There are endless jokes about the height
of some hair styles. The hairdresser has to work from a ladder in this caricature.

Hairdressing scene in Frankenthal porcelain, 18th-century
model by K. G. Lück, Wella-Museum, Darmstadt

‹151› Fashion accessories for well-dressed middle-class women
of the eighteenth century included fans, bottles for smelling salts, and lace
scarves as well as hymnbooks.

Historisches Museum, Basle

‹152› and ‹157› These gowns from the first half of the eighteenth century
are made out of costly French brocade (outside left and right).

Dresses for the wealthy, 18th century. Bayerisches Nationalmuseum, Munich

‹154› and ‹156› Shoes were an important fashion accessory with
their pointed toes, curved heels, and embroidery or openwork patterns.

Ladies shoes of the 17th and 18th centuries
(Ill. 154 top: *c.* 1700, bottom: *c.* 1780; Ill. 156 top: *c.* 1720, bottom: *c.* 1680).
Museum zur Geschichte der Fussbekleidung, Weissenfels

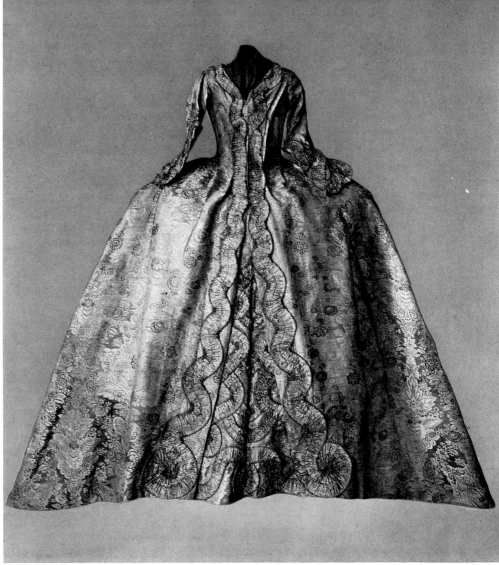

‹153› and ‹155› Before fashion magazines became
widespread dolls were used to demonstrate the latest fashion in full detail.
These two dolls display the skirt that was typical of the early eighteenth century.
The top layer is gathered up at the hips and left wide open at the front
to show off the decorated layer below.

Two French fashion dolls, 18th century.

Spielzeugmuseum, Sonneberg

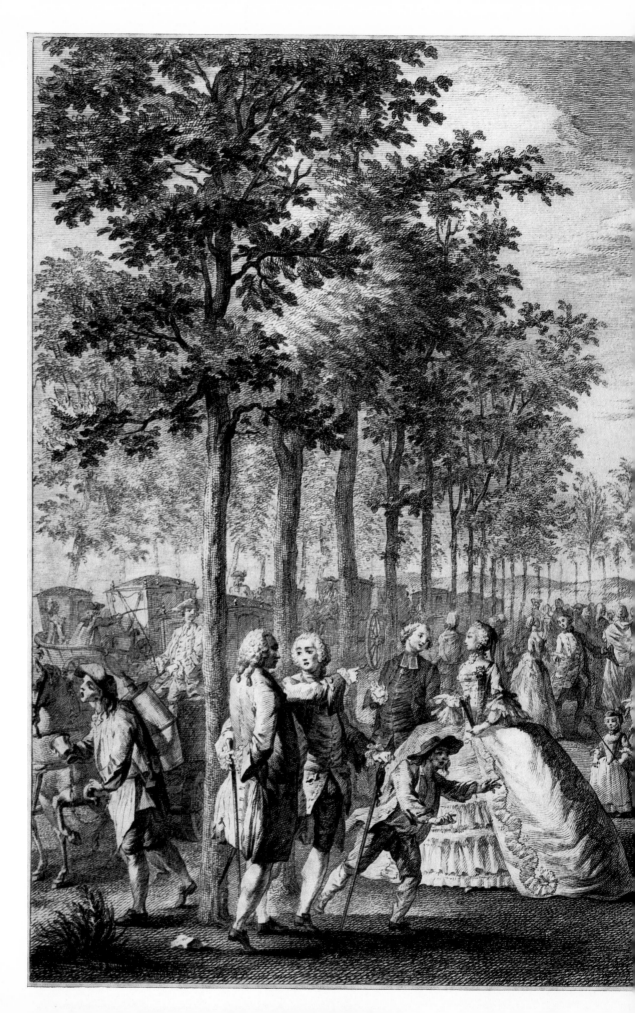

‹158› The huge farthingales
of the mid-eighteenth century were
a real obstacle at doors, in coaches,
and when out for a walk.

Pierre-François Courtois
after Augustin de Saint-Aubin,
Strolling Along the City Walls of Paris,
c. 1760. Copperplate engraving,
28.8 × 38.6 cm.
Staatliche Kunstsammlungen,
Kupferstichkabinett Dresden

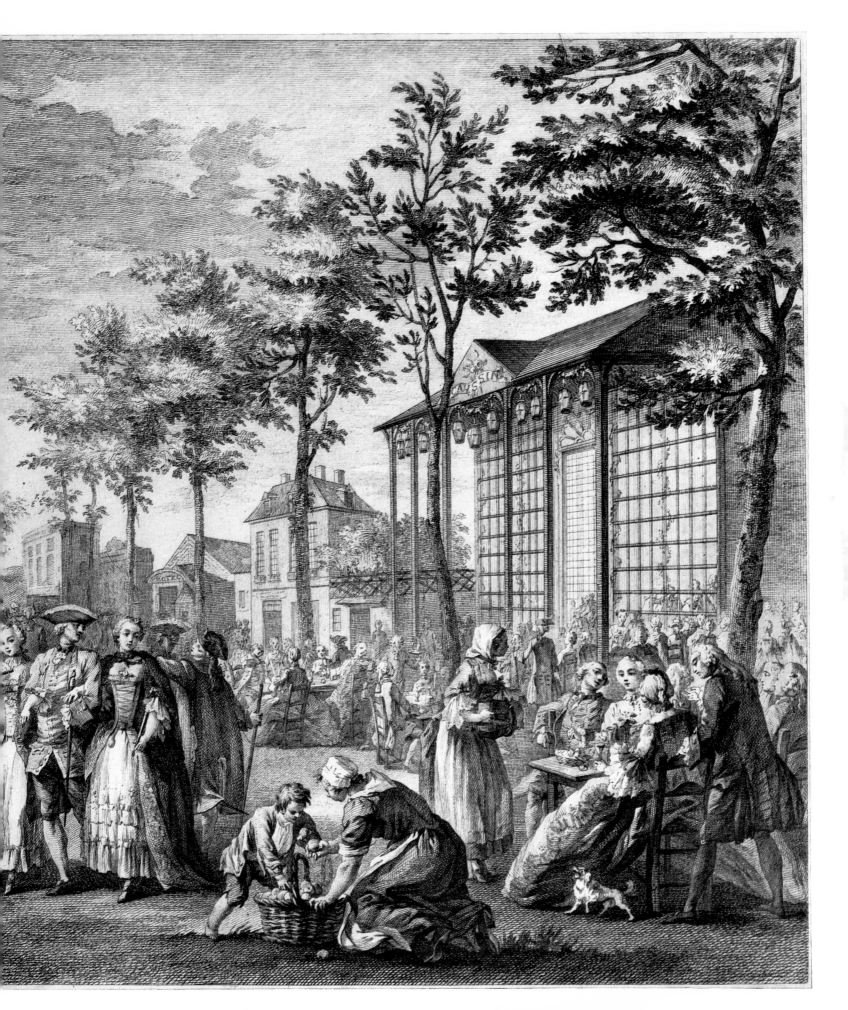

 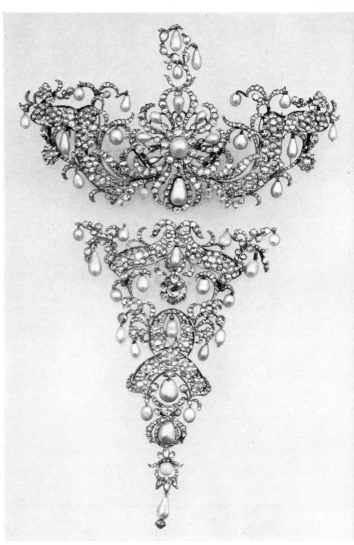

‹159› and ‹162› Throughout the seventeenth and eighteenth centuries lace
remained the most costly and artistic fashion accessory. Around 1665, sewn Venetian lace
with its flat and raised sections went well with the current pompous fashions (outside left).
The light French pillow lace of the 18th century (Northern France, *c.* 1780)
was suitable for various kinds of trimming as well as for entire gowns (outside right).

Lace. Museum des Kunsthandwerks, Leipzig

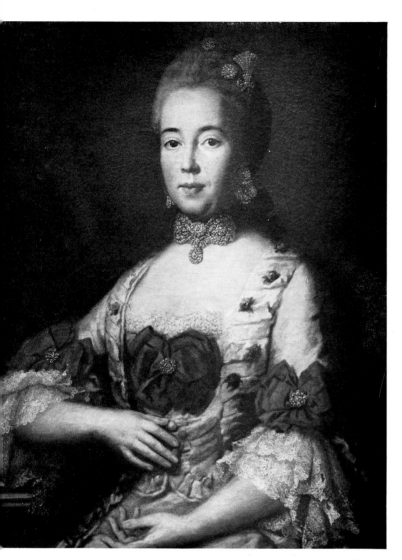

‹160› The brooch, a decoration for the bodice, emphasized the laced
waist of aristocratic dress. The one illustrated here splits into two parts and is made
of silver with diamonds and pearls (inside left).

Brooch, German, *c.* 1710–1720.
Staatliche Schlösser, Gärten und Seen, Schloss Nymphenburg, Munich

‹161› The picture shows precious jewelry of the Rococo: aigrettes, bow-shaped
brooches, and jewels which bring out the rosettes on the bodice and sleeves (inside right).

Georges de Marées, *Countess von Hohnstein*, 1773.
Oil on canvas, 88.5 × 70.5 cm. Stadtmuseum, Bautzen

‹163› This sewing basket in Meissen porcelain is decorated with scenes after Watteau,
as is the penknife. Perfume bottles often take the shape of figures or bouquets of flowers. Their dainty form
indicates that they are intended for ornamental rather than practical use.

Meissen porcelain, *c.* 1750. Staatliches Museum, Schwerin

er—quite disgusting, inhuman and frightening to behold." The fontange took the place of the farthingale. Since the human figure was bereft of its abnormal breadth, it sought to compensate for this loss in staggering height. The motivation behind both creations was to expand natural human dimensions, which were regarded as deficient. Only the desire to gain a majestic increase in height could have allowed this bizarre hair fashion to survive for so long.

A woman in the seventeenth and eighteenth centuries paid a high price to be a lady. She not only paid out excessive sums of money but also risked her health, vitality, and natural urge for activity in order to set herself apart from the mass of women who lived by working. Upper-class fashion and, above all, fashion for women, endeavored with all its devices to demonstrate idleness and to deny nature in order to maintain a gulf between the upper classes and the normal or "vulgar." The fashionable views of beauty, no matter how they might vary, were formed out of a contempt for work. Women, in particular, exposed themselves to a systematic undermining of all their bodily functions in order to achieve a stylized and ornamental ideal which fitted the aesthetic outlook of a powerful and idle ruling class. Beauty meant excessiveness in material value and external appearance—proof that there could be no limit imposed on the desires of this class.

Not only did the skirts hamper women's movement but so did the weight they had to drag around with them. There was metal stiffening around various parts of the body, the material itself was heavy, and it was made even heavier by embroidery in gold and silver thread. Then came the jewelry. It was expected of people in particularly high positions or at special occasions to indicate their prestige with riches that far exceeded the usual display. Gowns were trimmed with thousands of precious stones, pearls, and gold work. There are plenty of spiteful anecdotes written by women who were not quite so heavily burdened, describing the virtual immobility of these lavishly adorned ladies.

It was not enough that the ostentatious shape of the skirts, trains, puffed sleeves, and hair styles enormously extended the contours of the body, they also had to be properly set off. A laced-up bodice and planchette were used for this purpose first in Spain, where it also functioned to suppress the female form, and then in French fashion, where together with the décolleté it showed off the breasts to their best advantage. In order to achieve the desired effect, one laced up the body mercilessly tight and, with the help of metal stays extending down to the lower abdomen, the body looked like a thin stalk supporting a head and breasts. Even if the paintings by Watteau, Boucher, and de Troy were meant to be flattering, the effect thus achieved was certainly charming. The whole point was to gaze at the result of the hours of work that went into turning women into works of art day after day. The well-known aristocratic custom of dealing with all kinds of business during the morning toilet was based on the

‹164› Berlin fashions of the late eighteenth century.
Daniel Chodowiecki. 1781. Ornamental copper, 9.5 × 5.1 cm.

length and laborious process of transforming women—and men too, incidentally—into living works of art. Like Baroque festivities they had the disadvantage of being highly transitory but at the same time allowing innovations to be introduced every day. The morning toilet was as open as possible because there was no spectacle like the artificial creation of female beauty. This naturally included make-up, powder, and the much-cited *mouche*, the little beauty spot that took the form of a tiny moon or star, or when larger, a dove or cupid. The

mouche emphasized the powdered whiteness of the skin; in other words, it gave artificial color to the artificial, masklike pallor. Makeup was not used to achieve a natural look; the painted face was not supposed to contradict the character of a painting. The hair styles of the late Rococo were therefore extremely paradoxical. The fashion desire for "naturalness" (an inept attempt to adapt bourgeois ideals) led to a·heightened artificiality. In 1775, we find the following serious—not sneering—comment made in a Berlin newspaper about Parisian noblewomen:

> *. . . here is a woman with a village on her head, there with a whole forest, then another with a broad meadow or a huge bridge, others with windmills. One can imagine that these structures are quite spacious. Some of them provided the artist with an opportunity to raise the value of this ornamentation by adding a mechanical part. Where there was room he hid little organs which play on their own from time to time, and sometimes even canaries that flap about.*

It must be said that from about the middle of the eighteenth century a number of enlightened objections were raised. They did not attack the principles of dressing according to one's rank, but simply drew attention to the harmful effect of "the coercive instruments of beauty," referring to the corset, planchette, the misuse of powder and paint, and high-heeled shoes as "hidden thieves and murderers," which "worked untold damage to the insides" of women "turning them into sick and wretched machines during their lifetime." Western European travelers to Russia, who were used to seeing their women in tight corsets, were clearly struck by the completely different fashions of Russian women. When describing their journeys, as in the account by the Frenchman Jacques Margeret, they frequently remarked on the long, loose dresses falling in soft folds. Their dresses were "as wide at the shoulders as they were at the hem, usually in scarlet or some other beautiful cloth; underneath they wore a silk dress with sleeves which were wider than a Parisian ell." They made a veiled critical comparison with the fashions in their homeland by quoting the Russians as believing this "was healthier, that their bodies had enough room to take in food properly without hampering their digestion. This was much better than wearing tight dresses which were so firmly laced and tied that it hurt." However, even Russian women—that is, the wealthiest and most distinguished ones—had to carry a considerable weight around when dressed in their state robes. There was no difference here from Western European fashions. The travel descriptions reverently list the huge quantities of material threaded with gold, velvet, satin, damask, pearls, precious stones, gold and silver embellishments, and fur trimmings which were all considered a necessary part of their robes.

The various writings of the day that advised common sense and reason never mentioned the use of water, as this was regarded as extremely unhealthy. A small bowl was quite enough to wash the hands once a day and the face once a week. Owning a bathtub or a bathroom in the eighteenth century was regarded with suspicion and amusement as an odd fancy. The spread of epidemics discredited the Renaissance tradition of bathing which, although it may have survived in a few stately homes, was certainly forgotten in the palaces. Under these circumstances, it was quite clear why there was an enormous demand for perfume: bottles of scent replaced the bathtub.

The upper classes only became aware of the deplorable and grotesque position forced upon them by their ideals of beauty when they could compare it with the far more comfortable clothes of the post-revolutionary era. Many women wrote in their memoirs with a touch of horror of their youth, when for the sake of beauty and their reputation they too yielded to the constraints of fashion. In his *Erinnerungen an Paris* (Memories of Paris) of 1804, August von Kotzebue reminisced about past fashions:

> *That good old costume! It was invented to keep a check on our all too tender women. If a young person had to wear two big pads weighing five to six pounds, four inch heels on her shoes, a good tight corset that served as a cuirass, a farthingale that was 6 ells in circumference, a two foot high coiffure, thick, leatherlike material for her dress, a collar stiffened with wire which boxed in the face so much that she could neither move her head to the right nor left, a bouquet of flowers at her breast bigger than her head, diamond earrings wider than her hands, if, I say, she was decked out to such an extent, then there was no way that she could be as light in her movements and manners as is possible today.*

"Fashion goes with power." This observation by René König can be applied just as well to the struggle between the ruling feudal class trying to assert itself and the bourgeoisie making a bid for power, as to the changing hegemony between nations. Spanish fashion and etiquette achieved international standing when Spain dominated the economics and politics of Europe as a colonial and sea power. Its influence went far beyond the actual power of the country and was so strong that, from that time, characteristic forms of Spanish dress were accepted as the norm for official ceremonial attire. This was not only true of the countries that were directly linked with Spain but also especially of its political, economic, and religious opponent, Protestant, bourgeois Holland. Thus ruffs, stiff skirts, dark colors, and gowns that completely covered the body became the accepted forms of conservative dress and held that position for a long time.

At the beginning of the seventeenth century the influence of Spanish fashion started to wane. With the decline of Spain, there was a general realignment of power centers in Europe, as far as economics, politics, warfare, and religious dominations were concerned. This evolved through war, uprisings, and violent suppression: the Thirty Years' War is the most distinctive example. Clothes reflected these processes of realignment with unusual variety and relative informality. Without subordinating themselves unanimously to one dominating pattern, they took up numerous models and stimuli. For a while

Holland, as the leading economic and trading power of Europe, influenced trends in fashion toward the conservative and natural.

But the future still belonged to the absolute monarchies. The power of the French royal family, steadily expanded by Louis XIII, reached a climax under Louis XIV, with all attention focused on the person of the King. It is no coincidence that the ultimate prestige form in Baroque fashion was created in the reign of Louis XIV and was a fashion for men. This was the full-bottomed wig. The female version, the fontange, can only be described as a poor reflection of this monstrous male status symbol.

In the way that French absolutism seized a dominant position in trade, manufacturing, and financial and colonial policy, the court of Louis XIV also set the course of European fashion. After an informal start, the second half of the seventeenth century saw a conscious, steady stylizing of fashion, as in the heyday of Spain. Louis XIV used this apparently peripheral but highly conspicuous area to display the unlimited power of his person and form of government. The small principalities of Germany were particularly attracted by the total power of absolutism. They tried at least to portray an external image of ostentation since their political sphere of real influence was very limited. A bitter campaign, led mainly by the bourgeoisie, was fought against the forceful invasion of fashions from the French court. Although it was waged under the banner of morality and patriotism it was aimed at hitting German feudal absolutism, which was building up its influence. Nationalism was given as the reason for the abhorrence toward French fashions, but in effect this abhorrence was directed against the life-style of the aristocracy. What was expressed in literary feuds as deliberate isolation appeared largely as adaptation in the fashion of the day. After the French revolution, however, both the independence of the bourgeoisie became firmly established and the reemergence of Baroque opulence and ostentation among the aristocracy proved inevitable.

Appendix

BIBLIOGRAPHY AND SOURCES
(SELECTED)

1 ADO, ANATOLIJ VASILEVICH, *Krestyanskoye dviženiye vo Francii vo vremya velikoj buržuaznoj revolyucii konca XVIII veka.* Moscow, 1971.

2 *A la Mode. 600 Jahre europäische Mode in zeitgenössischen Dokumenten.* Ed. by Joachim Wachtel. Munich, 1963.

3 ALEWYN, RICHARD, and KARL SÄLZLE, *Das grosse Welttheater. Die Epoche der höfischen Feste in Dokument und Deutung.* Hamburg, 1959.

4 ARGAN, GIULIO CARLO, *Das Europa der Hauptstädte. 1600–1700.* Geneva, 1964.

5 ARNETH, ALFRED, *Geschichte Maria Theresias.* Vols. 1–10. Vienna, 1863–1879.

6 ASHLEY, MAURICE, *Das Zeitalter des Barock.* Munich, 1968.

7 *Aus der Zeit der Verzweiflung. Zur Genese und Aktualität des Hexenbildes.* Frankfurt am Main, 1977.

8 BANDMANN, GÜNTER, *Melancholie und Musik. Ikonographische Studien.* Cologne, Opladen, 1960. (Wissenschaftliche Abhandlungen der AG für Forschung des Landes Nordrhein-Westfalen Vol. 12)

9 *Deutsche Barockforschung. Dokumentation einer Epoche.* Ed. by Richard Alewyn. Cologne, Berlin (West), 1965.

10 BARTSCH, ROBERT, *Die Rechtsstellung der Frau als Gattin und Mutter.* Leipzig, 1903.

11 BARTSCH, LUDWIG, *Sächsische Kleiderordnungen aus der Zeit von 1450 bis 1750.* Annaberg, 1882/83. (Deutsche Schulprogramme)

12 BASEDOW, JOHANN BERNHARD, *Methodenbuch für Väter und Mütter der Familien und Völker.* Altona-Bremen, 1770.

13 BAUER, VERONIKA, *Kleiderordnungen in Bayern vom 14. bis zum 19. Jh.* Munich, 1975. (Neue Schriftenreihe des Stadtarchivs München 82)

14 BAVOUX, FRANCIS, *La sorcellerie en Franche-Comté (Pays de Quingey).* Monaco, 1954.

15 BEIER, ADRIAN, *Von der Zünfte Zwang.* Jena, 1688.

16 BLOCHMANN, ELISABETH, *Das "Frauenzimmer" und die "Gelehrsamkeit". Eine Studie über die Anfänge des Mädchenschulwesens in Deutschland.* Heidelberg, 1966.

17 BODIN, JEAN, *De la démonomanie des sorciers.* Anvers, 1593.

18 BOEHN, MAX VON, *Deutschland im 18. Jahrhundert.* Berlin, 1922.

19 BOEHN, MAX VON, *England im 18. Jahrhundert.* (2nd edition). Berlin, 1920.

20 BRAUN, LILY, *Die Frauenfrage. Ihre geschichtliche Entwicklung und ihre wirtschaftliche Seite.* Leipzig, 1901.

21 BRODMEIER, BEATE, *Die Frau im Handwerk in historischer Sicht.* Münster, 1963.

22 BRUNNER, OTTO, *Adeliges Landleben und europäischer Geist. Leben und Werk Wolf Helmhards von Hohberg 1612–1688.* Salzburg, 1949.

23 BRUYÈRE, JEAN DE LA, *Les caractères ou les mœurs de ce siècle.* 1688.

24 CAMPE, JOHANN HEINRICH, *Väterlicher Rath für meine Tochter.* 1789.

25 CHAUNU, PIERRE, *Europäische Kultur im Zeitalter des Barock.* Munich, Zurich, 1968.

26 DEFOE, DANIEL, *Sociale Fragen vor 200 Jahren. An Essay on Projects. 1697.* Translated by Hugo Fischer. Leipzig, 1890.

27 A Diderot pictorial encyclopedia of trades and industry. Manufacturing and the Technical Arts in Plates Selected from *L'Encyclopédie ou Dictionnaire raisonné des sciences, des arts et des metiers of Denis Diderot.* Ed. by Charles Coulston Gillispie. New York, 1959.

28 DONNERT, ERICH, *Politische Ideologie der russischen Gesellschaft zu Beginn der Regierungszeit Katharinas II.* Berlin, 1976.

29 *Geistliches Donnerwetter. Bayerische Barockpredigten.* Ed. by Georg Lohmeier. Munich, 1967.

30 EISENBART, LISELOTTE CONSTANCE, *Kleiderordnungen der deutschen Städte zwischen 1350 und 1700. Ein Beitrag zur Kulturgeschichte des deutschen Bürgertums.* Göttingen, 1962.

31 ELIAS, NORBERT, *Die höfische Gesellschaft. Untersuchungen zur Soziologie des Königtums und der höfischen Aristokratie.* (4th edition). Darmstadt, 1979. (Luchterhand Soziologische Texte 54)

32 *Briefe der Herzogin Elisabeth Charlotte von Orléans aus den Jahren 1676–1722.* Ed. by Ludwig Holland. Vols. 1–6. 1867–1881.

33 ERLE, MANFRED, *Die Ehe im Naturrecht des 17. Jahrhunderts. Ein Beitrag zu den geistesgeschichtlichen Grundlagen des modernen Eherechts.* Göttingen, 1952.

34 FOERSTER, ROLF HELLMUT, *Die Welt des Barock.* Berlin, Darmstadt, Vienna, 1970.

35 FORBERGER, RUDOLF, *Die Manufaktur in Sachsen vom Ende des 16. Jahrhunderts.* Berlin, 1958.

36 FRAAS, OTTO, *Das Zeitalter Maria Theresias und ihrer Söhne (1740–1792).* Graz, Vienna, 1946.

37 FRANCKE, AUGUST HERMANN, *Pädagogische Schriften.* Paderborn, 1957.

38 FRANCKE, AUGUST HERMANN, *Pädagogische Schriften.* Ed. by Gustav Kramer. Langensalza, 1885.

39 FUCHS, EDUARD, *Illustrierte Sittengeschichte vom Mittelalter bis zur Gegenwart.* Vols. 1–3. Munich, 1908–1912.

40 GAUS, MARIANNE, *Das Idealbild der Familie in den Moralischen Wochenschriften und seine Auswirkungen in der deutschen Literatur des 18. Jahrhunderts.* Rostock, 1937. (Rostocker Studien Vol. 3)

41 *Geschichte der deutschen Literatur 1600–1700.* Team of authors, Berlin, 1962.

42 *Geschichte der deutschen Literatur vom Ausgang des 17. Jh. bis 1789.* Team of authors, Berlin, 1979.

43 GONCOURT, EDMOND et JULES, *Les Maitresses de Louis XV. Lettres et documents inédits.* Paris, 1860.

Vol. 1: *Mesdemoiselles de Nesle. Madame de Pompadour.* Vol. 2: *Madame de Pompadour. Madame du Barry.* Paris, 1860.

44 GONCOURT, EDMOND et JULES, *La femme au XVIII^e siècle.* Vienna, Bern, Stuttgart, 1963.

45 GRAUERT, W.H., *Christina Königin von Schweden und ihr Hof.* Vols. 1–2. Bonn, 1837–1842.

46 GREY, JAN, *Katharina die Grosse.* Berlin (West), Darmstadt, Vienna, 1964.

47 GRIGULEVIC, J.R., *Ketzer–Hexen–Inquisitoren. (13.–20.Jh.).* Parts 1 and 2. Berlin, 1980 (2nd edition).

48 HAFNER, JOSEF, *Gesinderecht in Schwaben von den Anfängen bis zum 18.Jahrhundert.* Mainz, 1959.

49 HAMPEL-KALLBRUNNER, GERTRUD, *Beiträge zur Geschichte der Kleiderordnung mit besonderer Berücksichtigung Österreichs.* Vienna, 1962.

50 HANSTEIN, ADALBERT VON, *Die Frauen in der Geschichte des deutschen Geisteslebens des 18. und 19.Jahrhunderts.* Leipzig, 1899.

51 HEDEMANN, JUSTUS WILHELM, *Die Rechtsstellung der Frau, Vergangenheit und Zukunft.* Berlin, 1952.

52 HEIMBUCHER, MAX, *Die Orden und Kongregationen der katholischen Kirche.* (3rd edition). Paderborn, 1933/34.

53 HEITZ, GERHARD, "Der Zusammenhang zwischen den Bauernbewegungen und der Entwicklung des Absolutismus in Mitteleuropa," *Zeitschrift für Geschichtswissenschaft.* Special number 1965. Pp. 71–83.

54 HILDEBRANDT, HANS, *Die Frau als Künstlerin.* Berlin, 1928.

55 HIPPEL, THEODOR GOTTLIEB VON, *Über die Ehe.* Frankfurt, Leipzig, 1796. Reprint Selb, 1976.

56 HIPPEL, THEODOR GOTTLIEB VON, *Über die bürgerliche Verbesserung der Weiber.* Berlin, 1792.

57 HIRSCH, ANTON, *Die Frau in der bildenden Kunst.* Stuttgart, 1905.

58 HOFFMANN, JULIUS, *Die "Hausväterliteratur" und die "Predigten über den christlichen Hausstand". Lehre vom Hause und Bildung für das häusliche Leben im 16., 17. und 18.Jahrhundert.* Weinheim, 1959.

59 HORNER, JOYCE MARY, *The English Women Novelists and their Connection with the Feminist Movement (1688–1797).* Northampton/Mass., 1929/30.

60 HUIZINGA, JOHAN, *Holländische Kultur im 17.Jahrhundert.* Basle, 1961.

61 JONAS, WOLFGANG, VALENTINE LINSBAUER, and HELGA MARX, *Die Produktivkräfte in der Geschichte.* Vol. 1. Berlin, 1969.

62 KÄHLER, WILHELM, *Gesindewesen und Gesinderecht in Deutschland.* Jena, 1896.

63 *Memoiren der Kaiserin Katharina II.* Written by herself. Preface by Alexander Herzen. Hannover, 1859.

64 *Aus der Zeit Maria Theresias. Tagebücher des Fürsten Johann Josef Khevenhüller, 1742–1776.* Vols. 1–8. Vienna, Leipzig, 1909–1972.

65 KNIGGE, ADOLF, Frh. von, *Über den Umgang mit Menschen.* Hannover, 1788.

66 KÖNIG, RENÉ, *Kleider und Leute. Zur Soziologie der Mode.* Hamburg, 1967.

67 KÖNNECKE, OTTO, *Rechtsgeschichte des Gesindes in West- und Süddeutschland.* Marburg, 1912.

68 KRAUSS, WERNER, *Studien zur deutschen und französischen Aufklärung.* Berlin, 1963.

69 KREBS, PETER-PER, *Die Stellung der Handwerkerswitwe in der Zunft vom Spätmittelalter bis zum 18.Jahrhundert.* Regensburg, 1974.

70 KRICHBAUM, JÖRG, and REIN A. ZONDERGELD, *Künstlerinnen von der Antike bis zur Gegenwart.* Cologne, 1979. (dumont taschenbücher 82).

71 KRÜGER, HORST, *Zur Geschichte der Manufaktur und der Manufakturarbeit in Preussen. Die mittleren Provinzen in der 2.Hälfte des 18.Jahrhunderts.* Berlin, 1958.

72 KRULL, EDITH, *Das Wirken der Frau im frühen deutschen Zeitschriftenwesen.* Charlottenburg, 1939. (Beiträge zur Erforschung der deutschen Zeitschrift. Vol. 5)

73 KUCZYNSKI, JÜRGEN, *Die Geschichte der Lage der Arbeiter unter dem Kapitalismus.* Vol. 18: *Studien zur Geschichte der Lage der Arbeiterinnen Deutschlands von 1700 bis zur Gegenwart.* (2nd edition). Berlin, 1974.

74 KUCZYNSKI, JÜRGEN, *Geschichte des Alltags des deutschen Volkes.* Vol. 1: *1600–1650.* Berlin, 1980; vol. 2: *1650–1800.* Berlin, 1981.

75 KYBALOVÁ, LUDMILLA, OLGA HERBENOVÁ and MILENA LAMAROVÁ, *Das grosse Bilderlexikon der Mode. Vom Altertum zur Gegenwart.* Introduction by Hermann Exner. Dresden, 1980.

76 L'ANCRE, PIERRE DE, *Tableau de l'inconstance des mauvais anges et démons.* Paris, 1613.

77 LEPORIN, DOROTHEA CHRISTIANE, *Gründliche Untersuchung der Ursachen, die das weibliche Geschlecht vom Studieren abhalten.* Berlin, 1742. Reprint Hildesheim, New York, 1978.

78 Tot LERING en Vermaak. *Bedeutungen holländischer Genredarstellungen aus dem 17.Jahrhundert.* Amsterdam, 1976.

79 LOCKE, JOHN, *Some Thoughts Concerning Education.* London, 1693.

80 MAYASSOVA, N.A., *Altrussische Stickereien.* Moscow, 1978.

81 MÂLE, EMILE, *L'art religieuse de la fin du XVI^e siècle, du XVII^e et du XVIII^e siècle.* Paris, 1932.

82 *Maria Theresia als Herrscherin. Aus den deutschen Denkschriften, Briefen und Resolutionen (1740 bis 1756).* Ed. by Josef Kallbrunner. Leipzig, 1917.

83 *Maria Theresia in ihren Briefen und Staatsschriften.* Ed. and introduced by Ludwig F.Jedlicka. Vienna, 1955.

84 *Briefe der Kaiserin Maria Theresia an ihre Kinder und Freunde.* Ed. by A.Arneth. Vols. 1–4. Vienna, 1881.

85 MARTENS, WOLFGANG, *Die Botschaft der Tugend. Die Aufklärung im Spiegel der deutschen Moralischen Wochenschriften.* Stuttgart, 1968.

86 MENCK, URSULA, *Die Auffassung der Frau in den früheren Moralischen Wochenschriften.* Hamburg, 1940.

87 MITTENZWEI, INGRID, "Theorie und Praxis des aufgeklärten Absolutismus in Brandenburg-Preussen," *Jahrbuch für Geschichte.* Berlin, 1972, pp. 53–106.

88 MÖLLER, HELMUT, *Die kleinbürgerliche Familie im 18.Jahrhundert. Verhalten und Gruppenkultur.* Berlin, 1969. (Schriften zur Volksforschung 3)

89 MÖSER, JUSTUS, *Patriotische Phantasien.* Parts 1–3. Berlin, 1774–1780.

90 MOSCHEROSCH, HANS-MICHAEL, *Christliche Vermächtnis oder Schuldige Versorg...* Strasbourg, 1643.

91 MOSCHEROSCH, HANS-MICHAEL, *Gesichte Philanders von Sittewald.* 1650.

92 NASSE, PETER, *Die Frauenzimmer-Bibliothek des Hamburger "Patrioten" von 1724: Zur weiblichen Bildung der Frühaufklärung.* Stuttgart, 1976.

93 NOLHAC, PIERRE DE, *Madame de Pompadour et la politique.* (6th edition). Paris, 1928.

94 NOLTE, URSULA, *Die Entwicklung der weiblichen Bildung von der Aufklärung bis zur Romantik.* Mainz, 1952.

95 *Lettres de Madame la Marquise de Pompadour.* Vols. 1–2. Londres, 1772.

96 *Die vorzüglichsten Rechte der deutschen Weibsbilder: als Jungfern, Eheweiber, schwanger und gebährend betrachtet.* Vienna, 1791. Reprint Frankfurt am Main, 1975.

97 *Reiseberichte von Deutschen über Russland und von Russen über Deutschland.* Ed. by F.B.Kaiser and B.Stasiewski. Cologne, Vienna, 1979.

98 RENGER, KONRAD, *Lockere Gesellschaft. Zur Ikonographie des Verlorenen Sohnes und von Wirtshausszenen in der niederländischen Malerei.* Berlin, 1970.

99 REYNOLDS, MYRA, *The Learned Lady in England, 1650–1760.* Boston, New York, 1920.

100 RIEHL, WILHELM HEINRICH, *Die Naturgeschichte des Volkes als Grundlage einer deutschen Sozialpolitik.* Vol. 3: *Die Familie.* Stuttgart, Berlin, 1854.

101 RÜHLE, OTTO, *Illustrierte Kultur- und Sittengeschichte des Proletariats.* Preface by A.Lunacharski. 1st vol. Reprint Frankfurt am Main, 1971.

102 SALLWÜRK, ERNST VON, *Fénelon und die Literatur der weiblichen Bildung in Frankreich von Claude Fleury bis Frau Necker de Saussure.* Langensalza, 1886.

103 SCHMELZEISEN, GUSTAV K., *Die Rechtsstellung der Frau in der Stadtwirtschaft. Eine Untersuchung zur Geschichte des deutschen Rechts.* Stuttgart, 1935.

104 SCHNEEDE, UWE M., "Gabriel Metsu und der holländische Realismus," *Oud Holland, 83.* 1968 (1). Pp. 45–61.

105 SCHNEIDER, LOTHAR, *Der Arbeiterhaushalt im 18. und 19. Jahrhundert.* Berlin, 1967.

106 SCHÖNFELD, WALTER, *Frauen in der abendländischen Heilkunde.* Stuttgart, 1947.

107 *Schule und Staat im 18. und 19. Jahrhundert. Zur Sozialgeschichte der Schule in Deutschland.* Frankfurt am Main, 1974.

108 *Die ersten Schwestern des Ursulinenordens. Nach den Ordensannalen.* Preface by August Lehmkuhl S.J. Paderborn, 1897.

109 SOBOUL, ALBERT, *La Société française dans la seconde moitié du XVIIIᵉ siècle. Structures sociales, cultures et modes de vie.* Paris, 1969.

110 SOLDAN, WILHELM, and HEINRICH HEPPE, *Geschichte der Hexenprozesse.* Hanau, 1911.

111 SPEE, FRIEDRICH VON, *Cautio Criminalis oder rechtliches Bedenken wegen der Hexenprozesse.* Darmstadt, 1967.

112 *Die Sprache der Bilder. Realität und Bedeutung in der niederländischen Malerei des 17. Jahrhunderts.* Exhibition Brunswick, 1978.

113 STAROBINSKI, JEAN, *Die Erfindung der Freiheit, 1700–1789.* Geneva, 1964.

114 STILLICH, OSCAR, *Die Lage der weiblichen Dienstboten in Berlin.* Berlin, 1902.

115 STOCKAR, JÜRG, *Kultur und Kleidung der Barockzeit.* Stuttgart, Zurich, 1964.

116 STOPES, CHARLOTTE, *British Freewomen.* London, 1894.

117 SWIFT, JONATHAN, *Directions to Servants.* Dublin, 1745.

118 *Sämtliche Schriften der hl. Theresia von Jesu.* New German edition translated and revised by Aloysius Alkofer (2nd edition). Munich, 1956.

119 THIEL, ERIKA, *Geschichte des Kostüms. Die europäische Mode von den Anfängen bis zur Gegenwart.* Berlin, 1980.

120 THIENEN, F. VON, *Das Kostüm der Blütezeit Hollands 1600–1660.* Berlin, 1930.

121 THOMASIUS, CHRISTIAN, *Kurtzer Entwurff der Politischen Klugheit . . .* Frankfurt, Leipzig, 1710. Reprint Frankfurt am Main, 1971.

122 THOMASIUS, CHRISTIAN, *Über die Hexenprozesse.* Weimar, 1967. (Arbeiten aus dem Institut für Staats- und Rechtsgeschichte der Martin-Luther-Universität Halle-Wittenberg. Number 5)

123 TREVOR-ROPER, HUGH REDWALD, "Der europäische Hexenwahn des 16. und 17. Jahrhunderts," Trevor-Roper, *Religion, Reformation und sozialer Umbruch. Die Krisis des 17. Jahrhunderts.* Pp. 95–180. Darmstadt, 1970.

124 TUFTS, E., *Our Hidden Heritage. Five Centuries of Women Artists.* London, New York, 1974.

125 VEBLEN, THORSTEIN, *Theorie der feinen Leute.* Cologne, 1958.

126 WEBER, MARIANNE, *Ehefrau und Mutter in der Rechtsentwicklung.* Tübingen, 1907.

127 WEBER-KELLERMANN, INGEBORG, *Die deutsche Familie. Versuch einer Sozialgeschichte.* Frankfurt am Main, 1974.

128 WEISBACH, WERNER, *Der Barock als Kunst der Gegenreformation.* Berlin, 1921.

129 WILCKENS, LEONIE VON, *Tageslauf im Puppenhaus. Bürgerliches Leben vor 300 Jahren.* Munich, 1956.

130 WUTTKE, ROBERT, *Gesindeordnungen und Gesindezwangsdienst in Sachsen bis 1835.* Munich, 1893.

131 ZAHN, LEOPOLD, *Christine von Schweden, Königin des Barock.* Cologne, Berlin, 1953.

132 ZEDLER, JOHANN HEINRICH, *Grosses vollständiges Universallexikon.* Halle, Leipzig, 1739.

PHOTOGRAPH SOURCES